THE COMPLETE GUIDE TO
LIGHT
& LIGHTING
IN DIGITAL PHOTOGRAPHY

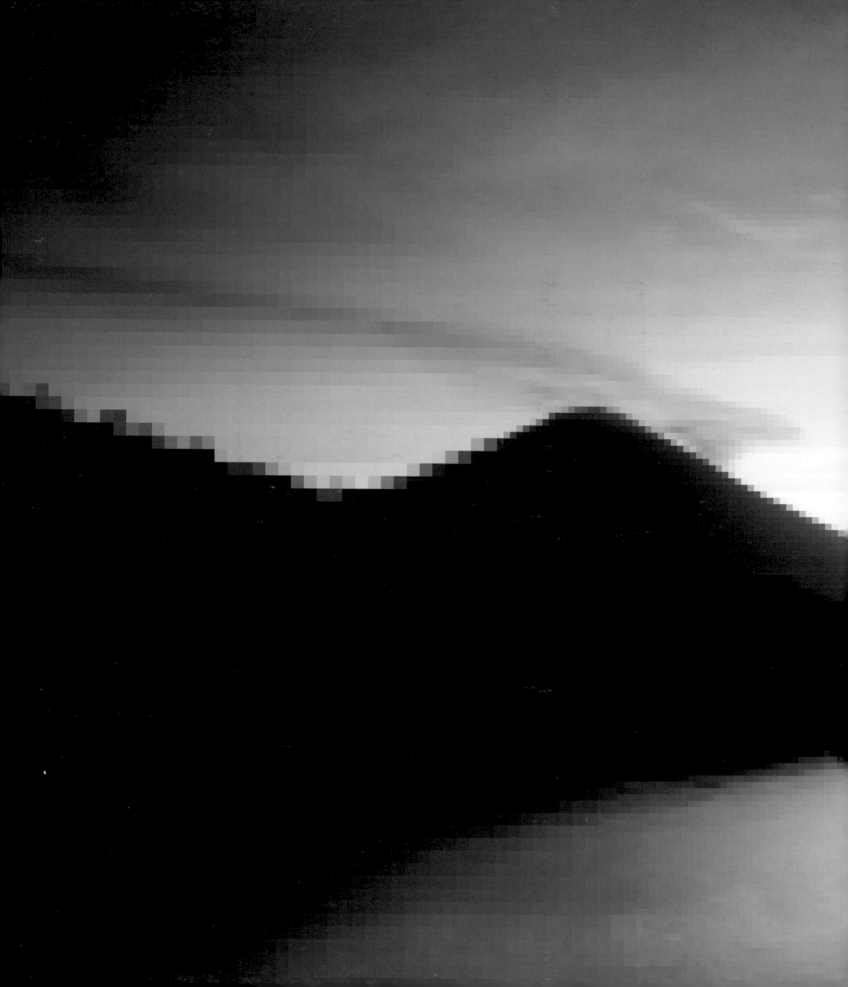

THE COMPLETE GUIDE TO
LIGHT
& LIGHTING
IN DIGITAL PHOTOGRAPHY

Michael Freeman

ILEX

First published in the United Kingdom in 2006 by

ILEX
The Old Candlemakers
West Street, Lewes
East Sussex, BN7 2NZ

www.ilex-press.com

Copyright © The Ilex Press Limited

This book was conceived by
ILEX
Cambridge
England

Publisher Alastair Campbell
Creative Director Peter Bridgewater
Editorial Director Tom Mugridge
Editor Adam Juniper
Art Director Julie Weir
Designers Chris and Jane Lanaway
Design Assistant Kate Haynes

British Library Cataloguing-in-Publication Data
A catalogue record for this book is available from
the British Library

ISBN 10: 1-904705-88-X
ISBN 13: 978-1-904705-88-8

Printed and bound in China

For more information on this title please visit:
www.web-linked.com/cgpluk

CONTENTS

INTRODUCTION 6

SECTION 1
LIGHT & THE CAMERA 8

LIGHT AS WE SEE IT 10
DYNAMIC RANGE 12
LIGHT ON THE SENSOR 14
BIT DEPTH AND LIGHT 16
THE COLOUR OF LIGHT 18
COLOUR TEMPERATURE, REAL AND CORRELATED 20
MEASURING LIGHT 22
THE HISTOGRAM 32
CHANGING SENSITIVITY 34
WHITE BALANCE AND HUE 36
EXPOSURE STRATEGIES 38

SECTION 2
DAYLIGHT 40

ONCE SOURCE, MANY VARIABLES 42
PURE SUNLIGHT 44
HEIGHT OF THE SUN 46
TROPICAL SUNLIGHT 48
CLOUDS AS DIFFUSERS 50
CLOUDS AS REFLECTORS 54
DAYBREAK 56
GOLDEN LIGHT 58
SOFT LIGHT 60
STORMLIGHT 64
A FOGGY DAY 66
TWILIGHT AND NIGHT 68
KEEPING PACE WITH THE END OF THE DAY 72
SHOOTING INTO SUNLIGHT 74

SECTION 3
ARTIFICIAL LIGHT 76

INCANDESCENT LIGHT 78
FLUORESCENT LIGHT 82
VAPOUR DISCHARGE LIGHT 84
MIXED LIGHT SOURCES 86

SECTION 4
PHOTOGRAPHIC LIGHTING 90

CAMERA-MOUNTED FLASH 92
MAINS FLASH 94
INCANDESCENT LIGHTING 96
DAYLIGHT (HMI) LIGHTING 98
HIGH-PERFORMANCE FLUORESCENT 100
LIGHTING SUPPORTS 102
REFLECTORS AND DIFFUSERS 106
REFLECTORS AND FLAGS 110
EFFECTS LIGHTS 112

SECTION 5
DIGITAL LIGHTING 116

CAMERA CALIBRATION 118
FITTING THE TONAL RANGE TO
THE GAMUT 120
CHANGING BRIGHTNESS 122
CHANGING CONTRAST 124
REVEALING SHADOWS 126
EYESIGHT AND HIGH DYNAMIC RANGE 128
HIGH DYNAMIC RANGE AND REALISM 130
EXPOSURE, BRACKETING,
PHOTOSHOP BLENDING 132
DEDICATED BLENDING SOFTWARE 134
HDR IMAGING 136
GENERATING HDRIS 138

TONE-MAPPING METHODS 140
TONE-MAPPING WITH A CURVE 142
ADVANCED HDR CURVE ADJUSTMENT 146
PREVIEWING HDR IMAGES 148
CHOOSING THE MERGING METHOD 150
TIME-LAPSE DAYLIGHT 152
MULTIPLE LAYERED LIGHTING 156
DIGITAL FLARE CONTROL 158
DIGITAL FOG 160
SYNTHETIC SUNLIGHT 162
LIGHTING FOR QTVR 164

SECTION 6
THE CRAFT OF LIGHTING 168

CHIAROSCURO 170
REVEALING TEXTURE 172
TRANSPARENCY & TRANSLUCENCY 174
POSITIONING THE MAIN LIGHT 176
FILL LIGHTS AND REFLECTORS 184
PORTRAITS WITH FILL 194
BACK-LIGHTING 196
SIDE- AND RIM-LIGHTING 198
FULL FRONTAL LIGHTING 200
OVERHEAD LIGHTING 202
MULTIPLE LIGHT SOURCES 204
LIGHTING SPACES 206
MAKING LIGHT SOFTER 208
ENVELOPING LIGHT 210
MAKING LIGHT SHARPER 214
OPTICAL PRECISION LIGHTING 216

GLOSSARY 218
INDEX 223

INTRODUCTION

I have always had a special fascination with light in photography, mainly, I suppose, because it is the one variable that always makes a difference to the shot. Whatever the subject, and whatever the style and approach, there is usually a choice of how to light it. Yes, certainly there are situations so completely driven by the subject and the moment, as in news and sports, that there is not the luxury of trying out different lighting, but even then, knowing how the sensor will respond and what the possibilities are in post-production gives important control. In more leisurely situations, or ones that can be planned for in advance, variations in light can create totally different images. For me, light is a visual commodity. The quality of lighting has the ability to make a picture worthwhile shooting, or not, and in some scenes it can even rival what is ostensibly the subject for attention. Above all, the play of light in a photograph can simply be enjoyable for its own sake.

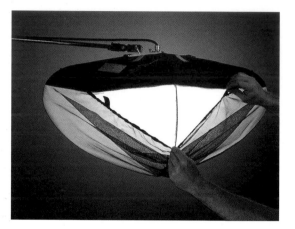

Lighting equipment is covered in detail, from the technologies that cast the light, to the techniques for precisely directing it.

As to why this matters, and why certain kinds of light quality are preferred over others, this is quite another question. The psychology of attraction is way beyond the scope of this book, nor am I qualified to talk about it. Yet the range of lighting effects can, if you want to, be arranged on some kind of scale of value. Some are more attractive, more boring, more dramatic, more strange, and as with all value judgments this is always according to the person taking the image or the person viewing. Naturally, these do not always coincide, although most of us like to think that what we shoot will find an enthusiastic audience.

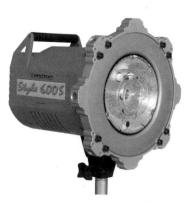

In Section 4 of this book you'll find the details you need to create the perfect lighting setup, whether you're creating a still life or shooting a model.

This new look at light and lighting combines what I see as two essential perspectives: that of the photographer who knows that the light that falls on the subject is likely to make or break the shot, and that of the digital camera user who can (and must) interpret and alter light through digital

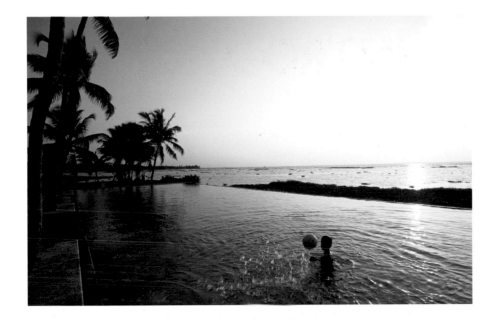

Natural light is just as important as artificial. Within these pages you'll find out how to anticipate the perfect light and refine your masterpiece on screen.

means. I've tried to address all of the key lighting skills, from dealing with found lighting to constructing illumination from scratch. In particular, the latest digital techniques are all included, from in-camera procedures to post-production, including some complex digital lighting effects. I make no apology for digging into the more technical digital issues. Digital cameras and digital imaging techniques are continuing to evolve, and photographers have ever more powerful tools to create images, in some cases beyond what we used to think was technically possible.

Cheap film cameras helped to spread photography worldwide, but digital cameras have made photography more universally successful and more instantly gratifying. At the same time, the Internet has created an explosion of image display. Photographs are now so common a currency, and there are so many of them everywhere, that there is an even greater need for photographers (as opposed to people who just use cameras) to work harder at creating images that stand out. One of the ways of doing this is to choose and use lighting with skill and care. After all, if the subject matter is available to everyone, as it often is, lighting is one of the key qualities that can set a photograph apart from the majority. To the viewer who pays considered attention to a photograph, and who to some degree makes a comparison with other images, the sense that the photographer was in control of the lighting and understood its nuances is an important factor in its appreciation.

LIGHT AS WE SEE IT 10

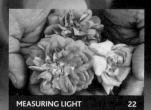

MEASURING LIGHT 22

DYNAMIC RANGE 12

THE HISTOGRAM 32

LIGHT ON THE SENSOR 14

CHANGING SENSITIVITY 34

BIT-DEPTH AND LIGHT 16

WHITE BALANCE AND HUE 36

THE COLOUR OF LIGHT 18

EXPOSURE STRATEGIES 38

COLOUR TEMPERATURE,
REAL AND CORRELATED 20

LIGHT & THE CAMERA

The ways in which we handle light to create an image depend ultimately on the way it is captured by the camera. Digital photography has revolutionized this because of the way in which the sensor works and because of the unbroken stream of information as the image data moves from sensor to memory card and onto the computer. Camera sensors react to and record light in a fundamentally different manner from analogue film, and this is the basis of the special control that digital gives over the image. Digital photography gives almost total control over the capture and manipulation of light. Not just more so than film, but in a different league altogether. This makes a comprehensive guide to all the techniques and possibilities a necessity, not just to help digital photographers through the minefield of white balance, clipped highlights and dynamic range, but so that they can get the most out of any situation, tuning the effects of lighting for high-performance photography that realizes their creative needs.

The camera is no longer a vehicle for carrying a light-sensitive receptor, as it arguably was with film. The sensor is not simply a component that fits behind the shutter and lens that can be slotted in and out. Rather, it is a key part of a system designed to interpret and process its response. An increasingly important part of this processing is automation of one kind or another. With all the huge capacity for processing the image within the camera, there are inevitably ways of automating everything, and that includes the key light settings. These are, of course, exposure, white balance, and contrast, and the convenience of the auto option applied to any of them is that the image can be assessed objectively and rendered 'correctly'. Auto is the natural default for image processing, for the simple reasons that brightness, overall colour and contrast can be measured, and then adjusted to fit known values. The 'correct' light settings are an exposure and contrast that puts the mid-tones near the middle of the histogram and avoids loss of highlights and shadows as much as possible. It also needs a colour balance that takes the mid-tones that are close to neutral and makes them exactly neutral. All of this is a huge convenience, but only as long as we know what the camera is doing on our behalf and can override it.

LIGHT AS WE SEE IT

Among other things, digital capture and post-production have created a more thoughtful and sophisticated approach to light. We have always seen a real-life scene in quite a different way from a recorded image, but before digital the options for reconciling the scene with the image were limited. So limited, in fact, that there was little point worrying over fundamentals like capturing the entire tonal range of a high-contrast scene, or trying to bring together the different colour casts from mixed-light scenes. Now that we can get close to the individual elements of the visual experience, we need to remind ourselves what these are.

How we ourselves see light is not necessarily how the camera records it, but the ultimate aim is to produce images that correspond to our visual experience.

First and most important, the eye builds up an image with unconscious rapid movements, flickering over the scene to take in first the most prominent parts, then the remainder, using a narrow angle of focused view. This happens very quickly, taking a fraction of a second at the start, adding more information over time. From the point of view of light information, the effect is that a huge range of brightness can be absorbed and factored into the view. A single exposure onto film or onto a sensor cannot come close. Instead photography has, over the years, established a syntax that includes silhouetted images and flared views. These are artificial constructs, in that we don't actually see in this way, but they are so familiar now that they have acquired a reality of their own.

Secondly, the visual cortex adapts to changing light conditions. As daylight gradually fades to night, we do not experience increasing darkness until quite late on, thanks to various mechanisms including dilation of the pupil. Equally, if you are sitting in a tungsten-lit room as the daylight fades and the room lights gradually take over, the colour of the light will not seem to change much, yet if you were to walk indoors from the evening light outside, it would instantly look orange. Any digital correction must be based on whether the viewer expects indoor light to have a warm tinge.

THE WAY WE SEE

The human eye accommodates for major differences in brightness by rapidly building up a 'memory' of a view, flickering across it according to what catches its attention in unconscious saccadic movements. The focused areas are relatively small, but 'build' to a complete view, with brightness and colour automatically equalized. This sequence, building to an image of a modern Japanese tea-ceremony room, is simulated but is basically the way I saw it.

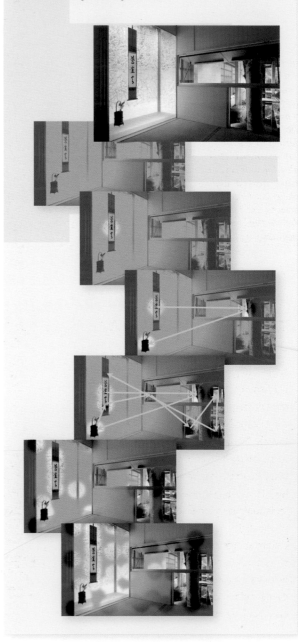

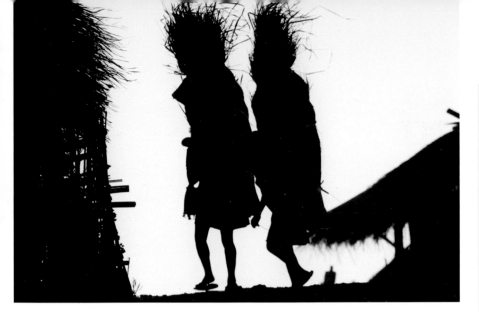

The graphic silhouette
Another inevitability of the narrow dynamic range of film is the into-the-light shot rendered as a silhouette, and photographers have learned to use this for graphic impact. Here, hill-tribe girls carrying thatch create a double-take effect on a first-time viewer – not immediately obvious but the view eventually makes sense.

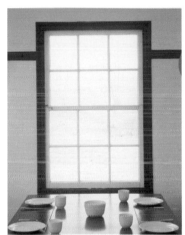

Acceptable flare
More than a century of looking at photographs has made this kind of image, looking out from a room onto a washed-out exterior, not just acceptable but in some ways attractive for the sensation of bright light flooding into the space.

SOURCES OF LIGHT

Most of the light we see by and photograph by is incandescent, which is to say it is generated by something burning. This, though not much else, is what the sun and a domestic lamp have in common. The important differences for photography are how big and how hot. On another principle altogether are lamps that rely on passing an electric current through an enclosed envelope of gas to excite electrons into emitting light. These have wavelength gaps in the emission that produce colour casts – to which the eye can adjust much more easily than the camera and sensor. Flash, a mainstay of photographic lighting, is not part of our visual experience, being too rapid to register an image on the retina.

Sunlight/daylight: Typically $1/125$ sec at $f16$ at ISO 100 at its brightest, white during most of the day, diffused and reduced with cloud and other weather conditions.

Incandescent light: Weak unless designed for photography, more orange in colour than daylight, emitted by a burning filament.

Fluorescent light: An electric current passing through a gas stimulates a coating of fluorescers inside of the tube. Common in superstores and offices though unfashionable in interior design circles. It looks more or less white to the eye but photographs with a difficult-to-predict colour cast.

Vapour discharge light: A cocktail of gases excited by an electric current to give a variety of colours of light. They are largely uncorrectable unless specifically designed for filming and photography, as with HMI.

THE INVERSE SQUARE LAW

The intensity of illumination falling on a subject diminishes with distance from the light source. Importantly, however, it diminishes in proportion to the square of the distance, and hence operates under the Inverse Square Law: $lux = cp \div d^2$ (where cp is the candle-power of the light and d is the distance to the surface being measured in lux). Thus, a bright distant light shows less variation over a scene in depth than does a weaker light close by. The brightest, most distant source is the sun, which effectively gives constant illumination over any distance on Earth. Local sources, like this candle held in a Buddhist festival, create only small pools of light.

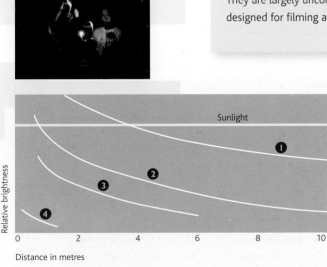

① 800-joule studio flash (guide number 210)

② on-camera flash (guide number 40)

③ 800-watt tungsten halogen lamp

④ 60-watt tungsten halogen lamp

Relative brightness

Sunlight

Distance in metres

11

DYNAMIC RANGE

More important than ever, given both the particular way in which sensors respond to light and the many possibilities for coping with it, dynamic range is an essential feature of the light in any scene in front of the camera. More than this, it is a characteristic not just of the camera's sensor, but of the display, which includes both the computer's monitor and the paper on which the image is printed. To make full use of the capabilities of digital photography, all three must somehow be matched. Briefly stated, the dynamic range of many scenes can be much higher than the ability of the sensor to record it, while the dynamic range of the image is itself often greater than that of an ordinary monitor, and certainly than of paper.

Dynamic range is of special importance to digital capture. This is the ratio of the brightest tone to the darkest, and affects the scene, the camera, and the way the image is displayed.

Most exposure and capture problems arise because of too high a dynamic range. Too high, that is, for the sensor, because the eye can cope with a very high range indeed, up to around 30,000:1 depending on the circumstances. It does this by fixing attention in rapid sequence on small local areas within the field of view, and adapting rapidly to the different levels of brightness. Its dynamic range for small local areas is probably around 100-150:1, but the visual cortex 'assembles' the experience of jumping around the scene into a wider view with a much higher range remembered.

The examples here show scenes from low to high dynamic range. The definition is flexible, but common sense suggests that a high dynamic range scene is one that exceeds the ability of an 8-bit JPEG or 8-bit monitor to encompass – in other words, more than 256:1, which is more than 8 f-stops. Very high dynamic range scenes are those that include the light source, which depending on how you define 'light source' can include not just the sun or a light fitting or street lamp, but also a shiny reflective surface. The camera's LCD histogram display gives an immediate clue: tones clumped together in the center indicate low dynamic range, while filling the entire field and pressed up against the left and right edges is a clear sign of high dynamic range. Remember that the histogram displayed is that of the 8-bit JPEG and not, in the case of cameras with 12-bit or higher sensors, the full Raw range.

As we'll see with High Dynamic Range (HDR) images on pages 122-123, there are advanced digital ways of dealing with this, but for normal shooting, high dynamic range means watching out for blown-out or 'clipped' highlights and blocked-up shadows. Making some kind of compromise is usually unavoidable – see exposure Strategies on pages 38-41.

DYNAMIC RANGE

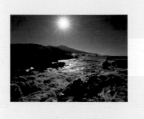

Full sunlight scene

50,000:1

16+ stops

Cumulative response of eye

30,000:1

15 stops

Digital Image

2,000:1

11+ stops

LCD display

350:1

8+ stops

Print

32:1

5 stops

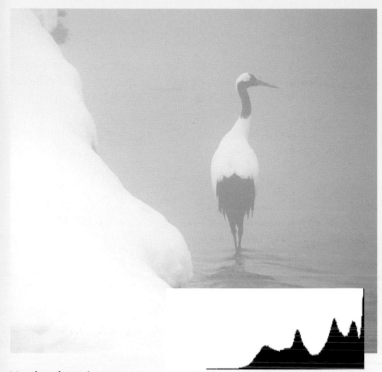

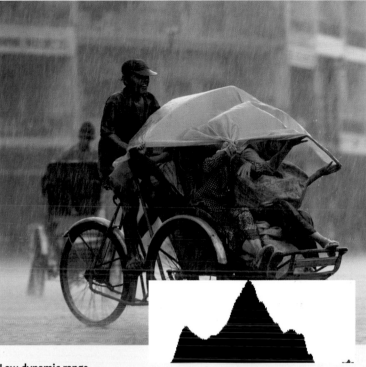

Very low dynamic range
A Japanese crane in snow and winter fog, which diffuses the light so strongly that the dynamic range is confined to only half of the scale (a full exposure ensures that the snow remains white).

Low dynamic range
Torrential rain in Phnom Penh, Cambodia, performs much the same function as the winter fog (left) in lowering the range. Note the gaps both left and right on the scale.

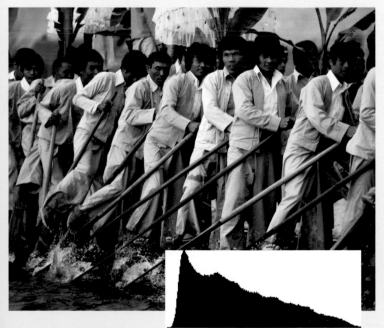

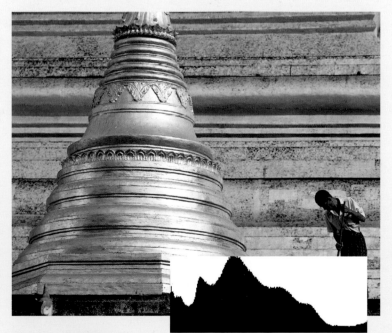

Average dynamic range
Where the dynamic range of the scene matches the 8-bit display, the histogram just fits, meaning that the deep shadows are almost black, and the highlights almost white, as in this shot of leg-rowers on Lake Inlé.

High dynamic range
By definition, any image that includes its light source has a high dynamic range, and in the case of this gilded stupa in Burma, this extends to large specular reflections. As the histogram shows, the tonal range is crushed up to both the left and right edges of the scale.

LIGHT ON THE SENSOR

Digital sensors react to light in a way that is substantially different from film, and their characteristic response changes how we think about shooting.

Superficially, and by the results, sensors may seem to be basically a solid-state version of a film emulsion. There are many points of comparison, and camera manufacturers naturally try hard to make the image captured by a sensor look like the film image that many people are familiar with (though interestingly, memories of how images on film should look are beginning to fade from the collective memory). The process is different, however, and in ways that will affect shooting.

The sensor is an array of individual photosites, often compared by analogy to tiny wells, each containing a photo-diode that responds to light falling on it by acquiring a charge. The charge is in proportion to the number of photons striking the diode, from zero (none/black) to full (white). This charge is then moved from the sensor through data transfer channels for processing. The important feature of this process from the point of view of exposure is that the photosite – the well – fills up one step at a time, in a linear fashion. When it's full, there is no useful information, just white. Now compare this with film, which does not react in a linear way. As the exposure gets fuller, the response slows down, meaning that what would be over-exposure in digital capture is not quite so damaging with film.

The diagrams opposite show the difference, with film's characteristic S-shaped response curve. As far as highlights are concerned, the gradual tailing off of response (the 'shoulder') helps to preserve delicate highlight detail. Digital capture lacks this failsafe to over-exposure. The same thing happens at the opposite, shadow end of the exposure scale. Film has a 'toe', a gentle slope that tends to preserve shadow detail, while the sensor does not. For mainly psycho-perceptual reasons, this does not seem to matter to the viewer quite as much as loss of highlights. The term commonly used for over- and under-exposure in digital capture is 'clipping', and a look at a histogram

THE RESPONSE OF SENSORS AND FILM

The characteristic curve is a graph in which the brightness of an image is plotted on a vertical scale against the brightness of the light falling on it on a horizontal scale. The mid-tones, as you would expect, fall on a straight line, which shows that an increase in the light results in a proportional lightening of tones in the image. This is a linear response, and is shared in these mid-tones by film and digital sensors.

The key difference is that the sensor (dotted line) continues at either end, shadows and highlights, to respond in this linear way. Film (yellow), on the other hand, slows down in its response at either end, resulting in the typical 'shoulder' and 'toe' on the characteristic curve. This means that film is more forgiving of over- and under-exposure than digital capture.

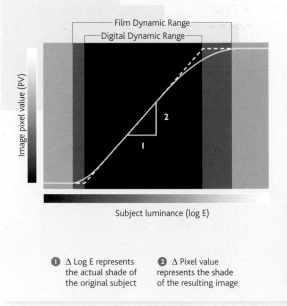

❶ Δ Log E represents the actual shade of the original subject

❷ Δ Pixel value represents the shade of the resulting image

makes this clear. With an over-exposed digital image, a number of the photo-sites return pure white pixels – at the right edge of the scale the tones are 'clipped'. A similar thing happens at the left, shadow end.

Continuing research and technological improvements are gradually addressing this problem. Fujifilm, for instance, use two diodes in each photo-site, the smaller one kicking in for high brightness levels. Shooting at a higher bit-depth, such as with a 12-bit Raw format instead of 8-bit TIFF or JPEG (even better, a high-end camera with a 14-bit sensor), also increases the dynamic range of the capture. Nevertheless, the standard precaution in a high-contrast situation is to preserve the highlights, and for this the clipping warning that most good cameras offer as an optional display is an essential tool.

DIGITAL'S NON-LINEAR RESPONSE

A simulated comparison between linear and non-linear response. On the left, the non-linear, film-like treatment holds the highlights in the headscarf, while the linear, digital-like treatment sends them off the scale. In fact, the image was shot as a high bit depth Raw, which can circumvent clipping, and converted digitally.

WARNING ON THE LCD

An extremely useful display that is accessible on most digital cameras is a Histogram. The clipped area is obvious on the histogram, crushed up against the right edge of the scale. Other cameras can also display a flashing clipped highlight warning over the areas of the image which were over exposed, as illustrated (see also page 38 for a similar example).

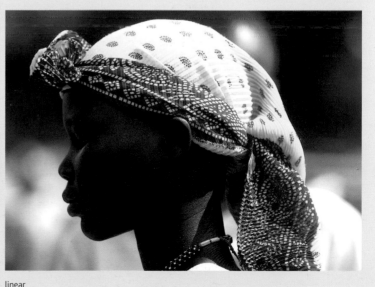

Histogram
A quick check of an image's histogram reveals any blown highlights. A tall spike at the far right indicates that large areas of pure white exist in the image, a sure sign that some detail has been clipped.

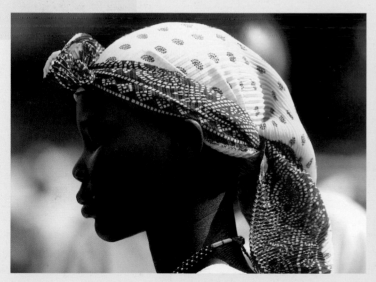

non-linear

linear

BIT-DEPTH AND LIGHT

Bit-depth is the degree of precision with which the sensor records the differences in brightness, and therefore colour, and affects image quality in post-production.

The defining feature of digital imaging is that tones and colours are assigned levels on a scale; each one is discrete. The subtlety and accuracy of these tones in a photograph depends on the number of levels into which the range is divided, and this is bit-depth. At one end of the scale is pure black, at the other pure white, and the bulk of digital photography, from in-camera capture to on-screen display, takes place in '8-bit colour'. A bit (short for binary digit) is either on or off, and is the basic unit of computing. 8 bits can store a number from 0 to 255 (2^8), or 256 values from black to white. Because colour in digital photography is recorded by a filter over the sensor with a pattern of red, green and blue, and then interpolating, these 256 levels are for each of the three colour channels. Multiply them all together (256 × 256 × 256) and we have a total of 16.7 million possible colours, well beyond the discriminating powers of the human eye.

This might seem to be more than sufficient, but there is still a danger of banding. This shows itself as steps across the gradient. For example, a clear blue sky photographed with a wide-angle lens will exhibit shading from light near the horizon to deeper blue near the zenith. However, if the difference between light and dark is not very great, but stretches over a large part of the frame, instead of 16.7 million different colours, the sky may be rendered by only a few tens of colours. Moreover, any significant change made to the image in post-production, such as an overall lightening or an alteration of contrast, will further exaggerate it.

Increasing the bit-depth greatly improves this situation, and the numbers speak for themselves. Cameras are starting to add a proprietary format known as Raw, which is 14-bits per channel (though computers often round this up to 16 for their own reasons). From 256 there are now 65,536 per channel, or is a huge 281 trillion colours, sufficient to protect even the most subtle shading from banding artefacts.

8-BIT VS 16-BIT MANIPULATION

This exercise in deliberately distressing an image demonstrates why 16 bits per channel are important. The original image, of a stained-glass window in a church in the Loire Valley, France, was first given a strong Curves adjustment, which was then reversed as closely as possible. This was performed on both an 8-bit and a 16-bit image, and the final histograms show that the 8-bit version, with its toothcomb appearance, suffered from lost tones and colours.

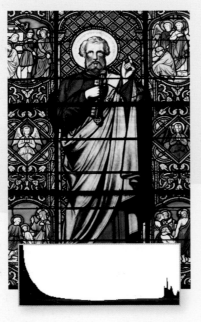

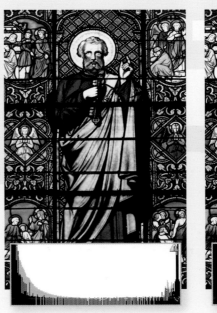

8-bit

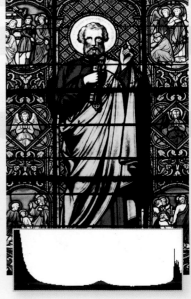

16-bit

GRADIENT BANDING

One of the more insidious effects of 8-bit manipulation is banding in smooth gradients – which in photography typically means skies. On this image of an African baobab tree at the tail-end of a dust-storm, the contrast was raised strongly on an 8-bit and a 16-bit version. The difference becomes just visible in a print on smooth paper, but is more evident here on when the black and white points are squashed in Levels. The damage is not major, but worth avoiding.

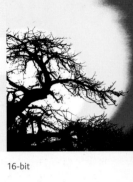

8-bit

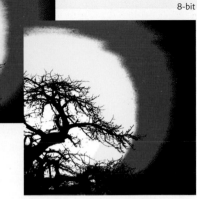

16-bit

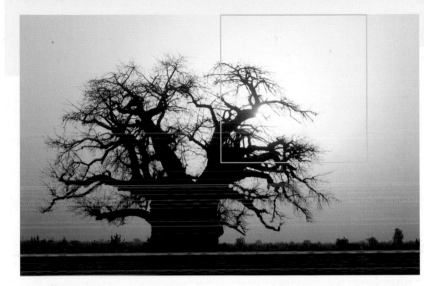

Original image
The highlighted section of the image has an evenly toned sky, a high risk area for gradient banding.

Result
Finally, the Levels sliders are pushed together tightly so only a narrow range of the original image remains. There is still more detail in the 16-bit one.

Curves adjustment
This strong Curves adjustment will make the shadows darker and the highlights brighter, exaggerating the contrast in the mid-tones around the sun.

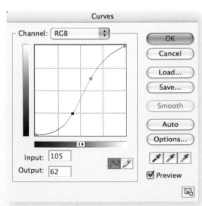

BITS PER WHAT?

Some confusion reigns because while it is conventional to talk in bits per channel, some manufacturers refer to the total number of bits for the image. Thus 8-bit produces 24 bits when all three red, green and blue channels are considered, 10-bit produces 30 bits, and 12-bit produces 36 bits. In HDR Imaging (*see pages 128-139*), it is common to deal in 32 bits per channel, to add to the confusion.

per-channel bit depth	total image bit-depth
8-bit	24-bit
10-bit	30-bit
12-bit	36-bit
14-bit	42-bit
16-bit	48-bit
32-bit	96-bit

THE COLOUR OF LIGHT

Light embraces the concept of colour, if for no other reason than the fact that we need to define colourless lighting – and in photography to achieve it. We can adjust the colour of light entering the lens by choosing the light sources and by adding filters, and we can make sophisticated and selective adjustments to the data that leaves the camera's sensor, but first we need to know the actual colours, and how to measure them.

What we call 'colour' is in reality a complex blending of the physics of light and the way in which our eye and brain interpret it.

Colour is actually a complex phenomenon, partly determined by the wavelengths emitted by a light source and reflected off surfaces, but partly also affected by human perception. Colour is what we judge it to be, and as many of the judgements that affect photography are on scales such as pleasant/unpleasant and correct/incorrect, colour management in photography, especially at this first stage of dealing with light sources, has to deal with the psychology of perception. The essential premise, obvious enough, is that the light which we evolved to see by is the standard: a colourless standard of 'white'. This is

sunlight during the major part of the day, and the colour of this stays fairly constant once the sun reaches about 20° above the horizon (approximately 0800 to 1600 at the equinox in middle latitudes).

In this way, 'white' light is self-defining, just as is the term 'light' itself. Technically, light occupies the visible part of the electromagnetic spectrum, from wavelengths around 400 nm (manometers) to 700 nm, meaning from just above infrared to just below ultraviolet. The entire range, as the diagram below shows, is much greater, from cosmic and gamma rays at the short end to radio waves at the long end. Within this narrow band of visible radiation, individual wavelengths are distinguished by our visual cortex as distinct colours – the colours of the spectrum. Taken altogether they produce an overall white.

Many of the issues to do with measuring and adjusting the colour of light in photography stem from the complete inability of the eye to distinguish between individual colours in a mix. This might seem strange, given the precision of human vision, our reliance on it, and the fact that in sound and taste we can break down the components. Moreover, the sensory mechanism

SPECTRUM, LIGHT, AND COLOUR

Light is the part of the electromagnetic spectrum that we can distinguish with our eyes. The shorter wavelengths can also be detected by the body because they penetrate tissue, and damage it, but longer wavelengths have insufficient energy to have an effect.

Wavelength (nanometers/mμ)

| 800 | 640 | 580 | 530 | 480 | 450 | 430 | 390 |

| Long LW radio | 10 cm Radar | 1 cm Microwaves | 0.1 mm Infrared | Visible | 5 nm Ultraviolet | 100 X-U X-rays | 1 X-U Gamma rays | Short Cosmic rays |

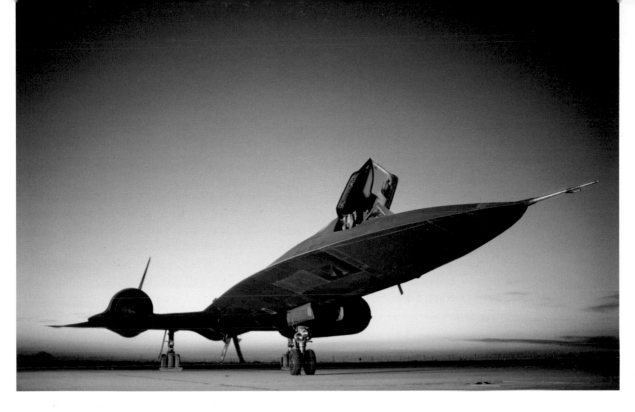

Discontinuous spectra
Most vapour discharge lamps register on the eye as an approximate white, if slightly bluish (though sodium vapour street lighting looks orange). Nevertheless, they record in a variety of unpredictable greenish and bluish ways, which can be surprise but impress: the green under-lighting on this SR-71 Blackbird counter-points the sunset behind.

Filtered light
The colour of light is changed by the materials it passes through, whether that is the atmosphere, or a translucent substance such as this traditional Pueblo Mica window in New Mexico.

for distinguishing wavelength and colour is actually in place in the retina, in the form of cones sensitive to red, blue, or green.

Nevertheless, in visual perception the eye and brain are remarkably adaptable. They adjust to different levels of brightness and to some colour in such a way that the lighting conditions appear normal. Photography has to deal with this phenomenon. All of the colour adjustments dealt with in this book, whether at source, through filtration, or in processing the data, are attempts to mimic 'normal' lighting, or at least to use this as a starting point. One of the most striking examples of how the visual cortex adjusts, and of the divergence between our experience and the recorded image, is with non-incandescent light sources such as fluorescent, sodium vapour and mercury vapour lamps. These have gaps in their spectra, yet the eye and brain manage to fill these in. The same scene recorded on a digital sensor or film, however, has a distinct and often strong colour cast.

THE EYE'S COLOUR PERCEPTION

Colour perception depends on tricolour sensitivity. The dense pattern of cones in the retina is made up of those that are individually sensitive to red, blue and green. The response of the red-sensitive cones actually peaks in the yellow, with the overall effect that the eye's maximum sensitivity is in yellow-green. However, the eye's scotopic vision (the rods, insensitive to colour but extra-sensitive to low light) peaks in blue-green, which gives an overall balance.

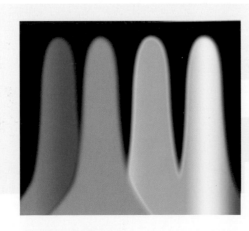

Combined sensitivity
Adding the three kinds of cone together with the scoptic rods gives an even spread of colour vision (though without the rods green would have a strong bias).

Blue-sensitive cones

Red-sensitive cones

Green-sensitive cones

Blue-green bias rods

COLOUR TEMPERATURE, REAL AND CORRELATED

The primary method for analyzing and correcting the 'whiteness' of light is based on the relationship between incandescence and colour.

olour temperature is an invention for measuring the colour departure of a light source from white. It relates colour to the temperature of a burning (that is, incandescent) object, which makes sense in that until fairly recently the majority of light sources in our daily lives were incandescent: the sun, candles, domestic tungsten lamps, and the traditional range of photographic continuous lights. At a relatively low temperature, a low dimmed light, the light emitted is reddish orange. The hotter something burns, the less red its light, as it emits more of the higher energy (blue and violet) wavelengths. The sun, as we saw on the previous pages, emits white light. Hotter stars appear tinged blue, and there is a scale of predictably changing colour that goes from reddish to bluish, passing through white in between.

In practice, things that burn also do other things, like oxidize, vapourize, and burst into flames, all of which alters the colour. The colour temperature scale is calculated on the emissions of a theoretical, inert 'black body' with no reflectivity. The lowest, and therefore reddest, colour temperature for practical photographic purposes is a flickering candle at less than 2000 K. Photographic incandescent lighting is standardized at 3200 K, while noon sunlight is approximately 5200 K. Actual daylight on a sunny day is higher than this because of the blue-sky component.

In reality, the two major modifiers of sunlight colour temperature are blue sky (or northlight) and the atmosphere near the horizon that makes the sun appear reddish close to sunrise and sunset. In the case of blue sky, which in shade gives a very blue illumination, the reason is the reflection of shorter wavelengths by the atmosphere. Scattering also accounts for a yellow, orange or red sun, because with the shorter, bluer wavelengths scattered, the redder wavelengths remain. The reasons for these colour shifts are nothing to do with the temperature of the light source, but they fit on the scale as shown. However, an increasing number of light sources are not based on incandescence, and so do not fit easily into this otherwise sensible scheme. Fluorescent and vapour discharge lamps have broken spectra, and the colour cast is not on the blue to orange-ish scale.

For all these non-incandescent sources there are two practical solutions. One is 'correlated colour temperature,' which is simply to use an approximation that fits on the scale. The other, digital, solution is to balance the spectra with a hue scale from red to green in combination with colour temperature.

THE PRACTICAL SCALE OF COLOUR TEMPERATURE

For photography, the important light sources for which colour temperature have to be calculated range from domestic tungsten to blue skylight. Precision is difficult, particularly with daylight, because weather and sky conditions vary so much. There are also differences of opinion on what constitutes pure white sunlight.

K	Mireds	Natural source	Artificial source
10,000	56	Blue sky	
7500	128	Shade under blue sky	
7000	135	Shade under partly cloudy sky	
6500	147	Daylight, deep shade	
6000	167	Overcast sky	Electronic flash
5200	182	Average noon daylight	Flash bulb
5000	200		
4500	222	Afternoon sunlight	Fluorescent "daylight"
4000	286		Fluorescent "warm light"
3500		Early morning/evening sunlight	Photofloods (3400K)
3000	333	Sunset	Photolamps/studio tungsten (3200K)
2500	400		Domestic tungsten
1930	518	Candlelight	

BLACK BODY RADIATOR AND ABSOLUTE ZERO

This fictional material has no reflective properties and no impurities, and heats to any temperature without decomposing. It simply emits light at a predictable colour, and the scale of this begins at Absolute Zero (-273° C). The units are Kelvins, which are equivalent to degrees Centigrade but start at Absolute Zero. Key photographic stops along the way are 3200 K (tungsten light), 5200 K ('pure' noon sunlight) and 5700 K (northern hemisphere summer sunlight). Note that the filament of a photographic lamp does not necessarily burn at 3200 K, only that its emission is the same colour as that of a Black Body at 3200 K.

Incandescent

Gold melts at 1064°, equivalent to 1337K, and this view into a small laboratory furnace with crucibles of the precious metal shows the colour associated with this temperature.

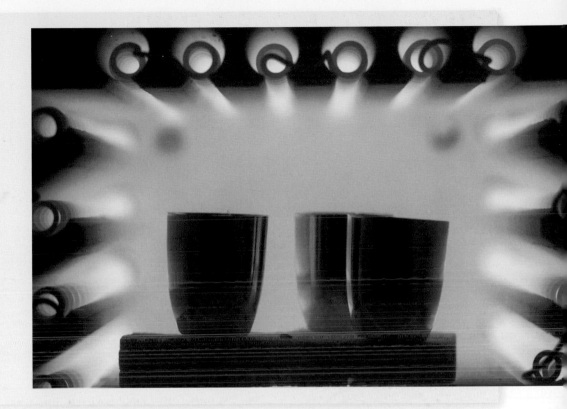

MIREDS

Now that colour correction and compensation tends to be performed digitally, either through the camera settings (*see page 36*) or in post-production (*see page 80*), filters are much less used during shooting than formerly. Nevertheless, they remain valuable as a means of balancing different colour temperatures of lighting, such as 3200 K incandescent with daylight. Mireds (Micro Reciprocal Degrees) are a measurement system that makes it easier to calculate the filter needed by assigning a constant shift value whatever the colour temperature being altered. A mired is derived by dividing the Kelvin degree into one million. So, converting a 3200 K light to 5700 K sunlight needs a 137 mired filter, and vice versa: 127 mired (3200 K is 313 mired, from 1 million ÷ 3200, and 5700 K is 175 mired, from 1 million ÷ 5700). Conveniently, mireds can be added and subtracted, which makes it straightforward to add and subtract filters.

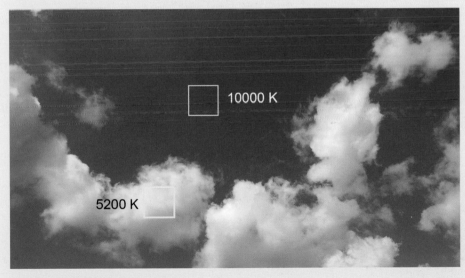

Correlated colour temperature of sky
Because the blue of a clear sky comes not from high temperature but from short wavelength scattering, it is not strictly on the colour temperature scale, but it fits, is useful for photography and so has a correlated value. Clouds in this position simply reflect sunlight, and so in the middle of the day are white.

MEASURING LIGHT

There are two different ways of calculating the appropriate exposure: by measuring the light falling on the scene, and by measuring the light reflected from the scene. Digital cameras make use of the second method, known as a direct reading, because it is simpler – measurements are taken from the image area. For most subjects and scenes it is perfectly accurate; it is after all, the brightness of whatever appears in the frame that you want to expose for. Problems arise typically when the scene is contrasty and/or when the surface of the subject is unusually light or dark. It is then that choices have to be made, and there are some obvious difficulties in trying to automate this.

The other method is measuring the light itself, irrespective of the subject, and this is known as an incident light reading. One way of doing this is to take a camera reading of a standardised surface that has average reflectivity – in other words, an 18% grey card (*see page 118*). The alternative is to fit a translucent plastic dome to the sensor on a handheld light meter (*see page 24*). In both cases the readings have to be taken in the scene itself, or at least in identical lighting, which on location and with telephoto shots may not be convenient. For these reasons, incident light readings are most commonly used in studios. These complications apart, the great advantage of incident readings is that they disregard the kind of subject surface that confuses direct camera readings – for example, a white shirt, snow, a black leather coat. Some cameras have an incident light sensor, and its readings are used in the calculations.

Camera meters use a variety of sophisticated systems for setting exposure according to the brightness of the scene and how it is distributed.

Nikon DX2
This Nikon professional SLR includes an incident light sensor, which gives the processor extra data not always in the shot.

CENTRE CIRCLE

Many cameras allow you to choose the area of the frame from which they assess light. Centre-weighted metering, for example, discards all of the information around the edges of the frame. The direct reading is taken only from the area shown.

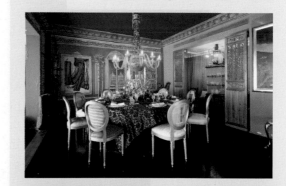

THE CENTRE CIRCLE'S CUT-OFF

The only practical way of knowing how soft or hard the edges of the weighted area are is to make your own test by moving the image area seen though the viewfinder over a hard edge between two contrasting tones. Note the change in reading as the circle crosses the line.

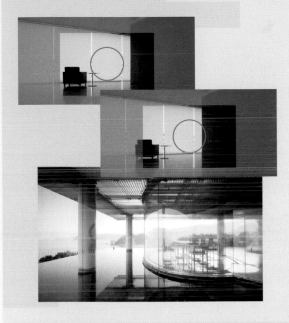

CENTRE WEIGHTED

A variant of centre-circle metering which weights the measurement towards the centre in a pattern that conforms to most horizontal picture-taking. Note that a narrow zone at the top is excluded from the measurement, on the grounds that in many outdoor views this is occupied by the sky.

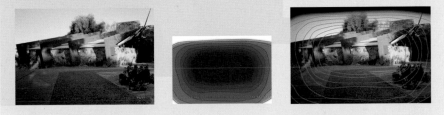

SPOT

A very precise model in which the reading is taken entirely from a small circle. In this example the circle is 3 mm in diameter, covering only 2% of the frame area. The normal way of using spot readings is to aim at the subject for which you want to expose, half-depress the shutter release to take the reading, hold this and re-compose. Some cameras automatically align the small circle with the centre of the area being focused, so that re-composition is unnecessary.

MATRIX

Also known by other names, such as multi-pattern and multi-zone, this is now the standard model, but the techniques used vary by manufacturer. The pattern shown here is that used by the Nikon D2X. The individual zones are measured, and not only averaged but the all-important highlight values measured also. Here, strong highlights are annotated for this example with an exclamation mark. The resulting pattern is then compared with computer-generated models of known picture types. Extra sophistication can be achieved by linking the measurement to focusing information, which gives additional clues to what the photographer considers to be the main subject — in other words, if one of the zones coincides with the area of sharp focus, it is likely that this contains the area that should be properly exposed. In a shot as complicated as this, though, there are still limits.

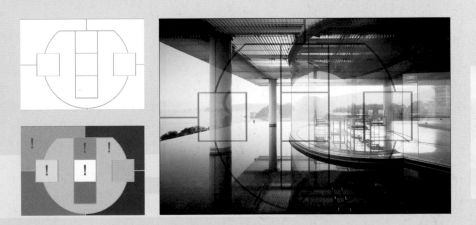

MEASURING LIGHT

HANDHELD METERS

For precise calculations, it's still hard to beat a handheld exposure meter. A model such as the one shown opposite will give, in addition to a direct reflected-light reading (as does the camera's built-in meter) a narrow spot reading, an incident-light reading and a flash reading. Incident-light readings use an opalescent dome attachment and measure the light falling on the subject, and so are independent of the subject's reflectivity. An obvious occasion for using an incident-light reading would be a snow scene. Studio lighting set-ups in particular can be complex, and make a handheld meter a valuable accessory.

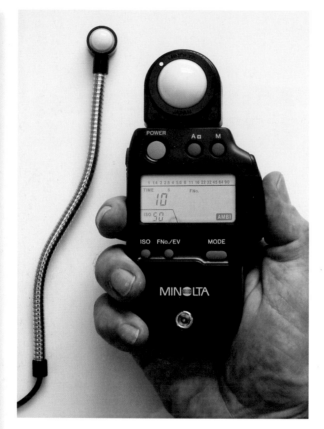

BRIGHTNESS ON THE SUBJECT

The many different units used for measuring light can be confusing, but the one that corresponds with the way we normally think about light is the lux. This is the measure of light that we see falling on an object – technically one lumen per square meter. Foot-candles are also used – the illumination falling on an object one foot away from a candle, and approximately 10 lux. The lumen (lm) is the standard unit for measuring the apparent brightness (or luminous flux) of a light source. It takes into account the sensitivity of the human eye to the radiant power of the source measured in watts; in other words, non-visible wavelengths are discounted, and it is weighted towards those which we see most clearly (peaking in yellow-green 555 nm).

Light meter
A handheld light meter will typically give a clear reading in terms of EV (see box).

There are three camera metering models, all of them available as alternatives in top-end meters. The simplest is centre-weighted, in which the entire frame is metered, but more attention paid to the centre. The weighting pattern varies from manufacturer to manufacturer, but the one shown on page 22, a feathered 8 mm circle, is typical. Its assumption is that the subject of interest will be somewhere close to the middle of the composition. More widely used, and more sophisticated, is matrix metering, in which the frame is divided into a number of zones. Readings are taken from each zone, and from these the pattern of brightness can be assessed. Moreover, the pattern gives a clue as to the kind of picture being taken, and this can be compared with known successful exposure settings. Thirdly, a spot reading allows an exact measurement of a small area of the image. If, for example, the impor-tant subject is bright but set against a much larger dark background, you can take a spot reading from the subject, ignoring the background, and apply that setting to the shot.

None of this is a complete replacement for judge-ment, because ultimately the measurement that should be taken the most seriously is the combination of light falling on and reflected by the important parts of the image. What defines 'important'? Only the photogra-pher knows, because the subject of the image as you see it may be quite different from what I see. It might be a person, or an event taking place somewhere within the frame, or even the pattern of light falling across the scene irrespective of content. The closest that the camera unaided can get to this kind of deci-sion is to draw on a bank of many kinds of photograph already taken and see where this prospective shot fits in. Indeed this is what most camera manufacturers do. They have a database of types of lighting situation for which good exposures have already been worked out. The arrangement of light and shade gives some clue. If

Lighting condition	Typical lux	Exposure Value at ISO 100	Approximate camera settings at ISO 100
Direct midday sunlight	100,000 to 130,000	EV 15 and a little higher	$1/125$ sec $f16$
Bright, hazy day	around 20,000	EV 13	$1/125$ sec $f8$
Open shade, bright day	4000 to 5000	EV 11	$1/125$ sec $f4$
Overcast day	2000	EV 10	$1/125$ sec $f2.8$
Television studio	1000	EV 9	$1/60$ sec $f2.8$
Indoor office	200 to 400	EV 7-8	$1/15$ - $1/30$ sec $f2.8$
Dark overcast	100	EV 5-6	$1/4$ - $1/8$ sec $f2.8$
Twilight	10	EV 2	2 sec $f2.8$
Deep twilight	1	EV -1.3	20 sec $f2.8$
Full moon	0.1	EV -3	1 min $f2.8$
Quarter moon	0.01	EV -5.5	6 min $f2.8$

A ROUGH GUIDE TO LUX

Strictly speaking, lux and camera metering don't correspond exactly, because lux is a measure of the light source, adjusted moreover for the sensitivity of the eye. Nevertheless, for practical purposes you can get an approximate idea of the light falling on a scene in lux by using the camera's built-in light meter and aiming at a white card. Allowing for some loss of light from the imperfect scattering from the card and that absorbed by the lens, the approximate calculation at ISO 100 is lux $= 2.5 \times 2^{EV}$ (the last part means 2 to the power of the Exposure Value). As an example, if the reading you get is 1/125 sec at $f8$ at ISO 100, as I just did in open shade on a fairly bright Spring day, this is EV 13. This becomes 2.5×2^{13}, which is 2.5×8192, or 20,480. To calculate the EV from lux at ISO 100,

$$EV = \frac{\log (lux \div 2.5)}{\log 2}.$$

$$lux = 2.5^{EV}$$
A rough approximation, but useful.

the top horizontal third of the frame is significantly lighter than the area below, for instance, the chances are good that this is sky and that the more important subject is below. If a smaller darker patch is somewhere close to the centre of the frame, chances are also good that this is the subject and that the lighter surrounds are the background.

This is actually all fairly hit and miss, and obviously depends on photographers choosing, framing and composing images in a predictable way. If you are not behaving predictably (and few photographers like to think they are), this kind of database automation is less likely to work. Fortunately, a glance at the LCD screen will show you whether the exposure was on target, but the risk is that if it's not what you wanted, you have lost time and maybe the opportunity for the shot. It's wise to be prepared to switch metering modes quickly, or at least to be able to adjust the over or under-exposure control when you think that it might be needed.

And it's worth remembering that at the end of the day, however many variables are factored in and computed, the result is still a single exposure setting of shutter speed and aperture. There are many ways of arriving at this, including guesswork.

EXPOSURE VALUE

Also known as EV, this is a system devised to make manual exposure settings simpler, and so features on handheld meters. It is a single number that combines the two variable camera settings of aperture (in fstops) and shutter speed (in fractions of a second), and by default is calculated at ISO 100. So, EV 0 is 1 sec at $f1.0$. EV 15 is typical of a bright, sunny day, giving $1/125$ sec at $f16$, or $1/60$ sec at $f22$, or $1/250$ sec at $f8$.

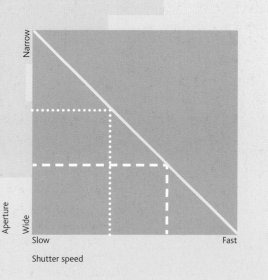

MEASURING LIGHT

IMAGE TYPES BY LIGHTING

It's possible to categorize images by the distribution of light and shade, and by the way this influences the exposure settings. Overall contrast, always important in photography, deserves even more care and attention with digital capture, partly because the linear response of sensors (*page 14*) makes clipped highlights and shadows a special danger, and partly because so much can be adjusted and altered in digital post-production. Problem and opportunity combine, in other words. Thus, the three major groupings are Average, Low Contrast, and High Contrast. Within these there are sub-categories. I used the term 'overall contrast' because the scale of tonal variation within the image has to be considered. Large areas that contrast need more careful attention than small areas. As you can see in the average example, it's possible to have an image that is average in tone overall, but which contains small areas of local high contrast. As becomes obvious, exposure is linked to the subject, and defining this is personal. For example, two photographers may be shooting the same landscape scene, yet the subject for one may be a physical feature while the subject for the other may be the abstract interplay of light and shade.

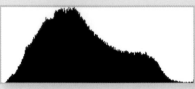

Tones equally distributed
No tone has priority, so although local contrast may be high, an average exposure for the whole frame is satisfactory. The histogram is typically centred and covers most of the scale, so looks big. Note that the bright areas are so small that it doesn't matter if a few of them are blown (but see Small bright subject, dark background, page 30, for the limits to this).

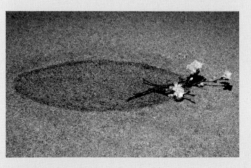

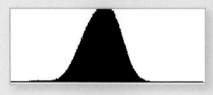

Key tones average
A variant on the above. There is a single main subject, average in tone, even though parts of the surroundings (here the flowers and stems) may show higher contrast. The histogram is still centred, as above, but is likely to be more concentrated. Centre weighting usually does well.

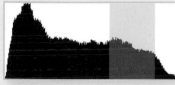

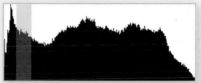

Key tones dark

The important areas are darker than average, but not so much so that are likely to be clipped in an average exposure. In this example, the two spiders are clearly the important subject, and need to be held with some detail. On the histogram their tones are highlighted.

Key tones bright

The important areas are bright, but not so much so that are likely to be clipped in an average exposure. Nevertheless, they should be checked. In this example, the overall is skewed rather towards the darker areas, but this is unimportant because the rose petals are the main subject and they are naturally brighter (in the highlighted area).

LOW CONTRAST

Here the range of tones is restricted, and the histogram shows them bunched. In post-production, applying Auto Levels will heighten the contrast by setting the black and white points wider on the histogram, stretching the tones to the full width of the scale. This generally makes the image more pleasing in an obvious way, but there are many occasions when you may want to keep the contrast low – in a foggy scene, for example.

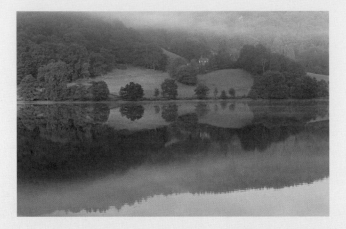

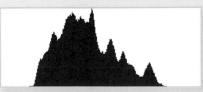

Average
The range of tones is in the middle, and as a result the histogram shows nothing on the left and right sides. Conventionally, and without paying attention to the subject matter, this looks like it ought to be equalized, and low-contrast images do change dramatically when they are auto-levelled, as shown above. However, this view of a soft summer morning mist over a lake might be better left as it is.

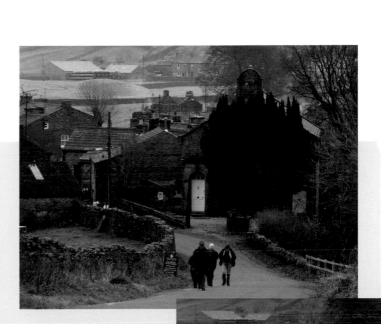

High key

The tonal range is shifted towards bright. This example, of sheets of vellum, actually needs to remain white, and the histogram is particularly narrow. Auto-levelling, as demonstrated beneath the original (top), creates a completely different kind of image – still valid, but possibly too strong, and no longer high-key.

Low key

The tonal range is shifted towards dark, and the right-hand half of the histogram scale is empty. As with the other low-contrast scenes, it's important to judge why the shot was taken. In this case, it is a view of a village at dusk. It could certainly do with some increase in contrast, as in the auto-levelled larger picture above, but it would probably be a mistake to brighten it more, since it loses the sense of the time of day.

MEASURING LIGHT

HIGH CONTRAST

More exposure problems are associated with high-contrast lighting than with any other. Unless you use a special technique such as High Dynamic Range Imaging or highlight/shadow blending, some tones will be clipped. Exposing for the highlights, which is usual with digital photography, will lose shadow detail.

Bright subject, dark background
The definition of the 'subject' depends on the photographer, and the exposure must cater to this (yet be full enough to keep the subject bright rather than average). In this example, of a cathedral in Cartagena, Colombia (in the high-lighted area of the histogram), seen along a narrow street in shadow, the framing balconies can be safely ignored – they work perfectly well as silhouettes.

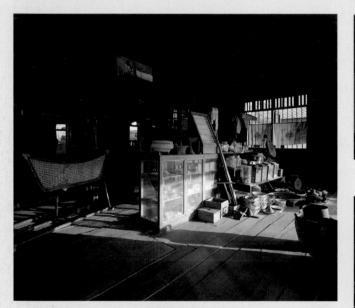

Tones equally distributed
None has priority, but note the difference between this and the 'Average' version (page 28). Here, as in this shot of late-afternoon sunlight pouring into an old Thai village store on a clear day, both shadow and highlight details remain important. The range here is high, so an average exposure will cause clipping, unless special HDR techniques are used.

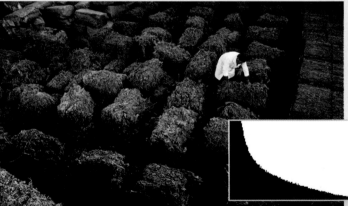

Small bright subject, dark background
When the subject is small but still principal, there is more likelihood of over-exposure. This type of subject needs more care than most. In this image of an inspector at a perfume producer inspecting bales of moss, his white coat occupies the highlighted range. It would be easy to blow the highlights in an image like this, and while not completely disastrous, it would be better to hold them.

LIGHT & THE CAMERA

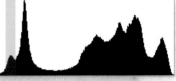

Edge-lit subject, dark background

A special variant of 'Small bright subject' in which it is generally acceptable to let the edge highlights blow out. The safe option is to bracket exposures and check them later. The delicacy of judging the exposure is illustrated by the histogram, where the edge-lit hair of the two women – important for the success of the shot – is the small blip indicated.

Small dark subject, light background

A variant on 'Dark subject'. Similar to a silhouette situation (see below), but usually needs some visible tones in the shadow areas. In this shot of a boat below one of the Nile cataracts, it occupies the small blip highlighted at the left – this position shows that it still retains detail, as it should.

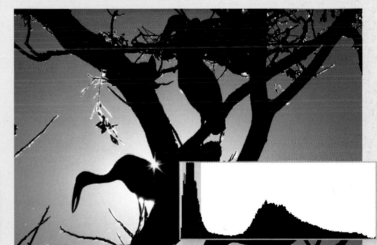

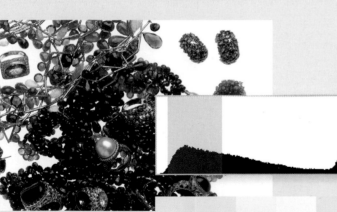

Dark subject, light background

The inverse of 'Bright subject, dark background', in which the exposure needs to be made for this darker-than-average area. In this shot of jewellery against a lit white background, the mass of darker stones lies on the histogram in the area highlighted.

Silhouette

A special case of the above, in which outline dominates, and shadow detail is generally unwanted. On the histogram, the silhouette of these nesting storks photographed against the sun is crammed up to the left edge – so no detail is visible. There is a strong figure-ground relationship.

THE HISTOGRAM

With experience, a glance at the histogram can tell you not only if the exposure was correct, but also the general appearance of an image. Many photographers avail themselves of their camera's histogram when shooting. Given the limitations of even the best on-camera LCD screens, this is a useful objective measurement of the light reflected from a scene as captured.

A chart of brightness, the histogram is an essential display of the range of tones in an image, and can be displayed on all good digital cameras.

In fact, without the histogram, you run two risks when checking the image. Firstly the viewing angle affects the appearance of the overall brightness, so it's hard to be sure you've seen the colours correctly. Secondly, the ambient lighting affects judgement; in bright sunlight, for example, a correctly exposed image will look under-exposed.

The histogram is actually a graph in the form of a bar chart, that maps the brightness values present in the image, from black at left to white at right. The number of pixels that have a particular value is represented by the height of each narrow column. The examples on these pages are keyed to show which part of each image is represented by significant peaks in the histogram. Once you are accustomed to it, analyzing it becomes second nature, and is always good practice.

ONE IMAGE, DIFFERENT EXPOSURES

This series shows the differences in the histogram between under-exposed, well-exposed, and over-exposed versions of the same shot. Note the overall shift from left to right, and the clipping of values at each end in the extreme versions. When the pixel values are crowded up against the left edge of the scale (shadows) or right end (highlights), this is a good indication that information has been lost.

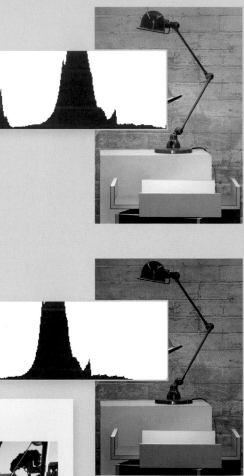

TRANSLATING IMAGE AND SCENE TO HISTOGRAM

Some images are easier to do this with than others (the easiest show clear separation of tones and colours), but it remains a useful skill to be able to 'read' a histogram like this. Peaks are often the most prominent – as the sunlit parts of the lifesaver – but some large massed areas may simply be, as here, the aggregate of different near-average areas. Colour channel histograms help identify areas – in this case, the prominent blue spike represents the pale blue sky.

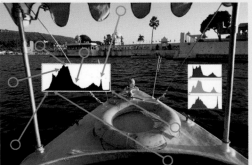

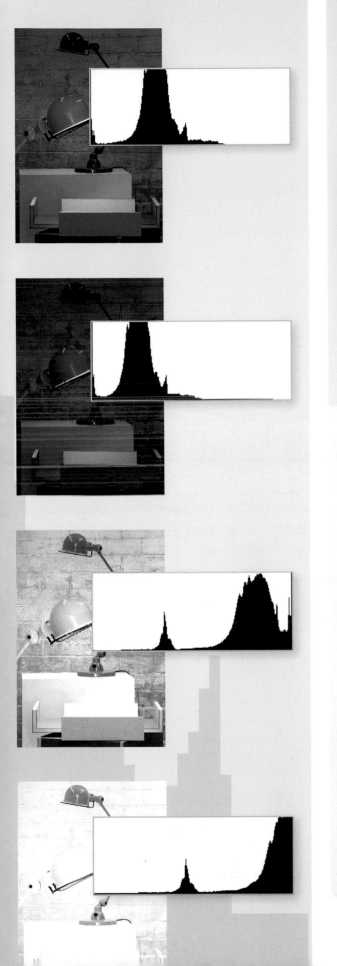

THE HISTOGRAM AT DIFFERENT STAGES

In theory, the histogram should appear identical whether viewed in-camera or in subsequent software on the computer. This example shows the different display options from the time of shooting, with a Nikon D2X, through the camera manufacturer's capture software, and Photoshop CS2.

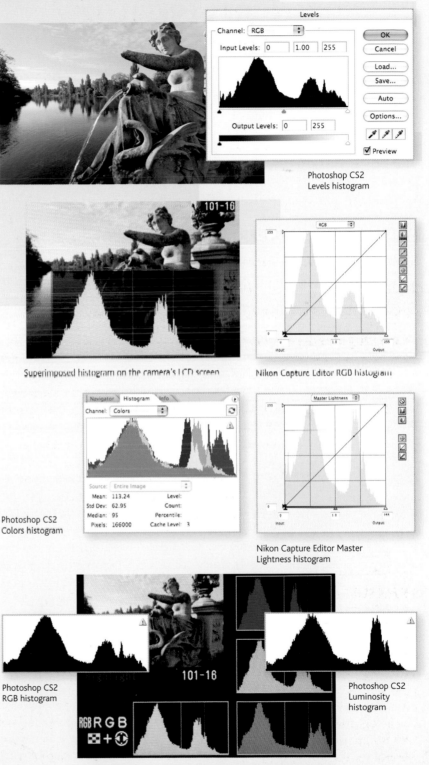

Photoshop CS2
Levels histogram

Superimposed histogram on the camera's LCD screen

Nikon Capture Editor RGB histogram

Photoshop CS2
Colors histogram

Nikon Capture Editor Master
Lightness histogram

Photoshop CS2
RGB histogram

Photoshop CS2
Luminosity
histogram

Multi-channel histogram on the camera's LCD screen

CHANGING SENSITIVITY

One of the great lighting advantages of shooting digitally is that the ISO sensitivity is instantly adjustable, which allows you to switch to whatever setting is appropriate for any situation. Moving from bright sunlight to a dark interior needs only a menu change. The film approach to this was either to carry a second camera body loaded with high-speed film, or to take the decision to switch films in one body, and both called for a certain amount of preparation and planning. The new potential offered by digital ISO switching is to be able to tackle more picture situations without any hesitation.

Efficient use of the camera's ISO setting makes it possible to keep pace with changing light levels while avoiding unnecessary noise.

This begs the question of why not to use a high ISO setting always. The reason is noise, which increases with the ISO setting, and has few fans. In appearance, noise approximates to grain in film, with the important difference that film grain is a structural part of the image and can even be admired for the tight texture it gives, while noise lacks this redeeming feature. A closer comparison is with static hiss in music, as digital image noise is an artifact caused by electrostatic charge. The appearance varies according to the exact cause, but generally is a random pattern of bright and multicoloured pixels.

From the perspective of effect, there is luminance noise (a monochrome random pattern), chrominance noise (variations in hue by pixel), individual stuck pixels (bright spots), and JPEG artifacting (blocks of 8 pixels sometimes prominent). Noise is at its most obvious and unwelcome in dark to mid-tone areas that lack detail. In very deep shadows and bright highlights there is too small a tonal range for noise to be obvious, and areas of sharp, tightly-packed detail (such as brightly lit foliage) tend to overwhelm the effect. Indeed, one of the key principles in assessing and treating noise is that at the pixel level noise IS detail. In many cases, only the eye's judgement can distinguish between them, and this is one of the things that makes noise reduction difficult to do. It's important to note that all noise effects are exaggerated by sharpening, and as the normal procedure is to perform sharpening at the last minute, before printing, this may come as an unwelcome surprise.

In low lighting there are two shooting techniques, which each create a particular kind of noise, and have different solutions. Switching to a higher ISO brings a random pattern of luminance and chrominance noise approximately in proportion to the ISO rating. Most cameras incorporate noise reduction, sometimes as an option, although this may contribute to an overall softening of the image. In post-production, there are noise-reduction tools built into manufacturer's own software, or generic image-editing software, and sold as stand-alone software. The one illustrated opposite is the highly effective Noise Ninja, which makes use of noise profiles for each make of camera and sensitivity setting. The second technique is a timed exposure on a tripod, suited to static subjects such as landscapes and architecture. In this case, it is possible to use the lowest ISO setting, and although the long exposure creates fixed-pattern noise, this can be treated very effectively in-camera by dark frame subtraction. Almost all cameras offer this option, and it works on the principle that the pattern is consistent at any given exposure, and so can be analyzed and subtracted.

DIAL-IN ISO

Some professional SLRs acknowledge the importance of choosing the sensitivity by offering a quicker, off-menu method of selection. In the example here, the main control dial alters the ISO when the appropriate button is depressed.

LIGHT AND NOISE

Noise, which appears in the image as a speckled pattern of artifacts, is directly related to the amount of light captured. While the origins of noise and the principles for removing it are complex, practically the bottom line is – less light, more noise. The different types include shot-noise, which is an inevitable result of the random nature of photons and sensor electrons, and read-noise, due to the way in which the sensor reads and the imaging engine processes the signal. Read-noise in turn includes amp-noise, generated by the processor, high sensor temperature noise, stronger when the camera and sensor are subjected to heating, and fixed-pattern noise caused by misfired pixels during long exposures (from imperfections in sensor manufacture). The detail example here shows how noise can appear even at a low ISO and a reasonable exposure, simply because less sampling occurs from shadow areas.

Noise can exist in all images

Detail

POST-PRODUCTION NOISE REDUCTION

Noise Ninja, produced independently from the camera manufacturers, uses profiles and proprietary wavelet-theory technology. The strength and radius of the effect need to be judged by eye for each image.

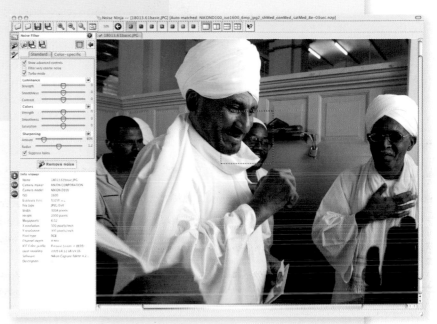

IN-CAMERA NOISE REDUCTION

Particularly with long exposures, much of the noise pattern can be calculated within the camera by the processor, making this a good time to reduce it.

WHITE BALANCE AND HUE

The camera's colour controls, based on a combination of colour temperature and hue adjustment, are designed to remove any overall cast and achieve neutral whites.

As we saw on pages 20-21, colour temperature in photography has long been used as a system for neutralizing colour casts, or at least for bringing them into a range acceptable to the eye. It has worked well for so long because the bulk of lighting that we meet everyday falls conveniently on or near this scale. More recently, artificial lighting, particularly as used in large interior spaces, has moved more towards sources that do not conform to the colour temperature scale, so the measurements of these have been shoehorned into the system and assigned a 'correlated colour temperature'.

Digital cameras continue the tradition of working to colour temperature, but are also able to make use of a second axis of colour correction, to handle any colour cast. The system is called white balance because in any image, whites are the easiest colour tones to find, and they most closely reflect the colour of the light source. Setting the brightest highlights to a pure white, with all the other colours shifting concurrently, is a good practical method of neutralizing colour casts. The normal procedure is to choose one of several standard settings from a menu, such as sunlight, shade or tungsten, or to set the white balance to Auto, in which the processor will attempt to judge the overall cast and neutralize it (in much the same way as Auto in Photoshop Levels or Curves). A more accurate but painstaking choice is called Preset, in which a neutral grey or white surface, in the same lighting as the picture to be taken, is first measured by aiming the camera at it. This is then brought to neutral and the setting saved for future use.

The easiest and most flexible choice of all is to shoot Raw if this is available in the camera. Because Raw format separates and preserves the settings from the raw data, and because the white balance choices are made to the settings, it does not matter at all which white balance you choose, unless you use a Preset. When the image is later opened in a Raw editor, you have the choice of applying any of the normally available white balance settings. Preset is a slightly different matter, as it is calculated at the time of shooting. Auto is also, and requires less effort, so there is an argument for shooting Auto in Raw simply to have the benefit of that extra on-the-spot calculation.

As usual, after all of this, judgement has to be added to the equation. As we'll see shortly when we look at different kinds of natural and artificial light, viewer expectations are a vital component. The most obvious situation is sunrise and sunset. Neutralizing the orange glow at these times to white simply looks unexpected. While the eye does adapt and sees scenes at these times of day not quite as orange as they are, we also have an impression that the sunlight is 'warmer'. Note, by the way, that the usual expressions of light being warm or cool makes perfect sense, but is at odds with the colour temperature scale, on which red is cooler than blue. Urban night scenes also carry an expectation of a yellow to orange cast, as do supermarket scenes a greenish tinge, and it is perfectly acceptable to leave a slight cast to promote the sense of 'actuality'. This is, of course, something of a matter of taste.

THE IN-CAMERA MENU

The standard choice of colour temperatures includes sunlight, cloudy, and shade, with artificial sources flash, tungsten, and fluorescent (the last approximated). These can often be further fine-tuned.

Option	Approximate colour temperature	Description
Auto	3000–8000 K	White balance adjusted automatically
Incandescent	3000 K	Use under incandescent lighting
Fluorescent	4200 K	Use under fluorescent lighting
Direct sunlight	5200 K	Use with subjects lit by direct sunlight
Flash	5400 K	Use with subjects lit by flash
Cloudy	6000 K	Use in daylight under overcast skies
Shade	8000 K	Use in daylight with subjects in shade
Choose colour temperature	2500–10,000 K	Choose colour temperature from list of values
White balance preset		Use subject, light source, or existing photograph as reference for white balance

HUE ADJUSTMENT

This camera menu offers, in addition to white balance, a hue adjustment in increments of 3° over a range of 18°, or ¹⁄₂₀ of the colour spectrum. In this, the spectral colours that can be generated on an RGB model are arranged in order around a 360° circle. So, raising the hue of red, for example, would shift it towards yellow, while lowering the hue would shift it towards purple. This example is chosen because it has a neutral element (the man's white clothes) and one basic hue – the sand, which as measured is a desaturated 35° on the colour circle. The 10° shifts in two directions give the results shown.

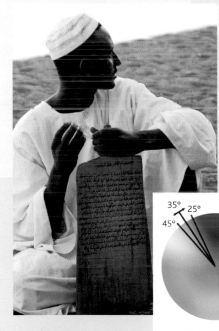

Colour wheel

Hue reduced by 10° in Photoshop

WHITE BALANCE AND COLOUR TEMPERATURE

Most of the camera's white balance options are based on colour temperature, as the menu opposite illustrates. Taking pure sunlight as an example, with a fairly consistent value in kelvins of 5200 K, this series shows the visual effect of the normal range of settings. Note that the kelvin values displayed in the menu are the colour temperature for which compensation is being made. Thus, the extreme 3200 K version is the setting appropriate for incandescent lighting, which is much more orange than daylight.

5200 K - as if sunlight during the middle of the day

3200 K - as if incandescent lighting

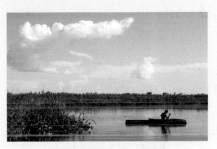

6000 K - as if cloudy overcast

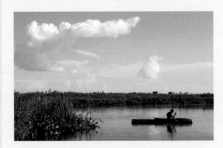

4400 K - as if a low sun

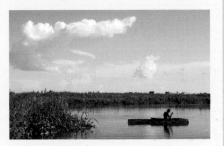

8000 K - as if shade under an averagely blue sky

Hue increased by 10° in Photoshop

EXPOSURE STRATEGIES

Taking all of the information in this chapter into account, it's important to develop a system of exposure and settings that does not over-complicate shooting. With all the menu choices available on the camera, it would be easy to waste valuable time making on-the-spot adjustments. Film cameras were much simpler in this respect simply because they offered fewer choices. Except with certain kinds of very static photography, most if us do not have the luxury of being able to play around with alternative settings. Brightness, contrast, and white balance are the major exposure concerns, and the strategies for dealing with them quickly and consistently depend to a large extent on the kind of shooting. In particular, there may simply be insufficient time to shoot Raw, with its attendant post-processing, yet this format, as we'll see, gives extra exposure latitude.

The sensor's linear response makes it prudent to pay attention to the highlights when choosing the exposure, but there are also special techniques for capturing a wide range of brightness.

Precaution one is to avoid clipped highlights as much as possible. Between some lost deep shadow detail and lost whites, the former is always more acceptable visually, so it is better to err slightly on the side of underexposure. The guide for highlight protection is the (usually) flashing highlight clipping warning in the LCD display. This is one of the display options, and one well-used strategy is to leave this on by default. Areas of the image that may be overexposed flash on and off, and a glance after shooting is normally sufficient as an alert. Most camera manufacturers set this clipping warning at a level or two less than 256 for safety, and it is worth checking the actual values in Photoshop of an image that just displays the warning, so as to familiarise yourself. An option for fast-reaction shooting when there is no time to check and re-shoot is to use Auto exposure with a minus 1/3 stop compensation.

Bracketing has long been a fail-safe measure in uncertain lighting conditions, meaning shooting extra frames at slightly different exposures, and it is usual to do this at increments of one-third or one-half of a stop. A good digital SLR now offers auto-bracketing bursts, and these can be set up for increments (such as 1/3, 1/2 or 1 f stop), order taken (normal-under-over or under-normal-over), and even number. Bracketing can also be used for flash, and for white balance. Having a set of different exposures is not only a way of getting one 'best' version, but if the scene has such high contrast that no single setting will be perfect, it is also a way of broadening the dynamic range (*see page 130*).

Knowing that post-production can solve many problems that arise during shooting is, in any case, a part of any exposure strategy. Bracketing is just one way of collecting extra data. In a sense, any auto setting acquires

HIGHLIGHT WARNING

One of the most useful fast indicators of over-exposure that will lose highlights is the clipping or highlight warning, which usually appears as a flashing tone over the affected areas. Here in red, though it may vary according to your camera or image manipulation software.

As shot

Highlight warning

extra data, because measurements are being taken directly from the scene. In addition, consider anything that will later give you greater choice in post-production. For instance, it is easier to increase contrast than to lower it, and high contrast increases the danger of clipping, so low-contrast camera setting is safe.

Safest of all is shooting Raw, for two important reasons. First, many of the variables, including white balance and contrast, are actually settings applied by the camera's processor to the raw data captured by the sensor. As Raw format allows direct access to the raw data, and keeps the settings used during capture as separate, white balance and contrast simply do not need to be chosen when shooting. Whatever the setting is, it can be altered later, with no loss of image quality. The second reason is that the sensors in most cameras that offer Raw format capture record in 14-bits per channel, which is a much higher colour accuracy than 8- or 12-bits. While this data is discarded when shooting TIFFs or JPEGs, it is kept in Raw format and made available to Photoshop and other image-editing programs as 16-bit. A higher bit depth means a higher potential dynamic range, and if the sensor is of sufficiently high quality to take advantage of this, you can raise or lower the actual exposure in post-production. Raw converter software typically offers leniency of up to 2 *f* stops in either direction. But it's important to remember that this is all potential gain – a 14-bit format has the capacity to record a wider dynamic range, but the sensor may not necessarily be up to it.

UNDER-EXPOSURE IN RAW

Paying heed to the clipping warning essentially means reducing exposure overall. This carries its own problems for the shadows, but often not if you shoot Raw, which has an inherently wider dynamic range. In this example, the as-shot version looks too dark and flat at first glance, but when given the Curves adjustment shown (brighter mid-tones but highlights and shadows pegged), opens up well. Compare this with the auto-contrast shot version, where the highlights in the tent's doorway have been lost.

❶ Shot with auto-contrast. Looks fine overall, but has clipped highlights where light emerges from the structure's door.

❷ Shot to avoid clipped highlights and minimum contrast. Looks under-exposed as is.

❸ Adjusted in the Raw converter With this curve applied, a good balance of tones is restored.

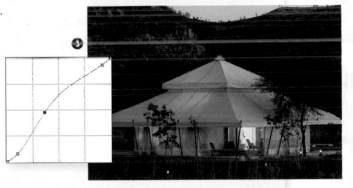

AUTO BRACKETING

Some cameras allow user to set up a short burst of exposures that brackets exposure. The menu will allow access to the precise settings.

Bracket beneath

As set

Bracket above

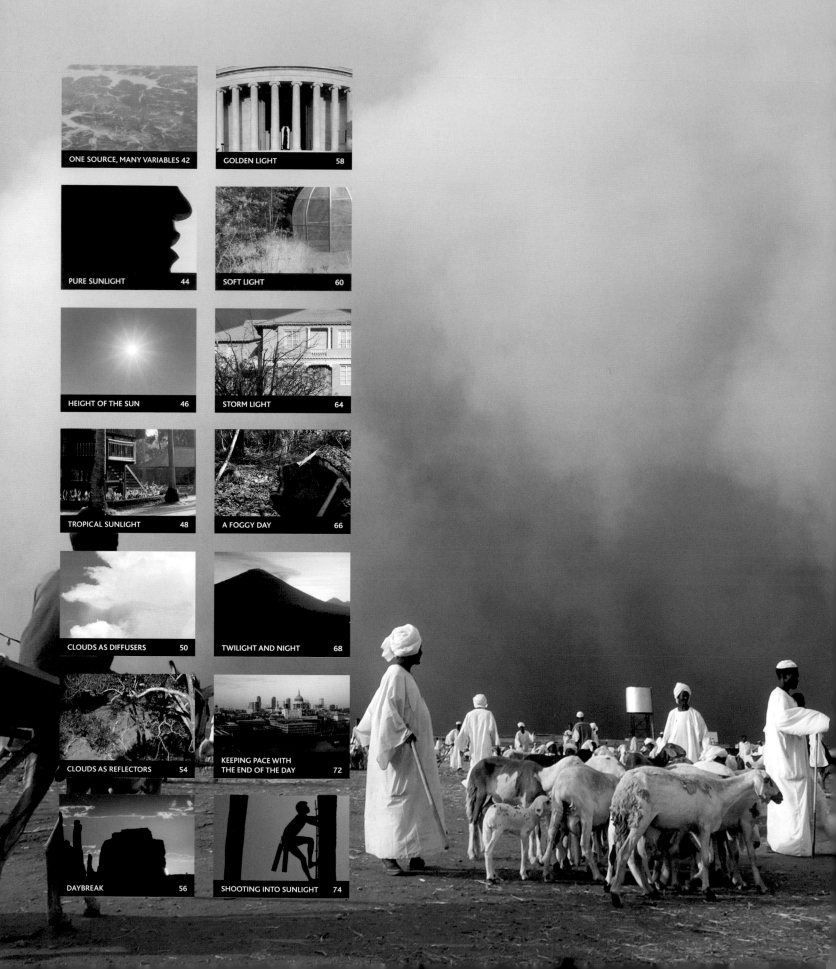

ONE SOURCE, MANY VARIABLES 42

GOLDEN LIGHT 58

PURE SUNLIGHT 44

SOFT LIGHT 60

HEIGHT OF THE SUN 46

STORM LIGHT 64

TROPICAL SUNLIGHT 48

A FOGGY DAY 66

CLOUDS AS DIFFUSERS 50

TWILIGHT AND NIGHT 68

CLOUDS AS REFLECTORS 54

KEEPING PACE WITH
THE END OF THE DAY 72

DAYBREAK 56

SHOOTING INTO SUNLIGHT 74

SECTION 2
DAYLIGHT

The default light for photography is daylight, and we probably take it too much for granted. It defines what we think of as normal and natural. For example, possibly the most common lighting situation of all is sunlight striking one side of a subject (a face, a building, or whatever your subject happens to be), with the shadowed side illuminated by reflected light. This seemingly simple condition is actually subtly complex, as attempts to reproduce it in the studio reveal. There is a colour temperature difference as well as one of brightness between the lit and shadowed areas – a warm key light accompanied by a cooler fill. This is just one small example of the complexity and visual richness of natural light.

This is not the first book I have written on light and lighting, but it seems to me that the time is right for a rather different approach – at least a new look at this huge subject. Perhaps unusually, I have tried to make this more of a technical book. If this sounds off-putting, let me explain. It is far too easy to be vague about lighting, and I'd like to get away from that. Studio photographers are used to thinking in technical terms about lighting – equipment types, colour balance, diffusion, the function of each fixture and so on – but I hardly ever see the same approach to natural light. Ansel Adams was a notable exception; and this attention to detail is undoubtedly a significant factor in his work's enduring appeal. Understanding the many components of natural light, from the changing colour temperature of sunlight to the infinite variety of cloud, simply makes it easier to work with it. As in music, knowing the technical details in no way takes away the pleasure.

ONE SOURCE,
MANY VARIABLES

As a way of bringing all lighting for photography into one arena, as it were, it can be very useful to treat sunlight and studio light within the same model. By this I mean that it helps to conceptualize the behaviour of sunlight by comparing it to a huge studio. From a photographic perspective, the sky is a dome and the sun is a moving spotlight. The dome, which is the atmosphere, acts as a very mild diffuser and also as a reflector that is coloured blue away from the sun. Of course, no-one would paint the ceiling and walls of a studio blue, and precisely for this reason of colour neutralization studios are painted white, grey or black. The other major difference is that the studio allows the light(s) to be positioned, whereas with sunlight there is only the choice of waiting for the right moment as it moves predictably over and around the 'set'.

All daylight derives ultimately from the sun, but its quality and intensity vary hugely, depending on the sun's position, atmosphere and weather.

When we add to the mix clouds, which are infinitely variable, and other kinds of weather such as haze, fog, rain and snow, the lighting effects become complex. This, too, is what happens in a studio when light is added, subtracted and manipulated with reflectors, flags and filters. Think of daylight as a single-light studio modified by a large menu of weather effects and you have a comprehensible view of how it works for photography. Digital photography can take even greater advantage of this by adapting, through camera settings and post-production software, the light that is recorded.

At the core of this is the movement of the sun itself, completely dominant under clear skies, progressively less so under increasing cloud, haze or fog. In the background of any decision is what an individual photographer decides is the most attractive angle of light and softness of light, and when shots can be planned in advance, this comes into play. Clearly, if you have no influence over when to shoot, such as at an event, none of this matters, and you simply have to make the best of the conditions.

THE SKY AS STUDIO

Consider the dome of the sky as a vast overhead cyclorama coloured blue, but modified by floating diffusers and reflectors (clouds and other weather conditions). The sun is a single spot travelling over this on a pre-determined track, becoming yellower and then more orange as it approaches the horizon. This analogy helps to make the constant changing of conditions seem more practical.

Sunlight filtered
Evening over Siberia, showing the colouring effects of the atmosphere, which simultaneously turns the direct light almost red through scattering, and leaves most of the landscape below blue from reflected light from the sky.

Landscape, architecture, and, in a different way, portraits, however, are usually capable of being planned, and as the first two of these are static, the height and position of the sun are very much the controlling factors. Depending on the location, there may or may not be a significant choice of viewpoint, and the less the choice the more important it is to be able to predict how the light will fall on the subject throughout the day. Landscapes are generally large and complex enough to be treated in all kinds of ways, and finding an interesting camera position and/or changing the focal length of lens make it possible to deal with most kinds of daylight. Buildings are less tractable, because most have a façade, and man-made structures in general (including sculptures) are generally designed to be seen from a particular direction. This gives less choice, but makes that choice more important. Non-static subjects, such as outdoor portraits, can be re-positioned, and this more or less removes the direction of sunlight from the equation.

A DAY IN THE MID-LATITUDES

A sequence of identical frames – a kind of time-lapse photography – over the daylight hours at 51° N 00° W – in other words, central London. I chose an ornamental sculpture for the foreground better to illustrate the modelling effect of a single light and how it changes the character of the shot as it moves. Sunrise in August, when this was shot, was 0530, and sunset 2040. Because of daylight saving time, zenith (the highest point reached by the sun, 60° above the horizon) occurred at 1300 instead of 1200. The location, Kensington Gardens, is close enough to the Greenwich Meridian to be right in the centre of the time zone.

Kensington Gardens
This sequence of images shows how the light appears at different points in a day, from 0600 to 2000, as explained (above).

PURE SUNLIGHT

Sharp shadows, high contrast and a sense of good, predictable weather are the characteristics of this, the clearest form of daylight, unmodified by clouds.

Let's start with direct sunlight, not because it is the most usual (certainly not in England, where I'm writing this) but because it is the raw source of all daylight. Whatever happens because of the weather, time of day, and location, it happens to sunlight. The variety of natural light is immense, but if we strip away the effect of clouds, haze, surroundings and so on, what we have is a single strong spotlight moving slowly across the sky, in a slightly different position every day and every hour. Yet even this apparently simple situation has some built-in complexity, because the atmosphere, however clear it may be, modifies the light.

The studio equivalent of direct sunlight is bare-bulb, or point source lighting. Seen from the earth, the sun has no area worth speaking of, and because of the distance, the light rays are collimated, meaning parallel to each other. There is no angular spread, as with a studio lamp, so that shadows in any one location all fall in the same direction. Because it is a point source, the edges of the shadows are sharp when they fall on a surface very close to the subject that casts them, though they soften a little with distance (for this effect, look at the shadow on the ground of any tall vertical edge, such as that of a tree trunk or telegraph pole).

In all discussions of light and its suitability for photography, there is the underlying assumption of attractiveness. Clearly this is very subjective and open to some interpretation, but also is influenced by the majority view. Even though most non-photographer viewers would not articulate it in this way, hard light is not generally considered ideal for portraits of people and objects of similar and smaller size. The reasons for this are less important than that it is generally accepted. However, on a large scale – landscapes and so on – tastes change, probably because bright sunlight is associated with good weather and comfort. Whatever, sunlight tends to be sought after for large scenes, particularly if the sun's angle is low, casting long shadows.

Yet, while for a pre-planned shot you might be looking for a particular kind of daylight, it is also possible to take any kind of daylight and work the other way around, looking for subject and viewpoint that takes full advantage of it. The greatest useful variety of sunlight falling on a subject is when the camera angle is either towards the south west or south east. This gives a range between three-quarter frontal and three-quarter back-lighting, as shown (*right*). Views from directly west or east give a range from silhouette to full flat frontal, which is less useful, from the south gives just a side-to-side variation, while from the north is all some degree of back-lighting. These directions are reversed for the southern hemisphere.

The complete control that digital gives over colour temperature opens up other possibilities, such as placing the subject in the shade on a bright day. The colour temperature will be high, meaning bluish, and while difficult to gauge by eye, can be completely compensated for with the camera's white balance settings, or later adjustments in post-production. Direct sunlight can also be modified by locally positioned reflectors, diffusers and black flags.

HOW THE SUN OCCUPIES THE SKY

The track of the sun is higher but narrower in the tropics, lower and wider in high latitudes. So, somewhere on the planet at some point in the year, the sun can be in any position except for the darker ellipse shown here – north-facing in the northern hemisphere, south-facing in the southern. There are many practical implications, for example this bas-relief at Angkor, Cambodia. On a north-facing wall of a temple, usually shielded from the sun, it nevertheless is lit in the middle of the day for a few weeks only in summer – which could never happen in middle or northern latitudes.

Bright sun, high contrast

A high, bright sun, unfiltered by clouds or haze, has the potential for high contrast, though this depends very much on the subject. In this case, a sculpture in polished black stone, the contrast is bound to be extreme if we include the specular highlight reflections, as the accompanying histogram shows. Nevertheless, the high contrast has been made to work by framing in a way that keeps everything simple and uses the sky to keep the upper half of the outline clean.

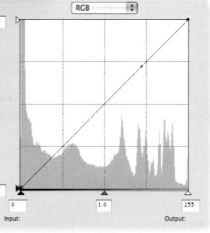

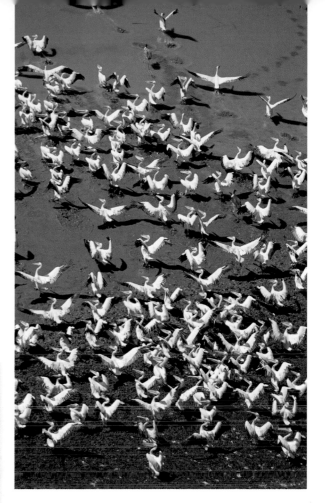

Shadows with distance

The harsh shadows from a high sun, so often a problem for portraiture and close views in general, become almost irrelevant from a distance, as in this shot of pelicans taking off from a lake shore. In fact, here the shadows of the birds help to define and accentuate their white plumage.

HEIGHT OF THE SUN

The sun's height has a major effect on lighting, both for the modelling it gives to objects and people, and for the shadows it casts. It depends on time of day, season and location.

Illustrating the sky
Although not strictly related to this page, the illustration opposite is a good example of composition using these original images and the Screen blending mode.

As we'll see under studio lighting (*see page 90*) the height of any light has an impact on scenes and subjects. With the sun, this is predictable yet varies hugely, and is the result of a mix of three variables. These are time of day, the season of the year, and latitude – but the mix is complicated by the direction of the sun as well. For instance, where I live, in London, the sun is high enough in the sky to clear the wall and light the garden at around 0830 in June, but at 1100 in November – same height, different times, and importantly, from a different direction with different shadows.

With some subjects, particularly landscapes and buildings, exact timing can be crucial if you want something, like a doorway, to catch the sun. The first two variables, time and season, are the most familiar, from our own experience of how the sun strikes where we live. Latitude, though, is just as important. International travel is now commonplace, and for photography it means that we experience a wider range of types of daylight. In particular, many more photographers now get to shoot with the sun in more extreme positions – from very high in the tropics during the middle of the day, to long periods of low sun in the far north and south. As examples: midday on the equator has the sun directly overhead, whereas the highest it reaches in the northern United States and Europe is around 70°; midsummer on the Arctic Circle has the sun making a full 360° circuit of the sky, never higher than 47°.

It goes without saying that the height of the sun is important for photography in the way sunlight strikes a particular aspect of a subject, and casts shadows. For psychological and cultural reasons, there is a wide consensus that certain kinds of sunlight are more attractive than others, and conventionally at least, a low sun has a certain visual quality, very much so in colour photography. We discuss this matter of taste on pages 56-75. As the sequence of shots on page 43 shows, the appearance of a scene really does change a great deal with the passage of the sun. Predicting this for an unfamiliar location is by no means easy, but at least the facts are available for any location. The first things to know are the directions of the key elements: sunrise and sunset, the façade (if a building), and the camera angle. Then timing, of sunrise, sunset, and the sun's zenith (which may vary from noon if there is daylight saving time and according to the longitude of the location within the time zone). The bottom line for most situations is: when will the sun strike the subject at what I judge to be the most attractive position? The tables and examples here may help, with the proviso that all of this ignores weather. Cloud cover changes the situation completely, and with full overcast there is usually no indication at all of the sun's height or position. We will deal with the effects of weather in a few pages' time.

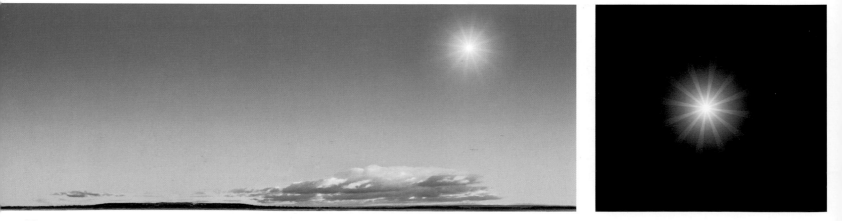

MID-LATITUDE SUN

At 45° N, the location of Portland, Oregon, of Ottawa, Turin and the northern tip of Japan, in spring and fall (the equinoxes) the sun rises and sets exactly 90° E and 90° W respectively. The directions are reversed for the southern hemisphere. Also, in the centre of any time zone and ignoring daylight saving time, sunrise is at 0600, zenith is at 1200 and sunset 1800. From the ground in spring or fall, the sun appears to follow the upper track shown here, rising to a maximum 45° elevation (70° in summer). The lower track is what happens in mid-winter, the sun rising to a maximum 22° elevation. At the considerable risk of sounding formulaic, 20° elevation, which is about the upper limit for what I define as 'golden light' (*see page 58*), is reached around 0800 in the morning and 1600 in the afternoon in spring and fall. All these positions and times change constantly, towards the two extremes of summer and winter solstice.

A ROUGH GUIDE TO ELEVATION

When the sun is fairly low, a quick way of finding its elevation is to use the coverage of your lens (published by the manufacturer). Most angles of coverage quoted are for the diagonal of the frame – that is, the full circle – so here, the camera has been tilted while aimed horizontally. Adjust the zoom until the sun appears at the top corner (for eye safety slightly obscured by vegetation or similar), and read off the focal length. The elevation is half the published figure.

Precise timing
Here's an example of a window of light (actually, the spaces between stone balusters) moving across a scene – bas-reliefs at Angkor Wat. Because the two gaps neatly fit two carved dancers, timing was important, and the shadow moved visibly.

TROPICAL SUNLIGHT

The greatest range of height in the angle of sunlight is on the Equator, where there is little seasonal variation but the maximum diurnal variation. Here, on the island of Bali, the location is just 8° S, sunrise (in August when this sequence was shot) is 0624 and sunset 1817. The camera direction is NE 45°, so that the sun rises in the right background of the frame and sets left and behind camera. If you're accustomed to mid-latitudes, the midday hours give the most unusual light – a small, dense shadow footprint which can look odd. The other area of unfamiliarity is the speed of sunrise and sunset. By 1900, only three-quarters of an hour after sunset, almost all daylight has gone.

Tropical days are characterized by one long period of unchanging overhead light and two short periods of rapidly changing low light.

0800
In this location, two hours after sunrise is arguably the ideal time to shoot in order to capture atmosphere and yet reveal detail. As the main image shows, humidity or smoke at this time of day adds valuable atmosphere.

0900
By this time, which would still have the appearance of early morning in mid-latitudes, the sun's elevation is almost 40° (½ the coverage of a 12mm lens) above the horizon.

Bali: 0800 hours
0800 on a different day from the sequence. Because the camera angle is three-quarters towards the sun, humidity in the atmosphere and a little smoke are backlit and give good aerial perspective.

0700
An hour after sunrise there are only a few shafts of light reaching the scene because of the density of coconut palms and other vegetation. The height of the sun is 15°, which in an open location would be good, but here the light is largely blocked by local features.

1000
At a height of almost 50°, the overall lighting appearance will now not change for around six hours – half of the daylight hours. The only variation is the position of shadows related to which way buildings and objects face.

1100

The sun is now overhead and will stay there for at least three hours. The effect on the spot is uncomfortable on the eyes. Tropical architecture deals with this by extending the roof to give shade, and for photography these shadows are deep.

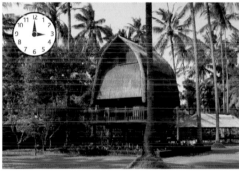

1400

The scene is very slowly becoming frontally lit, but though this is apparent in this time-lapse sequence, changes are still imperceptible to those experiencing them directly.

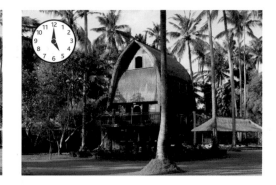

1700

An hour before sunset, and the lighting is rich, warm and attractive, more frontal than in the morning, so showing more detail. The sun is now low enough for local landscape features to have a major effect; the tall palms cast long shadows, not always easy to predict.

1200

Midday, and the sun is at its zenith, though it appears to have changed little in the last hour.

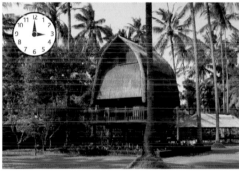

1500

There is now, in the middle of the afternoon, a hint of lowering sunlight, though not yet sufficient to fit most photographers' perceptions of attractive and useful lighting. The sun is at the same height as it was at 0900, but on the camera side of the sky.

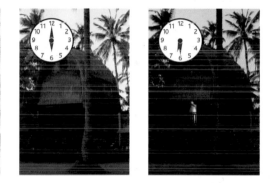

1800

Sunset, and the trees have cut off most direct light (common in all but the most exposed locations). Only the palm tops are catching the last rays. The speed of a tropical sunset can be sudden and unpredictable; a quarter of an hour after sunset it is full dusk.

1300

The apparent lack of movement in sunlight and shadows continues. From the perspective of lighting, the middle hours of tropical daylight seem to be static, in contrast to the rapid changes at either end of the day.

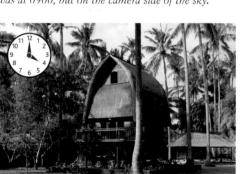

1600

By this time, two hours before sunset, the edge is beginning to be taken off the harshness and overhead direction of the sunlight. Most landscape and architectural photographers would begin to consider setting up.

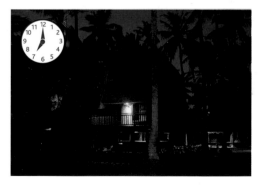

1900

Not even one hour after sunset, yet in practical terms night has already fallen. Most of the illumination here is actually residual tungsten from some nearby houses.

CLOUDS AS DIFFUSERS

Disregarding how clouds actually look, their main contribution to lighting is as variable diffusers. It's useful to bear in mind that they are inherently colourless, being composed of water vapour, but this means that they will transmit and even mix different colour temperatures from above, and will reflect different colours. We deal with clouds as reflectors on the following pages.

Depending very much on their type, clouds spread the point source of sunlight over a wider area, and also cut the amount of illumination.

The different cloud types are classified meteorologically but have never been, as far as I know, for their function as lighting accessories, so we might try and do a little of that now. The relevant qualities are opacity (thickness) and spread (the area they cover), just as with studio lighting. One of the key distinctions is between clouds that form sheets and those that are compact and shaped. The former embraces layer clouds (stratiform) and feathery clouds (cirriform), and include stratus, altostratus, cirrus and cirrostratus; these give a more even, overall diffusion. From the point of view of lighting, height is not particularly important, given that the light source, the sun, is so distant. Compact, shaped clouds, known as heap clouds (cumuliform) include various kinds of cumulus, and by definition these are thick and so have a strong effect when they pass in front of the sun. The stacking of different types of clouds complicates their combined effect, as does the movement of different types of cloud into different regions of the sky.

Looking at the detailed effects of clouds on sunlight, we can see several. First, there is diffusion, the amount by which sunlight is spread and softened, reducing shadows and their edges, and at maximum diffusion, on a heavily overcast day, the entire dome of the sky is an even light source. Second, there is the reduction in light intensity, and the maximum for this, under thick stratus, is from about 100,000 lux down to about 1000 lux, or 4 f stops less than raw sunlight. Then there is the pattern, which has a more subtle effect; with anything other than a 100% cover of stratus, there will be differences in thickness so that some parts of the sky will be brighter than others, and this slightly affects the direction of the diffused light.

Another effect is on colour temperature. In clear weather, as we saw, the lit parts of a scene are at around 5200 K, while the shadows are illuminated by the blue sky plus local reflections. In an open landscape, the

FLOATING DIFFUSERS

The degree of diffusion depends largely on the thickness of the cloud layer and on its height, as well as on how much of the sky it covers. Cloud thickness is often hard to gauge from the ground. When clouds overlap, their combined diffusion effect is greater. The accompanying series of sky pictures shows increasing thickness and therefore diffusion, although the actual form of the clouds can vary greatly.

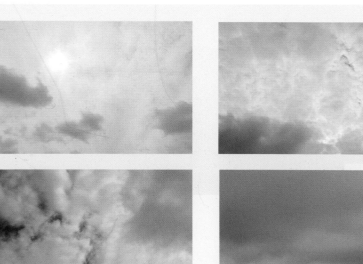

blue sky dominates, and this can typically be between 8000 K and 10,000 K. Cloud cover has the effect of blending the two colour temperature sources. An even diffusion mixes sunlight and blue sky reflection in proportion to their strength, and so the result, around 6000 K, is heavily biased towards the sunlight. However, broken cloud can raise this colour temperature. The maximum occurs when there are just a few compact, thick low cumulus and one passes in front of the sun, reducing its intensity by, say 3 *f* stops, and allowing the blue sky component to have a much greater effect. This weather situation, interestingly, also involves the last lighting effect of clouds – changeability and unpredictability. Cloud cover is always changing, however slowly, and the exact lighting effects are well beyond most weather forecasting. Practically for photography, high-level winds and moving air systems make life more difficult. Not only do they call for constant adjustment, as when a fleet of individual clouds passes across the sun, but they may invalidate a planned shot completely. Outdoor portraits, for example, are nearly always improved by some degree of diffusion (that is, haziness, light cloud), and if this changes towards hard sunlight or towards shapeless broadly diffused light (full overcast), you may need to re-think the location or accessory lighting.

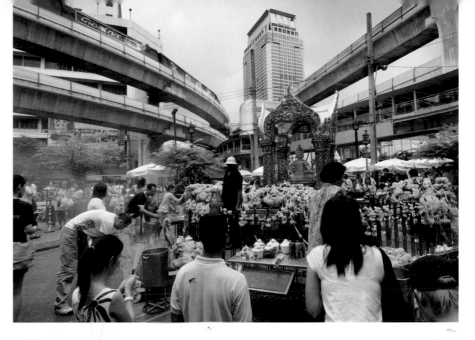

Bright overcast
A full cover of mainly medium-height cumulus here at Bangkok's Erawan Shrine gives diffused lighting that to the eye seems quite bright on the ground, and retains some sense of soft shadows (note the obvious highlights on the shoulders of the people in the foreground, and the shadowed folds of the t-shirts). The EV at ISO 100 is an expected 13 – brighter by about one stop than it would be in mid-latitudes.*

Flat lighting
This barn is lit by the very diffused light of ragged lower cumulus, much like those pictured to the right.

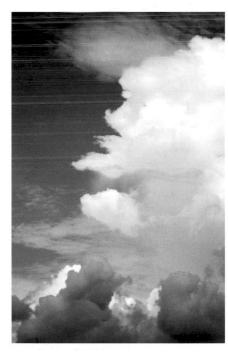

The variety of cloud cover
Not always apparent from ground level, but seen here very clearly, clouds are often ranged in different height decks, and in very different forms. Here, a towering cumulonimbus rises above ragged lower cumulus, with sheets of altostratus and cirrostratus above and beyond. Each has a particular diffusing effect, and when stacked can produce very flat lighting underneath.

High-level thin sheets

Mid-level thick cumulus

Low-level stratus sheets

Low-level stratus sheets

CLOUDS AS DIFFUSERS

DEGREES OF DIFFUSION

A practical demonstration of exactly how cloud diffusion varies, using the same tropical scene as in Tropical Sunlight (*pages 48-49*). The sequence moves from unfiltered sunlight in the middle of the day to moderately heavy overcast. Shadow edges are the first visual effect to go, as the shadows start to blend with the brighter areas. Next, individual, distinct shadows, such as that of the foreground palm tree, gradually disappear. Finally, the shadow areas under overhangs, such as the base of foliage and the base of the building, begin to fill. The steady compression of the main area of the histogram shows the decreasing contrast. The contrast between land and sky, however, actually increases – an important consideration. To demonstrate the lessening of local contrast more clearly, the pair of histograms below are drawn from a small rectangular selection near the centre of both the sunniest and cloudiest images.

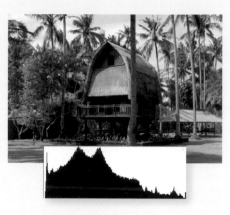

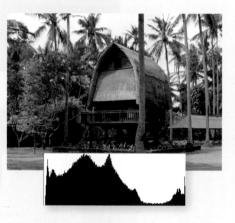

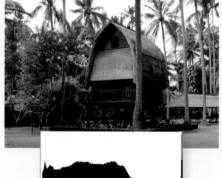

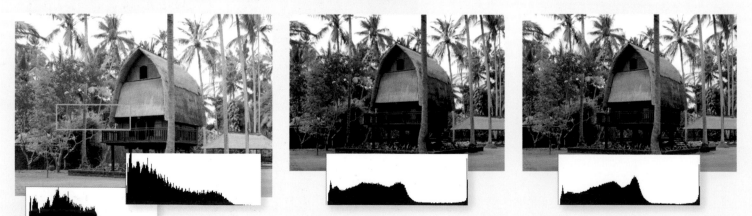

A BLEND OF COLOUR TEMPERATURE

A full cloud cover brings together the colour of the sun (white, 5200 K) and that of the blue sky (about 8000 K to 10,000 K), merging them into a colour temperature that is slightly higher than sunlight alone. The amount of blending depends on the cloud cover, but a general rule of thumb – and followed by most digital camera manufacturers – is 6000 K.

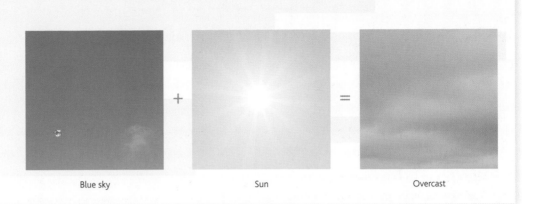

Blue sky + Sun = Overcast

SHADOW CUT-OFF

One of the trickiest daylight exposure situations is when a passage of individual clouds briefly shields the sun. The jump in illumination between full sunlight, the edge of a cloud and a thick cloud is considerable, and on a windy day when it can happen quickly is not easy to adjust for. The full drop in brightness varies according to how dense the clouds are, but the sharpest point in the drop is when the edge of the cloud reaches the sun. This makes shadow edges a reasonably foolproof indicator. At the point at which the shadow edge disappears, the illumination will have dropped by EV 2 – that is, 2 *f* stops. Depending on the type of cloud, this generally happens a little way in from the edge, as shown in the sequence to the right.

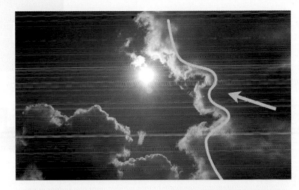

1. Sunlit illumination
1/125 sec at f16 at ISO 100

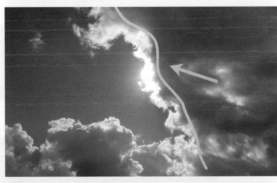

2. Edge of cloud
Illumination dropping quickly and variably by up to 2 f stops

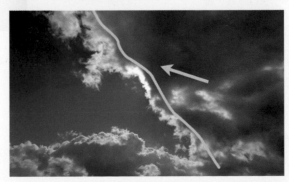

3. Sun obscured, no shadow edges
1/125 sec at f8 at ISO 100

CLOUDS AS REFLECTORS

As well as diffusing and reducing sunlight, certain kinds of cloud also act as reflectors. Their reflectivity depends on their size and how white they are, while their position vis à vis the sun determines how much they contribute to the overall lighting. Practically speaking, clouds as reflectors only occasionally have a noticeable effect as shadow fill, but more often influence the colour temperature. To work as reflectors, as in any studio, the clouds have to present a more or less vertical surface, and the cloud types that fit the specification are tall cumulus and cumulonimbus. As these cloud types are often associated with showers or thunderstorms, their reflection effect may be short-lived. Fair-weather cumulus, which are white, fluffy and not so tall, also work as reflectors, though not as strongly.

When clouds, particularly well-defined cumulus, occupy the opposite part of the sky from the sun, they also act as a kind of shadow-fill.

Also directly comparable with studio reflectors, their contribution to the overall lighting effect is greatest when their vertical extent is directly opposite the sun, in other words early or late in the day. Against this is the lower intensity of sunlight close to the horizon, so the maximum tends to be when the sun is somewhere in the region of 30-40° high. Early mid-morning and late mid-afternoon are the key times.

For the central part of the day, when the sun is higher than about 35°, the colour temperature of sunlight stays more or less unchanged at around 5200 K 'white'. This means that reflector clouds are also white, and in addition to lightening shadows, they also lower the colour temperature in shade towards that of sunlight. The amount depends on the extent and solidity of the clouds. Note that this works in a different way from the blending of colour temperature by means of diffusion. In diffusion, cloud cover over a substantial area of the sky mixes the sunlight and skylight from above it. In reflection, the sky needs to be sufficiently clear to allow direct sunlight on individual cloud cells, and this component is added to the skylight's colour temperature. At either end of the day clouds can make a vivid contribution to the light. The necessary conditions are clear sky on the horizon and medium to high clouds, so that the reddish rays are reflected from the base of these clouds. The strongest colour for these clouds is in the direction of sunrise/sunset, as the light reaches the photographer more directly. More rarely, a large cumulus or cumulonimbus opposite the sun adds an orange-ish note to shadows.

DEGREES OF REFLECTION

Distinctly shaped clouds are the principal reflectors, and the most prominent of these are cumulus and the less common cumulonimbus. These diagrams represent views away from the sun.

Shower cumulus
Bright white components, but usually with masses of grey, so only partially effective as reflectors.

Heavy cumulus (90%)
There is almost no reflective effect when cumulus covers most of the sky – 7/8 cloud cover in meteorological terminology. The colour temperature is around 6000 K.

Fair-weather cumulus (50%)
Small, individual, and compact white clouds, typical of good weather, make one of the strongest reflective weather conditions. Cloud cover here is about 3/8, and the effect on colour temperature in the shade would be significant.

Cumulonimbus
A great vertical extent is typical of cumulonimbus, building up to a storm. At this stage in its development, and seen from a distance, it makes a very strong reflector (see the photograph of the Grand Palace, Bangkok).

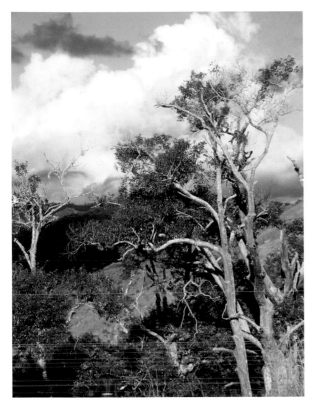

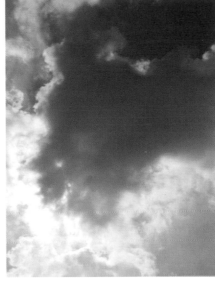

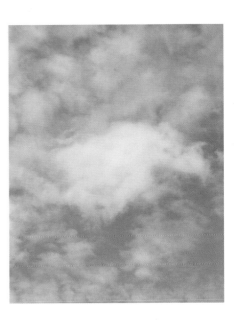

Clouds opposite the sun

In the highlands of the island of New Guinea, ragged cumulus on the opposite side of the sky from the sun (which was about 25° above the horizon) are in a classic position for shadow fill. The colour temperature is slightly less at this time of day than white – about 4900 K.

Diffusion vs reflection

Clouds in the direction of the sun not only look completely different from when they have moved to the other side of the sky, they affect the light in a completely different way. In front of the sun, they act as diffusers, as described over the last four pages; note also, as a cloud passes directly in front of the sun, the contrast between its edges and centre increases dramatically, so that what looked like a white cloud now appears grey. Away from the sun, individual clouds reflect its light, with a less strong overall effect on the lighting but still noticeable on bright days.

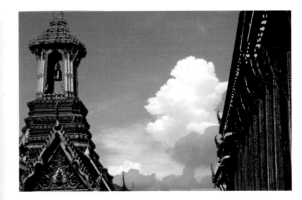

High-level cirrus

Thin but distinct layers of cirrus and cirrostratus have only a little reflective effect, although they do lower the colour temperature of the skylight.

Cumulus opposite low sun

Because the eye adjusts to slow changes in colour temperature, the slightly more yellow colour of clouds opposite a low sun (around 20° above the horizon) is not immediately obvious, but real nonetheless.

Cumulus opposite sunrise/sunset

A rich sunset in clear air. The reflection from these clouds is much less intense than it would be with the sun higher, but the colour effect on shadows can be significant.

White reflector

Even though at midday, with the sun almost directly overhead, the height of this towering cumulonimbus, shortly to develop into a rainstorm, allows it to catch the full illumination. Seen from Bangkok's Grand Palace, it is by far the brightest element in the scene, and while its reflection effect is obviously not visible from this angle, it acted as shadow fill in the same way as a white card in a studio.

DAYBREAK

The most rapid changes in lighting occur when the sun is on the horizon, either rising or setting. In the middle of the day, provided that the weather conditions stay the same it may take a few hours for the light levels to alter by one *f* stop, but the sun rising in very clear air and unobstructed by vegetation (such as in an Arizona desert) can take pre-dawn light levels up by around four stops in just several minutes. For anyone unfamiliar with the location looking at a sunrise image, there is usually no way of telling whether it was shot at this time or at sunset, but on the ground there may be important differences, apart from the obvious one of direction. Local weather conditions, for instance, may favour morning mist, or alternatively a build-up of haze during the afternoon. Things like this are highly specific and can be worked out only on the spot. Bearing this in mind, the lighting conditions for sunset are much the same as described here, though in reverse timing.

The beginning of the day is one of the least predictable times for shooting, but can bring sudden surprises and rich, dramatic light.

More significantly when shooting, preparing for the moment of sunrise is very different from anticipating sunset. The eye is adapting from dark to light, and photopic vision is taking over from monochrome scotopic. Perceptually, by the time the sun actually rises, the daylight seems much brighter than it really is, due to the eye's light adaptation. Another point of difference is when the sun is going to be in the shot, it is clearly important to know where it will appear on the horizon. In a landscape, there may be a particular feature, such as a hilltop, building, or tree that would make a good silhouetted point for the sun's appearance, and this might mean shifting the camera position slightly. Here a GPS handset can be useful, for displaying time and direction. Only on the equator does the sun rise vertically, which is to say, in the same place as the gradually brightening pre-dawn glow. In all other northern hemisphere locations the sun rises south – that is right – of the glow. The amount, which is seen as a shift of the centre of brightness on the horizon from left to right, depends on the angle of the sun's ascension (*see pages 44-45*). In the southern hemisphere this is reversed, a situation which seems never to fail to confuse visitors, and the sun rises north and left of the pre-dawn glow.

Scattering is responsible for the colour of sunrise. The sun's rays pass through a greater thickness of the lower atmosphere, and the greater scattering of high-energy short wavelengths (blue and violet) leaves behind a redder colour temperature. Exactly how red or orange, however, varies considerably. Indeed, predictability is an issue in all except the most weather-consistent locations, such as deserts. The major reason, which also gives daybreak its appealing qualities for photography, is the extremely low angle of the sun to the atmosphere, which gives a much greater likelihood of clouds getting in the way. And any clouds take longer to move out of the line of the sunlight, also because of the angle. The ideal conditions for a fiery sunset are medium-to-high clouds in the foreground, but a clear sky behind, so that the sun's unobstructed rays strike the base of these close clouds. In fact, red clouds are rather more likely when the sun is just below the horizon.

The second reason for unpredictability is that you do not have the advantage of being able to watch the

GPS INFORMATION

A GPS handset is a useful, arguably essential, accessory for outdoor location shooting. In addition to location data (which, incidentally, can be transferred to the EXIF data on images with some cameras by means of a cable attached during shooting), it also calculates and displays sunrise, sunset, moonrise, moonset, and the respective tracks across the sky for any day.

CHOOSING SUNRISE OR SUNSET

If the orientation of a subject favours either sunrise or sunset (as opposed to receiving cross-lighting at both ends of the day), it is often well worth checking out the very different lighting at each. On an extended location shoot, and if the subject is sufficiently important, it's quite usual to plan the itinerary so as to overnight nearby. As these two images show, each time of day offers a different and useful set of qualities.

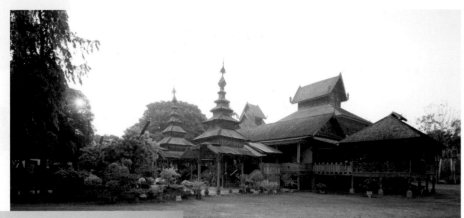

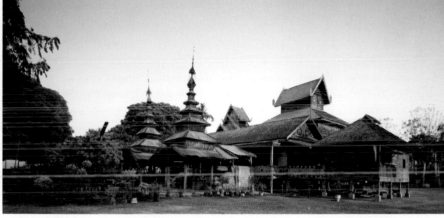

weather develop for several hours before, as happens with sunset shooting. This makes weather forecasting difficult, and this is added to by the inherent changeability of weather at this time of day, as the air begins to heat up. The result is that in many locations anything can happen to the light. In any case, a wise precaution is to scout the location the afternoon before to have some idea of the scene and possible camera positions. Simple things like access to a viewpoint call for some preparation, as roads and paths may not be easy to find in darkness. Also, if the location is in some way managed, such as an archaeological site or in a national park, there may even be obstructions, like locked gates. In sites like these, it is essential to find out opening times and/or make very clear arrangements. People have been known to oversleep.

THE POINT OF SUNRISE

Because the eye adjusts so well to the pre-dawn light, people tend to expect sunrise to happen earlier than it does, hence the importance of knowing the exact time in advance. If the placement of the sun in the frame is critical, as here behind Mitten Buttes in Monument Valley, it helps to choose a camera position that gives you some room to move left or right at the last moment. Even so, there are likely to be only several seconds at this point. The longer the focal length of the lens (here 400 mm), the greater distance you would have to move to affect the position.

GOLDEN LIGHT

As the sun clears the horizon, one of the key periods for outdoor photography begins. This is the usually short time when the sun's rays are low and warm in colour. Sometimes called 'golden light', it has no fixed beginning and end, but by common consensus lasts until the colour temperature is almost white. In practice this means from when the sun is about 5° above the horizon up to about 20°. This, as the descriptions of the sun's path on pages 40-47 show, varies with season and latitude. In a mid-latitude spring and autumn, which I'm using in this book as the default time and location, lasts around one and a half hours in the morning, from about 0630 to 0800, and the same length of time in the late afternoon, from about 1630 to 1800. In the tropics it can be down to about 45 minutes at each end of the day, while close to the Arctic Circle it lasts all day for much of the year, provided that the weather is clear.

The period when the sun is well above the horizon but still below about 20 degrees is, for many outdoor photographers, a favourite time for shooting.

The characteristics, as long as the sunlight is bright and unobscured by clouds, are a feeling of richness to the light, with long distinct shadows and subjects that are only partially, but strongly lit from one side. The question of why this lighting is so widely admired in photographs and in the real scenes is an interesting one, but little analysed. It may have to do with the fact that it is colourful and short-lived, so that scenes are lit in an unfamiliar way, and that because this visual drama is transient, it does take some effort, diligence, and luck to make photographs at this time of day. Whatever the reasons, given the choice and subtracting the inconvenience, most photographers tend to go for this 'golden light' period rather than the middle of the day, particularly when shooting large scenes. Inevitably, there is a counter-school of thought, concentrated mainly in the fine-art division of photography, that tends to despise this lighting for being too obviously likeable and lacking in nuance.

The colour temperature is typically between around 3500 K and 4500 K, which is generally thought of as pleasant, but of course this is infinitely adjustable in a digital image. What also adds to the overall attractiveness of this light for shooting is the variety that it offers at

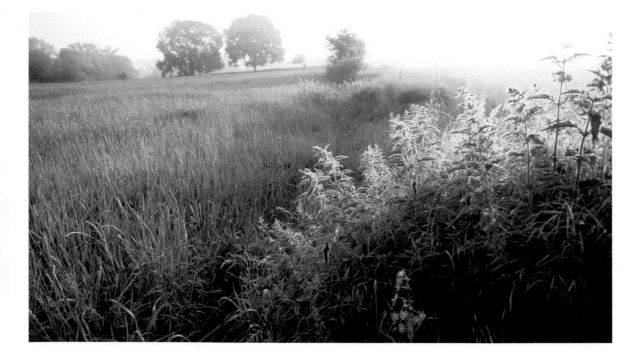

Atmosphere and colour contrast
Part of the appeal of this time of day for lighting is the low elevation of the sun, which creates a variety of choices: here, shooting more or less into the sun exploits the softness of morning mist over a water meadow, and edge-lighting for the nettles and other foreground plants. Another attraction is the yellowish 'golden' light from the sun, which contrasts sympathetically with the bluish cast to shadows, here visible in the close foreground and the distance.

DAYLIGHT

any one time. Shooting into the sun gives several subtle kinds of back-lighting, from silhouettes to edge-lighting. Turning 180° away from the sun gives full frontal lighting, which can be spectacular for brightly coloured and reflective subjects (although avoiding capturing your own shadow can be tricky, the solution being either to aim a little more off-axis or to blend your shadow with that of something natural, like a tree trunk, vegetation or rock). At any intermediate angle you have degrees of side-lighting, and as the diagram shows, and as is described in more detail under studio conditions on pages 186-191, there are important shades of difference in this according to the relative positions of the camera, subject and light. Side-lighting rakes across surfaces and is the means par-excellence for revealing texture.

FRONTAL LIGHTING AND SHADOWS

At sunrise and sunset, frontal lighting can be rich and intense, as shown here, on the Jefferson Memorial in Washington DC. Your own shadow, however, can be a problem. In this case it was minimized by using a timer and tripod, and my standing to one side for the shot. The shadow can then be cloned out in retouching.

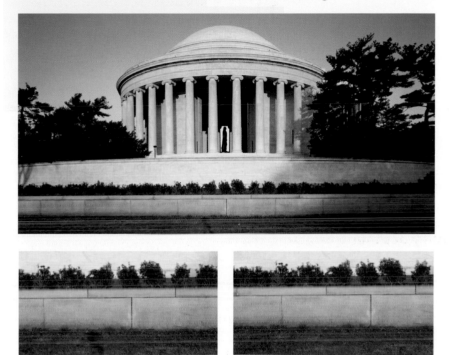

THE SUBTLE DIFFERENCES IN SIDE-LIGHTING

Light and shade
Side lighting produces the most distinct shadows. This sequence shows what happens as the direction of sunlight moves from frontal to back. The shadows are smallest from the camera's viewpoint in frontal lighting, while in backlighting shadows dominate to the extent that there are few sunlit parts to give local contrast. The maximum light/dark contrast is when the sun is at right angles to the camera.

High contrast
High contrast is typical of many side-lit scenes. The lighting is at right angles to the view, and thus the shadows are too. As the diagrams show, a surface needs to be angled only slightly away from the sun, or be shaded by quite a narrow obstruction, to give a high light/dark contrast.

SOFT LIGHT

There is a range of weather conditions that stops short of obscuring the sun but which nevertheless has a slight diffusing effect. Thin, high-level clouds such as light cirrus or cirrostratus (which is often detectable only by the halo it creates around the sun) soften sunlight without killing shadows, as do various degrees of haze, which is a low-level phenomenon that permeates the atmosphere. A stationary high-pressure system tends to cause a build-up of haze day by day, as does temperature inversion in winter. For photography, this means that even with direct sunlight the clarity of the air causes considerable differences in how hard or soft the light is. There are no standard measurements for daylight contrast, but the effects are obvious enough in the camera's LCD display with histogram and clipping warnings.

The atmosphere diffuses sunlight, with subtle variations, which weakens shadows and lowers contrast; a lighting effect that gives good modelling.

Softened sunlight lacks punch, but does a better job of displaying detail. Shadows are not so blocked and there is less danger of clipped highlights. Overall, this is one of the most useful kinds of daylight, and is fairly malleable to post-production adjustment. Applying a contrast-raising S-curve can often give the general effect of brighter sunlight. For portraits in particular, this is easy lighting to work with. For landscapes and architecture, if the softening is due to haze rather than high-level clouds, there will be stronger aerial perspective. It's possible to make use of this by composing a scene that distinguishes foreground, middle ground, and distance visually by the depth of atmosphere.

There are, in addition, lighting accessories for modifying sunlight and softening it. These work best on smaller subjects like people. Reflectors lower contrast and fill in shadows, diffusing sheets spread the light source, while black sheets and panels are a subtle way of raising contrast on cloudy days.

Light haze
An overall light haze, quite typical of many parts of India in winter, here softens the lighting over a modern roof terrace in New Delhi, even though the sun was moderately high – 40° at 1000 hours. Shadow edges, nevertheless, are still preserved. The histogram shows that most of the range is distinctly in from the edges, meaning lower contrast.

Haze into and away from the sun
A stronger haze than in the picture opposite – actually the aftermath of a dust storm – allowed two contrasting treatments of a ruined medieval stone fort overlooking the Nile in Nubia. The two shots were taken within an hour of each other, from different directions. Note the definite aerial perspective in both images.

Original image

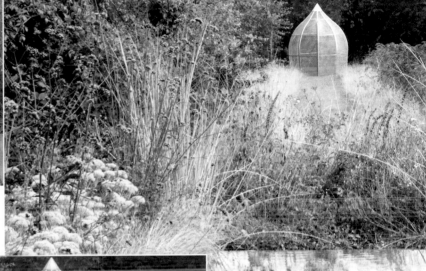

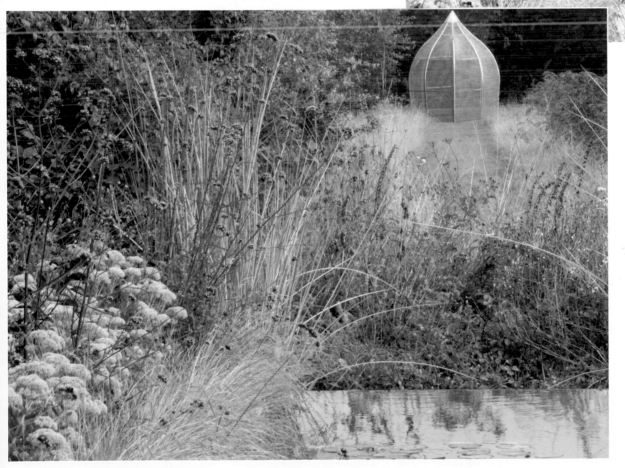

Taking care when optimizing

The softening of light here, over a garden in the West Country of England, is the result of low rain clouds that were starting to clear. The trace of a watery sun can be seen in the reflections in the steel gazebo in the distance. The large version is optimized, and for comparison, the original Raw image, with less contrast, and an auto-optimized treatment (i.e. Auto in Photoshop Levels with Enhance Monochrome Contrast selected), are also shown. There is plenty of room, and need, for judgement when deciding how to handle this kind of lighting in post-production.

Final image

SOFT LIGHT

SOFT LIGHT

MODIFYING LIGHT

When you don't have the luxury of time that allows you to wait for the perfect daylight conditions, stretching a sheet of diffusing material between the sun and the subject replicates soft daylight. The panels shown here are from Chimera (group shot) and Lastolite (location shot). For DIY versions, the standard material is spun, available in different strengths of translucency. Suspending it is never easy, because this has to be at least partly overhead and large enough to cover the key areas of the scene. The reverse of using reflectors is to add shadows in low-contrast lighting with a vertical black panel or sheet close to the subject (sometimes called subtractive lighting).

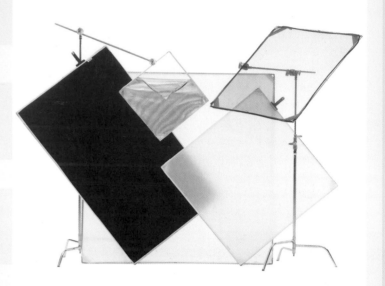

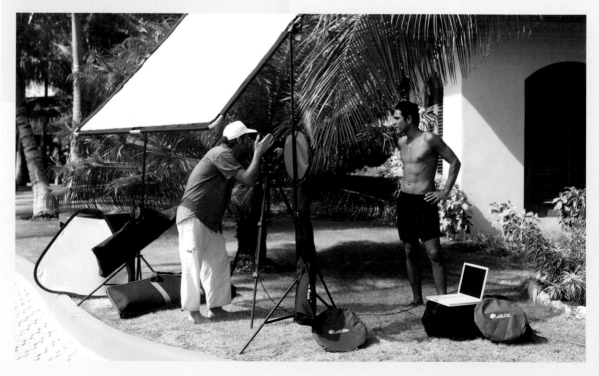

USING REFLECTORS

Reflectors work best when the sunlight is strong, and their primary use is to fill in obvious shadows and so even out the contrast range. Also, positioning one below the subject in outdoor fashion and portraiture improves the overall illumination by brightening the under-chin area. This is the same use as in beauty lighting in the studio, shown on page 184-189. The larger the area of the reflector, the more generous the fill, and on motion picture sets, large rigid panels hinged on frames are usual. The inconvenience of carrying large panels is allayed by collapsible fabric reflectors that spring open under the tension of a steel band when unwrapped, and these are standard in professional photography. They are available in many sizes, and the latest have a shape and grip that enables them to be held in one hand only.

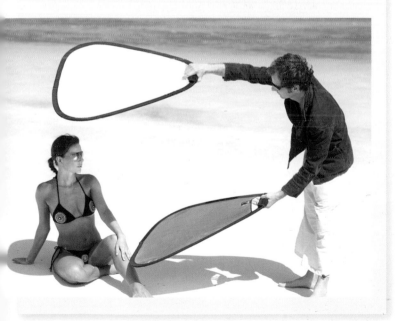

DAYLIGHT REFLECTOR SURFACES

The intensity of shadow fill can be controlled by using different surfaces. Very high reflectivity, as from polished metal or the shiny side of aluminium foil, is hard to control, and tends to produce hot-spots and unwanted patterns when aimed into a shadow. A more conventional surface is foil that has been crumpled, then flattened out and stuck to a flat panel. Using the dull side reduces the intensity but spreads the fill. Plain white, which is easy to improvise with sheets, has a much softer effect. More recent research has produced fabrics in which the colour temperature is more precisely controlled. In typical bright sunlight, the sky will be blue, and so the shadow colour temperature high. A colourless silver reflector will lower the colour temperature, but not all the way to 5200 K as it is unlikely to swamp the shadows completely. Adding gold stripes to the reflector raises the colour temperature above that of the sunlight, to compensate for the skylight.

STORM LIGHT

When lighting plays a stronger role than usual in an image, one factor is how special it appears to be. Because photography is so universal an activity, and we see so many images every day, it often provokes a reaction of "I could have done that," carrying the argument that if it were that easy and available, the image was not really worthwhile. Effort, skill, perseverance, and luck carry weight in an image, and whether or not you agree with this, few photographers would pass up the opportunity to shoot in lighting that has rarity value. One of the most fleeting and unpredictable in outdoor scenes is stormlight – patches of sunlight when the sun breaks through brief clearings in heavy cloud.

What makes this kind of lighting interesting and attractive is the contrast between the lit area and the surrounding bad weather, and including the stormy sky in the view makes this stronger. It can also play havoc with the exposure, with a difference typically of at least 2 *f* stops between the sunlit and area and the surroundings. Because stormy conditions are usually volatile and fast-moving, the light can appear and disappear very quickly, sometimes in several seconds, and in a landscape view can travel unpredictably. The key for exposure is the sunlit area – if and wherever it appears – but in the usual scenario, there is no way of accurately setting the camera for this in advance. Much depends on the metering mode being used. Centre-weighted average is quite likely to overexpose the scene, particularly if the hoped-for sunlit area is small and off-centre. Matrix/multi-pattern metering may work, but that depends on the make of camera. Spot metering certainly will work, and if you could be certain that the sunlit area would persist, that would be the method of choice; the risk is that in the time it takes to aim, measure and re-set the framing, the moment will be gone. If none of these standard methods seems reliable, one answer is to set the exposure manually to two *f* stops below the average reading for the overcast scene. Another, which could be combined with this, or else used with matrix metering, is to Auto-bracket the exposure.

This is one lighting condition that cannot be planned for. You can hope for it under certain weather conditions, such as the end of a stormy cold front as a depression moves across the country, or on the lee side of a mountain ridge when clouds are being formed by strong winds on the windward side, but that is about as far as it goes. It's quite possible to spend an hour or two quite fruitlessly waiting. If you do think the chances are good, it's essential to anticipate the effect and compose the frame accordingly, as there may be little time to waste when the light strikes. Then it's simply a matter of waiting and watching the weather.

> **Generally highly regarded and sought after because they cannot be planned for, sudden moments of bright light that break through heavy weather bring drama to a landscape.**

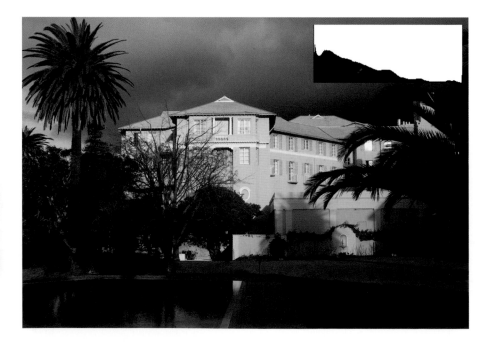

A narrow window of sunlight

An old Cape Town hotel during a brief break (several seconds) in fast-moving storm clouds. The sun was moderately close to the horizon in the late afternoon, and if the entire scene had been fully lit, the effect would have been pleasant but unremarkable. What gives the drama is the dark surroundings (and for this reason the camera was deliberately positioned to catch the silhouetted fronds in the right foreground), and also the thundery clouds behind. As the histogram shows, the black and white points were set for high contrast.

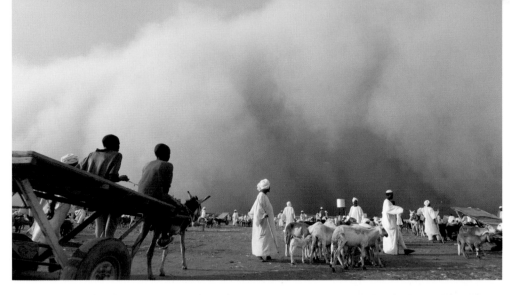

SUN-VIEWING FILTER

Storm conditions encourage you to look in the direction of the sun to check the approach of breaks in the cloud, and this, as everyone knows, can be damaging to eyesight. A sensible precaution is to use one of these specially tinted neutral viewing filters.

Duststorm

A different kind of lighting drama comes from duststorms – equally unpredictable and fast-moving. This huge approaching wall of red dust, which built from nothing in little more than 10 minutes, is a feature called the haboob, that occurs particularly in Sudan. A striking phenomenon in its own right, it also creates an unworldly dark and red light when it engulfs the scene.

RAINBOW

A possible side-effect of stormy weather is a rainbow, but they are rarer than most people think; the average for any one location in England, for example, is less than ten a year. Anticipating how and when a rainbow might appear involves knowing the pre-conditions, which are direct sunshine and falling rain, and on the opposite side of the sky from the sun. It therefore moves relative to your own position. The centre of a rainbow is the antisolar point, so the lower the sun, the higher the bow. Colour intensity depends on droplet size and is unpredictable.

A FOGGY DAY

Another lighting condition that is hard to predict, particularly in detail, is fog; it transforms any scene, often bringing a sense of mystery and oppressiveness.

Though it can sometimes persist for days along sea coasts, fog is generally a short-lived phenomenon. It forms when humid air at ground level is cooled. Radiation fog is the most common type, caused in clear, still air when wet ground cools overnight (hence meadows and valley bottoms), and disperses in the morning sun. Another kind is when a warm wind blows over cool ground, such as sea and coastal fog when there is a southerly airstream; if the air is forced to rise up at the coast, the fog can hug the upper part of the hills or cliffs. How soon it burns off is hard to predict; fog banks that form over the sea can persist for days.

The effect on lighting can be quite subtle, and what you can do with it in terms of imagery depends on the mix of fog density, subject matter and camera position. Aerial perspective is one of its main effects. There are several kinds of perspective – all of them ways of communicating a sense of distance and depth in a scene – and aerial perspective works by means of a gradually thickening atmosphere. Objects further from the camera appear paler and less detailed than those in the foreground. Fog does this more strongly than any other weather condition. Aerial perspective tends to work at its most definite when the parts of a scene are arranged in distinct planes with empty stretches between them.

This gives rise to a suite of specific lighting effects, including extreme diffusion, a low dynamic range, pastel colours, and silhouettes both strong and pale. Fog is the ultimate diffusing filter, with hardly any shadows, and a narrow tonal range. There is a choice both in shooting and in post-production of brightness and contrast, and it is very much a creative choice. The temptation is towards more contrast, but the soft, deadening experience of fog is low contrast. In terms of colour, fog desaturates, giving a typically pastel treatment. If the sun is low and the fog not too dense, shooting towards the light easily creates silhouettes. The closer the object, the stronger the silhouette; at a distance there can be paler, more enigmatic outlines.

Because the dynamic range of a typically fog-bound scene is very low, exposure can vary by two or more f stops and still be technically correct and within the scale. There is more room than usual for interpreting the lighting. You can expose fully for a bright, glowing effect, or less for a more sombre treatment. Exposing for a centred histogram (mid-grey) and shooting Raw format gives the maximum post-production choice, so you can make decisions later, with time to spare.

ADDING SMOKE

A smoke machine is one way of introducing artificial atmosphere on a relatively small scale, though with effort. Anything more than a slight breeze, however, causes rapid dispersal, and it is difficult to control. It can be useful in a setting like this, to give some aerial perspective and plane separation in woodland.

DECIDING BRIGHTNESS AND CONTRAST ATTITUDE

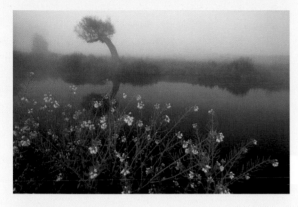

Original
As shot, this dawn photograph of a river bank in Dedham Vale, England, is low in contrast, as expected, and slightly under-exposed (though nevertheless acceptable).

Auto Color Correction Options

Algorithms
- ○ Enhance Monochromatic Contrast
- ● Enhance Per Channel Contrast
- ○ Find Dark & Light Colors

☐ Snap Neutral Midtones

Target Colors & Clipping

Shadows:	Clip:	0.10 %
Midtones:		
Highlights:	Clip:	0.10 %

☐ Save as defaults

OK
Cancel

Adjusting the auto
By holding Alt as you choose Auto Color Correction you can alter the preferences for Photoshop's automatic adjustments.

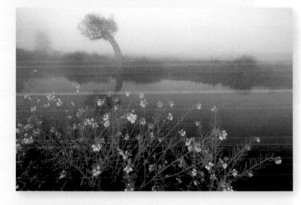

Contrast-enhanced #1
Using Levels Auto Color, with Enhance Monochrome Contrast selected.

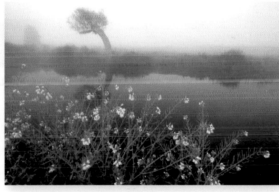

Contrast-enhanced #2
Using Levels Auto Color, with Enhance Per Channel Contrast selected, gives a more extreme contrast enhancement, with neutralization of the blue thrown in for good measure.

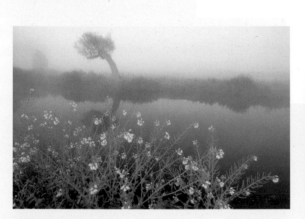

Lighter
Raising the mid-point in either Levels or Curves gives a paler version.

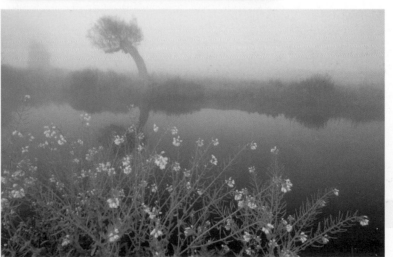

Less contrast
This would not be everyone's choice, but still a possibility, using the Output Levels.

TWILIGHT AND NIGHT

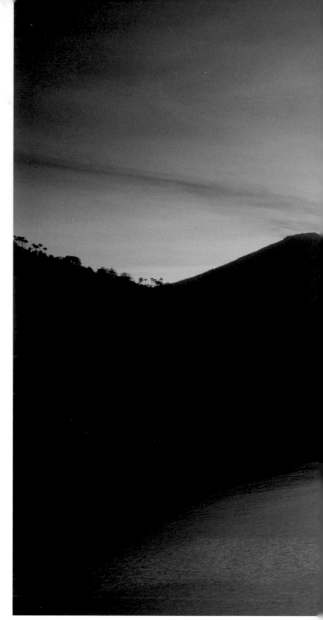

Twilight is the period of residual daylight when the sun is below the horizon, and while it is of little use as a source of light, shooting into it can be rewarding. How interesting it appears is heavily dependent on the weather. With a completely clear sky, there is an arc-shaped gradient of brightness and colour combined, and the effect can be complex. A light cloud cover can enhance the view, with the cloud bases picking up colour from the lower part of the sky. Facing away from the glow, twilight only rarely offers anything special in the way of lighting, and then only when the sun is just below the horizon and the colour is rich.

Unless heavily clouded, pre-dawn and dusk skies graduate in brightness and colour from the horizon upwards. They make good silhouettes and a good substitute for night itself.

The two main lighting uses for twilight in photography are as a backdrop for silhouettes and as a substitute for night. Silhouettes need no elaboration, other than the need to expose for the twilight itself, even reducing the exposure below what is necessary to avoid highlight clipping, so as to preserve the strength of the colours close to the horizon. For more on silhouettes see pages 68-69 (on Shooting light itself). Mid-to-late twilight is the usual time to shoot "night" scenes, because there is some detail still showing and because there is enough tone in the sky to show building and other outlines in partial silhouette. Building floodlighting and other exterior practical lights mix well with twilight, and as the natural light fades they become more prominent. Judging the timing to give the right balance takes some experience, and for safety, many photographers begin shooting early and continue until the twilight has almost gone. This gives more choice. It is always easier to lower brightness and raise contrast in post-production than to work with an image taken too late.

Night-time, defined in lighting terms as the hours when there is not even residual daylight, is only useful when there is a moon. Otherwise, it is simply dark and needs artificial lighting; worse still, with the sky black there is no definition to the outline of buildings, trees, and so on. (For moonlight, see the box on page 71.) Because human night vision is scotopic (the monochrome rods take over from the colour sensitive cones at low light levels), we experience hardly any colour, and this raises an issue for twilight and night photography. The LCD display of a long-exposure shot often surprises by being so much more colourful than the scene, and 'warmer'. Shots by moonlight, which is simply reflected sunlight, have the same colour temperature as daylight, but we expect a more monochromatic treatment, with some blue cast. This is easy enough to achieve in post-production, but the choice needs to be considered between reality (which is not as we experience it) and 'actuality' (as we expect it to be). Often a halfway stage between the two is an effective compromise.

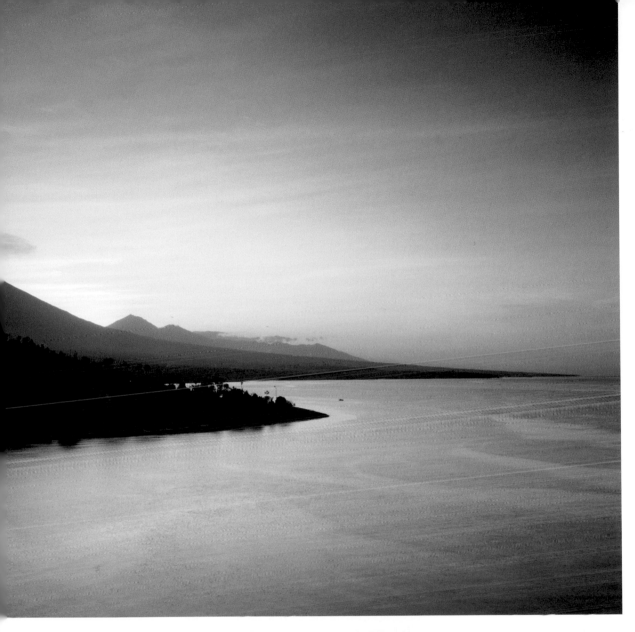

Restrained colours and reflections

Sunsets and sunrises are usually associated with rich reds and oranges – heavily saturated in colour. Waiting longer after sunset, as here, in a view from a Balinese coastal headland toward the island's principal volcano in the distance, gave time for the colours to retreat to a smaller area close to the horizon. The effect, with the wide-angle view dominated by a nearly neutral sky and its mirror reflection in the sea, is more subtle, and if anything draws more attention to the reddish highlight of the plume of smoke from the volcano's summit.

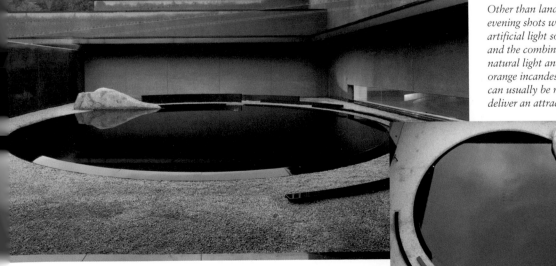

A reliable alternative

Other than landscapes, most evening shots will include artificial light somewhere, and the combination of bluish natural light and (generally) orange incandescent lamps can usually be relied upon to deliver an attractive image.

The other feature of twilight is the absence of any direct light, which can be very good for any reflective surfaces. In this case, the subject is a modern Zen stone garden and circular reflecting pool in a Japanese crematorium. Seen from overhead in the smaller image, this subtle construction reacts poorly to the flat daylight, but waiting until about half an hour after sunset produced a predictably more interesting result – smooth blue reflections in the polished granite and a complementary orange light from the low window.

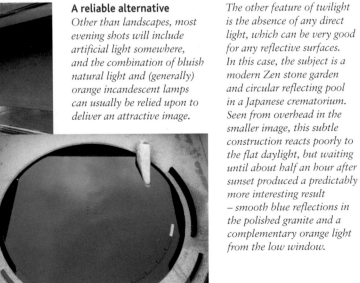

TWILIGHT AND NIGHT

Lighting for architecture

Standard exterior architectural views rely on finding a clear, legible viewpoint, and this is often limited – dictated by the orientation of the building and the space around it. With sunlight from the right direction, all well and good, but under an overcast sky, with or without rain, the situation may be almost hopeless. Under these circumstances, as here with a modern Bangkok home in the rainy season, there is a known solution – switching all the lights on, opening all blinds, and waiting until the level of natural twilight approximately matches the interior levels.

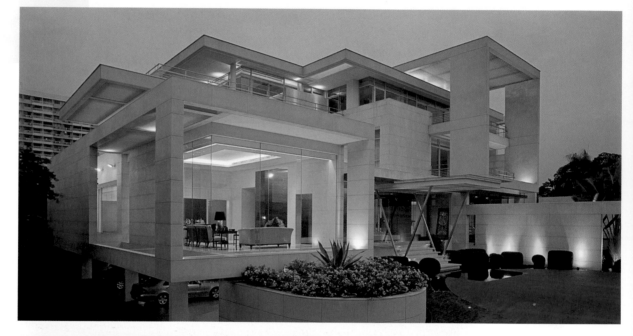

Shoot both ways

If there is any uncertainty at all about how the evening view will look (by no means always predictable), it's a good idea to begin shooting earlier, by late afternoon light, if appropriate. This gives a margin of safety. In this example, a stacked-glass sculpture by artist Danny Lane, the original assumption was that the partially lit evening view would be best. In the event, although this worked well, the late afternoon version was chosen.

SHOOTING BY MOONLIGHT

The ability to dial up the sensitivity in a digital camera, and even more importantly the lack of reciprocity failure that always dogged colour film photography at very long exposures, makes it relatively easy to tackle moonlit nights. Nor are the exposure calculations so demanding; as long as you have an approximate exposure time, the LCD display will quickly show what fine adjustments need to be made, if any. For lighting, the moon behaves as a very dim substitute sun, with some differences. It appears to be approximately the same size seen from Earth (just covers the sun's disc in a full eclipse) and, of course, reflects sunlight. Its brightness depends on its phase, with a quarter moon one tenth of the lux value of a full moon, and like the sun on haze and clouds, and on its height. At its brightest (full and fairly high in a clear sky) the starting exposure should be about one minute at $f2.8$ at ISO 100. This is the exposure arrived at by what is sometimes know as the 'loony 18' rule, a variation of the better known 'sunny 16' rule (the latter suggesting using a shutter stop of $f16$ on a sunny day, and shutter speed as near to the ISO as possible, so $1/100$ sec for ISO 100). The moon is approximately 250,000 dimmer than the sun, an 18-stop difference. Reducing the sunlight exposure gives approximately 35 minutes at $f16$, or 1 minute at $f2.8$. Think of this as a starting point. This is necessary for tripod photography, and to minimize fixed-pattern noise, it is recommended to use a low ISO setting and have the camera's noise-reduction option switched on (see pages 32-33). This image, of a full moon accompanied by Jupiter, was shot at 2030 in the evening, and the settings were 20 seconds at $f5.6$ at ISO 220.

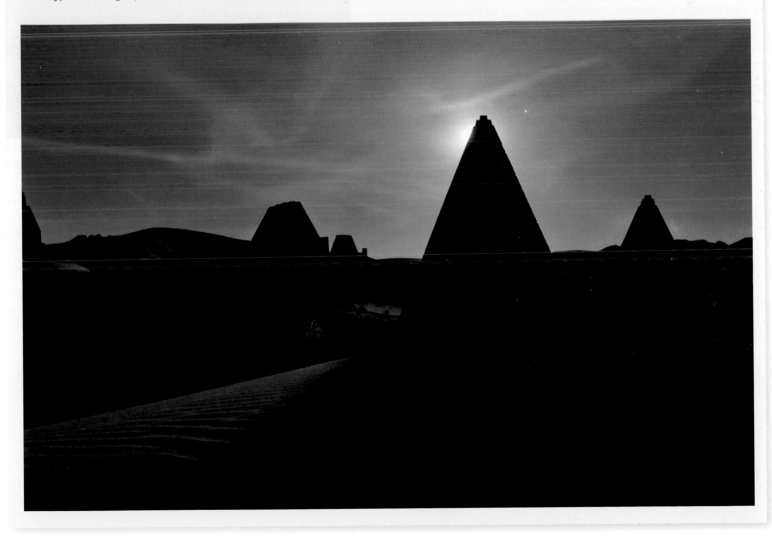

KEEPING PACE WITH THE END OF THE DAY

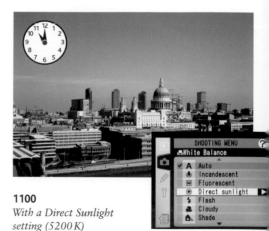

1100
With a Direct Sunlight setting (5200 K)

As we've just seen, the ends of the day are the times when the light changes the most rapidly. With many scenes, it is not at all obvious when the best moment will be for whatever image quality you are looking for, and the safest approach is to wait and see – provided of course that you have the time. In particular, it means making continuous adjustments to the colour and exposure settings, or at the very least making decisions about them.

Brightness and colour change more rapidly as the sun nears the horizon, sometimes in complex ways, and this calls for a series of decisions on camera settings.

Exposure adjustment is the simplest of these, and provided that the camera is set to Auto, it will make its own adjustments. Reciprocity failure, the bane of colour transparency shooting in low light, does not occur, but in its place there is the issue of noise. Long-exposure noise, also known as fixed-pattern noise, increases with lengthening shutter speed, even at low ISO settings. Fortunately, this can be reduced in-camera because each sensor behaves in a predictable way. Nevertheless, a fully exposed night-time view usually looks too similar to a daytime view, as we saw on page 71, and to preserve a sense of night, under-exposure is often a good idea.

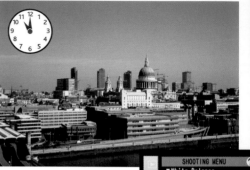

1100 Cloudy
The same moment with a slightly warmer cast: Cloudy setting (about 800 K warmer)

Colour temperature changes less noticeably, because the eye accommodates to the pace at which it falls as the sun nears the horizon, and then rises again at dusk. Nevertheless, the colour shifts can be dramatic in clear light. The question is, do you actually need to do anything about them? Decisions on colour temperature are, above all, perceptual, and there are two influences. One is that we expect late afternoon and early morning sunlight to be reddish, just as we think of dusk and night as bluish. The other, which runs counter to this, is that our eyes accommodate to the colour so that we notice less of the difference – hence the surprise of seeing just how red a sunset was on film. Now that digital white balance gives us total control, both in-camera and in post-production, we not only can decide on the appearance of light, we're obliged to.

In the example here, shot over the course of an early spring day in London, there are many possible decisions at each stage, and no 'right' ones. To complicate matters, I've chosen a cityscape because this kind of scene contains its own artificial lighting to add to the ambient daylight. As the last shot illustrates, specific floodlighting can make a strong impression.

1720

40 minutes before sunset: Direct Sunlight setting (5200 K)

1815

Shortly after sunset: Direct Sunlight setting (5200 K)

18:40

Just after the floodlighting was switched on: Direct Sunlight setting (5200 K)

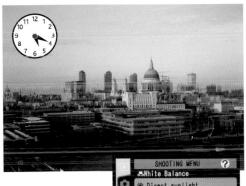

1720 Auto WB

The same time, with Auto White Balance, gives a strange midday appearance

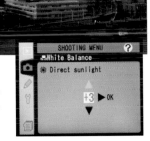

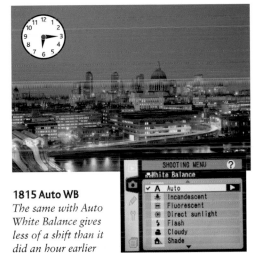

1815 Auto WB

The same with Auto White Balance gives less of a shift than it did an hour earlier

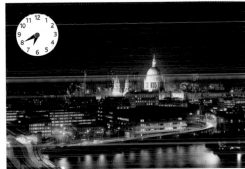

1840 Auto WB

The same with Auto White Balance, which neutralizes the mercury vapour floodlighting – now the dominant feature of the scene

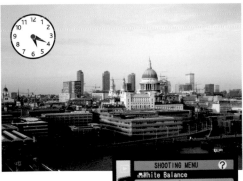

1720 Auto WB, cooler

The same with a cooler setting: +3 equals about 1000 K cooler

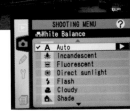

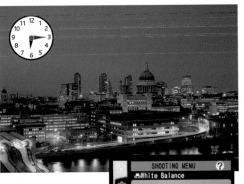

18:15 Auto WB, Cloudy

The same, but warmer to counteract the yellow sodium vapour lighting: Cloudy setting and -2 equals about 1600 K warmer than daylight

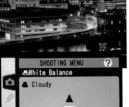

1840 Auto WB, Hue -6

The same, but using the Hue adjustment to add red: -6 setting equals 6° of hue angle

SHOOTING INTO SUNLIGHT

Taking care to avoid damage to sensor and eyesight, making the sun and its reflections the subject can produce atmospheric imagery and occasional surprises.

Shots into the sun tend to be low on detail but rich graphically and atmospherically. Provided that you can control the flare and contrast to your liking, contre-jour (as it's sometimes also called) is the lighting condition that gives the best opportunities for unusual and unexpected imagery. The extremely high contrast makes exposure judgement an issue, and while some highlights will almost inevitably be blown out, underexposure is often a safer option, provided that there are possibilities of doing something graphic with the image rather than documentary – a silhouette, for instance. There are variations, as illustrated, and these have specific effects. These are all high dynamic range lighting situations, and so can respond to the HDRI techniques described in Chapter 5. Right now, however, we'll look at the less technical, creative approaches.

These situations typically create flare of some kind, and this is by no means always a bad thing. Flare streaks and polygons from internal reflections in the lens barrel are characteristic of shots just off-axis, and the results have undeniable atmosphere. They also help images rate high on actuality, for occasions when you don't want the shot to look to locked down and planned. A measure of this is the existence of software for adding flare streaks and polygons too 'clean' images (see Digital Flare & Diffusion, page 158). One effect often aimed for is a tight, distinct star pattern around a clear sun. This is at its most intense with a wide-angle lens at a small aperture, and can also be enhanced by choosing a viewpoint that slightly hides the sun's disc behind an edge or vegetation, as in the picture shown top left on the opposite page.

SUBTLE VARIATIONS

Sun in frame
The most extreme form of high dynamic range image, and if the sun is to appear distinctly, the exposure will usually be so dark that foreground elements are silhouetted, or at any rate black.

Diffused sun in frame Less extreme in contrast than a clear sun, and a broader background.

Off-axis The sun just out of frame is a very useful condition. Contrast heavily dependant on the clarity of the air. Needs precise masking, not just with lens shade but often a flag or hand, to avoid image degradation.

Off-axis, dark background
A specific version of general off-axis conditions, in which the edge-lighting is dominant.

Off-axis flagged Another variety of off-axis in which some element, such as a doorway or corner of a building.

Sun's reflection A special case in which the angle of the camera's axis to a reflecting flat surface (usually water) is equal to that of the line of sight from the surface to the sun. Easiest to use when the sun is fairly low.

Partial masking

RIGHT *Careful positioning against foliage makes it possible to cut down the amount of direct sunlight reaching the lens while still giving the impression of the sun in frame. This is easiest to do with a wide-angle lens, which reduces the apparent size of the sun. In this image, of an Indonesian man climbing a toddy palm to collect sap, the exposure was also reduced to create a silhouette and retain all highlights, including the immediate flare star around the sun.*

The sun's reflection

FAR RIGHT *With this variation, the angles are critical – camera position and height of sun have to be the same in relation to the reflecting surface, in this case water. In fact, technically, this view from an aircraft of the upper Nile is an imperfect image because it was shot through a scratched plastic window. Nevertheless, it works very well on an impressionistic level, as a view of a ribbon of light, exactly because of the flare.*

Allowable flare

BELOW *The non-HDR exposure choices for this image of the sun low over Balinese ricefields ranged from high-key, with no loss of shadow detail, to silhouetted, holding the sky details. Even these extremes were valid, but the one I opted for was this – bright enough to show the colours of most of the green rice-stalks and, importantly, a legible outline of the volcano on the horizon (this was, indeed, the subject of a photo-essay).*

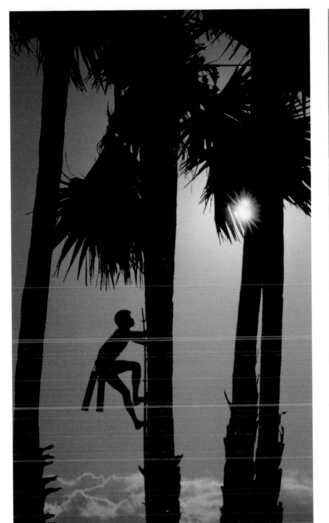

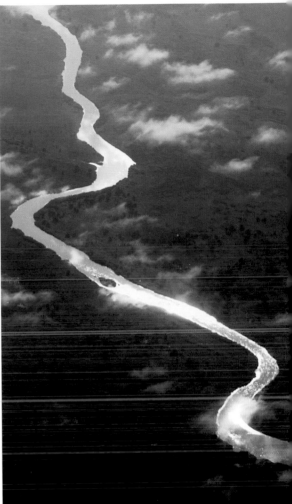

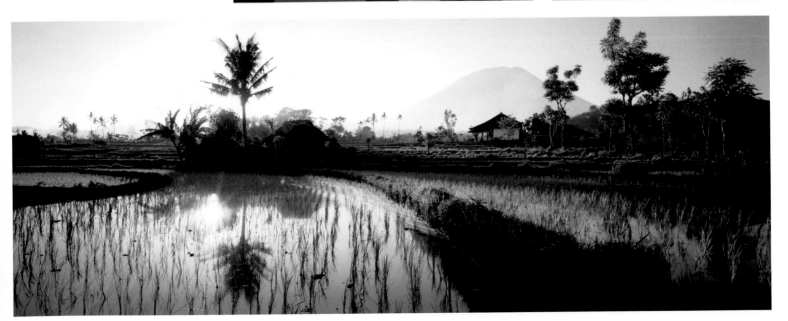

INCANDESCENT LIGHT 78

FLUORESCENT LIGHT 82

VAPOUR DISCHARGE LIGHT 84

MIXED LIGHT SOURCES 86

SECTION 3
ARTIFICIAL LIGHT

Artificial lighting in homes, shopping malls, and public spaces both indoors and outdoors continues to change, though largely unnoticed except by the architects who install it, and the photographers who work by it. There are lighting fashions which vary from culture to culture. Developed countries are moving away from fluorescent strip-lighting towards 'colour-balanced' vapour discharge lighting, fewer sodium lamps, and an increase in low-voltage, high-intensity spots in homes and more upmarket retailers. Light levels in downtown areas of cities continue to increase, particularly in newly-developing cities, because of display advertising and signs. Overall, there is now more variety of artificial light sources than ever before, and frequently they are mixed in the same space, as in shopping malls and department stores.

In a way, this increase in lighting complication has come at a good time, because digital cameras are uniquely placed to handle it with ease. Colour balancing for film was never easy, because of the guesswork involved. A colour meter with film was always highly recommended for interior and night-time shooting, even though its correlated colour temperature readings were never wholly accurate. Now, the instant review on the camera's screen is a vital fail-safe, while the auto white-balance setting can handle most situations. Beyond this, extensive colour correction is possible in post-production. If you shoot Raw, even the white-balance settings can be chosen after shooting. Raw's special advantage here is that settings such as white balance are recorded separately from the exposure data, and can be accessed later.

All in all, digital photography has turned artificial light situations from a chore into a pleasure, and in terms of both ISO sensitivity and white balance, the camera can be switched instantly. With all this choice and processing capability, there is now every reason to consider what kind of lighting effect, especially colour balance, you actually want. Years of filming in available-light situations has created a taste, even a demand, for what one commentator calls 'actuality'. Thus urban night-time street scenes seem more credible with an orange cast, as do supermarket scenes with a blue-green cast. Given the flexibility in correcting casts digitally, there is a hint of pseudo-realism to this, but at least it forces photographers to question the wisdom of neutralizing every cast in sight. After all, in the daylight world, few would think of neutralizing the orange glow of sunrise or sunset.

INCANDESCENT LIGHT

Lamps with burning filaments, usually tungsten, are still the mainstay of domestic interiors, although steadily departing large and public interior spaces.

Traditional artificial light illuminates by burning, hence 'incandescent'. First candles, then oil lamps, then gas and ultimately the electric filament lamp, first made successfully by Thomas Edison in 1879. The filament has to burn without burning up, and tungsten wire does this acceptably (Edison's invention actually utilized carbonized cotton sewing thread; tungsten came in 1906). So, with the filament nearly inert, tungsten lamps have an almost pure (as opposed to correlated) colour temperature. Lamps used for photographic lighting are designed to work at a consistent 3200 K, but domestic lamps vary considerably, and are all redder; that is, they have a lower colour temperature. It varies, with how hot the bulb burns. A 60 W bulb has a higher colour temperature (less orange) than a 40 W lamp.

Digital cameras adjust perfectly well to this end of the colour temperature scale. All cameras have at least one setting for incandescent, and more sophisticated models allow the colour temperature to be raised or lowered. The auto setting in the white balance menu is an alternative. Shooting in Raw format extends the choices into post-production, and here everything can be adjusted all over again if necessary. However, aiming for a complete white-balance adjustment with domestic incandescent is not necessarily a good idea. Viewers usually expect interiors lit in such a way to appear 'warm', which in a practical sense means slightly yellow-orange. More importantly, they tend to prefer the effect (*see pages 36-37*). With a 3200 K white-balance setting, domestic incandescent will appear as they do in the photograph below, the modern interior.

The second major issue with domestic incandescent light is the visibility of the lamp fittings themselves. Typically, several appear in frame, which makes for high contrast in a wide shot of an interior. Essentially, they become practical lights (*see page 68*). This is why the normal treatment for interiors is to use fill lighting (*see pages 208-209*). Alternatively, or even in combination with fill lighting, consider using HDR techniques (*see page 136 onwards*).

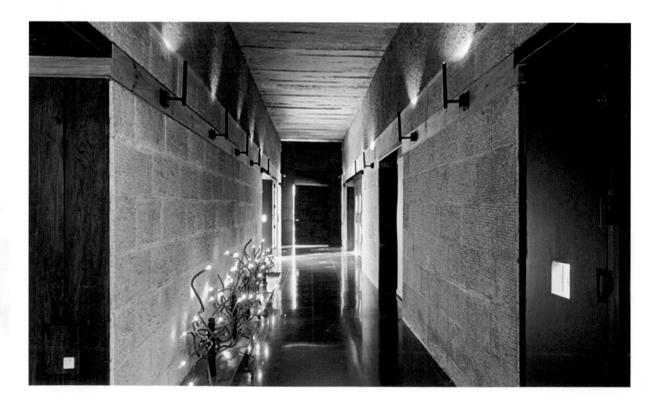

Incandescent against daylight
Daylight often leaks into an interior that is intended to be balanced for incandescent, and this is by no means always a bad thing. The essential decision, of course, is which colour temperature should dominate. If, as in this modern interior in an Indian house, 3200 K has been chosen, daylight elements will appear blue. In this case, it works to the advantage of the shot, because it adds to the existing blues in the interior design and does not overwhelm.

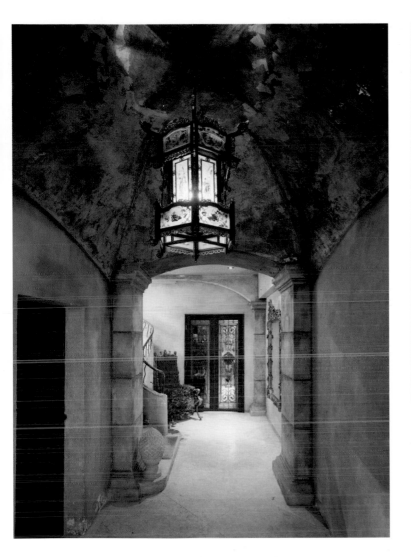

Decorative incandescent fittings

More than any other kind of domestic interior light fixture, incandescent lamps tend to be used decoratively rather than for their pure illumination effect. Chandeliers are perhaps the most obvious example (see page 142), but there are countless others, such as this wall fitting in a beach resort. This decorative use makes it all the more important to consider the ideal colour temperature (with the usual strong case for retaining some 'warmth'), and to judge the exposure to hold the highlights. In this example, the area immediately below the wall fitting can overexpose, but the palm tree stencil clearly needs to be held.

The need for fill

With many interiors, the incandescent light fittings are inevitably in shot – and indeed are often an important part of the scene, as in this Hong Kong lobby area. To help balance the high contrast of the visible lamps, two 600W photographic lights at 3200 K were bounced off the walls behind the camera to give a general fill for the foreground. Note also that the overall colour balance has been deliberately left slightly amber, as this is how domestic incandescent lighting is generally perceived to be.

THE PERFORMANCE OF LAMPS

Luminous performance is measured in lumens/watt. Incandescent lamps are particularly inefficient, at around 17 lm/w, giving off a great deal of heat instead.

Type of lamp	Lumens	Luminous performance (lumens/watt)
100 W incandescent (tungsten)	1,700	17
1000W incandescent (quartz-halogen)	25,000	25
600 mm 30W HP fluorescent	2,500	4
1200 mm 40W HP fluorescent	3,500	3

INCANDESCENT LIGHT

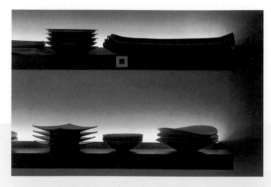

THE PROBLEM OF GRAY POINT: POST-PRODUCTION CORRECTION

Because most domestic and other non-photographic incandescent lamps run at much less than 3200 K, choosing the Incandescent white-balance setting in the camera will still give an orange cast. You may indeed want some of this warm-looking glow (see pages 36-37), but unless the shot was taken in Raw format, realistic neutralization is not always straightforward. As this detail of a shelf of crockery in a Japanese sushi bar demonstrates, the hues shift across the brightness range — this depends very much on the camera.

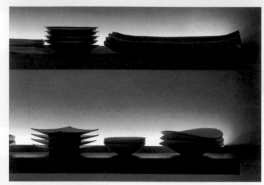

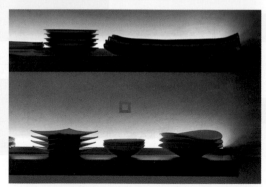

Gray Point choices
In Photoshop Levels, clicking the Gray Point dropper on different parts of the shot produces some wildly different results, none satisfactory. The points are indicated by the red boxes.

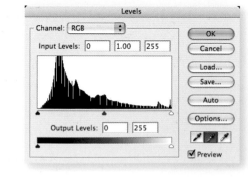

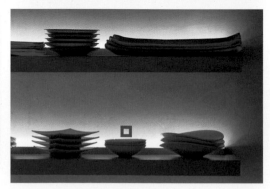

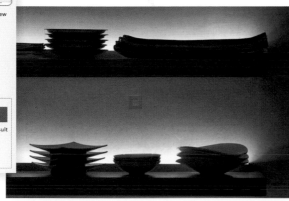

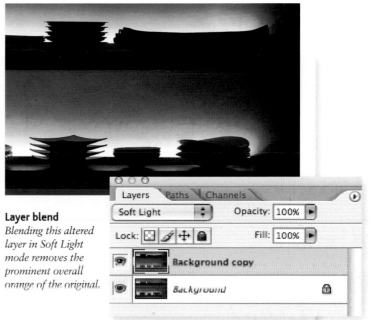

Replace Color on a layer
Within the hue range from greenish yellow to dark brown, no single procedure will work, other than total desaturation. Instead, we first make a duplicate layer, then do a fairly strong desaturation using the point indicated by the red box.

Duplicate Layer

Duplicate: Background

As: Background copy

Destination

Document: 17967.43.TIF

Name:

OK

Cancel

Layer blend
Blending this altered layer in Soft Light mode removes the prominent overall orange of the original.

Layers Paths Channels

Soft Light Opacity: 100%

Lock: Fill: 100%

Background copy

Background

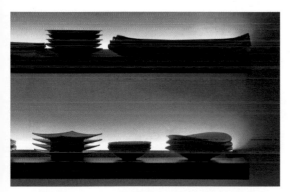

Hue change
Within the same Replace Color dialog, we next shift the hue towards blue. Hue shifts in this command, and in Hue Saturation Brightness, tend to be strong, hence the importance of doing this on a layer, which can later be blended.

Replace Color

Selection

Color:

Fuzziness: 182

Selection ○ Image

Replacement

Hue: +160

Saturation: -70 Result

Lightness: 0

OK

Cancel

Load...

Save...

Preview

Shadow lightening
Finally, the Shadow/Highlight tool is applied to the top layer to make a strong lightening of the shadows to counter the shadow-darkening effect of the Soft Light mode.

Shadow/Highlight

Shadows

Amount: 80 %

Tonal Width: 40 %

Radius: 30 px

Highlights

Amount: 0 %

Tonal Width: 25 %

Radius: 30 px

Adjustments

Color Correction: +20

Midtone Contrast: +12

Black Clip: 0.01 % White Clip: 0.01 %

Save As Defaults

Show More Options

OK

Cancel

Load...

Save...

Preview

FLUORESCENT LIGHT

In the evolution of interior artificial lighting, fluorescent followed tungsten incandescent, and began supplanting it decades ago, chiefly because in power consumption, fluorescent is more efficient. A fluorescent lamp (usually a tube) works on the principle of passing an electrical discharge through a gas in a sealed glass envelope; fluorescers coated on the inside of the glass are excited and emit light. The fluorescers are chemical phosphors, and their exact composition determines at which part of the spectrum they glow. The important thing to know is that each phosphor emits at a point on the spectrum, which looks like a spike on an emission graph. By combining several phosphors, lamp manufacturers can create the appearance of white light, but in reality this is a mix of several spikes and not a continuous spectrum like that from the sun or an incandescent lamp. The problem for shooting is that the eye can accommodate very well indeed, so that what you see

As a non-black-body source of light, fluorescent lamps emit a range of colours that does not conform to the normal scale of colour temperature, with a tendency towards green.

Unless specifically designed for photography or accurate daylight-balanced viewing, fluorescent lamps typically emit discontinuously across the spectrum, with peaks that are usually in the blues and greens, and often a deficiency of red. This emission graph from one well-known make contrasts strongly with the more even distribution of true daylight.

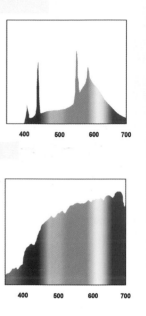

is often not what you get on film or a digital sensor. Typical fluorescent lamps tend to record as greenish, but this varies considerably and is hard to predict. Two certainties with found fluorescent lighting (as opposed to balanced, photographic fluorescent lighting) are that it will always be unpredictable, and that you cannot expect to set the white balance to give a completely natural appearance. This isn't to say that you can't achieve this, but it may need extra work.

Fortunately, digital cameras, through their white balance menus, are much more tolerant of and adaptable to the peculiarities of fluorescent than film. Moreover, the preview screen shows immediately whether or not the setting you select is in the ballpark. Nevertheless, because the spectrum of most fluorescents is discontinuous and limited, it may be impossible to recover the full colour range in the scene, even in post-production. However well-balanced they may be, many fluorescent-lit scenes look subtly colour-deficient to a viewer. This is a fact of life, though not necessarily a problem, as supermarket and open-plan office images are often expected to look this way. 'Full-spectrum' fluorescent lamps are made, which have both a high Colour Rendering Index (CRI) and a Correlated Colour Temperature (CCT) that looks like daylight, but these are more likely to be encountered as studio lighting.

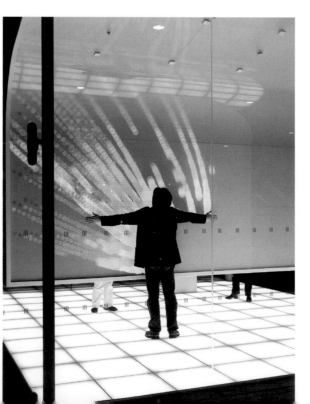

Bathed in fluorescent
A public booth designed for Bloomberg in Tokyo features ceiling and floor lighting that uses fluorescent lamps – concealed and therefore type unknown. I very much wanted to avoid neutrality, which would simply have been dull, so opted for a white balance that rendered the scene cool and technological.

POST-PRODUCTION CORRECTION

There are a number of ways of dealing with shots taken under fluorescent lighting that for one reason or another were not fully corrected when shooting.

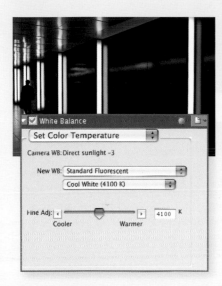

Raw re-selection
Taken with a Sunlight white-balance setting, this shot of a Tokyo subway appears typically green. The Raw window allows the original camera setting choices to be revisited.

Photo Filter
If the original had been shot in TIFF or JPEG, the straightforward solution would be to apply a filter of the opposite hue. This might need some experiment, but here, the opposite of green is magenta, and the Photoshop Photo Filter's two options of percentage density and preserving luminosity allow the balance to be finely tuned.

Snap to neutral
An alternative, less satisfactory in this case, would be to use the Options in Levels, with Snap Neutral Midtones selected.

WHITE BALANCE VARIATION

With normal fluorescent lamps, the colour changes slightly during the cycle, and this depends on the power supply. Normal AC power has a 50Hz cycle, which means that it goes from zero to full in 1/100 second. The eye does not notice the colour changes, but if the shutter speed is higher than the power cycle, variations similar to that shown here (of a grey card) are likely.

IN-CAMERA CHOICES

This unknown fluorescent lamp was the sole illumination for Sufi adherents reading poetry in the grounds of a Sudanese mosque. These different white-balance alternatives offered by a Nikon SLR demonstrate the need to experiment with fluorescent lighting. Even if it had been possible or practical to check the lamp, it would still have been quicker to ring the changes in the camera's white-balance menu — and also more reliable as lamps change colour with age. If shooting TIFF or JPEG, it helps if you have the time to run a test of all the options; if shooting Raw, all of these options are available later, in post-production.

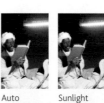

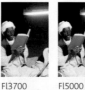

Auto	Sunlight	Coolwhite	Daylight
Fl3700	Fl5000	Hcr3700	Hcr5000
Hcr Cool white	Hcr daylight	Hcr warm white	warm white

VAPOUR DISCHARGE LIGHT

Like fluorescent lamps, this range of high-output lighting uses an electrical discharge through gas, controlled by a ballast. Also like fluorescent lamps, there are photographic versions (HMI), but in cities and stadia the lamps used often have unnatural emission spectra. In many ways, the solutions for shooting digitally are the same as for fluorescent lighting, which is to say experimenting with different white-balance choices, ideally shooting Raw, and relying heavily on post-production to clean up the colour imbalances.

Another, and increasingly widely used, form of non-black-body lighting uses metal halide discharge, and the metals used determine the colour.

Multi-vapour and mercury vapour lamps are by far the most common, used in stadia, car parks and other large spaces. Visually they are cool white, but as recorded on sensor (or film) tend more strongly towards blues and greens. Raw is definitely the format of choice because of the latitude it gives you in making post-production corrections. If there is time, the recommended white balance setting is Preset, in which you measure a patch of white or neutral grey (*see page 83*). Otherwise, choose Automatic to give yourself one extra choice

Neutralizing casts in post-production
There are several techniques, as already described, for making near-neutrals exactly balanced. Nevertheless, as in this shot of a computer manufacturing clean room, it's important to identify what should be neutral. The cap is clearly blue-green, and the key tones for balancing are the shadows on the white garment.

Desaturated colours
A typical effect of vapour discharge lighting, even after balancing in post-production, is an overall impression of weak colours, more monochromatic than normal, as in this shot of a woman inspector at a bottling plant.

Night in the city
The characteristic blue-green coldness of vapour lighting is now so well accepted that for a 'realistic' sensation of night-time it may well be better left uncorrected.

SODIUM FLOODLIGHTING

This Indian palace in Rajasthan was lit by a row of sodium floods pointing upwards from the lawn in front of the building. The yellow cast, slightly tinged with green, is typical and characteristic of images shot on both film and digital. There is no question of broadening the spectrum because there is virtually nothing else to recover, and the most sensible approach is to wait until post-production and treat it as a monochrome image. Photoshop's Replace Color is one obvious option, but a simple hue shift is not in itself sufficient. There is even a case for accepting the original cast.

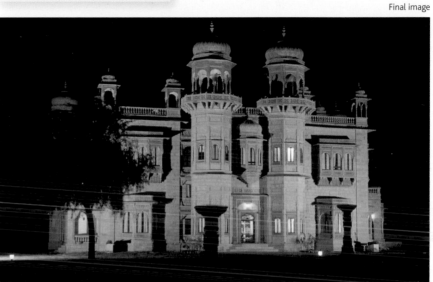

Saturation and Lightness
Modifying the hue shift by reducing the saturation and slightly increasing the lightness gives a more subdued effect, still lacking in colour overall but according better with what I already knew was the daylit colour of the stone.

Final image

Original image

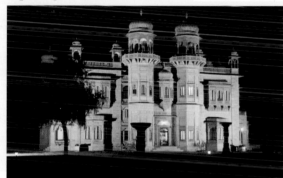

The uncorrected original
The colour cast as shot is yellow-green – neither inherently pleasant nor accurate, as the building material is a sandstone which in daylight appears brownish-grey.

Hue shift
Using the Replace Color command, a hue shift is clearly called for, but the options are limited to the adjacent hues on the colour circle. A shift towards red helps, but still leaves the sense of an over-filtered monochrome image.

later. Depending on how well spread the spectral emission of the lamps is, a simple click with a grey point dropper, or Auto Levels, may be sufficient to balance the image in post-production. If this still leaves unbalanced areas, Photoshop's Replace Color command (Under *Image > Adjustments*) is useful.

Sodium lamps are very specific and recognizable, with a limited emission confined to the yellow band of the spectrum. They are common as street-lighting and are also used in some forms of floodlighting. Sodium lamps are intrinsically impossible to correct, because they are so deficient in other areas of the spectrum, and scenes lit by them are almost monochromatic. However, this is not to say that they cannot later be treated to give a more normal appearance, as the example above illustrates.

MIXED LIGHT SOURCES

As the variety of lighting continues to increase, we have to learn to deal with a mix of colours that is often not apparent to the eye.

Increasingly in modern interiors, two or more of the artificial light sources that we've been looking at are present at the same time, and this complicates lighting decisions more and more. Worse still, oddly balanced fluorescent and vapour discharge lamps are making a greater contribution than ever. At least this trend coincides with digital photography, which can cope by using a combination of appropriate colour settings when shooting with post-production techniques when optimizing. The bottom line is that anything can be corrected, but it can take time and skill.

The first question to consider, however, is how critical it is to balance the entire image for colour. If this seems an odd question ('of course colour should be balanced'), it's because colour photographs need a variety of colour in the frame. The alternative is monochrome (monochrome grey, monochrome blue, monochrome red, etc.), and over-aggressive white-balancing can produce a slightly dreary, predictable result. This is complicated further by viewer expectations of different lighting conditions – what is sometimes referred to as 'actuality'. After decades of looking at not-fully-corrected photographs and film, audiences have built up expectations of homely tungsten or sterile fluorescent, as we've already seen. Mixing the sources mixes that expectation.

There are three strategies to consider in dealing with a mixed-light setting. One is to compromise and go for an overall average white balance, in which individual near-neutral colours may be askew, but the overall impression seems balanced to the eye. This is essentially what Auto white-balance settings in the camera attempt. The second strategy is to select which colour in-frame you want to make neutral, and allow the other colours to shift accordingly. The third is to work selectively, and adjust only a specific range of colours, leaving the rest of the image untouched – only possible in post-production. The different results of these procedures are shown on the right.

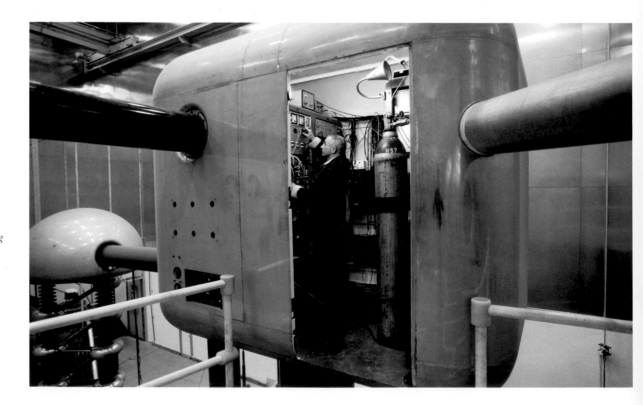

Never mind
Going back to the question 'Does it matter, anyway?' there are convincing arguments for doing nothing – or at least very little – to the basic Daylight setting. Clearly it depends on the circumstances, but as in this image of an early particle accelerator, the complementary colour contrast of blue-green (vapour discharge) and orange (incandescent) has a visual appeal.

THREE STRATEGIES FOR NEUTRALIZING

One lighting situation given three different treatments – an office lit with a mixture of daylight and vapour discharge (colour output unknown, as usual).

Original image

Auto white balance
This in-camera option makes an overall assessment of the total image and attempts to find a balance for all the colours in the frame.

Cloudy white balance
Here the issue has been forced in the camera by setting the camera's white balance to Cloudy. This is the correct balance for the natural light from the windows.

Setting a neutral 1
The post-production option, here using Photoshop's Levels dialog, involves using the Gray Point dropper on one part of the image (indicated by the red box).

Setting a neutral 2
There is an automatic variant in which Photoshop finds an average nearly-neutral colour in the image and then makes it exactly neutral (RGB 128).

Replace Color
A more subtle and interactive post-production procedure, this involves selecting an offending off-neutral and neutralizing it alone. The dialog allows the 'width' of the chosen colour within the hue spectrum to be adjusted – the monochrome preview window shows which parts of the image will be affected. The point chosen is the same as for the Gray Point.

MIXED LIGHT SOURCES

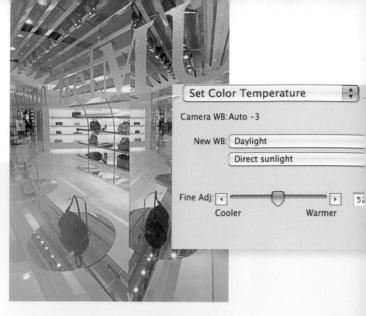

SHOPPING PLAZA

Here is an all-too-typical public-space lighting situation – a new shopping plaza full of glass, reflecting surfaces and a huge number of light sources that are unknown but varied in type. Planning is key, because there is no single magic bullet for this shot. And yet, by taking the correct decisions at the time of shooting, you can guarantee the result. The two correct decisions in this situation are first, to shoot Raw for maximum post-production colour choice; and second, to use Auto white balance in order to get into the right colour ball-park (auto calculation in post-production is not the same thing).

Daylight setting
Before shooting, the alternatives were tried and examined on the camera's LCD screen. The results yielded some surprises, including the strong orange of the Daylight rendering, suggesting possibly a high proportion of incandescent lighting...

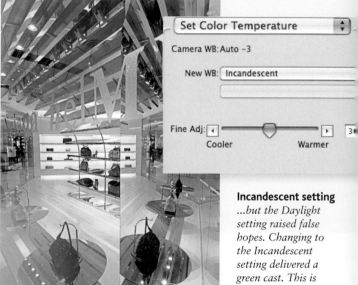

Incandescent setting
...but the Daylight setting raised false hopes. Changing to the Incandescent setting delivered a green cast. This is no improvement.

Auto, as recorded
The shot as taken in Raw format. This setting, the warmest Auto setting offered by the camera (a Nikon D2X) gave the most acceptable result of the available choices, even though it seems yellow.

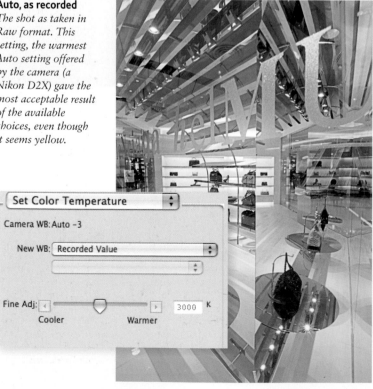

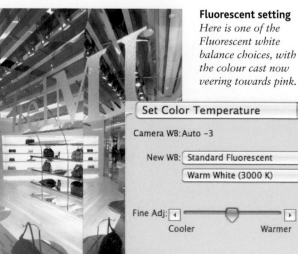

Fluorescent setting
Here is one of the Fluorescent white balance choices, with the colour cast now veering towards pink.

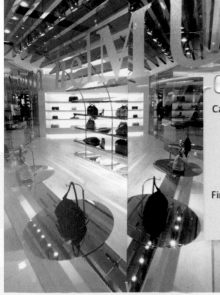

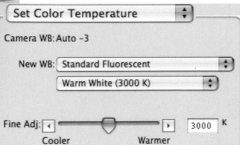

Post-production Auto

An interesting demonstration of why shooting Auto can be valuable. Performing Auto white balance on the Raw file in Nikon Capture Editor (the manufacturer's software) later came nowhere near the original – if anything, it is the worst version so far.

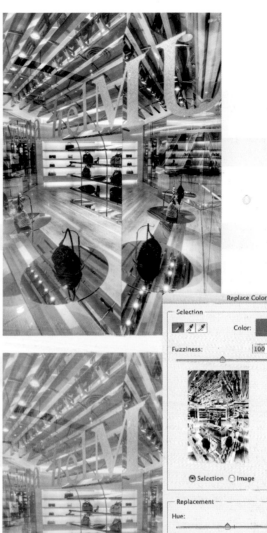

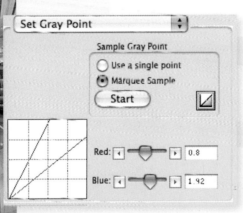

Grey marquee

Starting with the as-recorded, rather yellow, original, the key move in post-production is to set a neutral grey. However, in this situation, there are many light sources and reflections, so we could waste a lot of time clicking around to find the right point. Instead, it makes more sense to find an average grey across a broad area, and the Marquee Sample option is selected. The result is a great improvement, although it leaves some green and some blue colour casts in specific areas.

Replace Colour

There is one last step, to alter the green cast on various surfaces, using Photoshop's Replace Color command. The aim is to neutralize these somewhat, but it's important to go carefully with this, as we still want a colour image at the end of the procedure rather than a monochrome one. For the same reason, I elected to leave the blues alone (the small, more intense ones come from a small amount of daylight filtering in).

CAMERA-MOUNTED FLASH 92

LIGHTING SUPPORTS 102

AC FLASH 94

REFLECTORS & DIFFUSERS 106

INCANDESCENT LIGHTING 96

REFLECTORS & GOBOS 110

DAYLIGHT (HMI) LIGHTING 98

EFFECTS LIGHTS 112

HIGH-PERFORMANCE
FLUORESCENT 100

SECTION 4
PHOTOGRAPHIC LIGHTING

From the point of view of light and lighting, there are two kinds of photography, with some overlap. There is the photography of things as they are, as in reportage, landscape, wildlife and nature, and there is the photography of subjects that are created, organized and arranged, as in all studio shooting, from portraiture to still-life. These are conceptually different, and logistically separated by lighting. You could say that the distinction between the two is that between 'light' and 'lighting' – the former given, the latter constructed.

The range of lighting equipment available continues to grow, not least because continuous lighting (as opposed to flash) is needed in cinematography and television, and the size of these two industries funds the technological development. Over recent years, daylight lamps (HMI) have become more and more popular, while lighting fixtures in general have grown more specialized. There is now a huge variety of fittings for diffusing light, with subtle variations, and at the other end of the lighting scale there is more precision in creating concentrated, accurately placed lighting effects. These are all covered here, and in the final chapter.

The many different lamps and their attachments have evolved not solely for efficiency, but also to accommodate styles of lighting that have become popular. What tends to happen is that occasional major changes in lighting design made by one or a group of professional photographers catch the imagination of others, including the large amateur market, so lighting manufacturers adapt their ranges accordingly. In the early days of American fashion photography, for example, the romantic haze and flare created by De Meyer by means of soft, filtered back-lighting was very popular. Later, in the 1930s, the sharper, more visually active style of photographers such as Steichen, using large numbers of klieg lights from all directions became the norm. In another example, during the mid-1970s a number of photographers adapted powerful ringlights, originally designed for close-up photography, for fashion work. In common with many other distinct styles of lighting, this short-lived phase was a deliberate reaction to existing styles that some photographers were beginning to find boring. Thus, the design of photographic lighting is inextricably linked to style, which is dealt with in the last chapter of this book.

CAMERA-MOUNTED FLASH

A flash unit mounted in or on the camera is at best convenience lighting, but digital integration helps to give acceptable, if usually unexciting, results.

On-camera flash is almost certainly the most widely used type of photographic lighting, but it suffers the limitations of a small light in a frontal position. Extremely useful for reportage and impromptu situations where the overall lighting cannot be controlled, it is rarely the style of choice for formal portraiture and still-life photography *(but see Full frontal lighting, page 200)*. Being portable and mainly automated, on-camera flash has the advantage of offering instant, uncomplicated lighting. By the same token, however, it is not capable of great subtlety, and the small size of the flash tube is frequently a problem. There are two further problems. The first is that light falls off away from the camera, so that the correct level of brightness is only possible at a certain distance; anything closer will be overexposed, while backgrounds at any real distance are invariably dark. Digital cameras with integrated flash use various strategies to overcome this, including measuring the distance to the main subject by linking to the focus setting, and by varying the spread of the beam to match the focal length, but foregrounds will always be overexposed and backgrounds underexposed. The second problem is that this type of flat lighting does not suit very many subjects, and can produce red-eye reflections (caused by light reflecting from the retina). More often than not, these effects are a nuisance, although there are occasions when the rapid fall-off can be used to isolate a subject.

The principal use of portable flash is as fail safe illumination – making an inadequately lit shot possible. In news photography and reportage work in general, the subject is often much more important than creative considerations and if a camera-mounted flash unit is the only way of capturing an image, then its aesthetic defects are secondary. It is also useful for fill-in lighting – relieving shadows in a high-contrast scene. Backlit subjects, for example, always have high contrast, and if it is important to preserve shadow detail, some extra light will be needed. Fill-in flash works most realistically

Motion trails
This photograph shows significant motion trails, but the subject is frozen by the split-second burst of the flash, which is far quicker than the ambient light exposure.

ON-CAMERA FLASH FEATURES

POSITIVE	NEGATIVE
Convenient, small	Battery dependent
Linked to camera, easily programmed	Frontal, flat lighting
Emergency guaranteed lighting when ambient insufficient	Can give under-exposed backgrounds and over-exposed foregrounds
	No preview
Capable of interesting special effects, eg rear-curtain slo-mo	

when used at a relatively weak setting, so that it does not compete for attention with the main source of light (usually the sun). A typical ratio of flash to daylight would be about one to three or one to four; how this is achieved depends on the particular unit.

Solutions to the flat, frontal lighting effect either involve bouncing the light or taking the flash away from the camera. If there is a large, light-toned surface nearby, such as a white ceiling or wall, this can be used as a reflector to soften the light, by aiming the flash in that direction rather than straight at the subject. Flash heads tilt and swivel for this reason. Holding the flash head on an extension lead away from the camera is an alternative way of varying the lighting effect. This can also be combined with other flash units linked by infra-red or RF for a multiple lighting effect – but at this point we are no longer dealing with on-camera flash *(see Mixed light sources, page 86, and Fill lights and reflectors, page 184)*. The new generation of dedicated flash units can be used in multiples and without cables to create sophisticated lighting set-ups on location.

Rear-curtain sync is the one genuine lighting contribution from on-camera flash, in which the flash is timed to fire at the end of a long exposure. The purpose is to combine ambient lighting (in a relatively dark situation) with the crisp legibility of the flash, and as the flash image 'closes' any sequence of movement, whether of the subject or the camera, the effect can be compelling, as in the example here.

Rear-curtain sync
A quick look at the flashlight reveals the subject's movement during the whole exposure, set by the flash at the end of it.

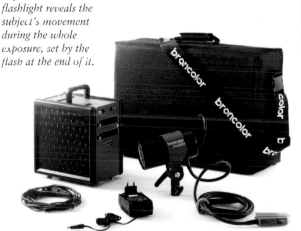

PORTABLE FLASH FEATURES

POSITIVE	NEGATIVE
Strong illumination where power is absent	Batteries need recharging eventually; may limit shoot
Near-studio quality lighting on location	Normally no preview
Multiples easy to set up	More bulky than regular portable flash
	Relatively expensive

MAINS FLASH

For many professional studio photographers, the lighting of choice is high-output mains-powered flash, with the most opportunities for modifying attachments.

Studio flash units work in broadly the same way as portable flashguns. To cope with the extra power, though, the flashtube must be very much larger than the tube in a portable flash. In studio units, the tube is usually formed into a ring. Typically, in the center of this circular tube is an incandescent lamp. Known as a modelling lamp, this allows the photographer to judge approximately the effect of moving lights around the subject, or reducing their intensity. In the studio, portability is not important, but versatility and power certainly are. The smallest studio flash units have a power output of around 100 Watt-seconds (or joules), as much as the largest portable flash units. A large studio may have flashes 200 times more powerful

Mains-powered flash units come in two main designs: units with separate flash heads that connect to a power pack via cables, or self-contained units with everything in one housing – commonly called monolights. The former has advantages for asymmetric distribution of light from a single control panel, and the heads are conveniently small, so easy to place in a variety of positions. The control unit on the studio floor houses the power supply – the capacitors, transformers, and other electronic components – and only the flashtube, reflector, and modeling light sit at the top of the light stand.

Monolight units integrate all the components in a single casing, with the flashtube, modelling light and reflector at the front; capacitors, transformers and electronics in the middle; and a panel of controls on the back. The units are portable, making them ideal for location as well as studio work. The principal disadvantage is instability; perched on top of a stand, a monolight can sometimes sway alarmingly, and tripping over a cable often has disastrous results.

With experience, in the controlled environment of the studio, you can usually make fairly good estimates of what the correct exposure will be, based on the ISO, power routed to each flash head, degree of diffusion of each light source, and other relevant factors. However, a flashmeter obviously helps, while the real work of exposure estimation is usually done by measuring the histogram results.

Flash-frozen images
Fast movement, such as close-ups of a poured liquid (here Mezcal in a simple still-life set-up) absolutely demands the motion-stopping power of flash. Note, however, that the larger the flashtube, the slower the pulse. This image illustrates a second advantage of studio flash, namely its colour accuracy – the ability to achieve neutrality even across a grade from white to mid-grey).

STUDIO FLASH HEADS

The standard flash head for a studio unit accepts a wide variety of different reflectors, diffusers and other accessories. There are also many lighting heads available.

Flashtubes
In ringlights the flashtube forms a wide circle – wide enough to poke a camera lens through. Since the tube totally surrounds the lens, these heads provide the shadowless illumination which is perodically in favour in fashion photography.

Small heads
For applications where the light source must be concealed, perhaps in a table lamp that forms part of a room set, very small heads are available. These are little bigger that a 150W domestic light bulb, and contain no modelling light.

Various studio flashes
Barndoors, translucent boxes and umbrellas are very common.

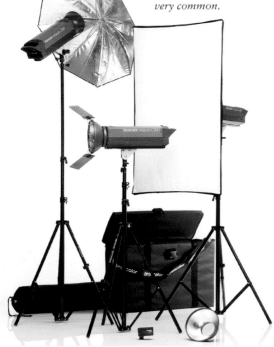

Striplights
Striplights also have longer flashtubes, but in these heads the tubes are straight, and usually about a metre (3ft) long. Striplights produce a very even light along their entire length, so they are ideal for illuminating studio backdrops. A fluorescent tube next to the flashtube acts as a modelling light.

Umbrella
The classic photographer's lighting accessory. Portable but totally effective at producing a diffuse light.

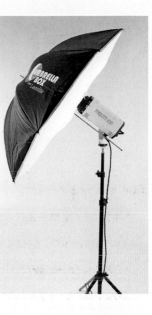

High power heads
High power electronic flash heads have specially lengthened flashtubes, which are wound into a short helix and can cope with the output from several linked power supplies. These heads incorporate a more powerful modelling light and a cooling fan.

MAINS FLASH FEATURES

POSITIVE	NEGATIVE
Powerful illumination, total lighting control	Needs a modelling light for preview, and this is too weak to gauge effects in combination with continuous light
Cool (for comfort, safety and protection of subjects from melting)	Relatively expensive
Motion-stopping	Can be bulky
Colour-balanced for daylight; mixes perfectly with daylight	
Accurate and consistent colour	

INCANDESCENT LIGHTING

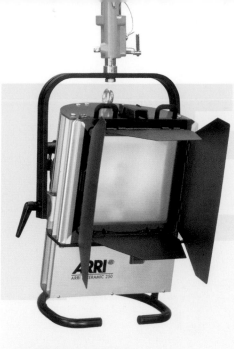

One of the reasons why incandescent light retains a following among professional photographers is because you see exactly what you get, and when the nuances are fine it is important to have no discrepancies as between a modelling lamp and its nearby tube. In particular, incandescent can easily be shaped into a tight beam – a parallel or converging beam if need be.

'Hot' lights have long been the mainstay for both stills and cinematography and consequently offer a highly developed range of lighting.

With flash, this is possible, but then the beam of the modelling light rarely matches the shape of the beam from the flashtube itself *(see Making light sharper on page 214 for more on this)*. Because of incandescent's inherent advantage over flash in this area, the range of lights available tends to be more specific and varied than flash heads, which rely on a variety of adaptors.

The majority of incandescent light fittings are designed for motion picture and television, which of course need continuous light sources. The workhorses of the industry are known as luminaires (spot lights or just spots) and they incorporate an internal focusing mechanism and a fresnel lens at the front. Smaller versions without the fresnel are commonly known as Redheads. These have a lightweight, cast alloy frame (painted red) and a fixed reflector inside. A round knob at the rear of the unit moves the lamp within the reflector. Moved forward, the lamp forms a broad beam. Moving the lamp back closer to the centre of the reflector makes the beam narrower. Redheads generally have a power of 650 W, though a larger, fan-cooled version produces 2000 W. Other units have their own unique advantages. Totalites are small, portable units which accept lamps of different voltages and so are useful for travelling; video lights produce a powerful beam, yet they can be hand-held and even run for half an hour from a rechargeable battery pack.

CERAMIC LAMPS

New low-temperature 3200 K lamps offer a cool alternative. The Arri X Ceramic light is based on a new Philips ceramic lamp that is something of a hybrid – a hot-restrike discharge lamp that is colour balanced to tungsten. Its low power consumption means a lower working temperature, with a relatively low loss of light output, and is particularly useful for sets that need to stay cool because of the products and materials in them. Like other discharge lights *(see Daylight (HMI) lighting, pages 98-99)*, it uses a ballast, but this is built into the fixture.

Focusing lights, however, cannot on their own deliver soft lighting, and need to be used with reflectors of one kind or another. Alternatively, there are dishes and other fittings, which are examined on the following pages *(see Reflectors & Diffusers, pages 106-109, and Reflectors & Flags, page 110)*.

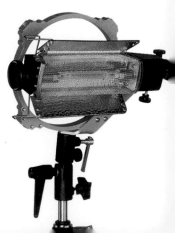

Strip lights
An incandescent bulb need not take the traditional shape; all that is required is a filament, shaped to suit the purpose.

PRECAUTIONS IN USE

The greatest risk when using tungsten light is that of fire, burns, or scorching. Though the beam can be softened by reflection from a white-painted ceiling, this soon yellows and chars the paintwork, and if continued, can set fire to timber or wallpaper.

Tungsten light also consumes a lot of power, and can easily overload a domestic power circuit causing a fire risk.

Tungsten bulbs themselves must be treated with respect. All types are fragile – especially when burning – and halogen bulbs must not be touched with ungloved hands. They are supplied in cardboard or plastic sleeves so that they can be fitted into the holder without coming into contact with finger grease. The life of the bulb is much shorter if it is inserted with bare hands.

MATCHING INCANDESCENT TO DAYLIGHT

One of the most valuable accessories is the dichroic filter. This heatproof glass plate fits over the front of the lampholder and adjusts the colour of the beam of tungsten light from 3200 K to 5500 K – the colour of daylight. So tungsten lamps can then be combined with daylight, using daylight-balanced film. Heat-resistant gels (full blues, half blues and so on) that do the same job are also available, and though these are less durable than the glass filters, some of them combine the function of diffuser and filter. Held a metre (yard) or two in front of a powerful tungsten lamp, such a filter/diffuser forms the light into a soft, daylight-coloured window light.

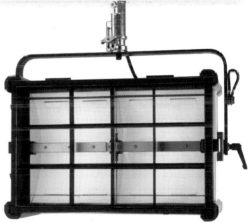

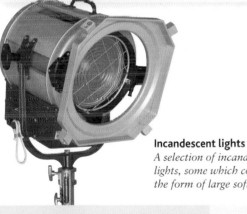

Incandescent lights
A selection of incandescent lights, some which come in the form of large softboxes.

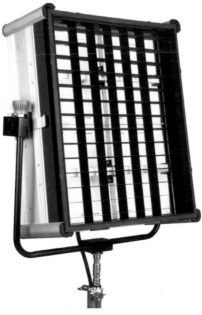

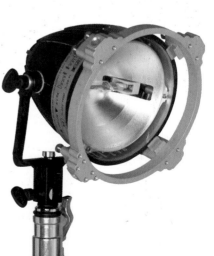

INCANDESCENT FEATURES

POSITIVE	NEGATIVE
You see exactly what you get	Hot (comfort and safety issues)
Unfiltered complements ambient incandescent lighting	Even moderate movement will blur
Easy to filter to match other colour temperatures	Large units very bulky and heavy
	Lamps are voltage-dependent
Simple, rugged, foolproof	Colour can change with age of lamps

DAYLIGHT (HMI) LIGHTING

Starting in the 1970s, lamp manufacturers began catering to the motion picture and theatrical industries by producing a type of tungsten halide discharge light that was approximately colour-controlled. The normal run of vapour discharge lamps is designed for lighting large public spaces efficiently on the principle of passing an electrical discharge through a mixture of gases *(see Vapour discharge lights, pages 84-85).*

For more convenient mixing with daylight, an alternative continuous lighting system is the more expensive metal halide discharge.

These uncorrected lights give a roughly visual white, but tend to favour the easier-to-make blues, greens and violets, and so are deficient in reds and yellows. The made-for-video versions are more carefully designed, and correspondingly more efficient. For general purposes, they work without the need for colour correction procedures, such as gels and lens filters, but for critical work it's as well to examine the shots carefully in post-production. Magenta and blue casts are not uncommon, and calibration with a colour target *(see Camera calibration, pages 118-119)* is recommended.

HMI, which stands for Hydrargyrum Medium-arc Iodide (the first word referring to the mercury component in the gas), is the type of metal halide most commonly used, and both double-ended and single-ended hot-strike lamps are the norm. In the industry, they are as often referred to as 'daylight' fixtures, and to all intents and purposes they work like incandescent lighting, but at a correlated colour temperature of 5600 K (the average colour temperature of sunlight) rather than 3200 K. Their clear advantage is evident when a set needs to be balanced to a partial daylight source, such as an interior with a window in view, or when a daylight scene needs efficient fill.

HMI bulb
A close up view of an HMI bulb, a delicate component which must be handled with care.

HMI light
HMI lights can be used in exactly the same way as standard incandescent.

PORTABLE FLASH FEATURES

POSITIVE	NEGATIVE
All the advantages of incandescent without the heat	Expensive
	Needs a bulky ballast

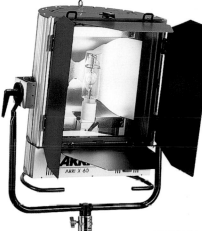

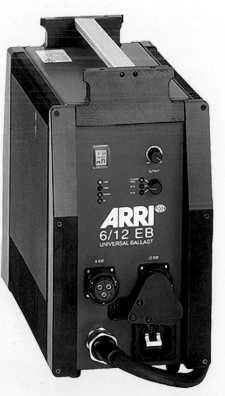

HMI lights
A selection of daylight lights, which are available in both traditional shapes and with built-in barndoors.

BALLASTS

HMI lamps need a ballast to provide a high initial voltage that initiates the discharge, then rapidly limits the lamp current to sustain the discharge safely, so these units are an extra consideration for bulk, weight and operation. Conventional ballasts are of the magnetic choke variety, which alter the voltage but not the frequency, while the newer electronic flicker-free ballasts maintain constant power and frequency despite variations in the AC supply.

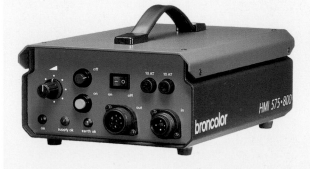

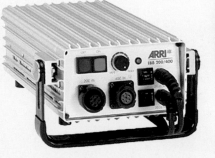

HIGH-PERFORMANCE FLUORESCENT

A new generation of continuous lighting takes advantage of fluorescent lamp technology to provide cool, flicker-free and powerful illumination.

Before the mid-1980s the choice of studio photographic lighting was a stark one between flash and incandescent, and the advantages of flash above and beyond its obvious motion-stopping ability were daylight colour balance and a relatively cool working environment. Incandescent, on the other hand, offered an as-you-see-it reliability of result, but at the price of a very different colour temperature – and heat. Colour balance as an issue is largely a thing of the past, now that the settings menu on a digital camera can adapt the image to any normal light source, which leaves the heat output of quartz-halogen and tungsten lamps.

High-performance fluorescent lamps are flicker-free, energy-efficient, and have coatings that match the spectral sensitivity curves of digital sensors and film, all of which makes them a completely different proposition than normal domestic and office fluorescent tubes, which are notorious for varying in their colour output. Different colour temperatures are available, but principally 5500 K

daylight and 3200 K tungsten, and this gives a choice when putting them side-by-side with other light sources. Lamps can be changed instantly in standard housings, which makes it easy to switch between daylight-balanced and tungsten-balanced. They use a ballast for starting and regulating, and the design of this unit is critical for controlled use in a studio.

Although shaped tubes are available, as in the case of a ring-light that fits around the lens to give axial illumination, the basic lamp is linear, and varies from 200 mm (8 inches) to over 2 m (six feet) long. Because of this shape, they are excellent for light banks that give a soft area illumination – this style of lighting tends in any case to be the preferred standard for still-life and product photography in general. To create an even spread, concave reflectors are placed behind a series of lamps arranged in parallel, and the light can be further refined by means of honeycomb louvres to reduce light-spill and by diffusing sheets of plastic or fabric stretched across the front of the bank. What fluorescent lighting is not good for, however, is focused lighting, which needs a point source and fresnel lenses.

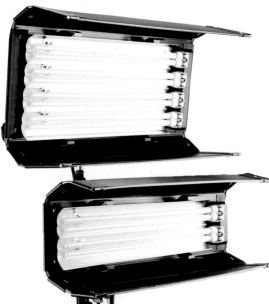

Medium and compact banks
These four-lamp and two-lamp light banks have on-board ballast and a dimmer control. Concave mirrored reflectors even the spread of illumination, which can be further diffused by fitting a light fabric sheet over the ends of the adjustable barn-doors. These two models are from Kino Flo.

FLUORESCENT FEATURES

POSITIVE	NEGATIVE
Thin, so convenient to position	Relatively expensive, particularly replacement lamps
Lamp shape suited for broad area lights and strip lights (for backgrounds)	Not suitable for focusing light
Needs no surrounding space for heat dissipation	
Energy efficient (high light output per watt) and long lamp life	

Ballasts

For larger units, a remote ballast is used; in others, the ballast is built in. Its functions are first, to initiate the discharge by giving a high voltage to begin with, then rapidly lowering the current to maintain the discharge at the desired light output, with the option in some designs of dimming. Electronic ballasts also use high-frequency operation to reduce lamp flicker to an imperceptible level.

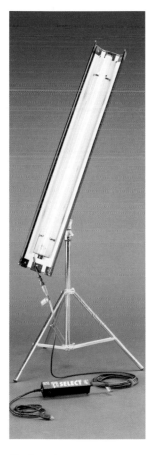

Single strip

The linear construction of fluorescent lamps makes them ideal for long, slim lights that are both easy to conceal and efficient at lighting backgrounds separately from the sides. The shape also suits standing figures.

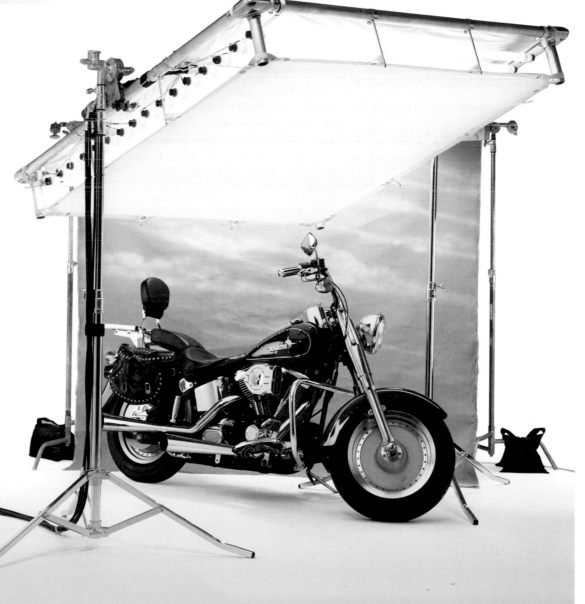

LIGHTING SUPPORTS

P lacing light fixtures where they ought to be is a skill appreciated only by those who need to do it. This is the blue-collar side of the business, and it tends to be ignored in writings on the theory of lighting, but in reality a good choice of stands and other supports is what makes set and studio lighting happen, and I make no apologies for devoting several pages to looking at the range available. In fact, you need only consider how exactly to suspend a large diffused light over a still-life set, or how to specify a lightweight stand that will carry a given light fixture (so as to avoid ruinous airline excess baggage charges) to see the importance of this. As it happens, most lights tend to be placed at a height of between one and three metres (3–9 feet) approximately, and for this a stand of one make or another is ideal. However, there are endless variations and limitations, including the need to fix lights overhead, or at ground level, or in a restricted space, while the weight of the fixture has to be taken into account, not to mention where its centre of gravity will be when you have it aimed in the direction you want. Somewhere, the support needed for any job exists, as these pages illustrate.

Positioning light fixtures securely yet conveniently involves a range of stands, tracks and clamps to accommodate different subjects and lighting styles.

Stands
Basic light stands come in a variety of configurations, including simple tripod and roller.

Support boom grips
These heavy-duty fittings hold the boom arm in place, and need to be adjusted firmly.

Winch mechanisms
These stands all feature a turn-handle to make fine adjustments to either their height or boom angle.

Portable
Though 'luggable' might be a more appropriate term, this softbox and support fit into the bag below.

Packaging
Easy to neglect, but just as essential as the supports themselves are the protective bags to transport them.

Small supports
Not all lights are created equal, in terms of size and weight as well as much else. Smaller supports are ideal for these, since they are lighter and easier to move.

Superboom
*This boom features
an extendable tube
to reach extra lengths.*

Counterbalance
*There is not always any
need to invest in weights
to counterbalance supports.
You will often find something
lying around which can be
attached securely to achieve
the same end.*

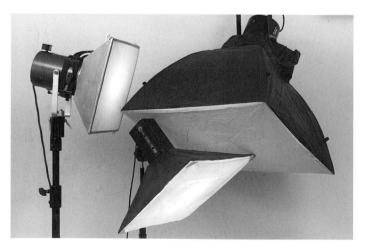

Little and large
*Some of the larger soft boxes
merit a ceiling support based
on little more than their size.*

Basic still-life setup
*Thanks to the variety of
equipment seen on these
pages, setups are essentially
endless in their possibilities.
This simple arrangement
works well for objects of
handheld size, using a track
over a table.*

CLAMPS AND GRIPS

Used in combination with the main support bars and booms, clamps and grips will help you attach anything, from another boom to a sheet of diffusing film.

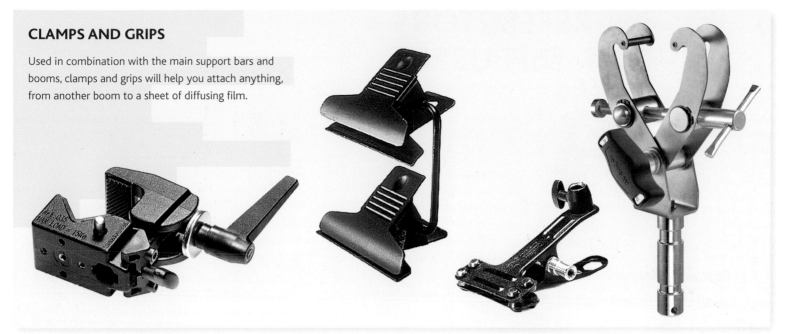

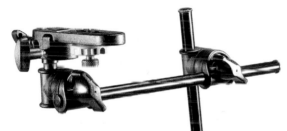

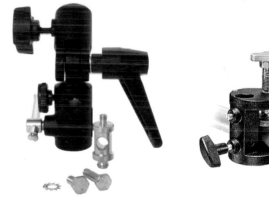

Arms, brackets, and bars
Choosing a support mechanism – and there is a choice depends on your purpose. If you're holding a gobo (see page 110) for example, you want flexibility while supporting heavier lights obviously demands a higher duty bar.

Support fittings
Different support fittings are available to suit a variety of applications (not to mention budgets).

REFLECTORS & DIFFUSERS

As light fixtures gradually become more specialized, designed for particular purposes and effects, more and more are available fitted with modifiers. This applies equally to flash and incandescent, and while in the past the higher heat output of quartz-halogen lamps precluded some of the enclosed fittings, principally diffusers, that were common with flash, new heat-resistant fabrics have overcome this limitation. The most basic fitting is a reflector, also known as a dish (but not to be confused with the separate reflectors that we deal with on pages 110-111), and its shape and inside surface control both the spread and the intensity of the output.

Lamps are rarely used naked, and there is an increasing number of reflectors and other attachments that fit directly onto the head.

The spread of the beam is a key issue in lighting, and a shaped reflector is the simplest way of achieving this (the other techniques are moving the lamp along the axis, and fitting a lens at the front). The lamp itself is fixed at the focus of the reflector. A parabolic profile to the reflector concentrates the beam, and shiny silver reflectors are the most efficient, producing a high output but a hard light. Matt silver is less hard. The broader and less shiny the reflector, the softer the light. Matt white reflectors are very soft, but have relatively weak beams. These lights are known by a variety of names, including 'broadlight' and 'softlight' among others. A development of these is to make the lamp face into the reflector, such as by placing a spill cap in front, so that only reflected light reaches the subject. This softens the beam even more, also producing soft-edged shadows.

Softer still are fixtures that extend outwards from the head to form an area of translucent material. These are variously known as soft boxes, area lights, and window lights (and in Europe some photographers even call the larger versions 'fish-fryers' and 'swimming pools'). The majority of these nowadays are collapsible and in heat-resistant fabric, although rigid aluminium fittings fronted with translucent plastic are still used.

Softbox
A softbox can have a variety of translucent materials attached to its surface to provide a diffuse light.

FIXTURE TERMINOLOGY

This is, unfortunately, inconsistent. The terms used to distinguish between the light source and the fitting that holds it (and usually modifies its output) vary between the motion picture, television and still photography industries, between manufacturers, and among photographers themselves. The source of light is, for most people, a lamp, but sometimes is called a light, even an envelope or tube (bulb is not a professional term). The unit that holds it can be a head, lampholder, fixture, fitting or luminaire, but confusingly, some of these terms have evolved to mean specific versions. You will also see 'light' being used to refer to any or all of these.

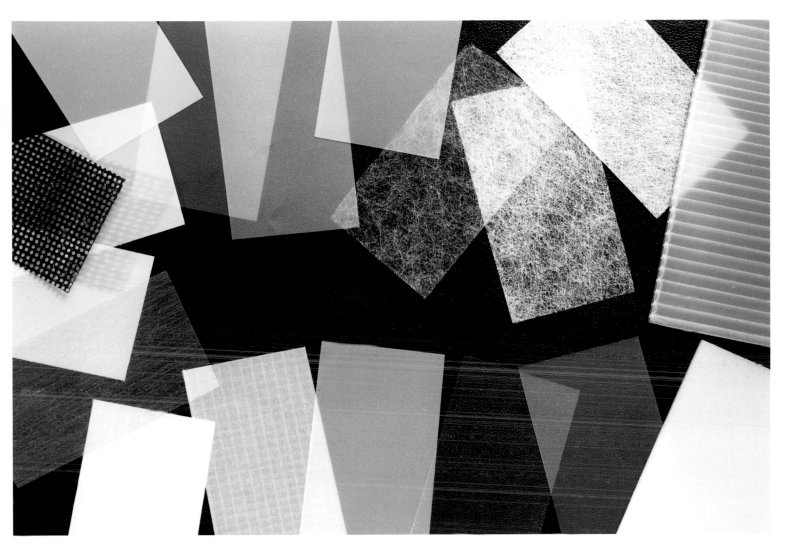

Diffusing materials

The variety of materials which can be used in conjunction with a softbox is extensive.

Reflectors

When attached to a light, these reflectors narrow the width of the beam for a reduced coverage angle.

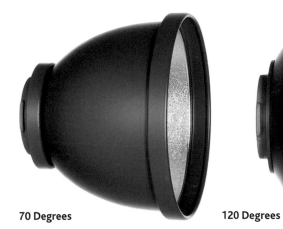

45 Degrees

70 Degrees

120 Degrees

REFLECTORS & DIFFUSERS

Snoot
By fitting a snoot over a light, the beam is concentrated in the direction the light points (light travelling at an angle is stopped by the mesh).

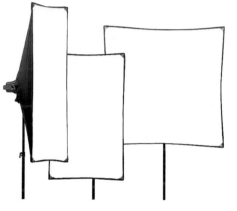

Variety of softboxes
A softbox provides a diffuse light much like that from a window. They are easily sourced in sizes up to 150×150cm (60×60 inches).

Parabolic dish
This dish offers a great deal of flexibility. By moving the light nearer or further from the centre of the parabolic shape, the quality of the light can be changed.

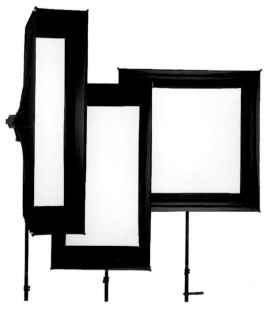

Wide-edged softboxes
These Broncolor softboxes can be fitted to small and portable lights, and their wide projecting edge is designed to reduce stray light.

PHOTOGRAPHIC LIGHTING

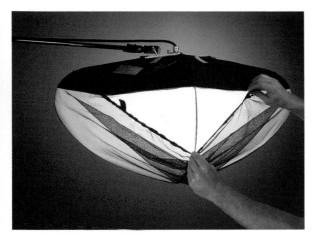

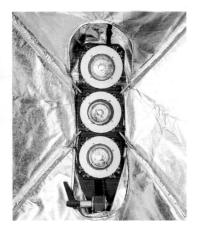

Scrim on softbox
The 'scrim' skin, when fitted to the softbox, diminishes the light emitted by one f stop.

OCTA
This range of softboxes is based on umbrella like rear fittings, giving them a convenient dual purpose.

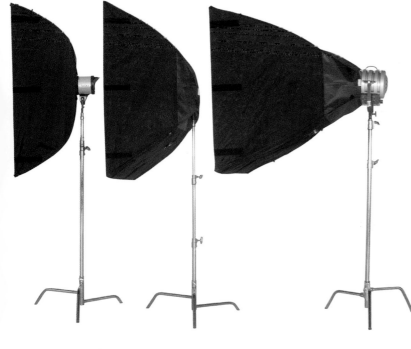

Satellite
While large parabolic umbrellas provide unlimited flexibility, centre-focussed reflectors offer an alternative for fashion photography: soft enough for faces, hard enough to emphasise fabric texture.

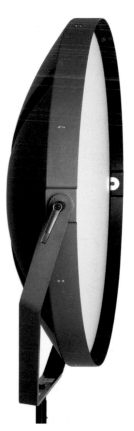

Softbox depth
Softboxes can have various depths, the deeper boxes serving to narrow the angle of the diffused light.

REFLECTORS & FLAGS

A basic technique for both softening a key light and filling in shadows is to aim the light away from the subject toward a relatively large surface that is sufficiently bright to reflect a significant quantity of light back into the scene. This is lighting without the precision normally needed for light fixtures, where beam control and spread are important, and so is very fast and easy to set up. The essential quality of any reflector is the reflectivity of its surface, and the table opposite shows the scale of efficiency and softness, from matte white to a mirror-like finish.

Passive shadow fill from reflective screens is standard practice at all scales, from close-up still-life to outdoor portraiture.

The basic form of reflector is a panel of one kind or another, and these can be as simple and homemade as a sheet of card, polystyrene/foamcore, or even a bed-sheet. The main difficulty with panels is their size – to be effective they have to be large, and supporting them in any elevated or overhead position can be tricky. As a result, the most widely used reflector is the umbrella, which has the advantages of fitting directly into the head and being collapsible. Portability is clearly important for any but the most unchanging studio sets, and another popular solution is the handheld collapsible circular reflector, which uses a flexible steel band that will fold into a much smaller shape.

FLAGS & BARNDOORS

These are used to shield lenses from flare, both from direct lights and from large areas of white. They can also be used as a kind of subtractive lighting – in a sense, the inverse of reflectors – adding shadow to the edges of objects. Flags are usually black cards that can be positioned to block light. Barndoors are hinged flaps that are attached to the light's reflector for controlling the area covered by the light. (*See Transparency, pages 174-175, for more on this.*)

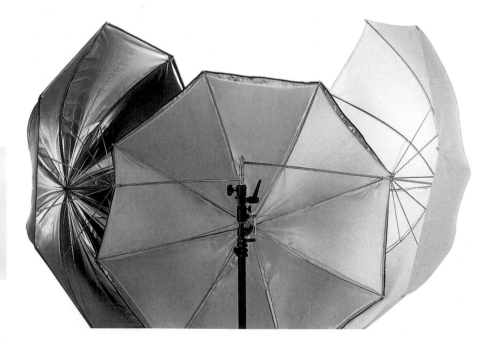

COLLAPSIBLE REFLECTORS

Designed with location work in mind, circular flexible reflectors that can be twisted into much smaller discs for packing are standard equipment. A sprung steel hoop sewn into the circumference holds the coated fabric taut, and they can be compacted by grasping opposite sides, twisting and folding as shown. Gold- and bronze-toned versions are for bringing some warmth to portraiture.

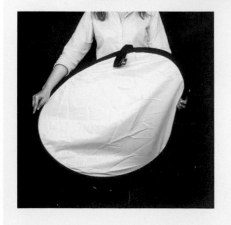

Reflectors

Reflectors are available in a variety of sizes and materials, both of which have an impact on the light reflected.

Umbrellas

Umbrellas, with a reflective material underneath, are available in a similarly extensive variety since they can easily form part of a studio or location set-up.

EFFECTS LIGHTS

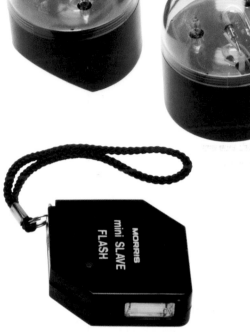

The lighting shown on the following pages is a grab-bag of different sources that do not fit neatly into any of the standard categories. They are for occasional use, either to create a special effect, to enhance a more regular set-up, or in some cases are actually the subject of the photograph. Digital cameras make it much easier to experiment with any light source, because the results can be checked immediately, removing any uncertainty.

Highly specialized lights, and even light sources not intended for photography, can produce striking and unusual results.

MINIATURE SLAVES

These tiny bare flash tubes are triggered by infra-red or light from a master flash, which can be either the camera's onboard flash, a studio AC unit, or, for open-shutter photography, the hand-triggered unit. They can be particularly useful for placing in otherwise inaccessible places, such as the inner workings of the early computer shown here.

Miniatures
A mini slave flash set in use, concealed in the workings of one of the original computers.

MINIATURE LED FLASHLIGHTS

Small pocket flashlights using white LEDs are commonly available and weigh very little; your mobile phone might even feature one. I keep a unit like this in the bag mainly for inspecting the camera sensor and its low-pass filter for dust, but it can, as here, make a useable emergency flash. This was deep inside a Burmese cave temple and I was on a recce. I had no other light with me, and the subject was not sufficiently important to be worth going back for lights. I did, however, have the tripod, so simply set the exposure for Auto and placed the LED on the crumbling part of an altar. The white balance was also set to Auto, and the results acceptable.

Pocket light
Miniature LED pocket light above, and left, as used to light part of a completely dark Buddhist cave.

ULTRAVIOLET

Although ultraviolet is, by definition, invisible, most ultraviolet lamps emit a spread of wavelengths, at least some of which are visible. What you can see is not exactly what the photograph will show, but the sensor will record ultraviolet as a colour somewhere between violet and blue, depending on the wavelengths of the source and the exposure (shorter exposures give more saturation). The most distinctive characteristic of a strong ultraviolet source is the fluorescence it creates in certain materials. White fabrics usually appear intensely blue-white because of the fluorescers deliberately included in modern detergents. Other dyes can have even more spectacular effects, such as those used in security printing. Weaker ultraviolet sources, such as sun-tanning lamps, simply appear more blue in photographs than they do to the eye. Exposure is difficult to measure, but start with an auto-exposure, check the LCD screen result, and adjust from there.

UV light
The fluorescing effect of ultraviolet used in a lab to search for repairs in a fragment of Egyptian bas-relief: in ordinary flash light (left), and ultraviolet-lit (right).

EFFECTS LIGHTS

LASERS

A laser is the ultimate in restricted wavelength, and this is determined by the materials used in its construction. The most commonly available are He-Ne (helium-neon) lasers, and these produce a red light. There is no way of filtering a laser and changing the colour, simply because it is a precise wavelength. The beam is also almost perfectly parallel, and hardly spreads at all, however many times it is reflected. The way of producing an apparent spread is to pass the laser-beam through a lens or some multiply refracting medium, such as certain plastics or liquids. If you play the beam in a pattern directly over a surface, the result on film will be a pattern of lines. To photograph the path of a beam, pass it through smoke; it will reflect off the small particles in its path. If you are photographing laser beams in a clean environment, you may not be permitted to use smoke, as it would damage delicate optical surfaces. Instead, hold a cigarette paper in the path of the laser, and move the paper to trace out the path of the beam during a long exposure: the brilliant, moving spot of light on the paper leaves a trail on film. Exposure is largely a hit-or-miss affair, so as with ultra-violet sources, start with auto-exposure.

POLARIZED LIGHT

Unlike sunlight, the beam from a photographic lamp is not naturally polarized. It can, however, be made so by covering it with a sheet of polarizing material. If this is done, a polarizing filter over the lens will have its usual

Shooting lasers

A Helium-Neon laser used as a measuring interferometer in a lab experiment. Smoke was injected into the set for a time exposure to reveal the laser beams. The flash exposure was made separately with a clean atmosphere.

effect of reducing reflections from non-metallic surfaces. More interestingly, cross-polarization can be used to display stress effects in certain plastics. The most effective way of doing this is with polarized backlighting, placing a sheet of polarizing material over the light source. The polarizing sheet and filter will each reduce the light intensity – the amount varies with the type, but is about 1½ stops for each. Note that in backlit cross-polarization the background will be between white and deep blue-violet, depending on the angle of the polarizers to each other. If the object is small and the background relatively large, this will affect the exposure (and may also create flare in the white-background version).

Shell

A cone shell, with a lustrous surface, photographed at left normally, under an area light, and right, with the same light, but in addition a polarizing sheet in front of the light and a polarizing filter in front of the lens.

SPECIALIST LIGHT FIXTURES

Among the many effects lights made for photography are a globe, light stick, picolite and miniature focusing projector spot.

Globe

Also known as a 'balloon', this is fitted over a standard light for a diffusing effect.

Light stick

With a removable reflector, the light stick can be placed behind some objects where a standard light would not fit.

Focusing spot

By turning the head, the spot beam can be precisely focused on the subject, providing crisp, sharp shadows.

Picolite

A small light with a simple snoot.

CAMERA CALIBRATION 118

HIGH DYNAMIC
RANGE AND REALISM 130

TONE-MAPPING
WITH A CURVE 142

MULTIPLE LAYERED LIGHTING 156

FITTING THE TONAL
RANGE TO THE GAMUT 120

EXPOSURE BRACKETING,
PHOTOSHOP BLENDING 132

ADVANCED HDR
CURVE ADJUSTMENT 146

DIGITAL FLARE CONTROL 158

CHANGING BRIGHTNESS 122

DEDICATED BLENDING
SOFTWARE 134

PREVIEWING HDR IMAGES 148

DIGITAL FOG 160

CHANGING CONTRAST 124

HDR IMAGING 136

CHOOSING THE
MERGING METHOD 150

SYNTHETIC SUNLIGHT 162

REVEALING SHADOWS 126

GENERATING HDRIS 138

TIME-LAPSE DAYLIGHT 152

LIGHTING FOR QTVR 164

EYESIGHT AND HIGH
DYNAMIC RANGE 128

TONE-MAPPING METHODS 140

SECTION 5
DIGITAL LIGHTING

Photography lies in a direct line of tradition with those painters for whom light was a central preoccupation, from Rembrandt to Degas. The difference is – or rather was, as I'm going to argue – that a painter would have to analyse the effect of light, and then find ways of reproducing it with pigment, while photographers capture the appearance of light as it falls. Constructing rather than taking, in other words. Well, this is less true now than it ever was, because digital photography allows a huge amount of control over the way light is translated into an image.

Most of this is in post-production, on the computer, but as the digital workflow becomes ever more integrated, knowing what the possibilities are later determines the way the shot is taken. An obvious example is shooting Raw when you know that will need to fine-tune the white balance on the computer. Another is shooting a range of exposures at a particular interval, with the camera locked down on a tripod, in order later to combine them into a high dynamic range image (HDRI).

HDRI, in fact, occupies a substantial part of this chapter – more than originally intended. In yet another instance of new technology demanding attention, high dynamic range imaging is set to overhaul the way some photographers think about lighting. Essentially, this is software that enables a range of exposures to be combined into a single file format that can cover an almost limitless range of brightness – and then manipulate this file to produce a regular digital image that realistically displays all the important tones. I've been using this regularly myself for some time in certain types of photography, and quickly realised that while the software engineering is developing fast, no-one has yet fully assessed the way it can be used in still photography. You might not yet need the depth of the technical exploration in the middle of this chapter, but this is a rising force in photography and worth having on the bookshelf. HDRI will only extend its impact on digital photography as a way of increasing the dynamic range of which sensors are capable. Already, procedures for aligning images are improving: a step towards combining images shot handheld. What is possible on the computer should eventually be possible in-camera. Like many other aspects of digital photography, this is work in progress.

CAMERA CALIBRATION

Quite apart from how you choose exposure and white balance when shooting, there are subtle issues concerning the camera's method of capturing and displaying colour. I say subtle because for the most part digital cameras, computers, monitors and software are all fairly well integrated. Colour management is the means for making sure that the several different devices, from camera to printer, are all basically speaking the same language, and over the last few years a great deal of effort has gone into making sure that this happens in the background, without the user having to bother about it too much.

Nevertheless, there are two areas that need attention. One is the basic setup. The other is precise calibration for situations that call for complete colour accuracy across the entire image. In setup, the key is to work in one colour space. Colour space determines the gamut, which is the range of colours that a device – camera, computer, printer

Essential to lighting accuracy is to know that the camera is recording colours and tones in exactly the way you expect, and in a way that software applications can read and handle.

– can handle. Here, the choice is usually very simple, as most cameras work to either Adobe RGB (1998) or sRGB. The former has a wider gamut and is the normal professional choice, while the latter is smaller but has advantages if images go straight to a printer without any significant Photoshop editing. In any case, whichever you select in the camera's menu, choose the same in Photoshop and/or whatever editing and browsing software you will use later.

Full camera calibration is another matter. It involves shooting a colour target for which the values of each colour are known, and then making a specific, one-off profile from this. The profile, a small file that Photoshop and other software can access, is a set of instructions to compensate for the small deviations between the way the camera has recorded the target and the real values. Now, it might sound as if this is a perfect, foolproof way of getting colours accurate, and so ought to be used every time possible. Not so, however, because calibration is too accurate for most situations, as well as being limited to the exact lighting of that moment. The procedures are shown step-by-step here, and the result is reliable, but it's essential to remember that the purpose of calibration is to remove all colour casts and shifts. Greys, whites and blacks will be rendered as neutral, whereas in the real world we tend to enjoy the apparent warmth of a low sun and the colourfulness of mixed lighting (see the first two chapters). Where calibration pays off is in the studio, and in particular with subjects that must appear accurately, such as packshots, fashion, and art. Ultimately, be prepared to temper measurement with judgment.

Standard target
The GretagMacbeth ColorChecker is the unopposed standard target for photography, with each color patch specially printed and tested. This is the one to use for most purposes.

CALIBRATION FOR A WORK OF ART

A more sophisticated target was used for shooting this painting by German artist Dieter Roth; also made by GretagMacbeth, this ColorChecker DC is designed for digital photography, has 177 colours, and includes a strip of gloss colour patches.

Shoot the target in position. The ColorChecker is placed in front of where the painting will stand, once the lighting has been set.

Next, the image of the painting, already shot, is opened in Photoshop.

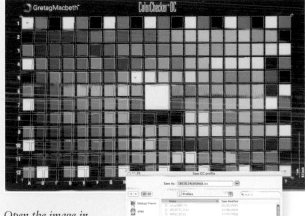

Open the image in calibration software, here inCamera 3.1 from Pictographics. This allows a grid to be positioned exactly over the patches, and creates a profile semi automatically.

This is saved to the appropriate folder for profiles.

The saved profile for this lighting situation is applied through Edit > Assign Profile. My method is to use my own image file number as the name for the profile.

An important final step is to convert this applied profile to the working space (already set as Adobe RGB (1998)).

The final, profiled image. Calibration removes the need to make manual colour adjustments, which would in any case be unlikely to be accurate across the whole gamut of colours.

In Photoshop's Color Settings, make sure that the Working Space and Color Management Policies are as shown.

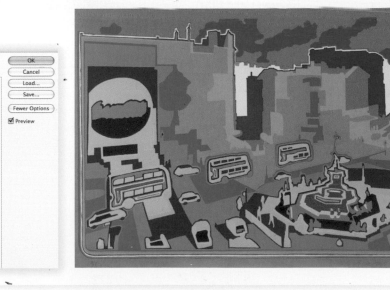

FITTING THE TONAL RANGE TO THE GAMUT

The most basic operation for optimizing the lighting in any image is to assign the minimum shadow and maximum highlight values.

If, as in most situations, you ignore the complexity of camera calibration using a target *(see pages 118-119)*, the first step in optimizing an image is to choose the values of the darkest shadows and brightest highlights. Specifically, we assign the very darkest tone to a value that is usually a little above pure black, and the brightest tone to a value slightly less than pure white. Another way of looking at this simple operation is as fitting the tonal range of the image as neatly as possible into the gamut.

There are different ways of doing it using different software, but the usual tool employs a histogram, such as Photoshop Levels. The full scale of the histogram shows the entire possible gamut from 0,0,0 black on the far left to 255,255,255 white on the far right. If the image as shot is contrasty, it is likely to have lost shadow and highlight detail, and so completely fill the scale. If, however, as in the example here, the image is weaker in contrast, its histogram will sit within the scale. This means that the darkest shadows are not deep black and the brightest highlights have not reached pure white. You may want to keep it that way, but it is more usual to stretch the range outwards so that it fills the scale, later adjusting the mid-tones to vary the brightness *(see pages 122-123)*.

If you use Photoshop to do this, you have the choice of dragging the black and white point sliders inwards to the edges of the histogram. Click OK, then reopen Levels to see the effect. There are also several useful automated and semi-automated procedures, some of which are illustrated here. Other image-editing applications, such as the camera manufacturers' own applications, or independent workflow programs such as PhaseOne Capture One and Apple Aperture, offer similar tools.

OPTIMIZING A LOW-CONTRAST IMAGE

I've deliberately chosen an under-scaled (low-contrast) image, shot Raw with low contrast, to demonstrate the several possibilities of setting the black and white points. Over-scaled (high-contrast) images present different problems that are best addressed with other tools, including HDR techniques *(see page 136)*.

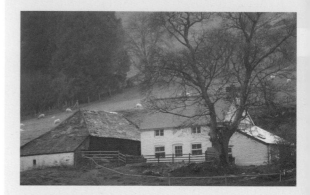

As shot
The original, of a Welsh farmhouse, has evidently low contrast because of the haze and the use of a tele-photo lens, which is doubtless picking up some low-grade flare from being aimed into the sunlight.

Manual Levels adjustment
The histogram, with almost all the values clumped in the centre, is typical of a low-contrast image. Closing up the black point on the left and the white point on the right is here done by eye (with the help of Alt-clicking to reveal clipped areas).

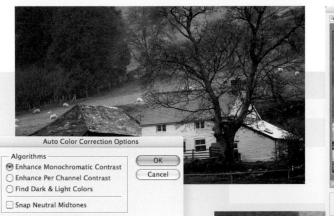

Auto Color

Photoshop's Auto Color option, here accessed from within the Levels dialog, is a faster and automated alternative. It offers a choice of three methods: Enhance Monochromatic Contrast (used here), Enhance Per Channel Contrast, and Find Dark & Light Colors. The effect is similar to, and slightly stronger than, the manual adjustment.

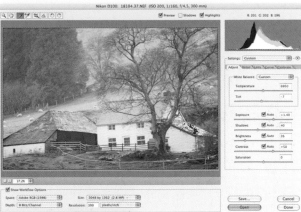

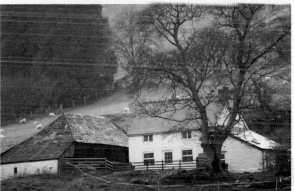

Working in Raw
If the shot has been taken in Raw format, as this was, a Raw converter is the more logical place to set the black and white points. This is the Photoshop converter, as opened in default, and with the Auto selected for all the sliders. The highlight clipping warning is in red and the result is significantly lighter than any of the other methods tried here.

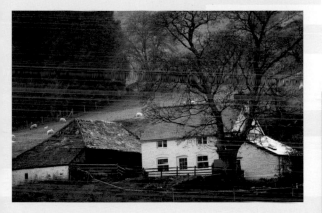

Auto Color Per Channel

The Enhance Per Channel Contrast method works on each channel (R, G, and B) separately, for maximum contrast-enhancing effect but obviously with the potential for a colour shift.

Manual adjust in Raw
With this particular image, manual adjustment turns out to be more useful than the Auto option, but ultimately everything must be judged according to individual taste.

Auto precautions with tinted subjects
Images that have an overall intended colour cast need to be handled carefully if you use the auto option. This close-up of a gold-tinted reflector material is handled properly with Enhance Monochrome Contrast, but loses its colour drastically with Enhance Per Channel Contrast and Find Dark & Light Colors.

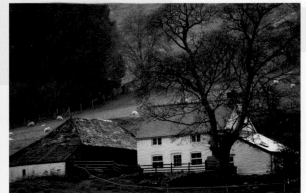

Auto Color Dark and Light

The Find Dark & Light Colors method makes its own approximations of the darkest and lightest colours, equivalent to using the eyedropper.

CHANGING BRIGHTNESS

Step two is to assess and if necessary adjust the brightness, for which there is a choice of technique for subtly different effects.

Having assigned the end-points of the tonal range – and it is important to do this first – we can move on to adjusting brightness and contrast within the overall range. The usual ways of doing this are with a mid-point slider on the histogram or more delicately by changing the shape of the curve. For clarity, we'll divide this into two: on this page a simple change to the brightness, followed by the more complex changes to contrast made by using two adjustment points.

At the risk of being repetitive, it's good procedure to make alterations to brightness within a range that has already been set. Otherwise, the upper or lower ends of the scale are in danger of shifting off the scale, with the result of washed-out highlights or blocked-up shadows. Using Photoshop Curves, if both ends of the curve are locked in the corners, the black and white points remain fixed. You can alter these in much the same way as with Levels, by dragging the handles out of the corner and along either axis.

The subject of the photograph opposite is a silver dish cover in a street market. First, let's look at where we are with the histogram and the black and white points. As this shows there is a very slight loss in the brightest highlights at right, but acceptable. The most basic brightness adjustment is a mid-point movement left (towards shadows) or right (towards highlights). The mid-point slider in Levels does just this, and the equivalent in Curves is moving a point on the middle line horizontally. Note the effect on the histogram after this has been done: the left and right sides remain essentially the same, but more of the tones have been spread into the middle.

A curve, however, offers a more subtle way of changing brightness than this. Taking a point lower in the curve, where the shadows are, gives a bias towards the shadows in any changes made. The resulting curve has a slightly different shape, bulging more to the lower part. Equally, taking a point higher in the curve will favour the highlights: there is simply more flexibility.

SUBTLE DIFFERENCES BETWEEN SIMPLE CURVES

The differences demonstrated here are subtle, but can be important, depending on which part of the tonal range you want to favour.

Black and white points set
The starting point is the end of the first operation (see pages 120-121). The black and white points have been set. The image has quite full contrast, and the highlight warning shows that some highlights are just white.

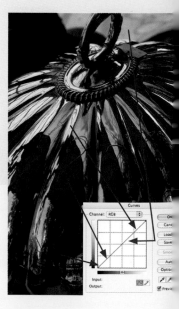

Checking points on the Curve
Clicking on different parts of the image shows where they lie on the curve, and this is a useful step before continuing. One immediately noticeable point is that the pale, out-of-focus area at the top, in the background, is actually on the mid-point on the curve, yet by expectation it should be brighter than that. The image clearly calls for lightening.

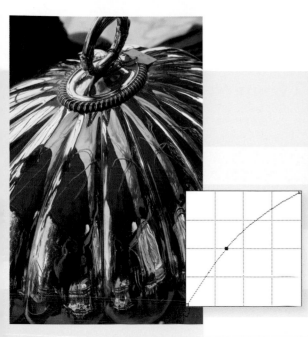

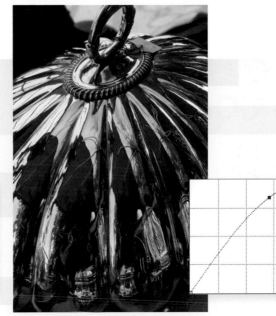

Highlight-favoured Curve
If, on the other hand, you would like to leave the shadows deep and concentrate on brightening the yellows, it is a better option to move a higher point on the curve.

Mid-tone Curve
This basic adjustment – mid-point to the left – is the equivalent of shifting the mid-point slider in Levels to the left. The biggest change is to the middle values; everything else is shifted proportionately to its nearness to a mid-tone.

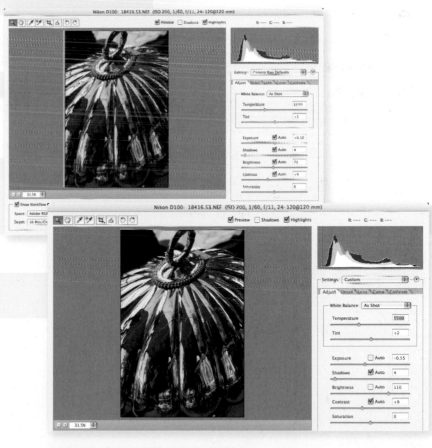

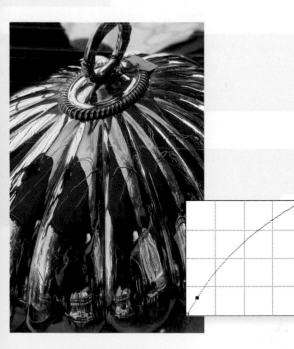

Shadow-favoured Curve
Moving a lower point to the left lightens the shadows more than it does the lighter tones. If you feel that the image has a shadow problem, this is the kind of adjustment you would make.

Brightness changes with a Raw converter
Brightness changes can also be made on a Raw image at the point of converting it, here using Photoshop's Raw converter. The Brightness slider (equivalent to a Levels mid-point slider) is unchecked from Auto and changed manually.

CHANGING CONTRAST

ontrast changes that are made within set black and white points are another Curves operation, but made with at least two adjustment points. One way of looking at this is as a variable brightness adjustment, with part of the curve dragged one way and another in the opposite direction. The classic contrast-enhancing curve has the shape of a lazy S; the brighter areas are made brighter and the darker areas made darker. Reducing contrast uses the inverse shape – the shadows lightened and the highlights lowered.

The difference between the brighter and darker tones can be manipulated within the tonal range that has already been decided.

AN ALTERNATIVE APPROACH

A completely different way of dealing with contrast is to use Photoshop's Shadow/Highlight command. This is intended to reduce contrast by opening up shadows and lowering highlights, but by making a strong upward adjustment to the Midtone Contrast slider (to +70), we can, in fact, increase the contrast noticeably where we need it.

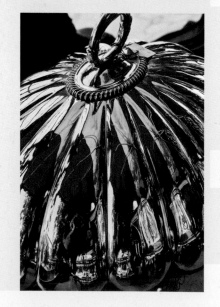

CONTRAST FOR A CLOUDY DAY

In this example, the contrast changes are made to a specific part of the tonal range only, while other areas are protected. The dull weather clearly calls for contrast enhancement, even after the black and white points have been set automatically, but what we really want is more contrast in the mid-to-darker tones, where the vegetation and woodwork lie. The glass roofs are in danger of being made too bright, so these need to be handled carefully.

As shot
*The original shot,
before any optimization.
Dull, but overall there
is more contrast than
you might expect.*

DEGREES OF CONTRAST

Here we continue with the same image, and see what happens when we raise, and lower, the contrast.

As shot
*This is the same starting
point as on pages 122-
123. Because we also need
an overall lightening, the
contrast curves will be
offset towards the left.*

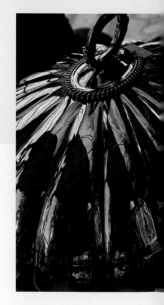

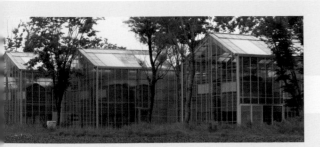

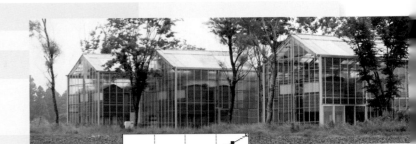

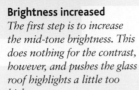

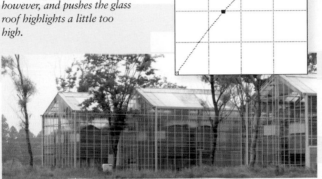

Brightness increased

The first step is to increase the mid-tone brightness. This does nothing for the contrast, however, and pushes the glass roof highlights a little too high.

Black and white points set

The black and white points are set using the Auto option (available in Photoshop from either the Levels or the Curves dialog).

Contrast increased

Taking a point low down on the curve and dragging it slightly right increases the contrast in the greens and browns, but drives the highlights even higher. To counter this, two points are selected high on the curve to, in effect, reduce contrast in the highlights. The overall curve is S-shaped for higher contrast but with a protective dip near the top.

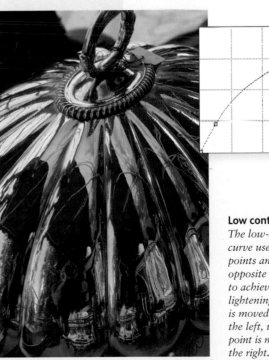

High contrast

A strong movement of the highlights to the left coupled with a more moderate movement in the lower shadows towards the right gives a high-contrast version that is also lighter overall than the original.

Low contrast

The low-contrast equivalent curve uses similarly placed points and moves them in opposite directions. Again, to achieve an overall lightening, the lower point is moved strongly towards the left, while the upper point is moved less towards the right.

REVEALING SHADOWS

Curves adjustments are reasonably easy to understand. The graphic display is intuitive. The range of tones from shadow (left) to highlights (right) are progressively shifted up or down in brightness. A more recently developed technique borrows from the algorithms used in sharpening (and blurring, among others). The principle is the filter technique that searches the neighbourhood around each pixel and alters the surrounding pixels in relationship to its value. The essential parameter is the radius around each pixel, and this is the key choice offered by the software. Because each pixel is analysed and the alterations overlap and interact, the procedure is fairly complex, and very obviously related to the size of the image – a 20-pixel radius in a high-resolution image has a smaller effect than the same radius in a low-resolution image). The user interfaces are easy enough to operate, but not to predict, so these procedures need to be tried out and judged on-screen. The advantage is that they offer a fairly radical alternative to Curves when it comes to altering brightness in post-production, for the key reason that they can limit their effect to a specific range of values – and do it naturally without the risk of artificiality that comes with making a hand-drawn selection. The most widely used software for this kind of procedure is the Shadow/Highlight tool within Photoshop's *Image>Adjustment* menu. Its most powerful use is in working on the shadow areas of a photograph, for reasons that will become obvious (although, as we saw on pages 124-125, the Midtone Contrast control is a powerful way of adjusting a zone that is defined by the Shadow and Highlight sliders). Bit-depth is an important consideration, as the changes to pixel values can be quite powerful: 16 bits per channel is definitely recommended. Essential precautions are not to get carried away with opening up shadows strongly, and always to use the Midtone Contrast slider to some extent – otherwise, results tend to appear false.

Software techniques that go beyond Curves adjustment allow the lower part of an image's dynamic range to be selected and opened up.

A HINT OF SHADOW DETAIL

In this image of an ancient Egyptian temple in Nubia, I wanted a romantic, Oriental feeling, with small figures in the distance, and the looming mass of backlit masonry in the foreground. Success, however, depends heavily on retaining a hint of detail in the shadowed stonework. As in a painting, the viewer needs to know something of the structure.

Silhouette
In this treatment, there is no detail, just a solid silhouette. A view of the clipped shadows (in Photoshop Levels with the Alt key depressed and the black point slider clicked) shows what is lost.

Mystery in the shadows
A less destructive treatment aims to hold some detail throughout the shadows – not sufficient to read clearly, but an indication.

SHIPBREAKERS

This image was part of a piece of reportage on shipbreaking in the Indian state of Gujarat.

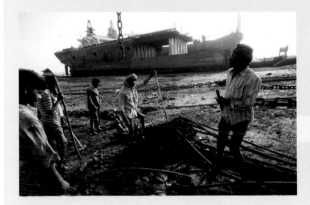

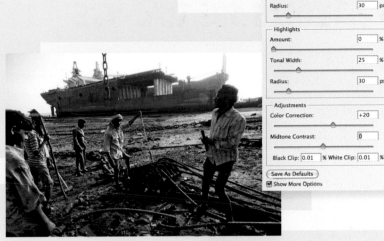

As shot
This shot, taken into the sun, is pretty much as you would expect – high contrast, some flare, good atmosphere and quite acceptable. Nevertheless, the shadows could benefit from opening up.

Shadow/Highlight tool
Lightening the shadows (but making no other adjustment) has a quite different effect, with good separation between the shadow tones in the foreground. Nevertheless, the dark-to-mid tones suffer the same problem as in the Curves adjustment – most noticeable on the man standing at right.

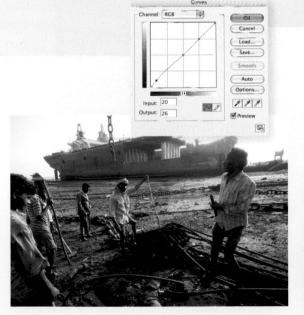

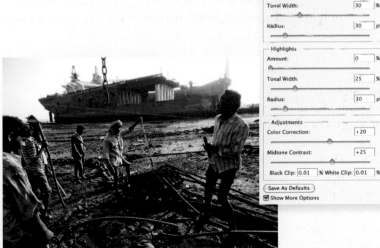

Opening shadows with Curves
The traditional method would be to make a controlled Curves adjustment, centred on the shadowed part of the block and tackle lying in the mud. Mid and highlight points are held, and just the lower sector lightened. The result is not necessarily an improvement overall, as the general lowering of contrast exacerbates the flare that already exists in the upper part of the image.

Shadow/Highlight plus contrast
One more adjustment makes all the difference; the Midtone Contrast slider is shifted right to +20. This enhances local contrast in the mid-tones above those already selected and adjusted by the Shadows sliders. The result is good contrast, as in the original, yet realistically opened up shadow details.

EYESIGHT AND HIGH DYNAMIC RANGE

W e had an introduction to dynamic range on pages 12-13, and this included two essential concepts. To recap, one of these is that dynamic range affects the scene, the recording device, and the display medium. All three are interconnected, and this becomes an important issue when the dynamic range is high. HDRI, or High Dynamic Range Imaging, is a method, or rather a collection of procedures, for capturing and displaying a wide range of brightness. 'Wide' means something comparable with the capability of our own eyesight, and more than the usual capacity of photography. The table opposite gives a comparison of dynamic ranges across scene, device, and display, and these three have to be looked at together. So for instance, even though a device (a sensor) may be able to cover a high dynamic range, this alone is insufficient if the image is shown on a medium (screen, paper) that cannot cover this range. When considering High Dynamic Range and whether its special imaging techniques are going to be needed, we should check all three factors: Does the range of the scene qualify as HDR? Can it be captured in one or more exposures? Is there a satisfactory way of converting this down to the display medium's dynamic range?

The second concept is that the eye handles the dynamic range in a completely different way to that used in a photograph. This deserves some elaboration. Before we move on to HDRI, which is one of the major innovative capabilities of digital imaging, it's essential to be completely familiar with the way we perceive brightness. After all, one technical aim in photography is to get close to this sensation. Typically, the eye flickers rapidly over a scene even without conscious direction in a pattern of what are called saccadic movements. The order is related to elements of interest, and so varies from individual to individual. Here we consider only the differences in brightness. By rapid adjustments of the iris, the eye can alter its sensitivity, so that while it has a fairly limited

Until now, it has been impossible to reconcile the huge differences in sensitivity to brightness between eye-and-brain and photographic images.

HOW THE EYE DEALS WITH CONTRAST

This high dynamic range scene contains highlights lit by a direct sun, and deep shadows under the overhangs. Impossible to record satisfactorily with a single exposure on film or a sensor, it nevertheless registers on the eye quite easily.

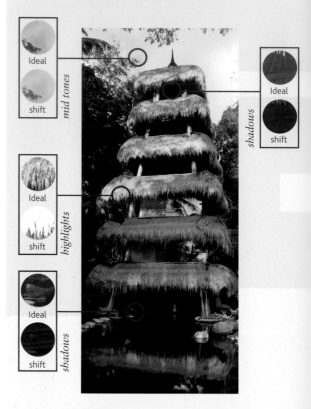

A range of brightness
The circles represent approximately what the eye takes in during a single focused moment. The upper of each pair shows the ideal brightness for that small area (what the eye registers) while the lower circle shows the shift necessary in a regular low dynamic range image to accommodate other parts of the scene. Effectively, this means that highlights would have to be over-exposed to accommodate the shadows, and shadows under-exposed to accommodate the highlights. Nearer the middle of the range, there is less shift.

dynamic range if staring at a small focused area, it can 'add up' a number of areas that vary widely in brightness to arrive at a perceived overall image with a high dynamic range. We saw an example of this in some detail on page 10. All this, though it occurs quickly, is a 'remembered' view, and so not directly comparable with a single, fixed photographic image.

Exposing for highlights
This was always the solution for transparency film, and remains so for digital sensors for a single shot and a low dynamic range (8 bits per channel) format. The highlights are preserved, but at the expense of blocked-up shadows.

The best of both worlds
Capturing and then compressing the entire range preserves highlights and shadows. The techniques are discussed over the next several pages, and in this instance involved two exposures, one for the highlights and the other for the shadows, processed into a single HDR image.

Film, as we've already seen, not only has severe limitations in the dynamic range that it can capture in a single exposure, but offers few ways of working around the problem. Black-and-white negative is the most adaptable, but colour transparency (especially Kodachrome) is very limited. One important result over the decades has been that some of the technical failures have become fully accepted as 'photographic' imagery. One of these is the flared, blown-out high-light, another is the dense silhouette. Neither have been a part of representational art until the arrival of photography in the nineteenth century, yet both are now completely accepted. More than this, because photography in general is much more than just getting things technically correct, these two visual treatments have contributed to the art of photography. There are several others, of course, such as defocused blur, but here we confine ourselves to issues of light. These effects can enhance the image, add atmosphere and even an impression of 'actuality'.

A mid-range compromise exposure
Exposing for the middle of the range damages highlights and shadows equally, and renders the mid-tones as they should be.

DYNAMIC RANGES

	Scene (sc) device (dv) or display (ds)	ratio	exponent	EV stops
dv	32-bit per channel image format: potential range	infinite	n/a	n/a
sc	High-contrast scene including light source (say the sun)	100,000:1	216 – 17	16 – 17
ds	16-bit per channel TIFF: potential range	65,536:1	216	16
dv	Human eye normal full working range	30,000:1	215	15
dv	16-bit per channel Raw from a 14-bit high-end CCD	16,384:1	214	14
dv	16-bit per channel Raw from a 12-bit CCD	4,096:1	213	12
sc	Sunlight-to-shadow in a very contrasty scene (white paint in sunlight to black paint in shadow)	1,600 – 2,500:1	211	about 11
sc	Sunlight-to-shadow in a quite contrasty scene (pale skin in sunlight to vegetation in shadow)	1,000:1	210	10
ds	Active matrix monitor	350:1	28+	8+
ds	8-bit per channel JPEG, TIFF: potential range	255:1	28	8
ds	Typical CRT monitor	200:1	27–28	7 – 8
ds	Glossy paper	128:1 – 256:1	27 – 28	7 – 8
dv	Human eye range when fixed on one part of scene	100:1	26–27	6+
ds	Matte paper	32:1	25	5

HIGH DYNAMIC RANGE AND REALISM

HDR imaging embraces a number of techniques, all of which culminate in compressing a wide range of tones into an image format that can be displayed normally – which means in practice as a print or on a regular monitor screen. Opinions vary as to what really counts as a High Dynamic Range image. By the strictest definition, it covers a range of brightness in excess of the 66,000:1 that can be handled by a 16 bits per channel TIFF (33,000 in the case of Photoshop's 16-bit format). What are considered to be HDR image file formats are 32-bits per channel (*see page 136*). This certainly includes any image that includes the major light source, such as a landscape into the sun. Some people consider Raw images from a high-end camera using a 14-bit CCD sensor to be HDR, and some extend this to Raw images from a standard DSLR that has a 12-bit sensor. There is validity to all of these, but in this book I'll distinguish between the broad definition by using lower case ('high dynamic range'), and the narrow definition which confines itself to 32-bit floating point formats and tone mapping by capitalizing ('High Dynamic Range' and 'HDR').

In any of these treatments, most of which involve different exposures, the result is an image without clipping at either end – a photograph in which all tones are displayed. This sounds ideal, but given the way that eyesight works (*see pages 128-129*), this kind of image presents a paradox. On the one hand it shows all that we would see if we were to look fairly carefully at the real scene, but on the other, it shows much more than we would take in at a single glance. In other words, it is either more realistic or less realistic than a traditional photograph, depending on opinion, visual experience, and expectations. An added complication, which I'll deal with on page 140, is that there are different algorithms for mapping the tones of an HDR image down to a viewable 8 bits – and in addition, many user choices within the software.

In fact, the best that a photograph can do for the dynamic range of the scene is to deliver a version that accords with our sense of reality. This means that both of the extremes in recording a high dynamic range – the limited 'photographic' way with flared highlights and black silhouetted shadow areas, and the extended 'digital' way with everything revealed – are valid interpretations of a real-life scene. The appropriate treatment is, for most people, a compromise between the two, and this is why there are several ways of dealing with high contrast in digital imaging. Ultimately, high dynamic range images involve judgement and go beyond the simply technical.

HDR technology may solve an old photographic problem, but it does not necessarily look realistic to viewers accustomed to traditional photographic images.

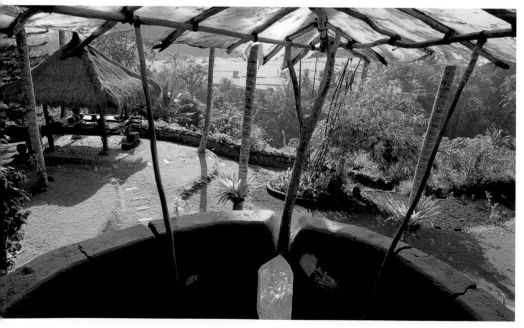

HDR garden
This garden was shot from under a shaded canopy looking across a brightly sun-lit scene. As your eyes move from detail to detail, the view seems natural.

NORMAL VS HDR

This high-contrast image of crystals fused into a chandelier has a range of about 6000:1, which is how many times brighter the sparkling highlights are than the darkest shadows. Put another way, the difference is between 12 and 13 EV stops. Treated without any special procedure, whether it had been shot on film or as an 8-bit TIFF or JPEG digitally, something will inevitably be lost. In the sequence of 8-bit exposures below, the image at the left (6 sec at ƒ32) reveals all the shadow details, but is hopelessly washed out in the highlights. At the far right (1/4 sec at ƒ32) the highlights are retained but at the cost of all shadow detail. The images in the middle lose something at both ends of the scale. But does it matter? The second image from the left (3 sec at ƒ32) is probably the most acceptable, and few people would consider this version in any way 'wrong', just contrasty. HDR software, which allows a sequence of images such as this to be combined into a single image file, and then output in a way that retains all the details, has moved the goalposts in the treatment of high-contrast scenes. The result can look like the larger image shown to the right. Here, every tone has been captured and displayed, extremely clearly, but the result is unfamiliar to most people accustomed to traditional photographs.

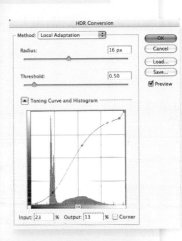

WHAT COUNTS AS HDR

Definition	Bit-depth per channel	Ratio
High dynamic range	32-bit floating point (96 bits RGB)	Infinite
Borderline	16-bit TIFF (48 bits RGB)	33,000:1 in Photoshop
Borderline	Raw from a high-end, 14-bit CCD, camera	16,000:1
Low dynamic range	Raw from a standard, 12-bit CCD, camera	4,000:1
Low dynamic range	8-bit TIFF or JPEG	255:1

EXPOSURE BRACKETING, PHOTOSHOP BLENDING

A key digital technique for dealing with high dynamic range is to bracket exposures and later combine them into a single image.

Not surprisingly, common to all the techniques for handling and displaying a high dynamic range is capture. As we've seen, there are many lighting situations that are beyond the capacity of either film or digital sensors to record in one shot, and digital has a harder time because of the unforgiving linear sensor response. Nevertheless, as long as nothing moves in the scene, there is no problem in capturing the whole range over several frames – in other words, bracketing. Once you have the data, you can choose how to combine it into a single image.

Depending on the camera's features, bracketing can be manual or automatic. In both cases it is important, though not entirely essential, to lock the camera down on a tripod, so that the sequence of frames is in register from the beginning. The usual precautions for using a tripod apply: it should be stable, and you should avoid the possibility of slight movements by touching it as little as possible (a cable release is recommended). If the lens has image stabilization, switch this function off. The two indicators for the extent of the exposure range are the camera LCDs highlight warning and the histogram. The former lets you set the lower limit for exposure, which is the setting that produces no flashing warning, and the latter shows the upper limit, which is a histogram in which there is a slight gap on the left side of the scale. If you feel it is important to show more shadow detail than usual, increase the over-exposed end of the bracketing sequence by even more. Practically, it is usually easier to start the bracketing sequence at the shortest exposure (holding the highlights), and simply shoot increasingly brighter frames from there. As a rule of thumb, make the gaps between frames between one and two *f* stops, though the exact optimum depends on the blending or HDR technique you later apply, and this may take some experimentation. As always, if in doubt, take more rather than fewer shots; the idea is to have access to the maximum amount of data.

Because these techniques work best with tripod-locked shots, there is usually enough time to make manual bracketing convenient. Nevertheless, some cameras allow an automated bracketing function that may cover a wide enough range to be useful, and the advantages of this are not only that, once set up, it is easy to shoot, but that the bracketing is quick, which may make it worthwhile attempting without a tripod.

DIY blending of different exposures is easy but time-consuming. The most simple, hands-on approach is to paste one image over another in Photoshop, then use the Eraser to remove the parts of the image that are in better detail underneath. In other words, with the dark version above the light version, erase the shadow areas. A more procedural solution is to use a combination of extreme adjustment to the Curves with a specific Layer mode. Usually, Multiply mode is used to blend bright highlight detail, and Screen mode to blend deep shadow detail. This is much easier to follow in an example, as illustrated, than by description.

BRACKETING WITHOUT A TRIPOD

Shooting a sequence of exposures hand-held creates the obvious problem of the frames being slightly out of register, but if the shot is important, this simply means more time spent in post-production. If the frames are only very slightly out of register, the register routine in dedicated blending software such as Photomatix will often, when checked, do the trick. Otherwise, the frames need to be registered manually and by eye in post-production. The major difficulty here is roll: rotating images to fit is more difficult than correcting horizontal and vertical shifts. The usual method is to copy one image over another, reduce its opacity to around 50-70% so that both images are visible, and move the upper layer to fit, at an on-screen magnification of at least 100%. As registration of near-identical images is a recognition issue, and already handled very well by stitching programs, expect this feature to be addressed by camera manufacturers in the future.

DIY BLENDING IN PHOTOSHOP

This is a well-tried though arduous technique, fine for occasional use, but if you expect to make exposure blends regularly, the dedicated software shown on the following pages is a sensible and inexpensive investment.

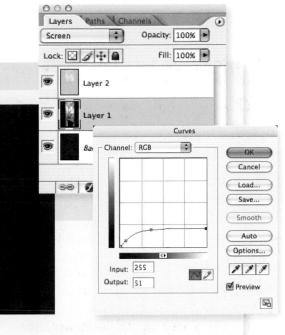

Shadows from the light image
This curve is applied to the bottom, lightest version to restrict it to the shadow areas. At the same time, the middle, medium layer, is set to Screen mode.

Highlights from the dark image
The reverse is performed for the dark version on top of the stack. A curve is applied to restrict the image to the highlights, and its blending mode is set to Multiply.

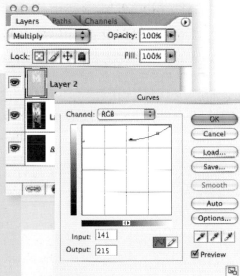

Adjusting contrast
This technique usually demands a slight increase in contrast, through a gentle S-curve (see page 124).

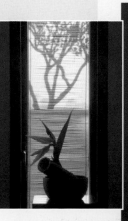

Three exposures
A through-the-window shot without any additional lighting. The three exposures each cover a different, though overlapping part of the range. The medium version is pasted onto the lightest, and then the dark version on top, in a three-layer stack.

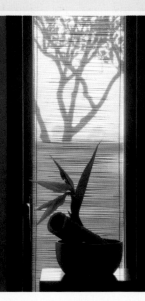

DEDICATED BLENDING SOFTWARE

There's no doubt that DIY blending of differently exposed frames in Photoshop *(see pages 132-133)* is both tedious and unnatural. It becomes particularly difficult to see in real time what is going on when there are more than two layers, and producing a perfect extreme curve usually takes some fiddling about. The software application shown here, Photomatix, is dedicated to doing just this kind of compositing, and removes the uncertainties. Later, we'll come to the more powerful but more demanding HDR imaging, but for many, perhaps most, lighting situations that have a dynamic range, this kind of blending is perfectly adequate. The principles are as already described for the manual procedure with Photoshop Layers.

If you make more than occasional use of multi-frame blending, dedicated software is the logical choice, offering automation and reliable algorithms.

What Photomatix calls Exposure Blending consists of combining the differently exposed input images in such a way that highlights details are taken from the underexposed photos (or at least those from the lower end of a deliberate range of exposures) and shadows details from the overexposed images. There are no changes to the bit-depth (as happens with HDR imaging), and the blending algorithms deal in weighted averages. In other words, the procedures are straightforward and easy to predict.

The advantage of Exposure Blending is that it is easy to understand and you can see what you are doing. Additionally, it is somewhat familiar to photographers who have become used to doing this process the hard way: using layers in image-editing software. In Photomatix, the Exposure Blending functions are named *H&S Details* and available under the Combine menu.

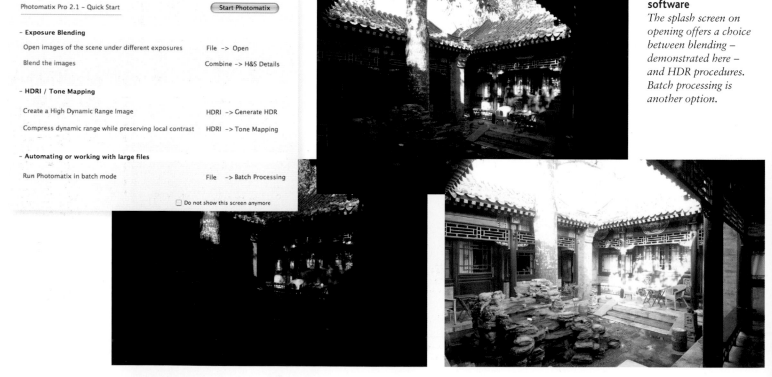

Dedicated blending software
The splash screen on opening offers a choice between blending – demonstrated here – and HDR procedures. Batch processing is another option.

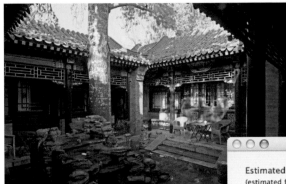

H&S Details – Auto

This aims for a result that has a more natural look than other methods, although it can be rather flat and generally needs a contrast curve applied to it afterwards.

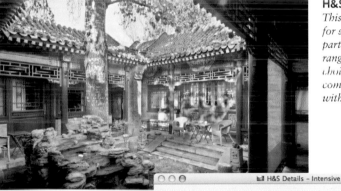

H&S Details – Intensive

This method is intended for scenes with a particularly high dynamic range. It offers two choices, and both are computationally intensive, with long processing times.

H&S Details – Adjust

This method allows the user to set the radius of the process (more for a larger image) and the blending point used for the calculation. Setting a high value for the radius will make the blending more accurate, which will result in a sharper-looking image. However, a higher radius increases processing times and may result in halo artifacts around strong luminosity edges. The blending point is used to weight the result towards either the dark or bright input images.

Batching

Batch processing is always useful for computationally intense processes that lend themselves to automation, as does blending. There is another advantage, in that the characteristics of the particular image may favour one blending method or another, and this is largely a matter of personal preference. Batch processing here can be used to run the same set of varyingly exposed images through the different procedures, then choose which you prefer at the end.

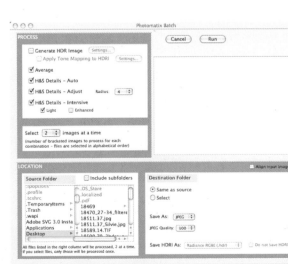

HDR IMAGING

High Dynamic Range Imaging is a technique that uses very high bit-depth and an advanced way of assigning tonal values in order to record all of the tones in any scene, however contrasty. As we saw on pages 12-13, a high dynamic range image is any that exceeds the ability of a standard camera to capture it in a single frame, and exceeds the range of a standard display device (essentially, an 8-bit monitor). Remember that any scene that includes the light source automatically has a high dynamic range – shooting straight into the sun, for example, or more practically, an interior looking out through a window onto a bright day. We'll use the latter as our example here.

A powerful new tool in the digital lighting armoury makes it possible to contain an infinite range of brightness within a single image, from a bright sun to the deepest shadow.

As the definition implies, there are two steps to using HDRI. The first is capture, the second converting the result into a viewable form. Capture involves shooting the same scene, exactly framed, at different exposures that are fairly well spaced (an *f* stop at least), then launching the software that will combine these images into a single HDR file. Photoshop has introduced this with CS2 as 'Merge to HDR', while a stand-alone application, Photomatix, is

dedicated to HDR. HDRI file formats, which include Radiance RGBE, Floating Point TIFF and Portable Float Maps (PFM), are 32 bits per channel, and in contrast to integer-based formats (in which, for example, a pixel is assigned to one of 256 values) use floating point numbers. As a result, any tonal value can be placed precisely. This part of the process, generating the HDR image, is automatic and fast.

But this image can still not be viewed on a normal display, let alone printed. It has to undergo a conversion to either 16-bit or 8-bit, in which the many values are reassigned to a fixed number of levels. This where HDRI becomes interesting and complex, because there is no single obvious way of automating the conversion. Simply scaling them down according to their value produces a flat appearance, and for some semblance of reality, the position of each pixel in its local area needs to be factored in. In other words, the scaling must take

A room with a view
This richly panelled room at the venerable Badrutt's Palace Hotel in St. Moritz was designed and used by Alfred Hitchcock. Introducing lighting would have destroyed the overall effect, which relies heavily on the warm reflected glow from the wooden floor and walls.

Generating the HDRI
Seen here with Photomatix, the HDR image appears very contrasty indeed, but a small window reveals the optimized view under the cursor.

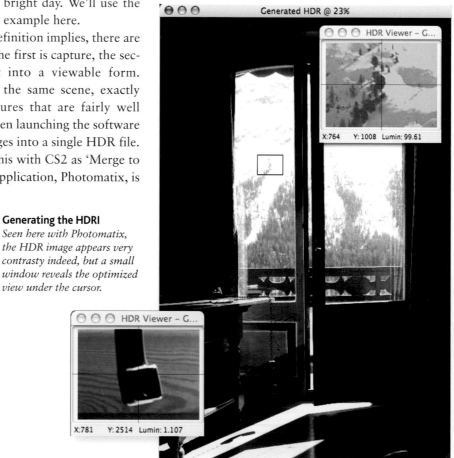

Exposed for the highlights at 1/160th second (f 32)

Exposed for the shadows at 1/40th second (f 32)

into account whether the pixel is in a bright or dark area. The local contrast makes a great difference, and the process is actually a complex tone mapping.

More than this, the very ability to encompass such a range in a single image challenges our long-held assumptions about how a photograph should look. A common complaint when seeing an HDR conversion for the first time is that in some way it looks more like a painting than a photograph. Exactly so. We have become accustomed over more than a century for photographs to be incapable of rendering scenes like this. Representative painters never had that problem, and now, using this technique, neither do photographers. It becomes a matter of taste as to what looks good.

SHOOTING TECHNIQUE

For HDRI to work efficiently, bracket the exposures around 1 or 1⅓ *f*-stops apart, so that the software that generates the HDR version has a sufficient difference on which to work. Fix the camera, ideally on a tripod. The in-camera highlight clipping warning is the logical place to begin – shoot the first frame so that it just preserves the brightest highlights. At the same aperture (in order to keep depth of field the same throughout), shoot the next frame at a longer exposure, and continue until you see, in the last frame, as much shadow detail as you would like to keep. Save the images in a folder.

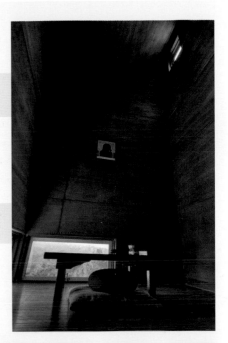

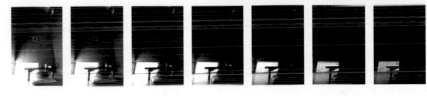

Tone mapping
The several adjustments possible, with the complication that the appearance depends on resolution, make the conversion a trial-and-error process. Moreover, as these two results show, the algorithms used by different software can produce very different effects. In this case, the Photoshop version has less tonal halo around the edges of the windows, but the Photomatix conversion better captures the contrast and saturation of the interior.

GENERATING HDRIS

The ideal, but as yet largely unavailable way of generating a High Dynamic Range Image would be at capture, but this is limited by current sensor design. Cameras using ILM's (Industrial Light and Magic) OpenEXR format are available in special effects cinematography, and for stills there is the German Spheron 360° panoramic camera (with a dynamic range of 26 f stops), but most camera sensors achieve only 14 bits per channel. While this is good, it does not really qualify for HDRI. So, for the time being, most HDRI generation involves shooting a locked-down sequence of several exposures, and then combining them using a choice of software. The algorithms vary, and there are several image file formats, but all have in common the allocation of values by floating point. In other words, instead of fitting the tonal value of a pixel into one of a fixed number of levels (256 in the case of a regular 8 bits per channel image or 32,768 in the case of a 16 bits per channel image in Photoshop, which uses 15 of the bits available), each is given a numerical value in the form of a floating point number that is 32 bits long.

In the current state of digital still photography, generating a high dynamic range image usually involves combining a range of differently exposed frames.

Any of the applications shown here will create an HDR Image, but to get the best results, the exposures should be fairly well spaced, meaning between 1 and 2 EV (1 and 2 f stop) apart. Most applications now include a procedure for helping to align the images, in case of small discrepancies. There are differences in features and performance between these HDR generators, though not easy to assess from a user's point of view. Greg Ward, a major figure in the development of HDRI, introduced the reading of exposure information from the image's EXIF header, and this was later incorporated in Photoshop CS2's generator. ILM's OpenEXR differs somewhat in that it is a 16-bit half data type, and so more compact for storage, and while it can run out of dynamic range, it works for most high dynamic range scenes. For most photographic pur-

poses, any of the HDRI floating point formats are fine. JPEG-HDR has the advantage of carrying a normal 8 bit per channel image in a sub-band that can be viewed easily as a kind of tone-mapping suggestion *(see Previewing HDR Images, pages 148-149).*

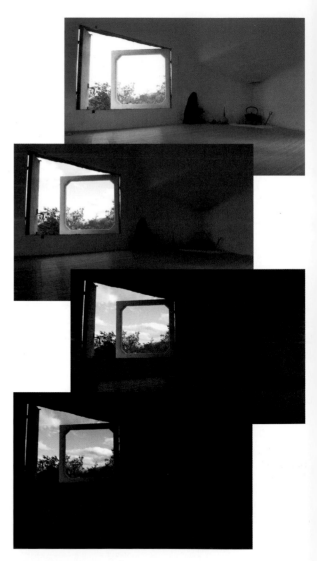

Room with a view
This sequence of images was the one fed into Photoshop's 'Exposuremerge' HDR routine (see right).

HDRI APPLICATIONS

PHOTOMATIX An HDR generator from the software company that specializes in exposure blending for photographers, with the advantage that it is easy to batch-process various methods, including LDR, on a single image for comparison *(see pages 134-135 and 150-151)*. Available for Mac or Windows.

PHOTOSPHERE Developed by Greg Ward, this generator from 2002 reads the EXIF header for exposure information, and also introduced automatic alignment and stabilization, all of these features running very fast. HDR creation features include automatic lens flare removal (when there is a substantial amount of light spill-over from bright areas) and ghost removal (when people or objects are moving in the scene and appear as ghosts in the combined result). Currently Mac only.

HDRGEN Also from Greg Ward but multi-platform, a command line program, operated by typing commands into a console window. Fast, good for people familiar with computers, but no friendly user interface.

PHOTOSHOP CS2 EXPOSURE

MERGE Photoshop's HDR generating algorithm is called 'Exposuremerge', and follows many of the Photosphere procedures, although it's not as fast. Mac or Windows.

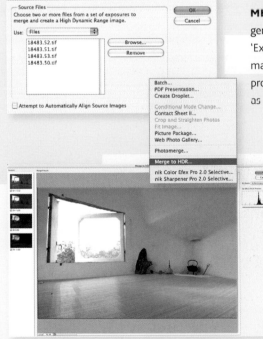

HDR SHOP Developed by Paul Debevec, this was one of the first HDR generators, available since 2000. A new version in 2004 supports OpenEXR and uses CameraRAW information. Currently Windows only.

AHDRIA/AHDRIC These are two related programs, Automatic High Dynamic Range Image Acquisition and Automatic High Dynamic Range Image Creation. AHDRIA, currently written for Canon cameras, controls multiple exposure shooting when the camera is tethered to a computer, optimizing the exposure steps. AHDRIC then generates the HDRI, and can perform the same from another existing series of images, as the other applications shown here. Currently Windows only.

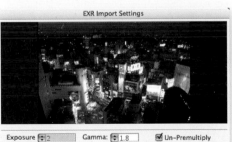

PHOTOGENICS

HDR Windows-based HDR generator (also works under Linux), with the advantage of accepting Camera RAW files.

TONE-MAPPING METHODS

Tone mapping

A strong S-curve in Photoshop, such as that used to enhance the tone-mapping example opposite.

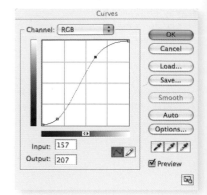

As we already noted, a 32-bit HDR format is essentially impossible to view; its value lies in the huge amount of tonal data stored. It has to be converted into a viewable low dynamic range (8-bit or 16-bit) format. There are various ways of doing this. Going from a high to a low dynamic range may sound easy. It is indeed easy if the process consists of merely scaling down the pixel values. The problem with this approach is that all pixels of the image are processed in a similar way, regardless of whether they are located in a bright or dark area of the image. It sacrifices a great deal, particularly contrast, and the opportunity to fine-tune the image. Called Highlight Compression by Photoshop, this method really misses the point and is not recommended.

The term used for the various ways of assigning each pixel to its final value in 8-bit or 16-bit form is Tone Mapping. Tone Mapping algorithms vary from a gamma curve (which is often what cameras are doing when converting 12-bit RAW data to 8-bit JPEGs) to more complex operators commonly divided into two categories: global and local. Global operators map by determining the pixel's intensity and global image characteristics, but not its spatial location.

The most important and complex decisions in HDR Imaging occur during tone mapping, and the results depend very much on the software design.

As shot

The shot sequence of five exposures, beginning with an exposure of 5 sec at f34 that reveals all the shadow detail (no shadow clipping) and ending with an exposure of 1/15 sec at f34 that holds the brightest tones (no highlight clipping).

Local operators map by taking into account the pixels' surroundings (in addition to intensity and image characteristics).

The main advantage of global operators is speed. The most useful method is the dual adjustment of Exposure and Gamma, and those applications that offer this do it in the form of sliders. It works easily, looks natural, but is not completely intuitive, usually needing trial and error with different combinations.

Local operators require longer processing times but they are better at producing a 'good-looking' photograph (the human eye adapts to contrast locally). This is the kind of tone-mapping used by Photomatix Pro, for example. Essentially, a radius around each pixel is examined and the value is determined according to the local detail (Photoshop calls it Local Adaptation for this reason, and compares it to the Shadow & Highlight tool because of its 'radius slider' method. It uses an edge-preserving blur to divide the image into regions of local brightness). The result is an image that preserves local contrast as well as details in highlights and shadows.

 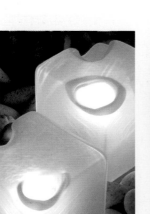 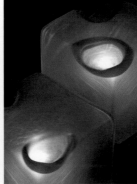

Highlight and shadow

As a control comparison, the set of five exposures was processed through Photomatix's Highlight & Shadow blending (see pages 134-135), a non-HDR technique.

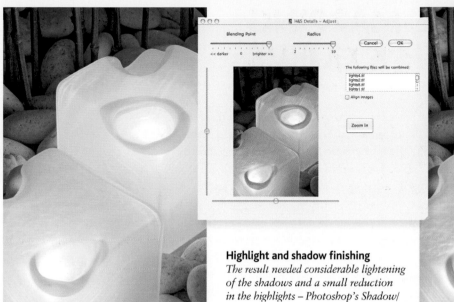

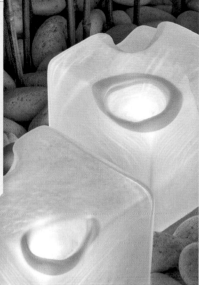

Highlight and shadow finishing

The result needed considerable lightening of the shadows and a small reduction in the highlights – Photoshop's Shadow/Highlight tool was used.

Tone mapping

Also processed through Photomatix, the same five images are first converted into a HDR file, then tone mapped. The result was felt to be lacking in contrast, and a contrast curve was applied in Photoshop.

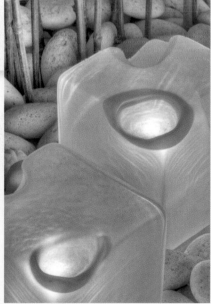

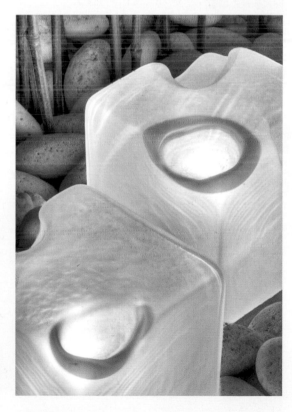

A composite result

Comparing the two quite different blends revealed pros and cons on both sides. The low dynamic range blend looks more realistic but lacks saturation and local contrast, while the HDRI has plenty of saturation and contrast but has a rather artificial appearance. Copying the HDRI version onto the LDR blend at a 50% opacity retains the best of both.

TONE-MAPPING WITH A CURVE

As we've seen, tone mapping that takes into account local contrast is for most situations the method of choice, but it brings its own working difficulties, principally that the previewing method cannot exactly match the final result; the radius-searching method depends on the number of pixels, so the size of the image has an effect and the preview is much smaller than the final.

Photoshop's Local Contrast conversion tool from 32-bit allows a curve to be manipulated in relation to the histogram, and offers a valuable, distinct way of working.

As most digital photographers are by now familiar with Curves adjustments, using a curve is quite intuitive, and is offered under the Local Adaptation option in Photoshop CS2. This toning algorithm uses a curve (contour) to control how it maps the brightness areas into the final image. It has the advantage that the superimposed histogram gives a visual guide to the different parts of the image, and so you can easily predict the effect of moving parts of the curve.

Local Adaptation starting position
Using the curve/contour control, click on key areas of the image to identify where they lie on the histogram. From left to right, the highlighted areas are the bulk of the black candles (not the absolute darkest shadows), the grey background, and, at the far right, the lamp highlights.

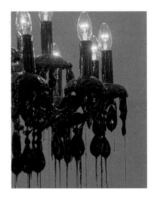
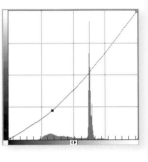

First curve adjustment
Using the above information, the first control point on the curve is dragged above the main shadow area, and downwards to hold the blacks firm and rich.

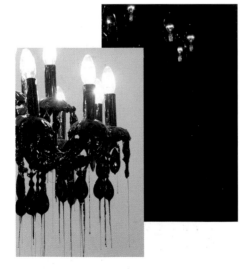
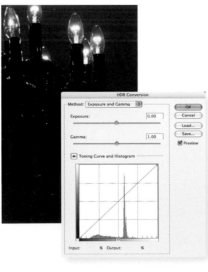

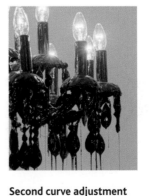

Original images
A sequence of six shots at a constant f5.6 aperture, from 1/500 sec to 1/6 sec at intervals of 1 1/3 stops.

Starting position
Opening the HDR image generated from the six originals in Photoshop, the tone-mapping dialog appears when 8-bit or 16-bit Mode is selected under the Image menu.

Second curve adjustment
Next, another control point is dragged to the mid-tone spike on the histogram (conveniently represented by the grey background) and upwards to lighten it to taste.

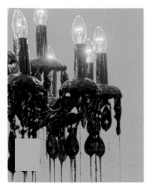
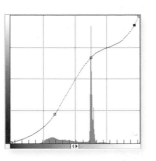

Third curve adjustment

The third control point is set to take care of the very brightest highlights in the lamps, darkening them to reveal more detail of the filaments. However, the next-brightest parts of the lamps appear strangely flat.

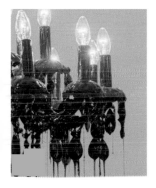
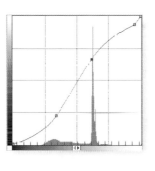

Final curve adjustment

The last problem is taken care of by turning the third, uppermost control point into what Photoshop call a 'corner'. This effectively makes the top of a section of curve, so that it doesn't drag the part below it. We now have two curves – the lower, a contrast enhancing curve, the upper a straight line holding the highlights in position.

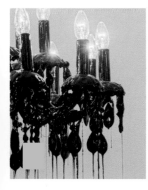
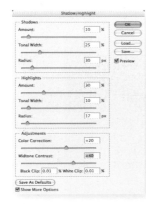

Mid-tone contrast

Final tweaking of the image involves moderate settings of the Shadow/Highlight tool, mainly aimed at increasing contrast broadly in the middle tones.

REJECTED METHODS

There are several alternatives to the Curves method opposite. Clockwise from the top left; adjusting the exposure, adjusting the gamma, adjusting both exposure and gamma, and finally the very bright Equalize Histogram option. The latter is a no-control algorithm with attempts to preserve contrast at the expense of highlights.

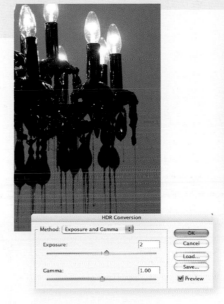

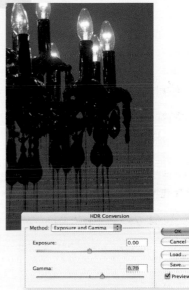

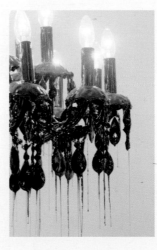

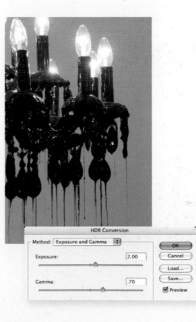

TONE-MAPPING WITH A CURVE

RESTAURANT

The subject here is a highly designed Japanese restaurant in Bangkok, the central feature of which is a huge laminated wave, spot-lit in overall subdued lighting. The aim was to keep the original lighting effect, and so not add photographic lights. The work shown here is on one section of what was ultimately a stitched panorama. For comparison with the HDR curve-controlled tone mapping, we also show the results of regular exposure blending in low dynamic range using Photomatix.

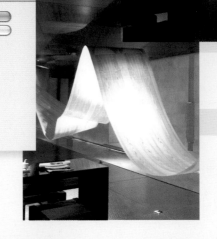

As shot
A pair of images were shot for each frame of the stitch, one at 1.6 sec, the other at 8 sec: 2 1/2 stops apart. The HDR 32-bit-per-channel image is then generated.

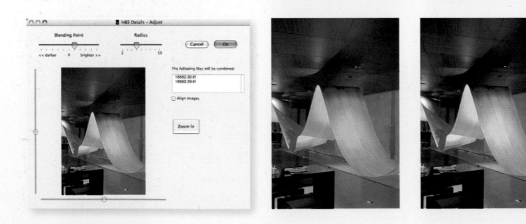

Photomatix Auto
Automatic exposure blending in Photomatix using the two 16-bit files (see pages 134-135).

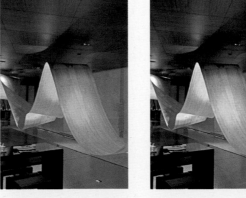

Photomatix Adjust
The Adjust method allows more control, in this case used to control the bright highlights on the underside of the 'wave' at left.

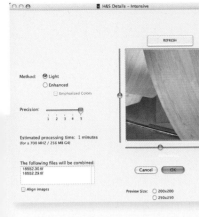

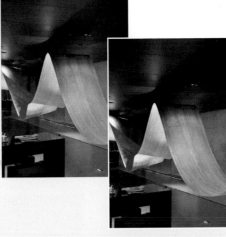

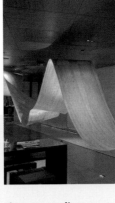

Photomatix Intensive
A third blending alternative takes longer but produces a smoother treatment of the spotlighting.

First curve adjustment
The first control point is added and dragged down to establish the shadow areas.

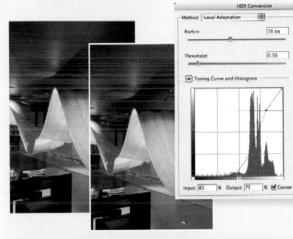

Final curve adjustment
Turning this second control point into a 'corner' effectively straightens the upper section, and this linear treatment mainly affects the main spot-lit area in the nearest surface if the 'wave', darkening it slightly and increasing its saturation usefully.

Local Adaptation starting position
The initial view in Photoshop's Local Adaptation.

Final Image

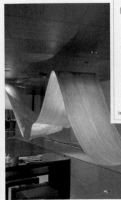

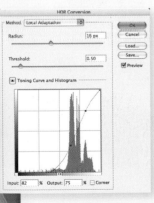

Second curve adjustment
Next, the mid-highlights are brightened with a second control point.

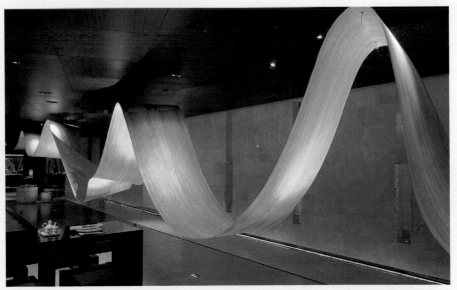

ADVANCED HDR CURVE ADJUSTMENT

Scenes with a high dynamic range often contain zones that need separate attention, which can be handled in a single curve, using special techniques.

I n a way, all Curves adjustments are advanced, certainly when compared to those performed normally on 8-bit and 16-bit images. As we saw on pages 126-129, two control points will take care of most normal adjustments (even though Photoshop allows up to 14). With a 32-bit HDR image, however, the much greater dynamic range, and the fact that if you are using it in the first place probably means the image contains a difficult distribution of tones, making a complex curve more necessary.

In a typical HDR situation, there is more than one 'zone' – by this, I mean a specific tonal range *within* the total image. For instance, in an interior looking out through a window into sunlight, the interior comprises one zone, and the exterior view another. Many of the problems in making a realistic conversion of an HDR image into 16-bit or 8-bit stem from trying to map these together. However, there is a twofold way of managing this, using Curves. The first step is to identify the zones from the histogram, the second is to subdivide the curve using the Corner option in Photoshop's Local Adaptation HDR conversion. Making a control point into a Corner creates a sharp break between sections of the curve so that you can, in effect, make an independent curve from each section. This is easiest to appreciate in a worked-through example, as here. In this image of downtown Shanghai, the bright neon signs constitute one zone, the night sky and deep shadows in the buildings a second, with the leftover mid-tones as a third. The plan is threefold: to keep the neon displays bright while maintaining full colour saturation, to have strong, dark shadows while holding a separation between the darkest parts of the buildings and the sky, and to add contrast to the mid-tones. The final curve is therefore in three sections, from bottom to top as follows: dark, contrasty for the shadows, a contrast-increasing curve for the mid-tones, and bright for the highlights. For comparison, see what happens when we remove the Corner option for the two control points – both the neon displays and the shadow areas become flatter, and perhaps even more important, the mid-tones merge into these two other zones in an unrealistic way. The conclusion: using Corners sharpens the separation between distinct areas of an image.

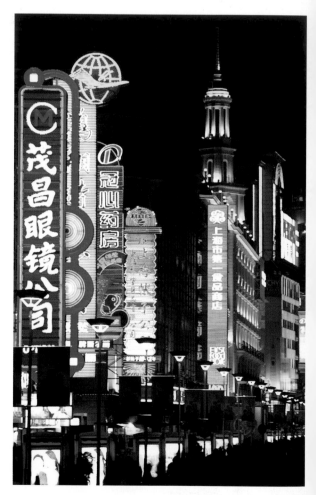

As shot
This is the initial appearance of the shot, of a well-known Shanghai shopping street, as a 32-bit HDR image opened in Photoshop (previews, as we saw earlier, vary according to the software).

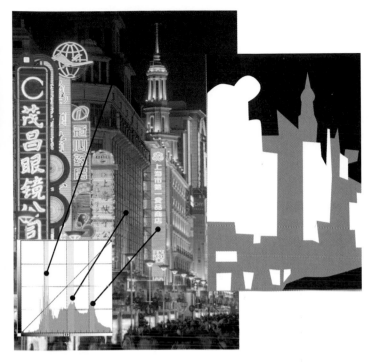

Identifying tones on the histogram

Choosing Local Adaptation from Photoshop's tone-mapping options, the image preview becomes quite artificial, with oversaturated colours and a sharp drop in contrast. Clicking the cursor on different parts of the image identifies where these fall on the curve – and so on the adjacent areas of the histogram. Here, three peaks can be matched to display highlights, midtones and deep shadows. For clarity, the diagram blocks these areas out.

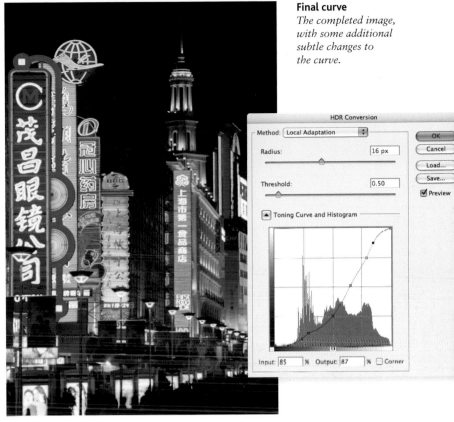

Final curve

The completed image, with some additional subtle changes to the curve.

Final Image

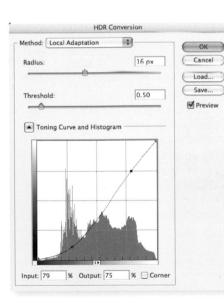

Basic curve

First, the curve is manipulated to give the effect described in the text.

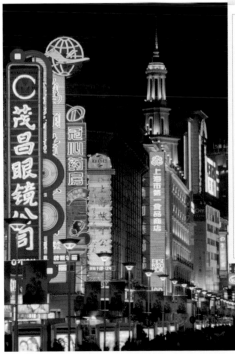

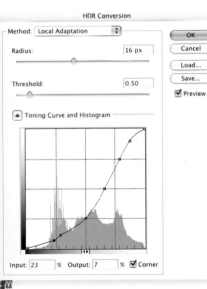

Curve without corners

For comparison only, this is what happens when the 'corner' option is unchecked. The entire curve is now unconstrained, with unwanted effects.

PREVIEWING HDR IMAGES

It's well beyond the ability of an 8-bit monitor to display 32-bit images fully, but there are previewing alternatives for working with these high-end files.

To state the obvious – yet a point that regularly causes conceptual confusion – the full range of an HDR image is impossible to see. No medium and no technology currently comes anywhere near the ability of the human eye to appreciate a high-contrast scene. As monitor displays are the medium for working with these images, and most are 8-bit, a newly created, 32-bit HDR image is unviewable in any meaningful way. This is hardly surprising, and in any case the HDR image file is really just a way-station in the process of creating the final tone-mapped 8-bit or 16-bit image. However, this inability to see in advance what an HDR image is fully capable of is definitely an obstacle, quite apart from the need to have at least a thumbnail or small reference image for browsing or in a database.

To dismiss one possibility right at the start, there are 14-bit monitors available and, while these have a substantially greater dynamic range than the usual 200-300:1, they do next to nothing for viewing a widely scaled 32-bit image. And they are much more expensive; valuable, certainly, for working at a high level of accuracy with images intended for repro, but not at this intermediate stage. All the solutions lie in making some sort of automated 8-bit interpretation, none of them completely satisfactory. Ultimately, viewing an HDR image involves some imagination – and a direct memory of how the scene actually looked to the eye. This may sound unsatisfactorily vague, but working with HDRI is not a mechanical process. Far from it; it involves interpretation and judgement every time, and it's unlikely that any two people will make the same final image from one HDR file.

The most accurate and arguably most useful, though maybe least intuitive, display is that adopted by Photomatix. Its main window shows the actual full range, which in the case of a fully scaled image is almost unrecognizably high-contrast, as in the example here. However, a small, floating second window displays the optimized view of a small area under the cursor. The idea is to move the cursor over the image in the main window and build up a mental image of the full range. For accurate tone-mapping, this close examination of the full dynamic range, detail by detail, is unbeatable.

Other applications attempt, with greater or lesser success, to present a recognizable low-dynamic range version. Some, like Photosphere, do this through a choice of pre-set, rough-and-ready tone-mapping versions; others, such as OpenEXR Viewer, offer an accompanying set of sliders to adjust the view. Photosphere deserves special mention as a cataloguing tool that handles HDR images easily, by means of generating a quick JPEG thumbnail.

BRIDGE

Like many basic browsers, Adobe's Bridge has no algorithms for presenting HDR thumbnails in a meaningful way.

PHOTOMATIX

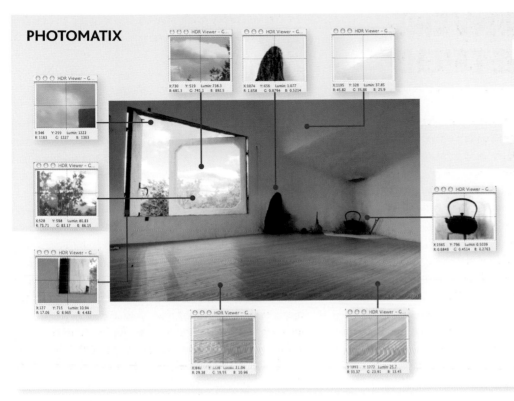

Photomatix software offers the extremely useful facility of a small window that shows the optimized tones directly under the cursor. For this demonstration, several of these are shown here, although as you work there is just one.

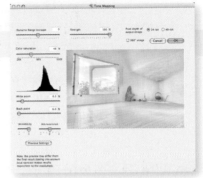

When it comes to tone mapping, Photomatix displays an approximate preview of the final effect, with the accompanying warning that this may not be exact because the process is resolution-dependent.

PHOTOSPHERE

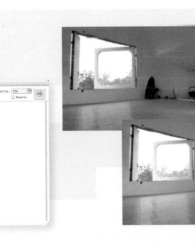

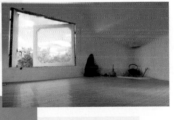

Previews
Photosphere offers four slightly different previews: without settings, auto, local and human.

Catalogue

A powerful cataloguing application for HDR images (it also includes a fast, sophisticated HDR generator, see pages 138-139), Photosphere takes a hands-off approach to viewing images, using a thumbnail cache. By incorporating a fast tone-mapping operator, which can optionally simulate human visual sensitivity, it is able to display 8 bit per channel JPEG recognizable versions for browsing purposes.

ILM VIEWER

ILM's viewer for its open-source OpenEXR software is relatively large on-screen, and accurate to the final result.

CHOOSING THE MERGING METHOD

With the several distinctly different methods of merging a set of different exposures, each of them valid, it's important to develop a logic for choosing which to use. Here opinions vary. Clearly, however, the higher the dynamic range, the stronger the case for going to true HDR imaging and converting to one of the HDRI file formats such as Radiance or EXR.

Because of the inherent unpredictability, and the range of methods available, each high dynamic range image needs to be treated on its own merits.

There's a sound argument for choosing according to the extremity of the dynamic range; in other words, maintaining two or a few procedures and applying them according to what you judge the image needs. So, for example, a scene with a dynamic range that is around two ƒ stops greater than can be captured in a single exposure would need just two shots to cover, and an automated blending procedure such as that used by Photomatix would be perfectly capable of making the combination. The impact on workflow is a very important consideration, and even if you think that going through the HDR process might yield a more accurate result, it may save time at no cost to quality to batch process pairs of images and then make moderate brightness and contrast adjustments in Photoshop afterwards (and these, too, can be automated as a batch process). For the finicky, doing all of this in 16-bit prevents any significant data loss.

Another factor is the less predictable matter of final image appearance. HDRI has the ability to pull out more colour saturation if used carefully, but against this is the possibility of a more artificial appearance.

Photomatix make a sensible, if rather time-consuming, recommendation to establish the best workflow. Because this depends on the dynamic range of the scene, the characteristics of the differently exposed images and the effect you want to achieve, they suggest systematically trying both HDRI and the range of blending methods by means of batch processing. You then open all the results in Photoshop and choose on a case by case basis.

HDR TONE MAPPING VERSUS EXPOSURE BLENDING

HDR Tone Mapping	Exposure Blending
Pros	*Pros*
Able to maintain local contrast even when dynamic range is particularly high	Blending the images has the effect of reducing noise
	Resulting images have a 'natural' look
Does not show halo artifacts around strong luminosity edges	Easy-to-understand process, no or few parameter settings
Enhances local details in shadows and highlights	
Cons	*Cons*
If camera is prone to noise, requires input images covering the whole dynamic range of the scene	Lack of local contrast when dynamic range is high, 'flat-looking' results in some cases
Preview is not always an accurate representation of final result	Trade-off between local details and halo artifacts with high-contrast scenes

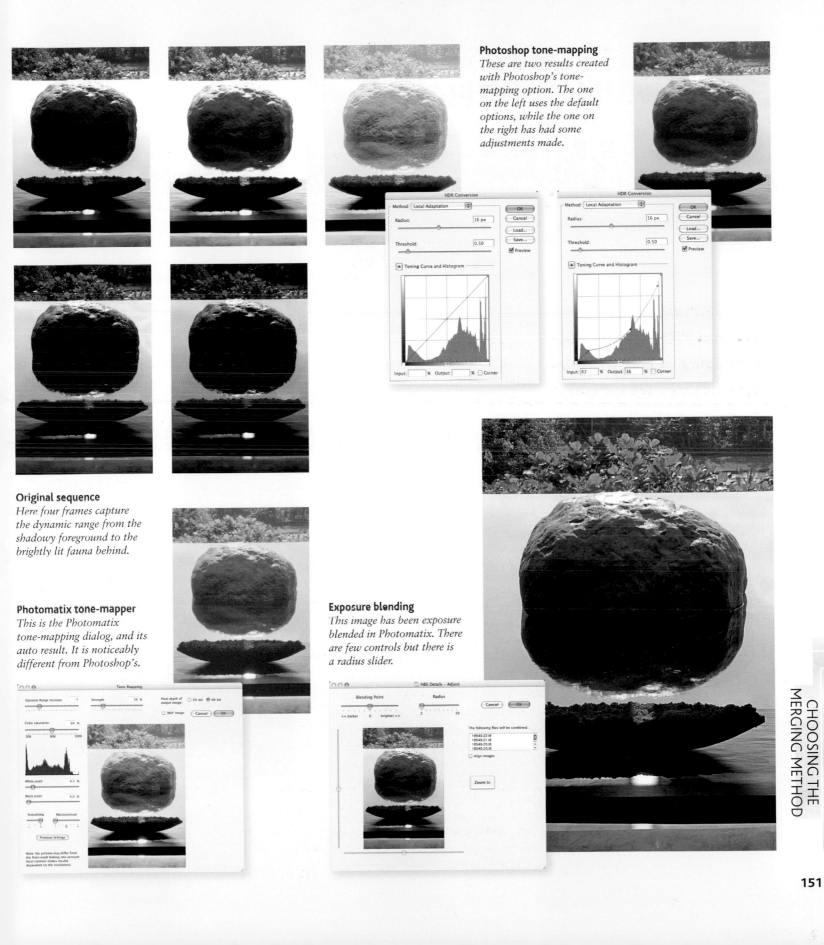

Photoshop tone-mapping

These are two results created with Photoshop's tone-mapping option. The one on the left uses the default options, while the one on the right has had some adjustments made.

Original sequence

Here four frames capture the dynamic range from the shadowy foreground to the brightly lit fauna behind.

Photomatix tone-mapper

This is the Photomatix tone-mapping dialog, and its auto result. It is noticeably different from Photoshop's.

Exposure blending

This image has been exposure blended in Photomatix. There are few controls but there is a radius slider.

TIME-LAPSE DAYLIGHT

An alternative use of high dynamic range techniques is to take the best lighting features from different times of day. There are practical limits to this, because the camera cannot be moved between shots, and so the practical applications are somewhat limited. It is, however, ideal for the situation shown here: the period around sunset. As with the usual bracketed exposures, the camera has to be locked down to guarantee perfect register, but because of the time lapse involved, rather more care needs to be taken in securing and protecting the tripod. Make sure that it is very firmly seated in place, particularly if there is any uncertainty about the ground (for instance, stony, or on grass). Consider weighting it for extra stability, and preventing accidental knocks by surrounding it with cases and other bits of equipment. Also, because the light will change, you should anticipate as much as possible the effect that this might have on the composition. Then check the scene for likely movement within it. The sky is an obvious candidate, but in practice clouds in different formations from frame to frame tend to blend successfully without being obvious, because they are usually fairly amorphous in shape. Movement of the air is always likely, and this will move light vegetation such as grass and leaves (as it does in normal bracketed exposures), while some plants may droop or strengthen naturally. This is more difficult to manage than blending images taken under identical lighting, and you can expect to do some detailed retouching.

Using the same range of blending techniques, it is possible to combine identical frames shot at different times of day for an optimal lighting effect.

The example opposite is a classic use of the technique, and a solution to the problem of combining a sunset sky and silhouetted outline to the buildings with the domestic tungsten lighting. The house, on a Balinese hillside overlooking a valley, had been designed to be partly surrounded by water bodies, and this view from the entrance path makes strong use of a reflecting pool. The specific problem was that the open structure of the living area made the interior tungsten lighting particularly important to capture, yet this was relatively weak. The time at which the balance of light would favour this would be well past the ideal time for a silhouette against twilight colours. An additional problem was that the foreground edge of the pond would be featureless, and while this did not matter for the boulders at right, it would leave an unsatisfactorily heavy mass at left.

So, the first frame was shot 10 minutes before sunset, the timing determined by the light on the clouds close to the horizon. If the sky had been completely clear, this might have been at about 10 minutes after. For safety, the shot was bracketed so that one exposure held all the highlights (that is, in the sky) while the other revealed full shadow detail (2 *f*stops more). In the event, only the first was used for blending, as it was later decided that just a hint of foreground shadow detail would be more realistic, and a moderate adjustment in the Shadow/Highlight dialog achieved this. The second frame was shot half an hour later.

As explained on the previous pages, the exact blending effect is difficult to predict, and in any case I wanted to see a variety of treatments. The two images were thus batch-processed through the range of Photomatix methods, including HDRI tone mapping. In the end, the version chosen was the Photomatix-generated HDRI, but the Photoshop layers method offered alternatives. The choice was subjective.

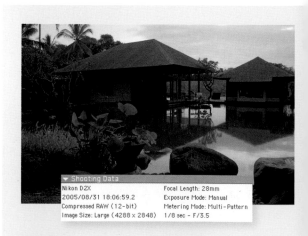

Pre-sunset
The first shot, with the camera locked down on the tripod, was taken shortly after 1800 hours. The EXIF data records the exposure, and this will be accessed by the blending software later.

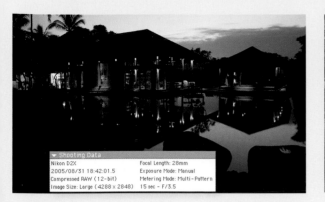

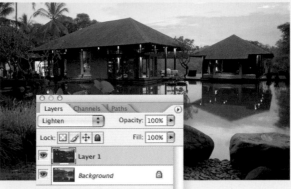

Lighten blending
In this layer method, also at 100%, the upper layer is set to Lighten mode to better preserve the sunset colours.

Post-sunset
The second frame, without moving the camera or altering the aperture, was taken at 1840.

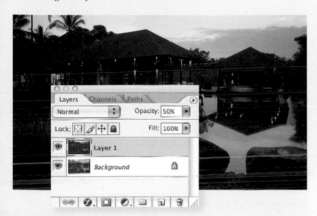

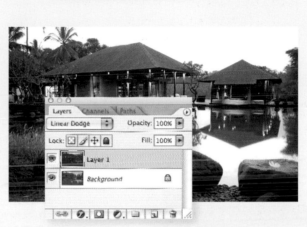

Linear Dodge blending
Another layer alternative, using Linear Dodge mode. This gives good contrast to the foreground, but the sky is washed out.

Layer blending
The do-it-yourself version involves pasting one frame over the other. The simplest method is to set the opacity of the upper layer to a percentage – here 50%. The result is rather dull and flat, though this could be improved later with a contrast curve on the flattened image.

Photomatix Average
One of the four Photomatix blending options – somewhat flat.

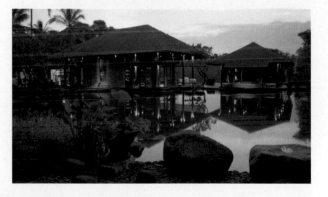

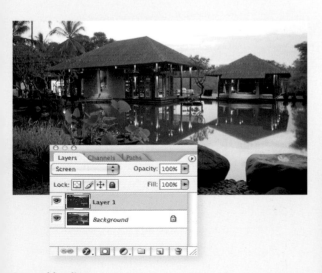

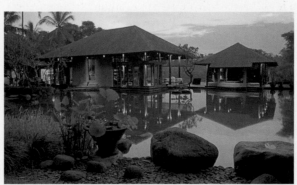

Photomatix Auto
A more successful alternative.

Screen blending
Another layer method is at 100% but with the upper layer set to Screen mode.

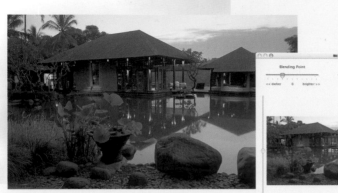

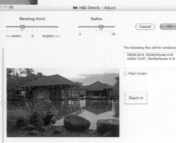

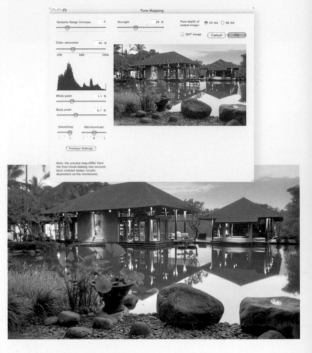

Photomatix Adjust
Adjust allows some user control.

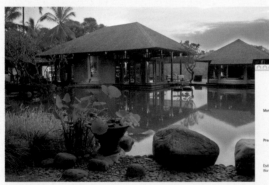

Photomatix tone mapping
The sequence for mapping the HDR file back to a low dynamic range image delivers a much more vibrant image overall.

Photomatix Intensive
In this case, Intensive leaves unsightly halo effects at the edges between dark and light areas.

Photomatix HDR generation
The sequence for creating a 32-bit HDR image in Photomatix. The preview appears contrasty, but the small adjacent window shows the optimized appearance in small areas under the cursor.

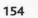

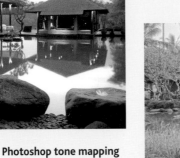

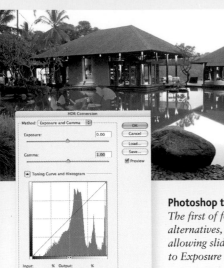

Photoshop tone mapping
The first of four Photoshop alternatives, this one allowing slider adjustments to Exposure and Gamma.

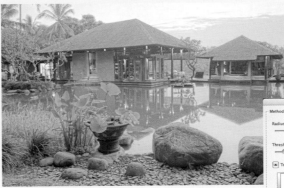

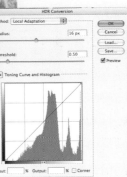

Photoshop Local Adaptation
The most controllable option, but shown here as it appears initially, oversaturated and strangely flat.

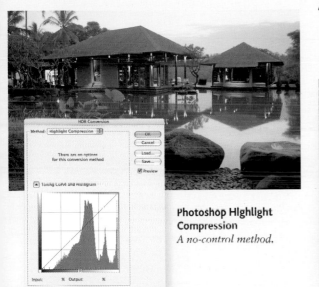

Photoshop Highlight Compression
A no-control method.

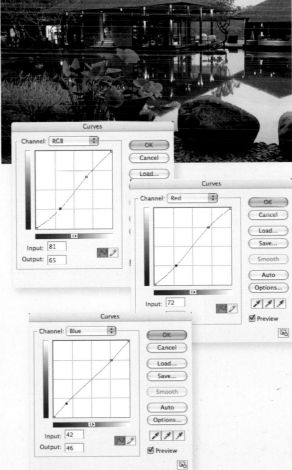

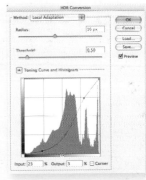

Local Adaptation with curves
The curve is first adjusted for increased contrast, making sure that the dusk shadows are appropriately deep. Then, after converting to a 16-bit image, the colours are given small adjustments as necessary – using the normal Curves dialog.

Photoshop Equalize Histogram
Another no-control method, with more contrast and saturation.

MULTIPLE LAYERED LIGHTING

A natural extension of the multi-exposure approach to dealing with a high dynamic range is to shoot a variety of lighting on the same scene for later combination. There are three principal reasons for this approach. One is when you have too few lights available, or when some other technical factor makes it impossible to use all the lights at the same time (for instance, if there is a danger of overloading the circuitry, if there are too few power points, or insufficient length of extension cable). Another is uncertainty over the final effect that you will want, not necessarily because of indecision (there may be a client who wants to make an input in deciding the final image, but later). Third, this technique allows you to exercise total fine control, by allowing the strength of lights to be combined to any degree, and over any part of the image. For instance, one light may be aimed at the entire scene, yet in post-production, using layers and an eraser, it can be turned into a precisely controlled spot effect, lighting certain surfaces only. The technique can, of course, become very time-consuming, but it may be worth it, and the actual photography should not take up more time than a normal, multiple-light setup.

With a fixed camera position to allow perfect register, place lights for separate shots that are composited later.

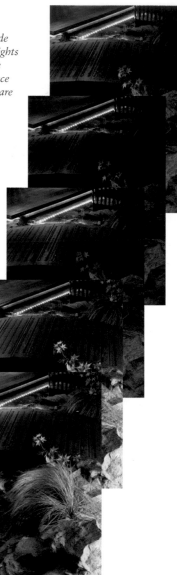

Interior garden
Before shooting, look at the lighting and decide which of the different lights you will need to expose for, then shoot a sequence accordingly. Here there are four distinct lighting areas in view.

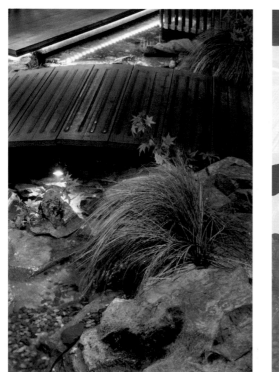

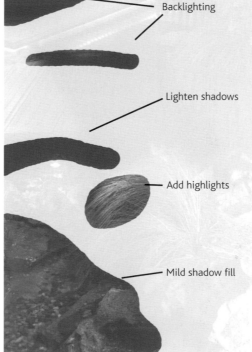

Backlighting

Lighten shadows

Add highlights

Mild shadow fill

HOTEL ROOM

 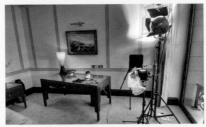 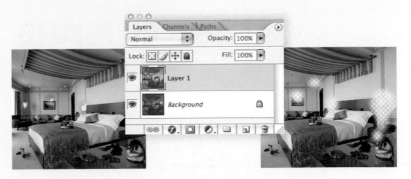

Starting frame
In this first exposure, there are no visible artificial or photographic lights. Instead, there is mainly natural daylight diffused through the net curtains at the window. Foreground shadows are filled with a 2000W blonde covered with a full blue gel and bounced off the wall behind the camera.

Layer compositing
The first compositing step is to layer the daylight frame over the frame that has the room lamps. These are rather too intense, so the upper layer is partially and selectively erased to reveal some, but not all of their light.

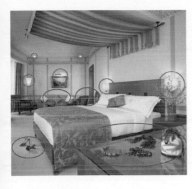 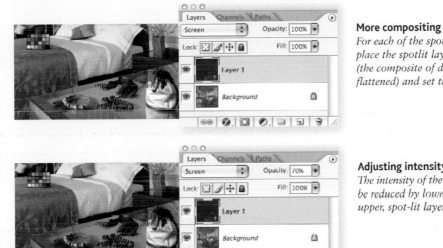 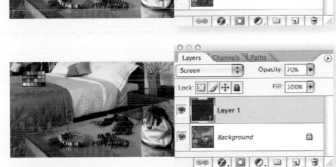

More compositing
For each of the spots, the technique is to place the spotlit layer over the base layer (the composite of daylight and room lights, flattened) and set the mode to Screen.

Lighting plan
This diagram illustrates the plan for combining the various lights that will be used – a combination of room lighting and a spot placed in various positions.

Adjusting intensity
The intensity of the spotlit effect can then be reduced by lowering the opacity of the upper, spot-lit layer – here to 70%.

 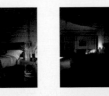 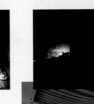

Final composite
With all layers composited in the above way, there is total control over the final image.

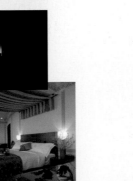 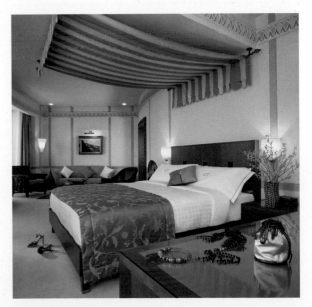

Separate light frames
With the camera locked down and aperture unchanged, a sequence of frames is shot using different lights, beginning with the room's own lamps. Note that the spots are used with curtains fully drawn.

DIGITAL FLARE CONTROL

Flare in non-image-forming light takes several forms. There are the polygonal flare patterns that are created by internal aperture reflections and refractions from a point source of light (such as the sun) that is either just inside or just outside the picture frame. There is the general degradation of contrast and shadow tones caused by large bright areas surrounding the image frame (such as a white studio background or a snow-covered sunlit landscape). There is also the diffusion effect surrounding bright areas in an image that has a high dynamic range.

Flare is neither inherently bad nor good, and digital techniques allow photographers the choice of both reducing and enhancing its effects.

Usually, these tend to be avoided as a lighting fault, and technically they do detract from the image, but there are compelling reasons for wanting some of their effect in an image. Flare adds atmosphere of a kind, and also a sense of actuality. Certainly, for strongly manipulated and special-effects imagery, adding flare can be a useful way of helping to convince the viewer that the scene is genuine.

The first place for controlling flare is during shooting – lens shades and flags help to reduce it, while filters and smeared glass over the lens can enhance it. Here, however, we look at the digital post-production techniques, and the two examples here illustrate reduction and enhancement. HDR images are prone to flare effects simply because of the range, and the problem occurs where there are sharp edges between bright highlights and deep shadows. Some HDR generators, such as Photosphere, incorporate flare removal. Alternatively, there are sometimes reasons for wanting flare artifacts, thus introducing them.

INTRODUCING DIGITAL FLARE

As this swimming pool scene demonstrates, there may be occasions for introducing flare effects for reasons of 'actuality', deliberately exploiting the artefacts. The starting point was a clean shot in which flare had been avoided by using a lens hood, but later there was a need for a treatment that conveyed the intensity of the sun and general feeling of heat. The software used was the Knoll Light factory plug-in for Photoshop.

In the Lens Editor dialog, various optical flare elements can be imported, and each adjusted with up to 10 parameter sliders. In this case, six likely elements have been imported, and from these three used – PolySpread for the polygonal aperture patterns, with StarFilter and PolySpikeBall superimposed for the light source.

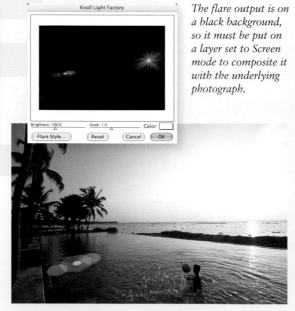

The flare output is on a black background, so it must be put on a layer set to Screen mode to composite it with the underlying photograph.

Keeping the generated flare on a separate layer also makes it easy to align with the sun and the rest of the scene. Here the layer is rotated to position the polygonal patterns in the lower left shadow area.

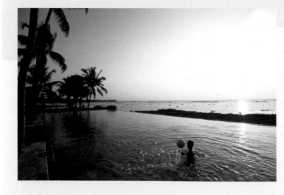

The clean original, without flare.

FLARE REDUCTION

In the well-exposed frames of a sequence shot for HDR, there will be flare at the junction of light sources and dark edges, as in this example, shot in a modern tea-ceremony room in Japan. HDR generators can sometimes deal with this automatically, but often manual correction is needed.

Second curve
A second treatment of the HDR image, applying a tone-mapping curve that deals correctly with the light source and flare.

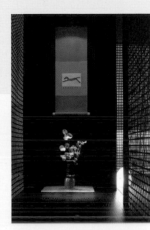

Layered tone-maps
The first tone-mapped version is pasted as a layer over the second, darker version, using Multiply mode.

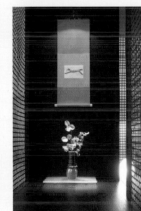

Erasing
All except the flare-free area immediately surrounding the light is manually erased from the background layer with a soft brush.

The sequence of four originals. Flare is obvious on the last frame.

The final image
Procedural techniques are always more elegant, but sometimes images need manual help in post-production.

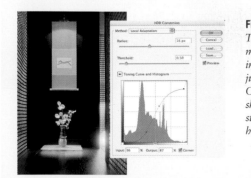

First curve
The tone-mapping curve in Photoshop judged best. Opening up the shadows creates strong flare, however.

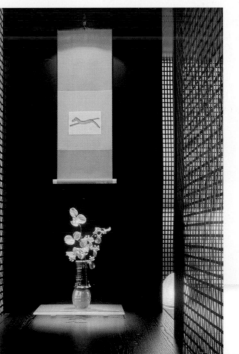

DIGITAL FOG

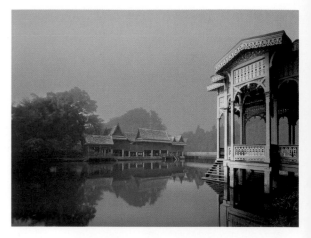

Atmospheric effects, meaning versions of haze, mist, smoke and fog, are in principle reasonably straightforward to add to images digitally, the reason being that they all create degradation of detail, tone, and colour rather than enhancement. In other words, it is always easier to remove information than to create it artificially.

By constructing a depth (or z-) map for an already-shot image, convincing interactive atmospheric effects can be added to a scene.

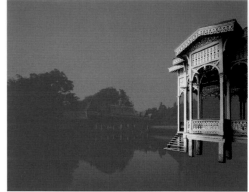

Pavilion mask
The most complex mask is that of the near pavilion, and this is created using Paths in Photoshop.

Planning

The first step is to construct a plan, though not normally as precise as this diagram. There is a break in distance formed by the row of trees and pavilions in the centre. Beyond this there would realistically be a constant density of fog; this is zone one. From the foreground towards the distance, the fog should increase on a vertical gradient; this is zone two. The water close to the foreground, however, will reflect some of this added fog, even though the fog over it will be minimal; this, zone three, will need a reverse gradient. Finally, the pavilion at right (zone four) projects through the other zones, and has its own direction of gradient.

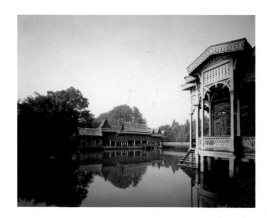

Bangkok pavilion
The original chosen for this experiment is of teak pavilions at one of the royal palaces in Bangkok. The fog/mist will have to be added progressively from a clear foreground towards the distance. The pavilion at right and the water surface will complicate this.

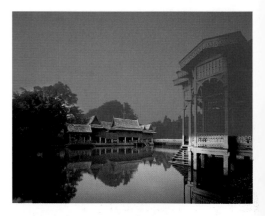

Sky mask
A second selection, made partly in Paths, and partly brushed, defines the upper distance.

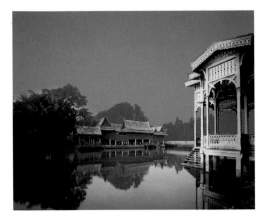

Merged zone 1
Intersecting the two masks creates a third, which is the final for zone 1.

Layers of fog
The process continues, with the remaining three masks constructed from the first. Each of these is then filled as a separate layer.

Combined fog
The four layers are then combined into one. Note that at this stage, the combined fog effect in a single layer could be saved as a selection – an Alpha channel – for further use and adjustment.

The colour of fog
A bluish colour is chosen for fog. The deep colour is not the colour you expect to see in the finished image, but a colour to represent fog. It will be blended to reach a suitable final tone.

Balancing the layers
With the background layer made invisible, the saturation and lightness of the four fog layers are individually adjusted so that they are in realistic proportion to each other. An alternative would be to adjust the opacity of each layer.

Finishing touches
An overall adjustment is then made to the combined fog layer, desaturating it. Opacity changes could also be made if necessary (to increase, a duplicate layer could be made, though unnecessary here).

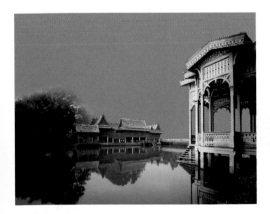

Filling in the fog
This is then used to fill the selection in a separate layer. At this stage, the fill density is left at 100%.

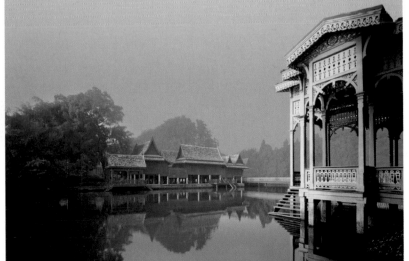

The final fog effect.

SYNTHETIC SUNLIGHT

As mentioned on the previous pages, degrading tones and detail is relatively uncomplicated, the main issue making the correct selection of zones in the image. More or less the opposite is to add the brightening and detail-enhancing effect of sunlight. This is difficult to achieve realistically, yet there are many occasions for which there is a real demand for it. The problems are formidable, and the expected adjustments to saturation, contrast, and brightness are only the beginning. Many of the effects really need to be applied to local detail, which suggests algorithms similar in principle to those used for tone-mapping HDR images. Moreover, the tonal and colour relationships between the ground and the sky are quite different for a sunny than to those for an overcast one. Finally, sunlight casts sharp shadows at all levels of scale, and introducing these could involve an unrealistic amount of time.

Sophisticated light-casting algorithms make it possible to simulate direct sunlight artificially in a scene that has been shot in cloudy or diffuse lighting.

Unusually, there is still only one filter specifically designed to do most of this – the Sunlight filter from nikMultimedia. It works best, as you might imagine, in converting weak or hazy sunlight into a brighter, sharper version, but it can also, with extra work, produce something resembling sunlit effects from an overcast day, as in this example. Usefully, there is a real sunlit version here for comparison, as I returned on another day when the weather had improved. The direct comparison may be a little unfair, because the filter can only do the best job possible under the circumstances. The proprietary algorithms include a pre-filter and several light-casting ones for different interpretations and degrees of sunlight. For this experiment, I've used two of the pre-set light-casting algorithms available. Note that the sky is a relatively easy fix – turning it blue has a psychological effect. Adding key shadows by hand, but ignoring the fine detail, is another piece of perceptual assistance.

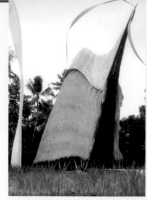

Algorithm A
Using light-casting algorithm A, which is the strongest choice offered, creates a strongly saturated result, with blue added to the sky.

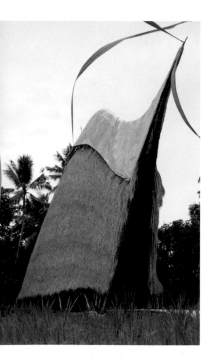

Original
The original, shot in unpromisingly overcast conditions.

Algorithm B
Another light-casting algorithm, B, is milder and more realistic, but further from 'sunlight'. A split-screen can be used to compare the before and after effects.

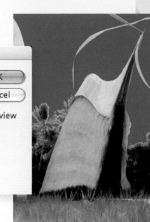

Photo Filter

Use
● Filter: Cooling Filter (82)
○ Color:

Density: 25 %

☑ Preserve Luminosity

OK
Cancel
☑ Preview

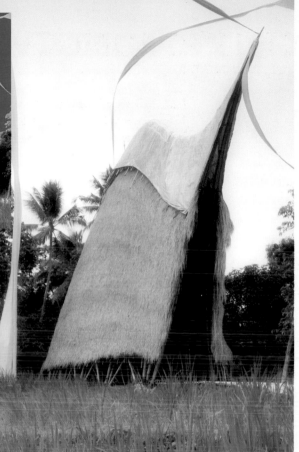

Building on B
The second, milder effect is then enhanced by adding blue to the sky by means of a selection.

Working with A
An alternative, working on the first, stronger version, is to weaken the strong orange of the palm-thatched building, and then add, by hand, key shadows on its surface.

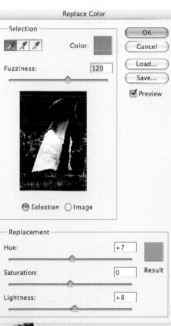

Replace Color

Selection

Color:

Fuzziness: 120

OK
Cancel
Load...
Save...
☑ Preview

○ Selection ○ Image

Replacement

Hue: +7
Saturation: 0
Lightness: +8

Result

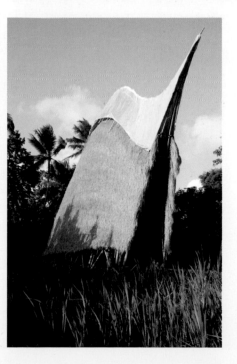

Real sunlight
For comparison, this is the same scene photographed under real late-afternoon sunshine, at the same time of day as the overcast version.

LIGHTING FOR QTVR

QuickTime Virtual Reality (QTVR) movies are an established and very specific form of digital photography, presented mainly on websites. The procedure involves shooting a sequence of overlapping frames as the camera is rotated in a full circle, using a special panning head that allows it to be positioned so that it rotates exactly around the nodal point of the lens (to avoid parallax misalignments). The sequence is then stitched together digitally, with a wide choice of software available, and then output in the QTVR format so that viewers can interactively pan around and zoom into the scene, using the cursor in a viewer window. Here is definitely not the place to go into production details, which are well beyond the scope of this book. That said, lighting needs particular care and attention. Scenes vary widely, of course, but the common denominator is that they cover the full surround, making it difficult to avoid areas with difficult lighting.

Probably the most frequent lighting issue is that light sources are often included in shot. This can make for a very high range of contrast across the 360º, and many QTVR images qualify as HDR (High Dynamic Range). This does not necessarily mean that the shots have to be treated with HDRI procedure (see pages 136-151), although this is one possibility. An alternative is to position the camera so that a main light source, such as the sun, is obscured. Another is to reduce exposure carefully and incrementally as the sequence

360-degree panoramas bring total coverage of a scene, but include light sources in view and sometimes conflicting colour temperature.

swings towards the light source. This runs counter to the usual advice given for stitcher software, which tends to recommend an unchanging exposure for all the frames, but it often works. Much depends on the equalization procedures used by the application, so you would need to experiment with this.

Another possible problem for which the software instructions are frequently unhelpful is a change of colour temperature around the whole scene, which might move from 3200 K incandescent to 5200 K sunlight. Choosing one white-balance setting for all the images guarantees stitching success, but the result can be unacceptable combinations of colour temperature, which are difficult to remove in post-production (such as by using the Replace Color command in Photoshop). In reality, as shown here, most stitcher software can

cope successfully with a white-balance setting that changes from frame to frame. An Auto white-balance setting often works well.

The most painstaking procedure of all is to introduce lighting that moves with each frame. A light mounted on the camera has limited use because it creates a flat effect (much like a flash in a compact camera) but a light placed behind and to one side can help fill shadows all the way round – but it needs to be moved in tandem with the camera pan, a frame at a time.

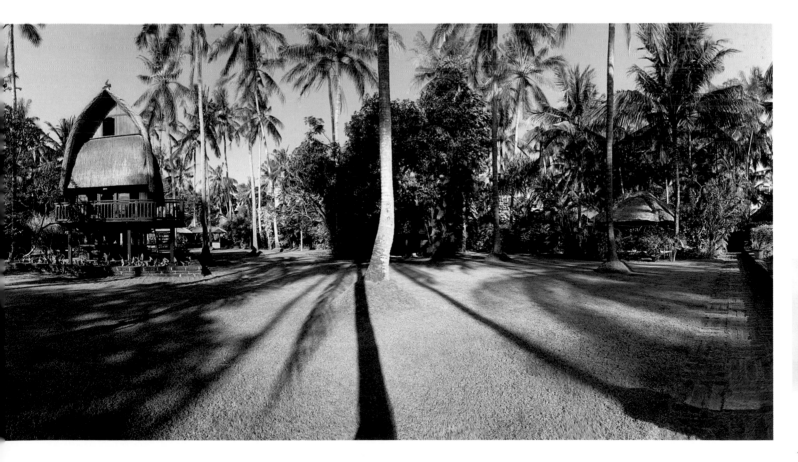

LIGHTING FOR QTVR

INTERIOR BALANCE

A shop interior contained two lighting problems: many practical lights in shot and two major conflicting colour temperatures.

A test pair before beginning the 360° sequence, shot with Daylight and Incandescent white-balance settings, reveals the scale of the colour-balance problem.

The decision was taken to allow the camera to make the colour corrections, with Auto white balance. There will obviously be colour-balance shifting from frame to frame, but the stitching program should be able to deal with that during equalization.

The second technical issue is high dynamic range because of light sources in shot. One solution was to shoot with a 1000 watt photo light next to the camera, turning with it from frame to frame. The second was to shoot bracketed pairs of exposures.

Exposure blending was applied to the pairs using Photomatix Pro, adjusting for brightness.

The finished sequence of frames. Remaining problems are that most are a little too dark, there is slightly too much red overall, and local colour anomalies of blue and green.

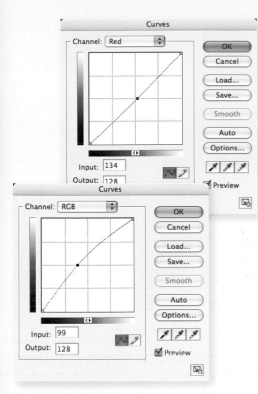

The final set of 14 overlapping frames, ready to assemble and stitch.

The brightness of each frame is adjusted using Curves, and the red channel lowered slightly.

The higher, bluer colour temperature in the stairwell is reduced using Replace Color, and a similar procedure is applied to the small fluorescent-lit areas at the far end of the shop.

The start of the stitching process, using Stitcher 5 from RealViz.

The panorama is first rendered as a flat 2D image so that it can be inspected in detail.

Once approved, the final output is as a QuickTime VR movie, ready to play on the shop's website.

CHIAROSCURO 170

BACK-LIGHTING 196

MAKING LIGHT SOFTER 208

REVEALING TEXTURE 172

SIDE- AND RIM-LIGHTING 198

ENVELOPING LIGHT 210

TRANSPARENCY & TRANSLUCENCY 174

FULL FRONTAL LIGHTING 200

MAKING LIGHT SHARPER 214

POSITIONING THE MAIN LIGHT 176

OVERHEAD LIGHTING 202

OPTICAL PRECISION LIGHTING 216

FILL LIGHTS AND REFLECTORS 184

MULTIPLE LIGHT SOURCES 204

PORTRAITS WITH FILL 194

LIGHTING SPACES 206

THE CRAFT OF LIGHTING

I mentioned earlier that light can be thought of as a commodity in photography. And, as an almost material component, it can be crafted, using the equipment demonstrated in Chapter 4. This applies to an extent to natural light, although the techniques there revolve more around the anticipation and choice of light outside anyone's control. For the most part, therefore, this final chapter is concerned with created lighting, although where comparisons are useful I include similar effects from daylight.

As we saw in Chapter 4, lighting equipment and lighting style go hand-in-hand; one feeds the other. Sometimes improvements in technology, such as HMI, have opened up new possibilities in lighting. On other occasions, equipment manufacturers have followed photographer innovators, and produced commercial versions of lights that had previously been custom built, both fulfilling a demand and encouraging more use among a much wider group of photographers. An example of this is the now common rectangular diffusing fitting known variously as a window-light, area-light or soft-box. It was being used in custom versions during the 1960s by still-life photographers in response to changing tastes in advertising illustration, but it took until the mid 1970s for mass-produced versions to appear.

In natural-light photography a certain level of contrast exists in a scene before you even think of taking a photograph, and this creates a certain type of approach: adapting to given conditions of lighting. With photographic lighting, however, and particularly in a studio, the contrast is entirely what you decide it should be. Another way of putting this is that natural light relieves you of the decision; the contrast is as it is, and there are limits to what you can do about it. Along with every other aspect of lighting, controlled studio photography forces you to select the appropriate contrast. If you choose not to bother, you are not in full control of the light.

Not surprisingly, as a fashion in lighting design percolates through the market (and lighting is certainly subject to fashion), some photographers will always experiment with new techniques. Inevitably, as most styles have already been tried, inspiration may be a renewed interest in an old style long fallen out of fashion. For instance, in 1980s design there was a renewed interest in Constructivism and the Bauhaus design movement (Bauhaus was a hugely influential modernist art and architecture school that operated in Germany from 1919 until 1933). This encouraged experimentation with the sharp shadow shapes from naked lamps and spotlights, mimicking the bright, hard, utilitarian sense of style that characterized the Bauhaus. Styles come and go, and tend to repeat themselves, and if there's any lesson to be learned from all of this, it is that nothing is cast in stone. Other than within the narrow confines of the purely technical realm, there is no 'correct'.

CHIAROSCURO

A pattern of dappled, high-contrast light playing across a subject can invoke atmosphere and drama, bringing interest to an otherwise ordinary scene.

Of the many lighting styles possible, I've chosen chiaroscuro to feature at the beginning of this chapter, partly because it seems to me to be one of the richest areas to explore, and partly because it is inextricably tied up with the question of contrast. The term chiaroscuro is an Italian construction from 'light' (chiaro) and 'dark' (scuro), and has both general and specific meanings when applied to painting, but both related to high contrast. Much of this book, in one way or another, is devoted to issues of contrast: when and how to use it; what to do about it; treating it as a problem and as an enriching quality.

Chiaroscuro became a highly developed technique of painting during the Renaissance, and it is interesting to note the various interpretations of it. Some refer to it as a way of creating the illusion of rounded, three-dimensional form created through gradations of light and shade (rather than through line). Another interpretation is as the way in which objects can be emphasized by patches of light, or obscured by shadow. Yet another is the creation of dramatic effects by placing very light and very dark areas of an image in opposition, with a palette limited in colour. All of this is as relevant to photography as to painting, and serves as an antidote to some of the more technical parts of this book, in which we have been looking at ways of overcoming high contrast.

Contrast – the difference between light and shade in an image – affects the quality of lighting and so the aesthetics of the photograph, and before all else it is important to consider these. The degree of contrast that seems appropriate depends on three things: what detail you want to stay visible in the shadows, the graphic design of the image, and the atmosphere of the

Iban man sleeping
An Iban man sleeps on the floor of a longhouse in Borneo. The window just above, combined with the generally dark interior, creates a pooling effect that abstracts the scene and delays its reading.

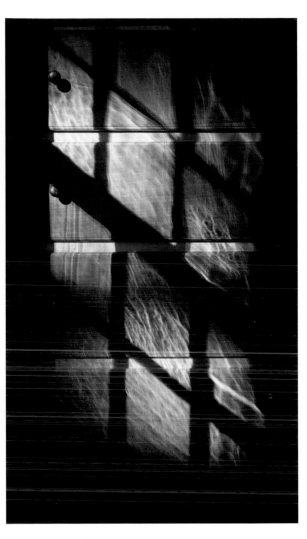

GOBOS

Patterned screens that fit into or in front of a focusing spot to throw chiaroscuro shadow patterns across a scene are known as cookies (or sometimes flags or cookies). These are from manufacturer Chimera — as they say, 'no more pulling Venetian blinds from windows or chopping tree branches'.

Shaker light
The imperfections in glass window panes in a Shaker building in Massachussetts cast mottled, wavy patterns known as caustics on a chest of drawers.

picture. The necessary shadow detail is usually a straightforward decision. If the purpose of the photograph is pure representation, blocked-up shadows are not normally a good idea, and the nature of the subject should immediately show whether there is important or interesting detail in the shadows (the frieze on the circumference of a vase, for instance).

Shadows, however, can contribute to the design of an image through their shape and by being dark blocks of tone to balance lighter ones. If they are hard and deep, their geometric effect may be reason enough to keep them like that. Atmosphere, the third consideration, is less open to exact definition, but is often the vital constituent in a photograph. High contrast and strong shadows produce the impression of hardness and sometimes drama; low contrast is gentler and less strident.

DIY cookie
Any arrangement of objects or patterns drawn with a marker on a clear gel can be placed in the beam of a focusing spot to create shadows, as in this image of a pre-Columbian gold necklace.

Geometry of shadows
In this telephoto shot taken along a line of pillars in an Egyptian temple near Luxor, compressed perspective coupled with sharp, deep shadows creates a geometric abstraction.

CHIAROSCURO

REVEALING TEXTURE

Technically, texture is a tonal quality, revealed or concealed mainly through the control of shadows on a macro and micro scale. It is almost a cliché that raking light, at a shallow angle to the surface of whatever is being photographed, brings out the texture most strongly. To a large extent this is true, but it ignores other, more subtle matters, such as the nature and scale of the texture, whether the light is from the front, side, or rear, and the diffusion or concentration of the light source. More fundamentally, revealing texture assumes that the more strongly it appears in a photograph, the better. Again, while probably more often true than not, strong texture in an image will take attention away from some other element.

The direction and quality of light is responsible more than anything else for the appearance of texture, which can vary hugely according to the material.

The scale of texture relates to the shooting distance, so that the ricefields shown opposite appear, at a couple of hundred meters through a medium telephoto lens, as extremely fine, rather like the fur on an animal. Fine texture like this appears at its most definite under point-source lighting, because the individual shadow 'units' – blades of grass in this case – are so small in the frame. More diffuse lighting would give them softer edges, which at this scale would hardly register. Hard lighting on a coarser textured surface might overcomplicate the shot by hiding detail in the shadows. Direction, too, is important. All the positions between side-lighting and back-lighting tend to create more shadows than the frontal positions (see pages 176-193), and so tend to show more texture.

Most surfaces also contain more than one scale of texture, which complicates the choice of lighting. On a stone bas-relief wall, for example, the carving is itself texture at a macro scale, viewing a large area from a distance. Moving closer, however, the stone can be seen to have a texture related to the grains of its different elements.

Egyptian statue
Direct midday sunlight glances off the face of this statue at an acute angle, clearly showing the difference between the original smooth polished texture and the broken area around the nose.

Bangkok rice barges
Backlighting in the late afternoon displays two rich textures at the same time – the choppy water and the corrugated tin roofing on the barges.

Vellum
A spotlight from almost exactly edge-on to sheets of white vellum brings out the subtle texture of this parchment.

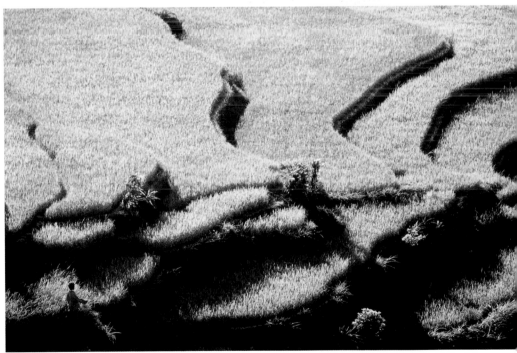

Rice terraces
Scale defines texture as well as lighting. From a distance, the rice crop on these Balinese terraces is textural, like close-cropped fur.

TRANSPARENCY & TRANSLUCENCY

Objects that transmit light offer wonderful opportunities for dramatic and elegant illumination, with backlighting and refraction playing a central role.

The distinction between transparency and translucency is one of visibility, with associated side effects from refraction. A transparent material is sufficiently clear to be able to see through it; a translucent object allows light to pass through it, sufficient for it to glow when back-lit but not coherently enough to be able to see an image through it. Translucency, in fact, offers more of a choice in treatment than does transparency, because you can ignore this quality of the material.

The principal way of dealing with both transparency and translucency is to use back-lighting, with suitable precautions (see pages 196-197). One approach is to set up a broad area of back-lighting, with a sheet of diffusing material behind the object, facing the camera, with the lamp(s) sufficiently far behind to give an even edge-to-edge illumination. Key to the success of this approach is to make sure that you retain edge definition. One of the most difficult situations is a colourless transparent object with a round or spherical body, in which the edges curve away from the camera. These edges will tend to disappear by reflecting the backlight. The usual

Bottle blanks
Carved and cast blocks of coloured resin at a design studio for perfume bottles are arranged on the translucent Perspex of a lightbox for a clean backlighting effect.

Glass tunnel
At an engineering company offices in Japan, the lighting design emphasizes the long box-like shape of the entrance, while leaving the surrounding glass walls of the building dark at night.

Backlit quills
The translucency of a blind drawn down over a window in a studio provides a more-or-less even backlighting for jars of quills ready to be carved into pens.

solution is to place pieces of black card on both sides, just out of view; the transparent edges will then reflect these and pick up some definition. Cutting cards to the shape of the edge is a further refinement. In any case, masking down the area to just outside the frame will reduce any flare.

With some translucent objects which absorb a considerable amount of light, however, the relatively dense translucent material will lose out significantly in comparison with its background. A precaution in this situation is to limit the extent of the backlight and to confine to right behind the object. The strongest impression is by placing the object against a dark background and aiming a light source directly behind it, shining straight into the material but hidden from view by the object's outline. A large object causes little difficulty since its size will hide the backlight. If it is small, however, you will need to find a way of either reducing its apparent size or masking it down so that no illumination spills around its edges (easier if you shoot a close-up). A variation on this approach is to use a spotlight from behind but out of frame.

Ice window
Daylight filtering through a window carved in the outline of a woolly mammoth in Sweden's Ice Hotel.

Sheet glass sculpture
A wall of glass sheets by artist Danny Lane refracts and reflects late afternoon sunlight.

LIQUIDS

When completely still, liquids in transparent containers such as glasses and decanters can be treated as any other transparent material, but when movement is involved they demand special care and technique with lighting in order to capture the flow of bubbles. Flash with a short duration is a prerequisite, but individual frames are unpredictable. Typically, if there is going to be an unrepeatable action, such as pouring a liquid into a vessel or dropping an ice cube, the set will have to be changed for each shot, meaning emptying, cleaning and repositioning. Expect to have to make a series of tests first.

POSITIONING THE MAIN LIGHT

The angular relationship between light, subject, and camera is the basis of any set-up, and placing the light determines the character of the shot.

With one or more of the stands and other types of support illustrated in Chapter 4, lamps and their fittings can be arranged at any angle to the subject and to the camera. The most common camera angles are between horizontal and about 30 degrees downward, but this limited range is mainly a matter of convenience. Here we are interested in the apparent direction of the light, regardless of whether the whole structure of camera, subject, and lighting has been angled or inverted to make the shot easier to take.

On pages 42-47 we considered the different angles of sunlight in the form of a lighting sphere surrounding the subject. The same can be done for controlled photographic lighting, with a few differences. One is that several lamps can be used, so that there may be different directions; in most lighting sets, however, one direction predominates. Another difference is that the lower half of the lighting sphere becomes, in the studio, a practical direction; either the light can be lowered to point upward or, as is often more convenient, the subject is laid flat and the camera aimed downward, allowing more conventional lighting support. Nevertheless, lighting from below remains the least common direction; from our everyday experience, it looks unusual. A third difference is that in the studio we can make a more detailed subdivision of the sphere, because of the control that is possible with photographic lighting. As a result, our discrimination of lighting direction should be stronger. Small changes, in the order of just a few degrees, become important decisions, simply because they can be acted upon.

Just as the angle of the sun makes a qualitative difference to outdoor photographs, so the varieties of lighting position in a studio will be more appropriate or less appropriate for different subjects and surfaces. As a practical guide, over the next several pages, we show two objects – one a Phrenology head painted white, the other a roughly spherical painted art object – both under the same lighting positions. The easiest lighting directions are very similar to the most common camera angles, between horizontal and 30 degree to 40 degree downwards, because for these you need only a simple tripod stand. The folded height of the stand sets a limit to how low you can position the light, although raising the height of the subject is an

THREE-QUARTER LIGHTING

The most standard position of all for a single main light is at an angle (to the subject) between frontal and side, typically from slightly above.

Variations in angle
Even within this definition of three-quarter lighting, differences between frontal and side can suit different subjects. The symmetry of this old Edison telegraph argued for an exact frontal position of a softbox, while the group of model figures were better served with a more conventional angle to one side.

alternative. Overhead positions take more effort, but are useful, as we show on pages 201-202. As an exercise, doing this with an appropriately sized object of your own is a valuable way of studying the nuances of direction, even more so if combined with variations in shadow fill, as on pages 184-193. Ideally, do this with more than one subject: a still-life object, a face, and anything else that you can think of. The more rounded it is and the greater variety of planes it has, the finer the differences will be between lighting angles. This is mainly an exercise in judging effect, but also partly a practical exercise in working with studio lighting equipment; pay particular attention to keeping the light stable and secure, avoiding such obvious dangers as overbalancing the lamp and trailing cables along the floor where they can be tripped over.

PROJECT: DIFFERENT LIGHTING DIRECTIONS

The easiest lighting directions are very similar to the most common camera angles – between horizontal and 30-40 degrees downward, because for these you need only a simple tripod stand. The folded height of the stand sets a limit to how low you can position the light, but raising the height of the subject is a useful alternative.

Talking head
Standardized lighting for television interviews uses a single softbox in three quarter position. Reflectors or secondary lights fill in the shadows.

POSITIONING
THE MAIN LIGHT

KEY TO CAPTIONS

Simple caption boxes giving the lamp's horizontal and vertical position have been used here. Any reflectors used are numbered according to their position in the illustration, followed by any other notes.

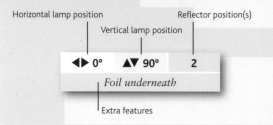

Horizontal lamp position

Vertical lamp position

Reflector position(s)

◀▶ 0° ▲▼ 90° 2

Foil underneath

Extra features

LIGHTING POSITIONS

The lighting positions here are given in terms of vertical and horizontal position measured from the subject. The possible reflector positions are numbered. The camera and subject remain fixed.

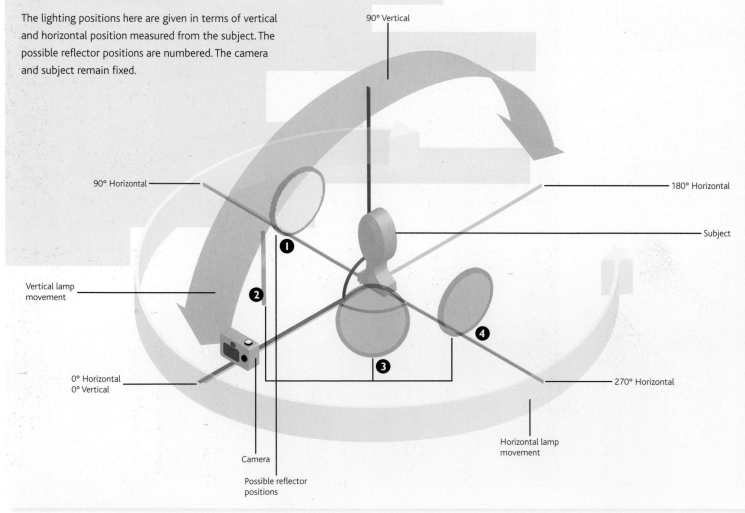

90° Vertical

90° Horizontal

180° Horizontal

Subject

Vertical lamp movement

0° Horizontal
0° Vertical

270° Horizontal

Horizontal lamp movement

Camera

Possible reflector positions

178

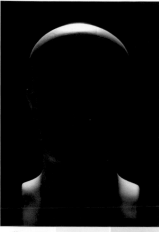
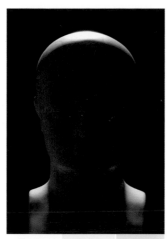

| ◀▶ 180° | ▲▼ 45° | none | | ◀▶ 180° | ▲▼ 45° | none | | ◀▶ 180° | ▲▼ 45° | 1 | | ◀▶ 180° | ▲▼ 45° | 1, 4 |

Foil underneath | *Foil underneath* | *Foil underneath*

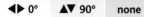

| ◀▶ 0° | ▲▼ 90° | none | | ◀▶ 0° | ▲▼ 90° | none | | ◀▶ 0° | ▲▼ 90° | 1 | | ◀▶ 0° | ▲▼ 0° | 1, 4 |

Foil underneath | *Foil underneath* | *Foil underneath*

| ◀▶ 0° | ▲▼ 45° | none | | ◀▶ 0° | ▲▼ 45° | none | | ◀▶ 0° | ▲▼ 90° | 2 | | ◀▶ 0° | ▲▼ 45° | 1, 3 |

Foil underneath | *Foil underneath* | *Foil underneath*

POSITIONING THE
MAIN LIGHT

179

◀▶ 45°　▲▼ 45°　none

◀▶ 45°　▲▼ 45°　none

Foil underneath

◀▶ 45°　▲▼ 45°　3

Foil underneath

◀▶ 90°　▲▼ 45°　none

◀▶ 90°　▲▼ 45°　none

Foil underneath

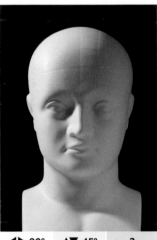

◀▶ 90°　▲▼ 45°　3

Foil underneath

◀▶ 135°　▲▼ 45°　none

Foil underneath

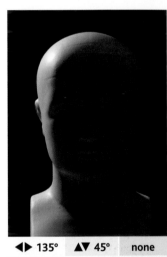

◀▶ 135°　▲▼ 45°　none

Foil underneath

◀▶ 135°　▲▼ 45°　3

Foil underneath

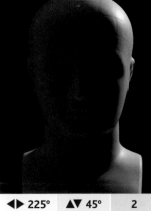

◀▶ 225°　▲▼ 45°　none

◀▶ 225°　▲▼ 45°　2

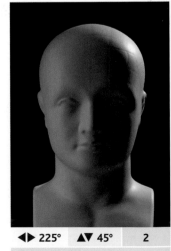

◀▶ 225°　▲▼ 45°　2

Foil underneath

◀▶ 270°　▲▼ 45°　none

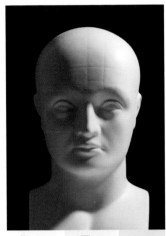

◀▶ 270°　▲▼ 45°　none

Foil underneath

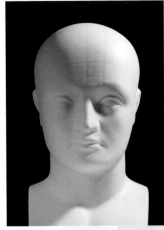

◀▶ 270°　▲▼ 45°　2

Foil underneath

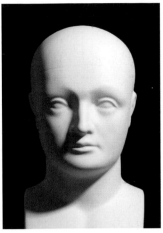

◀▶ 315°　▲▼ 45°　none

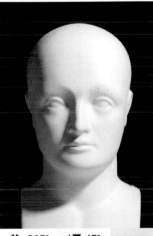

◀▶ 315°　▲▼ 45°　none

Foil underneath

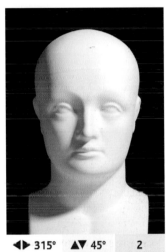

◀▶ 315°　▲▼ 45°　2

Foil underneath

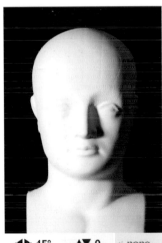

◀▶ 45°　▲▼ 0　none

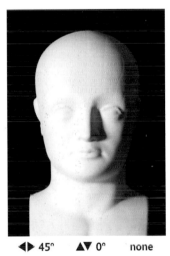

◀▶ 45°　▲▼ 0°　none

Foil underneath

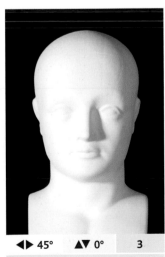

◀▶ 45°　▲▼ 0°　3

Foil underneath

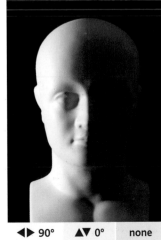

◀▶ 90°　▲▼ 0°　none

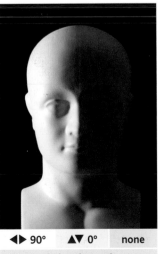

◀▶ 90°　▲▼ 0°　none

Foil underneath

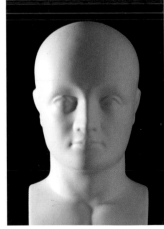

◀▶ 90°　▲▼ 0°　3

Foil underneath

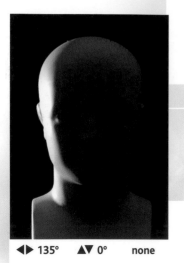

◀▶ 135°　▲▼ 0°　none

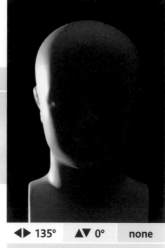

◀▶ 135°　▲▼ 0°　none

Foil underneath

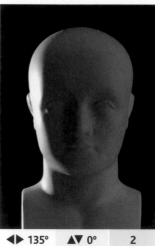

◀▶ 135°　▲▼ 0°　2

Foil underneath

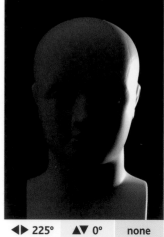

◀▶ 225°　▲▼ 0°　none

◀▶ 225°　▲▼ 0°　none

Foil underneath

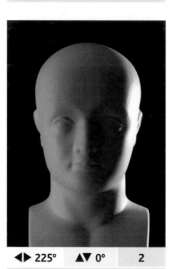

◀▶ 225°　▲▼ 0°　2

Foil underneath

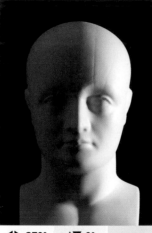

◀▶ 270°　▲▼ 0°　none

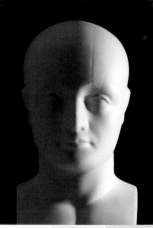

◀▶ 270°　▲▼ 0°　none

Foil underneath

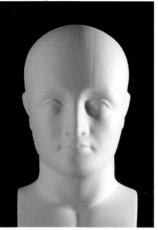

◀▶ 270°　▲▼ 0°　2

Foil underneath

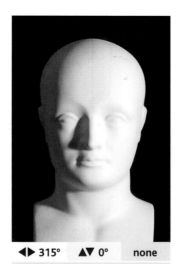

◀▶ 315°　▲▼ 0°　none

Foil underneath

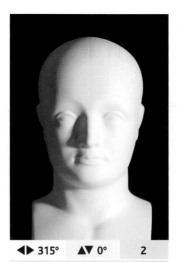

◀▶ 315°　▲▼ 0°　2

Foil underneath

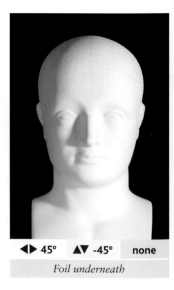

◀▶ 45°　▲▼ -45°　none

Foil underneath

◀▶ 45° ▲▼ -45° 3

◀▶ 270° ▲▼ 45° none

Foil underneath

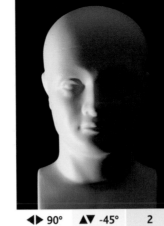

◀▶ 90° ▲▼ -45° 2

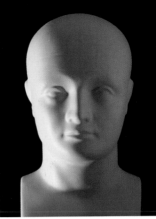

◀▶ 90° ▲▼ -45° 3

Foil underneath

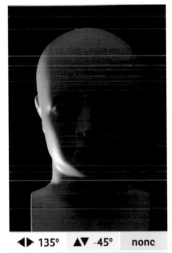

◀▶ 135° ▲▼ -45° none

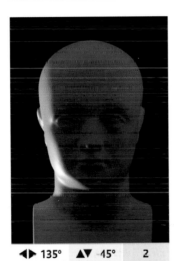

◀▶ 135° ▲▼ -45° 2

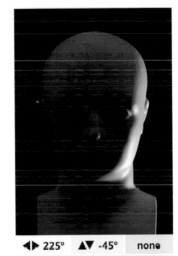

◀▶ 225° ▲▼ -45° none

◀▶ 225° ▲▼ -45° 2

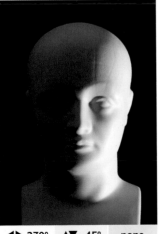

◀▶ 270° ▲▼ -45° none

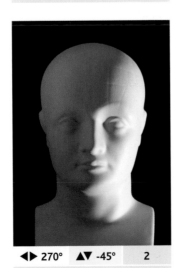

◀▶ 270° ▲▼ -45° 2

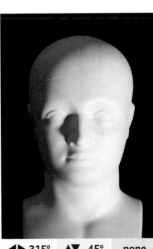

◀▶ 315° ▲▼ -45° none

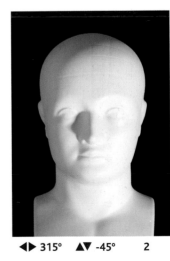

◀▶ 315° ▲▼ -45° 2

POSITIONING THE
MAIN LIGHT

FILL LIGHTS & REFLECTORS

As we saw over the previous several pages, a single key light leaves a shadow on the opposite side of the subject, and the density of this depends on the direction and on the degree of diffusion of the light. The measure of this is the range of contrast (the dynamic range). As we saw on pages 170-171, strong shadows may contribute to the image, but in most conventional studio photography, where it is important to show the subject clearly, there is a greater need to control the contrast.

In building up a lighting set, a typical second step is to open up the shadows opposite the main light, with either reflectors or a lower-intensity light.

The basic method is shadow fill by means of reflecting some of the key light into the shadows. A development of this is to add extra lighting – a fill light – opposite the key. To begin with, however, you should find out what the basic conditions are in the room you are using. Most interiors, including studios, reflect some light from walls, ceiling, and furnishings. The smaller the room, the closer these will be to the subject and set of the photography, and so the greater the natural reflection. It is often not possible to do anything about this and it may not even be necessary. It simply sets a limit to the maximum that you can create without introducing blacked-out surfaces. The ideal circumstances, to give full control over contrast, would be a room that produced no reflections at all; a room painted black. This would be the photographic equivalent of starting with a blank sheet of paper.

The amount of shadow fill from a reflector depends on the reflectivity of the material and on its size (relative to the subject). The table already shown on pages 110-111 illustrates the range of efficiency. To increase the amount of shadow fill beyond this, add a fill light, using it either to reflect (by aiming it away from the set and into a reflector), or aiming it directly at the side of the subject from opposite the key light. For the relative effects of this, see the following pages.

REFLECTOR MATERIALS

Min diffusion; least light loss

- Mylar/mirror
- Aluminium foil: smooth, shiny side
- Aluminium foil: smooth, dull side, Fabric: metallic
- Aluminium foil: crumpled, shiny side
- Aluminium foil: crumpled, dull side
- Painted board: high gloss
- Painted board: medium gloss
- Painted board: semi-matte, Fabric: white, Card/paper: white
- Painted board: matte white
- Polystyrene/foamcore

Max diffusion; most light loss

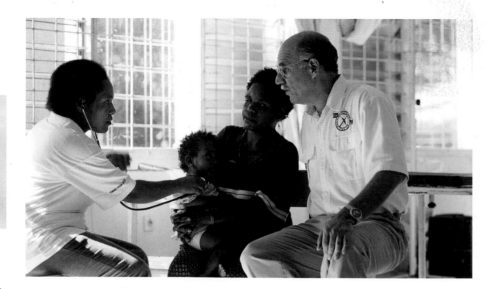

Off-camera fill flash
The natural illumination for this clinic in Irian Jaya was a flood of daylight from the many windows behind and to the left, but the subject, in particular the dark skin of the women and child, was still strongly shaded facing the camera. A small flash unit was held to the left of the camera on an extension sync cord.

① ②

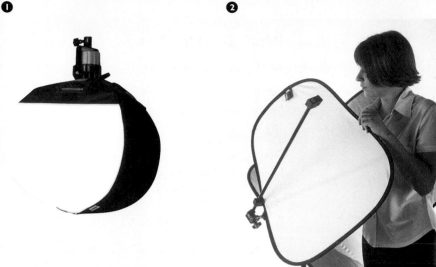

Begin by setting a single, undiffused lamp in a position for side-lighting, as shown on the following pages. If you have access to a hand-held incident meter, take one reading with the meter facing the light, and a second with the meter facing away from the light. The difference is the contrast range. Next, hang a sheet of black material – ideally black velvet – facing the light, and take a third reading with the meter facing into it, again away from the light. The first and third readings give the maximum contrast range; if the black material makes much of a difference, the room is quite bright.

③ ④ ⑤

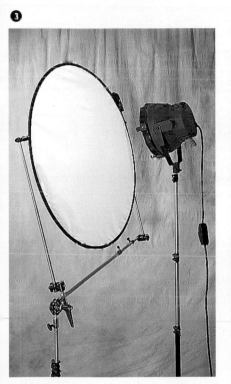

Reflectors

① *A Chimera Lantern is designed to produce a soft, omni-directional 'bare-bulb' effect, very useful for fill. Here a hook and loop-attached black skirt selectively blocks light.*

② *Bracket and frame on a small lighting stand, to adjust and hold the position of a reflector.*

③ *A circular silvered reflector held in a diffuser bracket is a fast way of diffusing a basic luminaire.*

④ *A hinged reflector system designed specifically for beauty shots, the Triflector from Lastolite. The hinge mechanism allows individual adjustment of each collapsible panel, and the arrangement both fills in under-chin shadows and adds catchlights to the eyes.*

⑤ *A 1.8 x 1.2 metre collapsible silvered reflector in position against a similarly constructed collapsible background, both from Lastolite. This size is designed for full standing figures.*

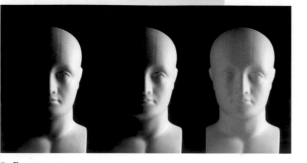

Reflector

From left to right, this sequence of shots shows no reflector, a base reflector, and a base plus side reflector.

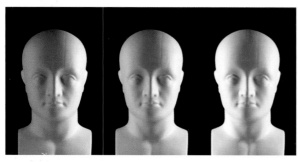

Three-quarter light

This sequence shows an opposing light at three-quarter position (45° horizontal as illustrated on page 178) at ¼, ½ and full power.

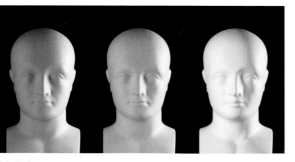

Side light

This sequence shows an opposing light at ¼, ½ and full power.

SPHERE

This sequence shows a sphere lit the same way from the right in each shot, but with varying light from the left provided by a reflector or a fill light at quarter, half and maximum settings. Black and white backgrounds are shown for comparison.

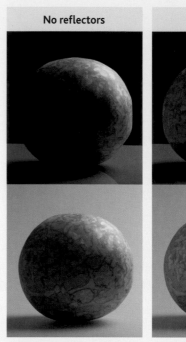

No reflectors	Reflector

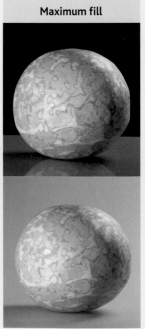

Quarter fill	Half fill	Maximum fill

FIGURINE

This sequence shows a figurine lit from the right using an 80 × 60 cm window in every shot. Different reflective materials and lights are then used on the left hand side. Black and white backgrounds are shown for comparison.

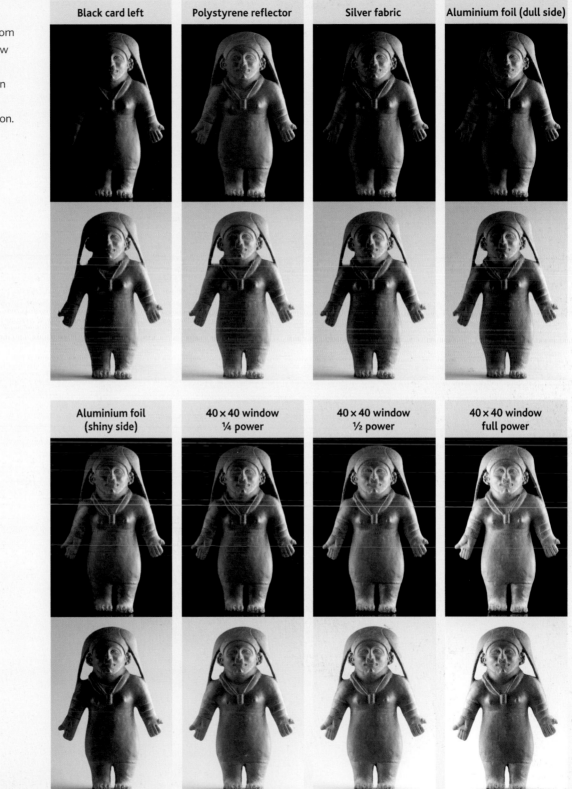

| Black card left | Polystyrene reflector | Silver fabric | Aluminium foil (dull side) |

| Aluminium foil (shiny side) | 40 × 40 window ¼ power | 40 × 40 window ½ power | 40 × 40 window full power |

FILL LIGHTS & REFLECTORS

KEY TO CAPTIONS

This table presents rows of images taken under the same lighting conditions but using either a diffused 'window' light or a bare light. Each row's key explains where the light was, and refers to the illustration on page 178 for horizontal, vertical, and reflector position.

Shadow-fill

The purpose here is to compare shadow-fill effects, using a standard matte silver reflector (note how much less insistent this is than the fill light used on the previous pages). Each lighting direction has a pair of images: without fill and with fill. The base is neutral grey plastic and the background is drop-out black (velvet). Shadow fill is more obvious, and more necessary, when the key light is behind rather than in front of the subject.

Exactly the same sequence of lighting directions, with and without shadow fill, as on the previous pages, the difference being that the sphere is placed on a white plastic scoop. This immediately gives a substantial ambient fill, and when the light is overhead, for example, the effect of a matte silver reflector is hardly noticeable. The light, as before, is a 40 × 40 cm square 'window'.

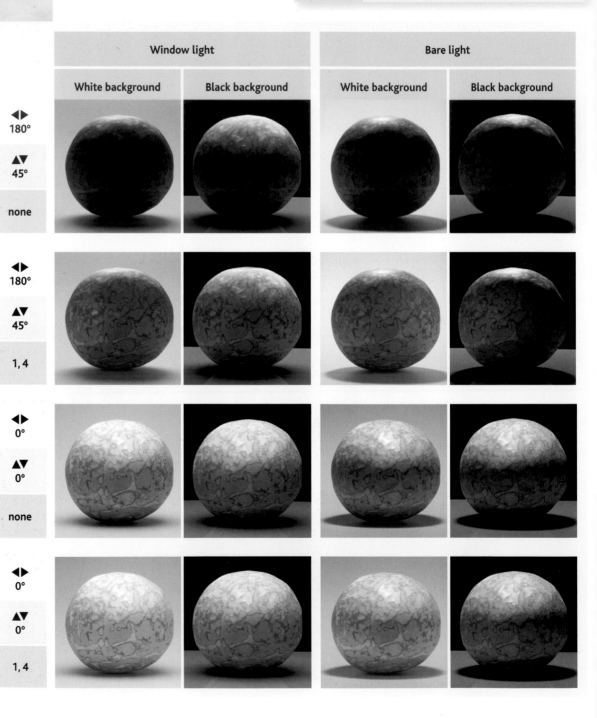

	Window light		Bare light	
	White background	Black background	White background	Black background
◀▶ 180° ▲▼ 45° none				
◀▶ 180° ▲▼ 45° 1, 4				
◀▶ 0° ▲▼ 0° none				
◀▶ 0° ▲▼ 0° 1, 4				

	Window light		Bare light	
	White background	Black background	White background	Black background
◀▶ 0° / ▲▼ 45° / none	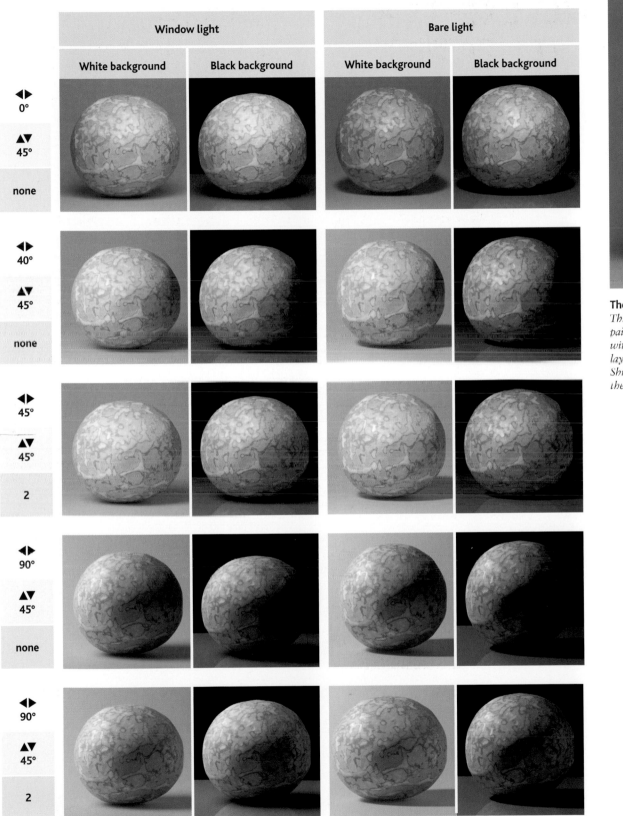			
◀▶ 40° / ▲▼ 45° / none				
◀▶ 45° / ▲▼ 45° / 2				
◀▶ 90° / ▲▼ 45° / none				
◀▶ 90° / ▲▼ 45° / 2				

The subject
This near-spherical piece, painted in a marbled fashion with selective removal of layers, by artist Yukako Shibata, is the model on these and photographs.

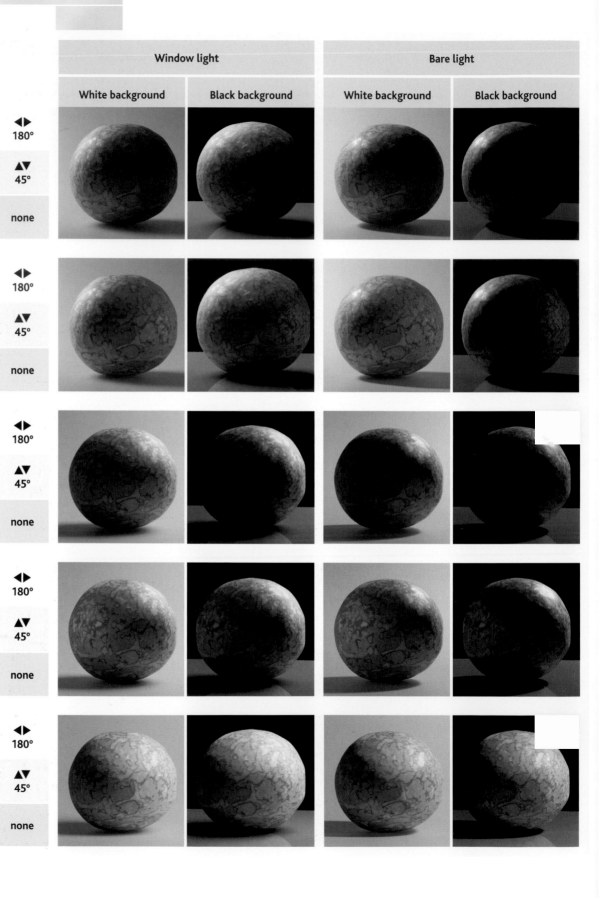

	Window light		Bare light	
	White background	Black background	White background	Black background
◀▶ 180° ▲▼ 45° none				
◀▶ 180° ▲▼ 45° none				
◀▶ 180° ▲▼ 45° none				
◀▶ 180° ▲▼ 45° none				
◀▶ 180° ▲▼ 45° none				

Window light
Window light, or softbox, providing a diffused light.

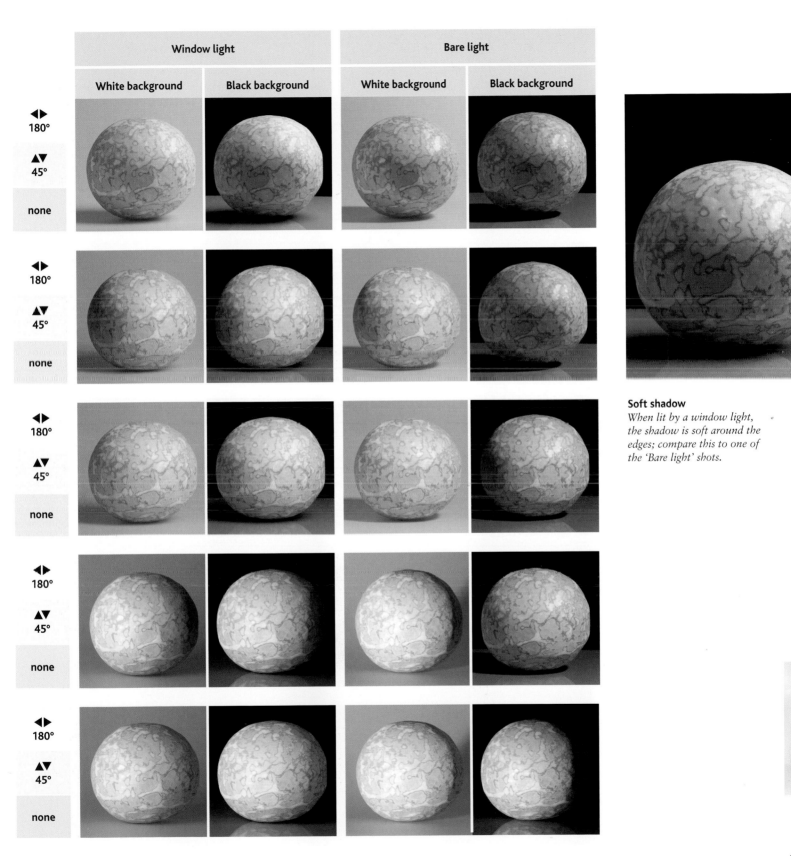

Soft shadow
When lit by a window light, the shadow is soft around the edges; compare this to one of the 'Bare light' shots.

	Window light		Bare light	
	White background	Black background	White background	Black background
◄► 180° / ▲▼ 45° / none				
◄► 180° / ▲▼ 45° / none				
◄► 180° / ▲▼ 45° / none				
◄► 180° / ▲▼ 45° / none				
◄► 180° / ▲▼ 45° / none				

Bare light

In contrast to the diffused window light, the bare light leaves a sharp shadow.

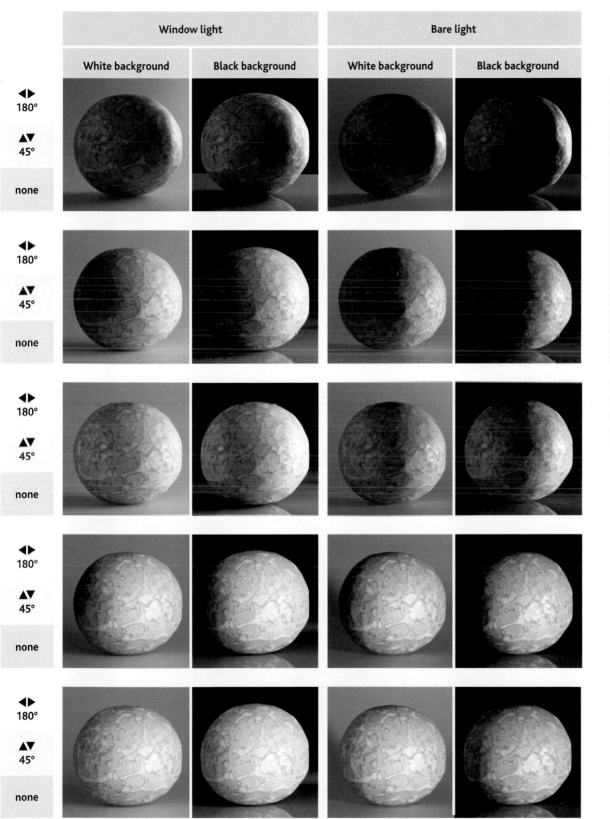

	Window light		Bare light	
	White background	Black background	White background	Black background
◄► 180° ▲▼ 45° none				
◄► 180° ▲▼ 45° none				
◄► 180° ▲▼ 45° none				
◄► 180° ▲▼ 45° none				
◄► 180° ▲▼ 45° none				

Bare light
Even where a reflector is used, the shadow cast by the bare light is clearly visible to the left of the sphere.

PORTRAITS WITH FILL

Lighting for beauty, as opposed to lighting for character, demands a high degree of fill, to reduce skin texture and to lift shadows on downward-facing planes.

For the camera, the face has two sets of physical properties. One comprises its physical appearance and the way its shape responds to light; the other concerns the aesthetic qualities. In shape, the face is rather more complex than it might at first seem; although the head is roughly spherical, the face has a number of planes in different directions. Some face up and out: the forehead, cheekbones, upper lip, and the ridge of the nose all catch an overhead light more strongly than the rest of the face, particularly if the skin is shiny. The downward-facing planes – the underside of the eyebrow ridge, the lower cheeks, under the chin and the two small areas under the nose and lower lip – tend to be shadowed under overhead lighting. The nose projects, and can cast a strong, definite shadow, while the eyes, which are recessed, usually need some frontal element of lighting. In addition, the face is bilateral, which means that any degree of side lighting tends to bisect it. In general, the contrast in a facial portrait tends to be greater than most people expect.

Aesthetically, by far the most important feature is the dominance of the eyes. They attract such immediate attention that if they are not adequately lit, the face appears expressionless. Second in importance to the eyes is the mouth, the other major component of expression. The least highly regarded facial features are the nose and ears; although occasionally they can be prominent and handsome at the same time, for most tastes they are best when subdued in appearance. Taken together, all these visual characteristics encourage a strong element of conservatism in portrait lighting, and by far the most popular style is diffuse frontal overhead lighting, which resembles most natural light. The object in most portrait photography is clarity, and this calls for shadow control.

Even within the range of diffuse frontal overhead lighting, there is considerable choice of effect, and the seemingly slight differences between the many diffusing

THREE LIGHTS + REFLECTOR

One of the standard setups was shown on pages 184-185, featuring a single broad key-light in an overhead frontal position and reflectors left, below and right. Another, used here, is two broad lights in three-quarter position left and right (power distributed asymmetrically if wanted) with one reflector (large matte silver fabric) below.

Left three-quarter lighting
The main component of the three is this partly side, partly frontal softbox illumination from the left.

Right three-quarter light
Balancing the above is a similarly positioned lamp but on the right. The balance of illumination between the two was adjusted to favour the left light by asymmetrical switching.

Final image
*Near-front lit, the final version gets a lot
of light onto the face, though at the expense
of the shape brought out by the three-quarter
lighting options.*

Backlight
*The third lighting component was two flash units (close,
but one above the other) aimed from behind the girl towards
camera, through a thick diffusing sheet of translucent Perspex.*

and reflecting fittings on pages 106-111 matter.
Umbrellas usually work well and are probably the most
common fitting, although their effect may be so diffuse
and directionless that they give insufficient structure
to the face. Also, they are difficult to use close to the
face because of the support fittings, and because their
light spill is largely uncontrollable and can easily cause
flare. Area lights are more precise and controllable,
but as they are also more directional should be used
very close. Reflectors are the simplest method, and the
degree of shadow fill is largely a matter of taste. The
strongest reflectors – mirrors and metal foil – often
work too well, making themselves obvious, and matte
silver (or gold for warmth) is more usual. An alternative
is a fill-light, heavily diffused and of relatively low
power (one quarter of the main light's output is
reasonable). Secondary shadows from undiffused fill
lights are distracting, and complicate the picture.

BACK-LIGHTING

This is the studio version of shooting against the sun, or into a diffused or reflected version. Most techniques, indeed, are designed to create a broad background of light rather than a point source. Studio back-lighting normally has one of two uses. Alone, or with minimal fill from the front, it provides the setting for a silhouette. Used with stronger frontal or side lighting, it ensures a clean, bright background, without shadows,

Light from behind the subject strengthens outline and therefore shape, and can be used for background separation or for heightened graphic composition.

and it is, of course, the principal technique with transparent and translucent objects (*see pages 174-175*). The real skill with back lighting is in knowing how to control the shape and evenness of the area, and achieving a completely even light from side on a large scale is not easy.

The broad area lights on pages 106-109 are useful if positioned facing the camera from behind the subject. If these are soft-boxes, be careful that there are no creases visible. There are, in fact, several translucent materials that will do the job of diffusion well enough, but very few that are completely without texture. This is critical if the light is to form the background to the shot. There should be no wrinkles, streaks, spots of dirt, or even pattern in a fabric. To an extent, the distance of the backlight behind a subject will help to make some of these less obvious because they are likely to be partly out of focus, but the best precaution is to use only a completely smooth material, like acrylic.

The chief problem with a direct back-lighting source is to make the illumination even. With a single lamp, there are two basic ways of evening out the light: one is to increase the thickness of the diffusing material, the other is to spread the beam. Both reduce the light level. The most efficient way of increasing the diffusion is in two stages, by placing a smaller diffusing sheet in front of the lamp. To spread the beam, either adjust the beam focus control on the lamp (if it has one), or move the light further back. It also helps a little to position bright reflectors at the sides, to throw some light onto the edges of the main back-lighting

Base lighting
Lighting from below the subject is uncommon in real life, but extremely useful for still-life in lifting and separating objects from their background.

LIGHT TABLE

One of several similar constructions designed for still-life photography, this flexible sheet of opalescent plastic provides a base of diffused light when a light is positioned below, pointing upward. The amount of vignetting (fall-off outward to shadow from the centre of the table) is adjusted by the proximity of the light beneath and its diffusion. The metal frame, here an adjustable one, curves the sheet to give a horizonless cyclorama effect behind, while a pre-formed curve at the front allows the base to fall away for a low camera position. The upper surface is matte to eliminate reflections.

sheet. Adding extra lamps makes it possible to overlap the beams, but even this needs care and skill. Usually, it is easier to produce an even spread if you cross the beams, aiming each lamp towards the farther side of the back-lighting sheet. Meter the result from side to

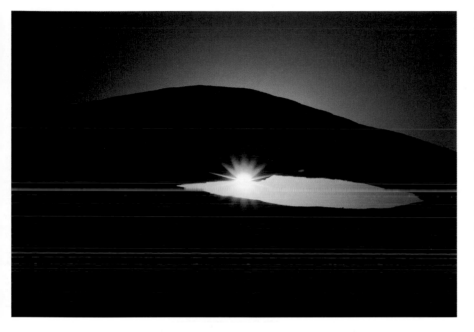

side, ideally with a hand-held meter. To measure the light for exposure, the most straightforward method is to use a hand-held meter at the position of the subject, aiming away from the camera towards the back light. If you use a reflected light reading in-camera, the exposure should typically be between 2 and 2 ½ stops more in order to give a clean white effect.

Direct back-lighting is not the only method. Reflected back-lighting is in many ways simpler to arrange, particularly for a large area, using a clean, unmarked white wall or similar surface. Aim concealed lights at this, making sure that they do not spill onto the subject: it is easier if the background is well behind the subject, and if the lights are flagged. For even lighting, use at least two lamps, crossing the beams as explained above. Four lamps, one for each corner of the picture area, are better. Striplights are specifically designed for background lighting.

Sunlight
Shooting into the sun provides an incredibly strong backlight, ideal for defining a silhouette.

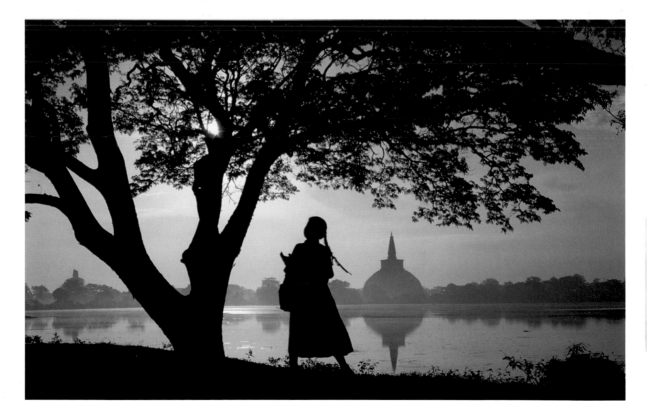

Dagoba schoolgirl
By exposing for the hazy but bright backlighting, a background now exists for the silhouette.

SIDE- AND RIM- LIGHTING

Side-lighting can be very effective, and dramatic, with fully rounded subjects, and the transitional area from light to shade that appears in the centre picks out texture strongly. In portraiture, because of the bilateral symmetry of the face, it produces a half-and-half effect in a full-face shot, dividing it down the middle (hence one name for it, 'hatchet lighting'). Although a little unusual, this can be graphically strong. With the head turned to a three-quarter profile, however, the shadows tend to be complicated. In many ways, a full profile is the most appropriate pose for side lighting –the picture becomes a side view of a frontally lit face.

An intense modelling effect can be achieved with lighting aimed from about 90 degrees to the camera axis, modulated by the amount of fill.

With a single key-light moved back, side-lighting turns into rim-lighting. In this lighting technique the edge or rim of the subject is picked out against a dark background. The most dramatic, high-contrast effects are when there is no other kind of lighting used, and the brightly lit edge from a single lamp defines the shape of the subject. The subjects that respond best to this kind of lighting are those with relatively simple, clear outlines. Projection features tend to confuse the image, particularly if they cast shadows across the brightly lit line of the edge. Rim-lighting is also used as secondary lighting, particularly in portrait, fashion, and beauty photography.

The simplest rim-lighting technique is to mimic sunlight: a single direct lamp aimed at the subject from behind, either by the subject if exactly behind, or by being positioned out of frame. If out of frame, it may be necessary to concentrate the beam, or at least to prevent it from spilling either onto the lens or onto other parts of the scene. If the width of the beam just covers the subject, the rim-lighting effect will be at its strongest. The essential precaution in rim-lighting is to keep the background dark. Not only must the material be black, but it must be shielded from the light. One way of doing this is to have the background well behind the light; another is to have it between the light and the subject, with the beam passing close to its

Sidelight on vertical forms
Shortly after sunrise over the Temple of Luxor, Egypt. The verticality of form, emphasized by the crop and the telephoto treatment, reaches its most definite modelling under side-lighting.

edge. A back-spot is good for textured edges like hair and fur that reflect and refract light, and its concentrated beam can create quite a strong halo. Smoother and shiny surfaces are likely to respond better to a broader area light, or better still, a strip-light, which spreads the reflection more evenly.

Rim-lighting and contrast

Valued for its relative scarcity in natural situations, rim-lighting needs two conditions – the light from behind and to one side falling on the edge of a subject, and the isolation of that subject against deep shadow, as here on a river bank in Surinam.

Maximizing relief

A vertically-down shot of an antique cake of vermilion on an artist's drawing board. The ambient lighting is diffuse daylight, which does little to bring out the intricate pattern on its surface, and for this a spotlight was aimed from a grazing angle.

Rim-light and texture

A once-common sight on the back canals around Bangkok, a man, stripped to the waist, poles a barge through the narrow waterway. Here, the rim-lighting catches the sheen of sweat on his skin.

Postbox

A low sun from one side, lighting an old Japanese mailbox (modelled after the British design) fulfils a similar function as on the Egyptian temple opposite. Additionally, the light helps it to stand out against a dark background shadow cast by the sun.

FULL FRONTAL LIGHTING

Ring-flash
A circular flash tube that fits around the front of the lens is the simplest way of guaranteeing shadowless axial lighting. This model is the Broncolor Ringflash, a circular 3200W head with a universal camera mount.

Axial lighting is precisely frontal, following the axis of view through the camera's lens. No shadows at all are visible, and it is this that makes axial lighting worth the effort to create it for a few special situations. There is only one way of making true axial lighting – by splitting the beam in front of the lens – but there are, however, some close equivalents.

Axial lighting, from or behind the camera position, produces a flat, almost shadowless effect which, used appropriately, can have an almost startling clarity.

First, the beam-splitting method. This is how a front-projection system works, and it is possible to make something similar yourself. The principle is that a semi-silvered mirror directly in front of the lens is angled to reflect a beam of light straight forward. Being semi-silvered, it only dims the view through the lens instead of blocking it, as would an ordinary mirror. If it is positioned at exactly 45° to the view, and if a light shines onto it at 90° to the view, the beam travels precisely along the lens axis, in exactly the direction you see when looking through the viewfinder. In principle, there is no more to it than that, although setting up camera, light, and mirror in alignment may demand some ingenuity. A less efficient version is possible with a thin sheet of ordinary glass (this and the semi-silvered mirror must be thin in order to avoid serious loss of image quality). Try this on a number of different subjects. The most obvious feature is the total lack of shadows; some edges that curve away from view may appear darker, but that is all. Backgrounds are dark due to the light fall-off away from the camera, exactly as with portable flash, but all fairly shallow subjects become images purely of tone and colour.

Emphasizing camouflage
This rattlesnake has a natural pattern and colouring that helps to camouflage it against the arid terrain. Normal lighting from an angle that brought out the form would show the reptile more clearly, but a ring-flash's shadowless look makes the camouflage appear more effective.

Another quality is that shiny surfaces that are face-on to the camera reflect the light back exactly into the lens. This is the origin of red-eye reflections in portraits, and the way that a front projection screen works. The screen is coated with large numbers of extremely small transparent spheres. These, like the retina and 'cat's-eye' reflectors on roads, reflect only directly back to the viewer. The projected image in a front projection system travels along the line of view, and then back from the screen to the lens; it is invisible from any other direction. Those screens are made of 3-M Scotchlite (a reflective material); buy some and experiment with your own beam-splitting mirror.

The final interesting use of axial lighting is that the lamp, however large, can be positioned out of the way. In close-up photography, where the working distances are all extremely small, this can be a considerable advantage.

A ring-light comes as close as possible to axial lighting while still using direct illumination. The lamp surrounds the lens, so giving a different type of shadowless light, in which the thin shadows from each side are cancelled out by the light from the opposite side. The conventional design is a flash unit that fits onto the front of the lens; a tungsten lamp powerful enough to give efficient lighting at normal distances would be too hot. In a special design of lens for dedicated use, the ring-flash is integrated, and different levels of magnification are achieved by means of a set of supplementary lenses. The principal use of ring-flash is for close-up and macro pictures; it is at these scales that strong shadows are often unavoidable with ordinary lighting because of the difficulty of positioning lamps close enough to the subject.

Grand piano
Placing a softbox right next to the camera in this overhead shot gives a more striking, less conventional view of the open interior of a grand piano.

Antique silver box
Normally, a ring-flash, used here, would be an inappropriate choice for reflective silver, but the lack of shadow contrast is compensated for by high contrast in reflectivity between the painted and polished areas, and the effect is unusual.

OVERHEAD LIGHTING

P robably the most common lighting direction for daylight is more or less overhead, particularly when cloud cover modifies sunlight so that a large area of the sky becomes a broad light source (*see pages 50-51*). In the studio, however, despite its good credentials for still-life photography, it tends to be considerably less common. The reason is practical, because fitting lights overhead takes more effort than placing them on stands, and it is admittedly not a very good reason. Boom stands, goal-post configurations with a horizontal bar attached between two stands or two auto-poles, and ceiling tracks are the solutions. Still-life photography, probably more than any other kind, calls for flexibility of lighting position over and around a limited set, and argues for a system that allows lights to be positioned for almost any direction conveniently. Cables (power and sync) easily get in the way from overhead positions, and always need to be safely secured.

Lighting from directly above runs the risk of pooling shadows, but while rarely attractive for portraits, it can be cool, clean and elegant for still-life subjects when the shadows are controlled.

Top-lighting with scoop
A classically simple treatment of a 19th century model brass engine, which utilizes the natural contrast of tonal ranges from a softbox suspended over a curved sheet of white plastic – top-down bright to dark on the subject versus bottom-up bright to dark on the scoop background.

One of the standard lighting treatments in still-life is an overhead area light, suspended so that it illuminates the objects almost directly from above. When this is combined with a smooth white base, potential shadow areas underneath the objects are automatically filled by reflection. Extending the base backward and upward as a scoop beyond the pool of light causes a gradual shading in the visible background, accentuated by curving the base sheet up (by suspending it or by resting it against a wall). This alone, depending on the camera angle, can create a clean and attractive tonal contrast between the subject (highlights above, shadows below) and the background (light below, dark above).

White on black
An antique ivory sundial responds well to an overhead diffused single light. The angle of the light was adjusted so that the inside of the lid received fractionally less illumination.

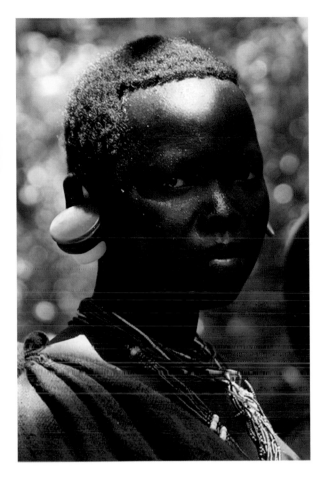

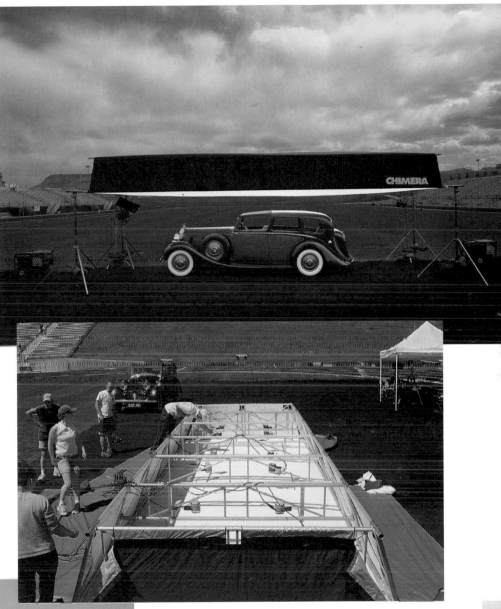

Tropical sunlight

For flattering portrait lighting, an overhead sun is not an orthodox choice, but in reportage photography it matters little – dappled tropical shade is here an essential part of the atmosphere. Shooting Raw enabled some of the highlight and shadow losses to be recovered in post-production.

Lightbank

When production costs allow, lightbanks can both guarantee overhead lighting on location and, as here, provide an unusual mix of illumination on an overcast day. The shape and surface gloss of automobiles make diffuse overhead lighting appropriate, This 3 × 9.2 metre (10 × 30 foot) lightbank from manufacturer Chimera uses a lightweight aluminum tubing frame weighing only 91 kg (200 pounds), lined with a soft silver reflector skin, and is designed to accept bare-bulb flash, bare-bulb HMI or wide-beam open-faced tungsten lamps.

MULTIPLE LIGHT SOURCES

For most of this chapter, we have assumed a single light with different degrees of shadow fill. For much, maybe most photography, this is quite acceptable. Indeed, all daylight situations have a single source, even though often heavily modified by reflections and shade. Apart from being easy to conceive, single-source lighting also has the advantage of being straightforward and simple for the viewer; it has the capacity to be unobtrusive. Studio and interior photography, however, is not constrained to a single light source, and the bigger the set, the more necessary it becomes to think about several lights, each being responsible for a different area.

As much a stylistic as a technical approach, multiple-source lighting builds up its effect by treating different object planes separately.

There are two ways to approach this. The first follows the logic of the single light source by beginning with a main light, or key-light, then adding secondary lights for specific purposes. The second in the sequence is usually the fill-light(s), followed by, for instance, background light(s), a catch-light for the eyes in portraiture, a rim-light or backspot, and so on. With precision lighting such as projector spots, it is also possible to pick out small defined areas to fine-tune the balance of brightness across the set. Conceptually different is the idea of no key light, instead building up the lighting object plane or area at a time, and this is common with interiors and large sets (see the following pages). In terms of equipment and time, of course, this is more complicated than most single light source sets.

Ink stick
In this detail of a calligrapher's workbench, diffuse daylight from windows and skylight provided a basic overall illumination, but to highlight the gilded antique Chinese stick of ink, and add interest, a 300-watt small focused spot was aimed at a shallow, grazing angle from lower left.

Star Wars warehouse

The ILM props warehouse in California in a frame-filling shot that includes as many recognizable items as possible from the Star Wars and Indiana Jones series. For this reason, a large number of lights were used to illuminate individual subjects.

Lobster dish

Of the many styles of lighting food, a deliberate contrast of colour temperature and beam can bring vitality, particularly with glazed surfaces that will pick up reflections. Here, a 3200 K spot provides the contrast for the much higher colour temperature of light from a north-facing window behind.

Multiple softboxes

A studio lighting set using five softboxes on incandescent lights, in which no single source completely dominates. The largest softbox is used from a rear three-quarter position for an effect close to rim-lighting. Essentially, each of the five lights is responsible for a different segment of the Harley Davidson plus rider. The amount of chrome and the different planes account for the predominance of lighting positions to the rear. The camera position is as this view.

Caviar

Flash from a softbox in front and overhead gave adequate diffusion for the reflective silverware, but a small tungsten lamp added sparkle (important for the caviar granules) and a touch of colour.

LIGHTING SPACES

nteriors and room sets form a lighting category of their own, and differ from the general run of lit studio shots in that the camera is perceptually inside the subject rather than outside looking at it. Disregarding detail shots, most of such spaces tend to be shot with a wide-angle lens, and generally as wide an angle of view as possible without showing noticeable edge and corner distortion. As a result, they normally cover three or four of the six interior planes of what is usually approximately a cube. With the wide angle of view, the lighting positions are restricted to the 200° or so (angle of view subtracted from 360°) behind and to the sides of the camera, and to concealed locations in front of the camera. Relatively small lights can be concealed within the view (such as behind a bed or another large piece of furniture), and larger luminaires can be aimed from outside the set through doors, windows, and from behind walls.

Photographing interiors almost inevitably involves handling multiple light sources, and demands a plan aimed at an intended effect.

China Club
The interior of an old colonial building in Hong Kong. The decision was taken to use existing light with fill, and favour the artificial lighting (tungsten) for white balance and overall effect. The size and output of the lamps needed for an interior depend very much on the dimensions of the space, and if the lights are used to bounce off walls and ceiling, they will lose a great deal. 800W per lamp would normally be the minimum.

Printing shop
The provided lighting for this museum-constructed interior (as the set on the opposite page) was inadequate for showing the dark details of the press. Three lights were set up: a diffused lamp on left out of frame, a bounced light behind and to right of camera, and a third aimed through a large sheet of tracing paper covering the door.

THE CRAFT OF LIGHTING

206

Reconstructed room set
This interior is a reconstruction at the National Museum of American History in Washington DC, and as such calls for some realism. Accordingly, the main lighting is through the windows from outside, diffused by sheets of translucent material and allowed to flare for a more atmospheric effect.

Natural lighting
This modern office reception area in Japan had such a specific atmosphere that it was felt appropriate not to add photographic lighting, but instead to use Photoshop's Shadow/Highlight tool at a mild setting on a purely natural-light shot.

Before even considering a lighting plan, the overall lighting concept needs to be considered. Almost all spaces, at least habitable ones, already have their own lighting, and a first decision is whether or not to convey this. If so, there is often then a choice between the daylight-dominated state and the artificially lit, evening state. There may also be several other natural states if there is a lot of window space and the location catches the sun at different times of the day. The alternative is a complete photographic lighting construction, but even here there is a choice between a setup that appears to replicate natural, found lighting, and one without any reference to this that is a complete, freshly created design. There are also intermediate states, in which, for example, lights are used to add to the existing effect if it is felt to be deficient (for example, lighting the ceiling of a cathedral that would normally be relatively dark).

The issue of shadow fill for existing lighting has changed since the days of film. Then, it was almost always necessary to add some fill in order to restore the interior to its visual appearance, and at its simplest this involved aiming one or two lights at rear walls, behind the camera. No precision is necessary, and the same technique helps digital photography. However, instead, even such a simple digital post-production technique as Photoshop's Shadow/Highlight tool can remove the need for this, and the advantage is the saving in time and weight. Going a step further, exposure blending and HDRI can handle any existing lighting situation, and so offer the realistic choice of shooting without lights. Apart from convenience, this allows the exact atmosphere of an interior to be captured, and this might be important with certain architectural interiors (an old church, for example, or a Japanese tea-ceremony room). Time and expense saved on lighting equipment, however, may be more than made up for by extra post-production.

MAKING LIGHT SOFTER

Diffuse daylight
In interiors, large window areas will give soft lighting provided that there is no direct sunlight. In this two-story reception space in a house in Thailand, the windows, behind the camera, face north.

Just as it can help to think of the components that make up daylight in terms of a giant studio, so photographic lighting can be used to mimic natural lighting effects. Diffusion is certainly the most widely used adjustment, not least because by far the majority of lamps are small intense sources. The range of diffusing attachments on pages 106-111 is just a start. For many photographers a softbox or umbrella is the standard attachment.

Diffusing the principal light source has the general effect of giving a more rounded, legible image, by eliminating sharp highlights and shadow edges, and by lightening shadows.

The case for softening the light source is partly efficiency, and partly taste and fashion. Efficient means lighting that reveals as much of the content as possible, and with the least distraction in the form of lighting 'artefacts' such as spectral highlights and sharp shadows. Lighting from a large area source achieves this by broadening highlights, reducing contrast, and filling in shadows, as well as softening shadow edges to the point where they are virtually indistinguishable.

The matter of taste is less rational but often more important, and I link it with fashion because visual tastes, particularly in photography, change often. In still-life photography, the use of soft light is nothing new (think Edward Weston's famous Pepper No. 30, shot in 1930), but it became standardized in advertising around the late 1960s, and has never left the genre as a norm. In particular, the overhead softbox which bathes the subject in top-lighting has proved itself to be widely attractive, or at least inoffensive, and so well-suited to basic product photography. The worst that can be said for it is that soft light can be boring and predictable.

Silver lid
This shiny silver pot-pourri container was lit first (far right) with a single window light. Then tracing paper was rolled into a conical light tent and placed around it for full diffusion with the same light (right).

SOFTENING LIGHT

Nearly all photographic lamps are effectively point sources of light giving harsh, contrasting lighting and must usually be diffused to give a manageable light. Every method of softening a lamp follows just one principle: it increases the size of the light so that the effective source, from the point of view of the subject, is larger. The two main ways of doing this are diffusion and reflection. The best method to use varies with the type of lamp, the conditions and on the precise result the photographer is looking for; each method has a distinctive effect.

Diffusers fit in front of the lamp, and most use some kind of translucent material, such as opal perspex, white fabric, tracing paper, or frosted glass. More open screens such as gauze or ray honeycomb do similar work. When light spill from between the lamp and diffuser is likely to be troublesome, an enclosed diffusion fitting is an advantage. An area light for use with flash heads is designed specifically for this. Otherwise, a free-standing trace frame, corrugated translucent plastic, or a translucent umbrella can be used.

With reflectors, the light is spread out by reflection from a diffusing surface; the lamp is aimed towards the reflector and bounced back toward the subject. More light is lost through bouncing it off one of these reflective surfaces than shining it through a diffuser, but it is often easier to install a large reflector. Indeed, white-painted walls and ceilings are the simplest of all large reflectors. The most commonly used reflectors are collapsible umbrellas, with a variety of inner linings (white to metallic), but plain sheets of virtually any bright material hung from a frame (or the ceiling) may be quite adequate. The more matte the surface, the broader and more even is the reflected light, but also the more light is lost. Matte white, glossy white, wrinkled metallic foil, matte metal finish, and mirror finish comprise the basic range of surfaces.

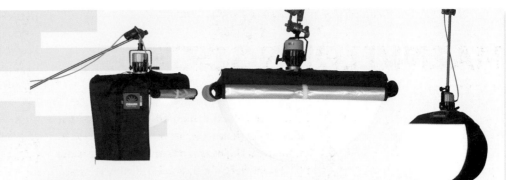

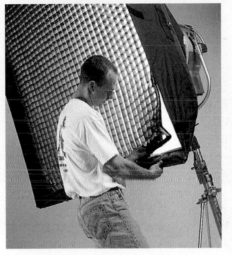

Controlling spread
Beam spread is often an issue with soft lights, and three solutions are honeycomb grids (below), collapsible fabric grids (left, being fitted, and the two taller lights on stands below) and barn doors (the lower left of the three lights below).

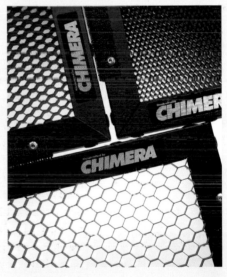

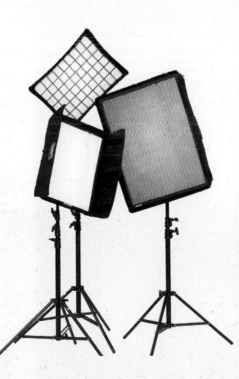

Lantern
Omni-directional covers, or lanterns, also give a soft fill effect. This lantern is being fitted with a fabric cover to diffuse the light even further.

ENVELOPING LIGHT

The most extreme method of softening light is to surround the set with a diffuse light source. This is not the same thing as using several light sources from different directions in such a way that all shadows are filled. Multiple light-source techniques, as we saw on pages 202-203, involve a variety of highlights, contrast of local detail, and a sense of directionality. It is obvious that a number of lights are being used. Enveloping light techniques are extensions of diffusion, in the round, and are characterized by a lack of directionality. There are two reasons for wanting to do this. One is for an ultimate soft, gentle, and shadowless effect; the other is to solve the problem of extremely reflective objects, such as those with mirror surfaces that inconveniently image their surroundings, including camera, lights, and studio.

The traditional construction is a light tent. By surrounding the photography set with the same diffusing material – a translucent fabric, or even tracing paper – it takes the place of a diffusing attachment over the lamp. The light can be placed in any position outside the light tent and it will be diffused. At the same time, because the objects are surrounded by a white material, this reflects light internally and so gives an important degree of shadow fill. Immediately, the objects arranged for photography are enveloped in a softened light. This is not only more efficient at revealing detail all around each object, but gives what is perceived by most people as a gentler and rather more attractive lighting. A simple way of adjusting this is to move the light outside the tent closer or farther away. The farther it is, the more diffuse the light will be, meaning that there will be less of a noticeable hotspot on the fabric wall. At the same time, the light reaching the set will be cut down in quantity, calling for a longer shutter speed and/or a wider aperture.

Using one key-light retains some directionality, and shadows can be filled further simply by placing a reflective surface on the opposite side of the subject from the light, inside the tent. Adding a second light on the opposite side fills the shadows even more strongly. Moving this second light closer or farther away will change its brightness relationship to the main light. There are, of course, no limits to the number of lights that can be used, and precision is not important. The more lights surrounding the tent, the more enveloping and directionless the illumination.

True light tents are a little tricky to assemble and use, as they have to be suspended from above. Also, to maintain the full surround and reduce any reflections of the camera itself in a shiny surface, the lens must just poke through a small hole in the fabric (which can be closed tight around it. A more generally useable design is a collapsible fabric cube made by Lastolite (who specialize in reflectors). At the expense of having corners and edges, which could cause reflection issues in rounded, highly-polished objects (a minority), the cube is easy to erect, position and use.

Techniques for surrounding a subject with directionless shadowless light are easiest to apply on the smaller scales of still-life and close-up, and give a special control over reflections.

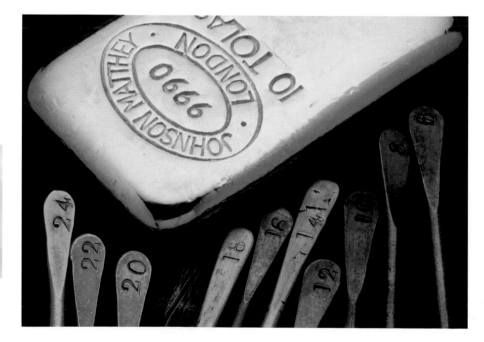

Gold bar
Objects which have reflective surfaces that curve, such as this gold bar, are candidates for all-round light diffusion. Here, large sheets of tracing paper were positioned around the small set. The gap for the camera is visible on the corner, but judged acceptable.

Light tent

A typical light-tent setup, with a boom on a stand supporting the tent. This is ideal for very highly reflective subjects, such as the gold bar on the facing page.

Coving and reflectors

Automobile photography has the problem of scale to add to curved reflective surfaces. A typical lighting approach makes use of coving (a large-scale scoop from floor to wall) and large reflectors precisely positioned.

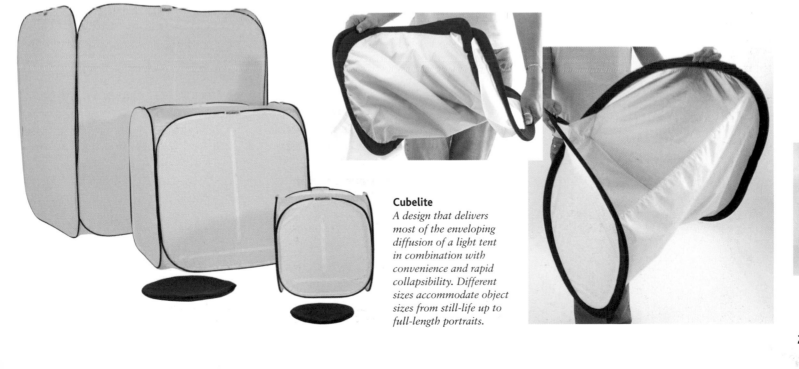

Cubelite

A design that delivers most of the enveloping diffusion of a light tent in combination with convenience and rapid collapsibility. Different sizes accommodate object sizes from still-life up to full-length portraits.

ENVELOPING LIGHT

Silver container
This silver container is used below to illustrate a series of possible lighting setups. Lights were placed as illustrated opposite.

	No fill light	Low fill light

BARE LIGHT SEQUENCE

In this series of shots, bare lights were used, which cast stronger shadows. These provide the least diffusion in this series of examples.

WINDOW LIGHT SEQUENCE

The light was provided by a 40 × 80 cm 'window'. The light's position is described in terms of degrees (horizontal then vertical) from the object.

CUBELITE SEQUENCE

Here, the figurine was placed inside a Lastolite Cubelite (*see page 211*), which diffuses light evenly around the subject. This provides the most diffuse light.

LIGHTING SETUP

The table below uses a single main light, always at full strength. The fill light is shown at increasing brightness (low, mid, and max) and additionally a base light is used in the final column.

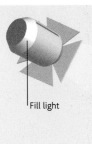

Fill light

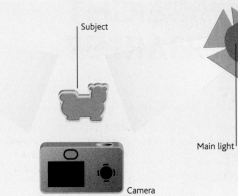

Subject

Main light

Camera

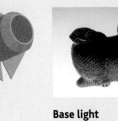

Base light
For illustrative purposes, this shot is lit only with the base light; it is positioned beneath the translucent surface.

Mid fill light	Max fill light	Fill and base light

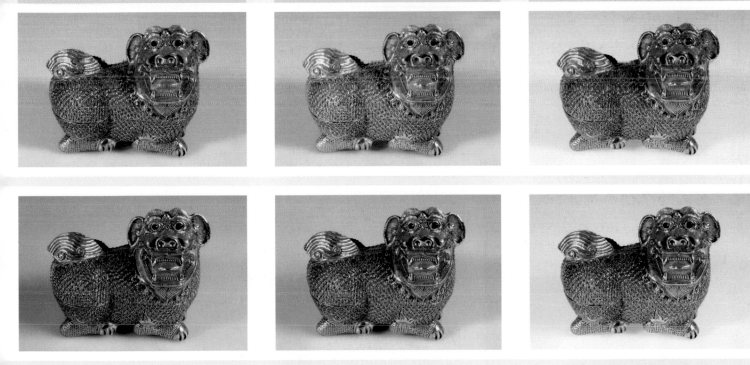

ENVELOPING LIGHT

MAKING LIGHT SHARPER

Snoot
A conical attachment without lens, concentrating the beam by masking it down to a circle.

Concentrating the light into a narrow beam is not quite the opposite of diffusion – a bare lamp bulb on its own casts strong, hard shadows, as in the example on pages 178-179. The purpose of concentration is to limit the area that is lit, and this inevitably means defining a shape. The simplest method is to enclose the sides of the light source, channeling the beam through a narrow opening. Cones and snoots do this by means of a kind of extended masking to produce a circular area of light. Less extreme shaping of the light is achieved by barn doors fitted to the front of the light fixture, and which can be swung into the beam of light to create a rectangular or trapezoidal shape of light. More precision and more choice of effect comes from using lensed spots, including Fresnels. These have a condenser lens to give sharp edges to the circle of illumination, often

The stylistic opposite of enveloping light is the concentrated spotlight, with an array of techniques to define the shadows and shadow edges.

with a means for moving the lamp along the axis. A Fresnel lens, incidentally, is a flattened design that uses stepped arcs of a normal condenser lens profile and compresses them into an almost-flat disc.

Digital techniques offer a hugely valuable extra level of control over the precision of the effect, if spotlighting is combined with multiple layered lighting (*see pages 156-157*). As demonstrated in one of the examples there, edges from one light can be extended or reduced by erasing or history brushing in Photoshop. Applying this quasi-spot technique to an actual spotlit frame allows a completely realistic result, as the example opposite shows.

Sunlight
By virtue of its intensity and distance, the sun in a clear sky functions as a point-source of light, and casts focused shadows. If the weather is reliable, as in this shot of an Ayurvedic dish in the Indian Himalayas in late afternoon, it may be easier to shoot by sunlight than set up photographic lighting.

Focused shadow
Detail of quills, paper and golden inks. A lensed spot has been used to create a sharp light, so perfectly clear shadows of the quills emerge on the paper.

DIGITAL SPOTLIGHTING CONTROL

In this sequence, the spotlighting was shot separately in order to allow for full control over the final effect later. Nothing is lost by doing this.

Layer and erase
The original shot is copied as a layer over the spotlit version. A soft eraser brush is then used to reveal just the parts needed from the spotlighting.

Existing shop lighting
A detail of a shelf with glass in a London shop, where the existing lighting has already been carefully thought through. However, the top of the glass is partly lost against the shadow on the wall, and the glass itself could do with direct illumination.

Added spotlight
A lensed spot with barndoors from a low angle brings some life to the glass, opens up the wall shadow, and casts an extra shadow in the desired position to emphasize the tulip shape. However, the edge of the shelf is now overlit, despite attempts to mask down with the barndoors, and the new light cuts into the wall shadow too strongly.

Final combination
Note that the shadow structure on the wall now conforms to the outlines of the glass and its shadow – the equivalent of a very precisely shaped beam.

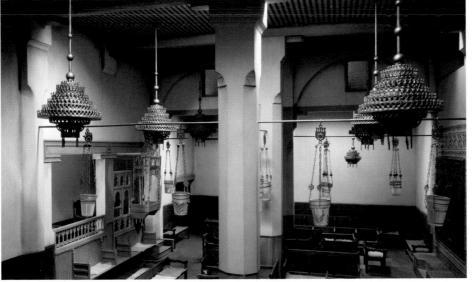

Miniature lighting
Maintaining realism when lighting a scale model means using miniature lights in order to keep shadow edges sharp, as in this model of the interior of a synagogue in a museum.

OPTICAL PRECISION LIGHTING

E ven a regular lensed spotlight – typically a Fresnel – is limited in the shape of the beam it throws, and the edges of the beam can be controlled only by adjusting barndoors or by placing flags strategically between the light and the set. Moreover, Fresnels tend to suffer from 'hot shoulders', meaning that the outer edge of the circular beam is usually brighter than the central area. With daylight HMI lamps, an extra small deficiency is that the lamps themselves do not have homogenous colour properties, with the risk of bluish rims to the beam in some focus positions.

Projection spots and projection spot attachments are the solution when precise shapes with precise edges are needed. Many of these feature an adjustable aperture close to the nodal point of the lens system, and/or space for a custom shape (a gobo). In combination with the focusing system, the beam shape created by masking down this aperture can be rendered sharp or blurred. One proprietary lighting system, Dedolight, is dedicated to this kind of precision, and can throw exactly defined shapes of light across a large set without interfering with other components of the lighting.

A step further in shape control comes from a projection spot, featuring a lensed attachment that will focus a shape on part of the set.

Eye attachment

Originally designed to create eye-bars in cinematography (to highlight an actor's eyes), this filter attachment is for use with a projection spot, and consists of three polycarbonate filters that soften shadow edges – these are not diffusion filters. At full edge-softening, the effect becomes a glow rather than a recognizable shape.

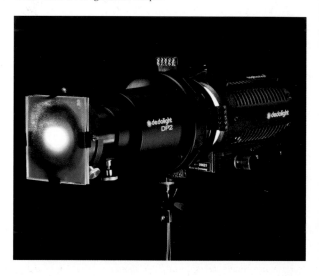

Dedolight

The self contained Dedolight DLHM4-300 works with an integrated electronic power supply, in four different input voltage versions: 240V, 230V, 120V, and 100V. It features a double aspheric lens system (see opposite), and is dimmable. The focus angle varies from 48° down to 4.5°.

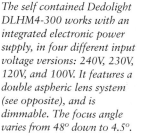

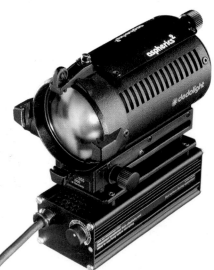

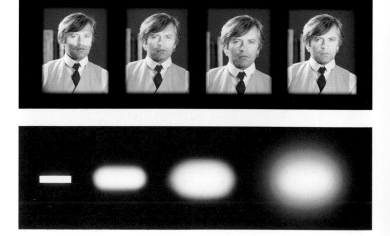

Projection spot

The Dedolight Series 400 Imager is a projection attachment and modular system. The back part of the projection attachment contains a two lens condenser system, while an image plane adjustment control allows projections from an off-angle position to be focus-corrected. A framing shutter assembly sets the edges of the lit area, with either adjustable leaves or an inserted gobo.

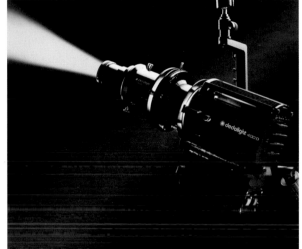

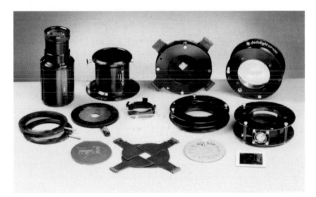

Shaped brightening

A Dedolight with projection spot and eye filters used to define a highlight a label. Focused and unfiltered, the label pops out strongly. Increasing strengths of filter blend the effect more into the overall lighting.

The weakest filter (picture 1) just takes the edge off a shadow border, while the strongest filter (picture 3) or a combination creates a transition so gentle that the effect is no longer obvious, but just glows softly.

Beam adjustment

A linked sequence of three different mechanical operations adjusts the relative positions of the lamp, mirror, and second lens, for a 20:1 variation in intensity from spot to flood. In Motion 1, from a 56° beam super-flood down to flood, the lamp and mirror move in unison back from the two lenses. At a particular point in the beam's mid-range (Motion 2), the second lens joins the lamp and mirror and all move back together. Finally, in Motion 3, the second lens stops and the lamp and mirror continue backwards for a tight spot.

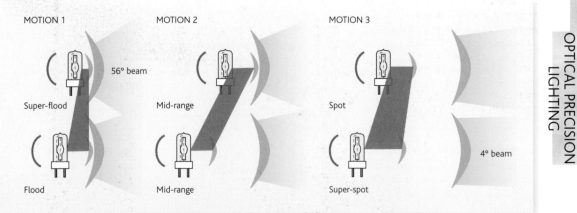

MOTION 1 · Super-flood · 56° beam · Flood

MOTION 2 · Mid-range · Mid-range

MOTION 3 · Spot · Super-spot · 4° beam

GLOSSARY

Computing is awash with jargon. No, worse than that – it *breeds* jargon, making a large part of most computer magazines, for example, unintelligible to any but the initiated. Similarly photography and the assortment of associated arts (of which lighting is just one), is a world which can shield itself from outsiders in a protective cloak of terminology. Merge the two, as we must for this book, and life can become complicated for even the most patient of readers. On top of that, and especially in the area of lighting terminology, there are always crossovers in meaning; a 'flag' and a 'gobo' (go between) can mean the same thing to one photographer and be separate entities to another, for example.

Despite rigorous attempts at editing, I realise that this book still uses a fairly full complement of jargon, and to be honest, removing any more than I already have would not help. If you find some of the computer terms especially difficult, you might like to try this book's sister title, *The Complete Guide to Digital Photography (ISBN 1-50054-277-8)* for a more gentle learning curve. Here, though, I've attempted to compile all the terms that may be unfamiliar when you first open the book. Explaining concepts in many words every time would simply become irritating to read, as well as to write. I'm afraid that we're stuck with much of this jargon. The best solution seems to me to have a substantial glossary to cope with it.

aperture The opening behind the camera lens through which light passes on its way to the image sensor (CCD/CMOS).

artifact A flaw in a digital image.

axis lighting Light aimed at the subject from close to the camera's lens.

backlighting The result of shooting with a light source, natural or artificial, behind the subject to create a silhouette or rim-lighting effect.

ballast The power pack unit for an HMI light which provides a high initial voltage.

barn doors The adjustable flaps on studio lighting equipment which can be used to control the beam emitted.

barn door tracker A remarkably effective device used by amateur photographers to turn a camera to follow the movement of stars across the night sky.

bit (binary digit) The smallest data unit of binary computing, being a single 1 or 0.

bit depth The number of bits of colour data for each pixel in a digital image. A photographic-quality image needs eight bits for each of the red, green, and blue channels, making for a bit depth of 24.

boom A support arm for attaching lights or fittings to.

bracketing A method of ensuring a correctly exposed photograph by taking three shots; one with the supposed correct exposure, one slightly underexposed, and one slightly overexposed.

brightness The level of light intensity. One of the three dimensions of colour in the HSB colour system. See also Hue and Saturation

byte Eight bits. The basic unit of desktop computing. 1,024 **bytes** equals one kilobyte (KB), 1,024 kilobytes equals one megabyte (MB), and 1,024 megabytes equals one gigabyte (GB).

calibration The process of adjusting a device, such as a monitor, so that it works consistently with others, such as scanners or printers.

candela Measure of the brightness of a light source itself.

CCD (Charge-Coupled Device) A tiny photocell used to convert light into an electronic signal. Used in densely packed arrays, CCDs are the recording medium in most digital cameras.

channel Part of an image as stored in the computer; similar to a layer. Commonly, a colour image will have a channel allocated to each primary colour (e.g. RGB) and sometimes one or more for a mask or other effects.

cloning In an image-editing program, the process of duplicating pixels from one part of an image to another.

CMOS (Complementary Metal-Oxide Semiconductor) An alternative sensor technology to the CCD, CMOS chips are used in ultra-high-resolution cameras from Canon and Kodak.

CMYK (Cyan, Magenta, Yellow, Key) The four process colours used for printing, including black (key).

colour gamut The range of colour that can be produced by an output device, such as a printer, a monitor, or a film recorder.

colour temperature A way of describing the colour differences in light, measured in Kelvins and using a scale that ranges from dull red (1900 K), through orange, to yellow, white, and blue (10,000 K).

compression Technique for reducing the amount of space that a file occupies, by removing redundant data. There are two kinds of compression: standard and lossy. While the first simply uses different, more processor-intensive routines to store data than the standard file formats (see LZW), the latter actually discards some data from the image. The best known lossy compression system is JPEG, which allows the user to choose how much data is lost as the file is saved.

contrast The range of tones across an image, from bright highlights to dark shadows.

cropping The process of removing unwanted areas of an image, leaving behind the most significant elements.

depth of field The distance in front of and behind the point of focus in a photograph, in which the scene remains in acceptable sharp focus.

dialog box An onscreen window, part of a program, for entering settings to complete a procedure.

diffusion The scattering of light by a material, resulting in a softening of the light and of any shadows cast. Diffusion occurs in nature through mist and cloud cover, and can also be simulated using diffusion sheets and soft-boxes.

digital zoom Many cheaper cameras offer a digital zoom function. This simply crops from the centre of the image and scales the image up using image processing algorithms (indeed the same effect can be achieved in an image editor later). Unlike a zoom lens, or 'optical zoom', the effective resolution is reduced as the zoom level increases; 2× digital zoom uses ¼ of the image sensor area, 3× uses ⅑, and so on. The effect of this is very poor image quality; Even if you start with an eight megapixel sensor, at just 3× digital zoom your image would be taken from less than one megapixel of it.

DMax (Maximum Density) The maximum density – that is, the darkest tone – that can be recorded by a device.

DMin (Minimum Density) The minimum density – that is, the brightest tone – that can be recorded by a device.

dye sublimation printer A colour printer that works by transferring dye images to a substrate (paper, card, etc.) by heat, to give near photographic-quality prints.

edge lighting Light that hits the subject from behind and slightly to one side, creating flare or a bright 'rim lighting' effect around the edges of the subject.

feathering In image-editing, the fading of the edge of an image or selection.

file format The method of writing and storing information (such as an image) in digital form. Formats commonly used for photographs include TIFF, BMP, and JPEG.

fill-in flash A technique that uses the on-camera flash or an external flash in combination with natural or ambient light to reveal detail in the scene and reduce shadows.

fill light An additional light used to supplement the main light source. Fill can be provided by a separate unit or a reflector.

filter (1) A thin sheet of transparent material placed over a camera lens or light source to modify the quality or colour of the light passing through. (2) A feature in an image-editing application that alters or transforms selected pixels for some kind of visual effect.

flag Something used to partially block a light source to control the amount of light that falls on the subject.

flash meter A light meter especially designed to verify exposure in flash photography. It does this by recording values from the moment of a test flash, rather than simply measuring the 'live' light level.

focal length The distance between the optical centre of a lens and its point of focus when the lens is focused on infinity.

focal range The range over which a camera or lens is able to focus on a subject (for example, 0.5m to Infinity).

focus The optical state where the light rays converge on the film or CCD to produce the sharpest possible image.

fringe In image-editing, an unwanted border effect to a selection, where the pixels combine some of the colours inside the selection and some from the background.

frontal light Light that hits the subject from behind the camera, creating bright, high-contrast images, but with flat shadows and less relief.

f-stop The calibration of the aperture size of a photographic lens.

gamma A measure of the contrast of an image, expressed as the steepness of the characteristic curve of an image.

gobo A corruption of 'go between', this is anything used to block or partially block light.

gradation The smooth blending of one tone or colour into another, or from transparent to coloured in a tint. A graduated lens filter, for instance, might be dark on one side, fading to clear on the other.

greyscale An image made up of a sequential series of 256 grey tones, covering the entire gamut between black and white.

halogen bulb Common in modern spotlighting, halogen lights use a tungsten filament surrounded by halogen gas, allowing it to burn hotter, longer and brighter.

haze The scattering of light by particles in the atmosphere, usually caused by fine dust, high humidity, or pollution. Haze makes a scene paler with distance, and softens the hard edges of sunlight.

HDRI (High Dynamic Range Imaging) A method of combining digital images taken at different exposures to draw detail from areas which would traditionally have been over or under exposed. This effect is typically achieved using a Photoshop plugin, and HDRI images can contain significantly more information than can be rendered on screen or even perceived by the human eye.

histogram A map of the distribution of tones in an image, arranged as a graph. The horizontal axis goes from the darkest tones to the lightest, while the vertical axis shows the number of pixels in that range.

HMI (Hydrargyrum Medium-arc Iodide) A lighting technology known as 'daylight' since it provides light with a colour temperature of around 5600 K.

honeycomb grid In lighting, a grid can be placed over a light to prevent light straying. The light can either travel through the grid in the correct direction, or will be absorbed by the walls of each cell in the honeycomb.

hot-shoe An accessory fitting found on most digital and film SLR cameras and some high-end compact models, normally used to control an external flash unit. Depending on the model of camera, pass information to lighting attachments via the metal contacts of the shoe.

HSB (Hue, Saturation, Brightness) The three dimensions of colour, and the standard colour model used to adjust colour in many image-editing applications.

hue The pure colour defined by position on the colour spectrum; what is generally meant by 'colour' in lay terms.

incandescent lighting This strictly means light created by burning, referring to traditional filament bulbs. They are also know as hotlights, since they remain on and become very hot.

incident meter A light meter as opposed to the metering systems built into many cameras. These are used by hand to measure the light falling at a particular place, rather than (as the camera does) the light reflected from a subject.

ISO An international standard rating for film speed, with the film getting faster as the rating increases. ISO 400 film is twice as fast as ISO 200, and will produce a correct exposure with less light and/or a shorter exposure. However, higher-speed film tends to produce more grain in the exposure, too.

Joule Measure of power, see watt-seconds.

JPEG (Joint Photograhic Experts Group) Pronounced 'jay-peg', a system for compressing images, developed as an industry standard by the International Standards Organization. Compression ratios are typically between 10:1 and 20:1, although lossy (but not necessarily noticeable to the eye).

kelvin Scientific measure of temperature based on absolute zero (simply take 273.15 from any temperature in Celsius to convert to kelvin). In photography measurements in kelvin refer to colour temperature. Unlike other measures of temperature, the degrees symbol in not used.

lasso In image-editing, a tool used to draw an outline around an area of an image for the purposes of selection.

layer In image-editing, one level of an image file, separate from the rest, allowing different elements to be edited separately.

LCD (Liquid Crystal Display) Flat screen display used in digital cameras and some monitors. A liquid-crystal solution held between two clear polarizing sheets is subject to an electrical current, which alters the alignment of the crystals so that they either pass or block the light.

light pipe A clear plastic material that transmits like, like a prism or optical fibre.

light tent A tent-like structure, varying in size and material, used to diffuse light over a wider area for close-up shots.

lumens A measure of the light emitted by a lightsource, derived from candela.

luminaires A complete light unit, comprising an internal focusing mechanism and a fresnel lens. An example would be a focusing spot light. The name luminaires derives from the French, but is used by professional photographers across the world.

luminosity The brightness of a colour, independent of the hue or saturation.

lux A scale for measuring illumination, derived from lumens. It is defined as one lumen per square metre, or the amount of light falling from a light source of one candela one metre from the subject.

LZW (Lempel-Ziv-Welch) A standard option when saving TIFF files which reduces file sizes, especially in images with large areas of similar colour. This option does not lose any data from the image, but cannot be opened by some image editing programs.

macro A mode offered by some lenses and cameras that enables the lens or camera to focus in extreme close-up.

mask In image-editing, a greyscale template that hides part of an image. One of the most important tools in editing an image, it is used to limit changes to a particular area or protect part of an image from alteration.

megapixel A rating of resolution for a digital camera, directly related to the number of pixels forming or output by the CMOS or CCD sensor. The higher the megapixel rating, the higher the resolution of images created by the camera.

midtone The parts of an image that are approximately average in tone, falling midway between the highlights and shadows.

modelling light A small light built into studio flash units which remains on continuously. It can be used to position the flash, approximating the light that will be cast by the flash.

monobloc An all-in-one flash unit with the controls and power supply built-in. Monoblocs can be synchronized together to create more elaborate lighting setups.

noise Random pattern of small spots on a digital image that are generally unwanted, caused by nonimage-forming electrical signals.

open flash The technique of leaving the shutter open and triggering the flash one or more times, perhaps from different positions in the scene.

peripheral An additional hardware device connected to and operated by the computer, such as a drive or printer.

pixel (PICture ELement) The smallest units of a digital image, pixels are the square screen dots that make up a bitmapped picture. Each pixel carries a specific tone and colour.

photoflood bulb A special tungsten light, usually in a reflective dish, which produces an especially bright (and if suitably coated white) light. The bulbs have a limited lifetime.

plug-in In image-editing, software produced by a third party and intended to supplement a program's features or performance.

power pack The separate unit in flash lighting systems (other than monoblocks) which provides power to the lights.

ppi (pixels-per-inch) A measure of resolution for a bitmapped image.

processor A silicon chip containing millions of micro-switches, designed for performing specific functions in a computer or digital camera.

QuickTime VR An Apple-developed technology that allows a series of photos to be joined in a single file which the user can then use to look around, say, a product or a room.

RAID (Redundant Array of Independent Disks) A stack of hard disks that function as one, but with greater capacity.

RAM (Random Access Memory) The working memory of a computer, to which the central processing unit (cpu) has direct, immediate access.

raw files A digital image format, known sometimes as the 'digital negative', which preserves higher levels of colour depth than traditional 8 bits per channel images. The image can then be adjusted in software – potentially by three *f* stops – without loss of quality. The file also stores camera data including meter readings, aperture settings and more. In fact each camera model creates its own kind of raw file, though leading models are supported by software like Adobe Photoshop.

reflector An object or material used to bounce available light or studio lighting onto the subject, often softening and dispersing the light for a more attractive end result.

resampling Changing the resolution of an image either by removing pixels (lowering resolution) or adding them by interpolation (increasing resolution).

resolution The level of detail in a digital image, measured in pixels (e.g. 1,024 by 768 pixels), or dots-per-inch (in a half-tone image, e.g. 1200 dpi).

RFS (Radio Frequency System) A technology used to control lights where control signals are passed by radio rather than cable. It has the advantage of not requiring line-of-sight between the transceiver and device.

RGB (Red, Green, Blue) The primary colours of the additive model, used in monitors and image-editing programs.

rim-lighting Light from the side and behind a subject which falls on the edge (hence rim) of the subject.

ring-flash A lighting device with a hole in the centre so that the lens can be placed through it, resulting in shadow-free images.

satellite In lighting, this is a parabolic dish designed to reflect and diffuse light.

saturation The purity of a colour, going from the lightest tint to the deepest, most saturated tone.

scrim a light open-weave fabric, used to cover softboxes.

selection In image-editing, a part of an on-screen image that is chosen and defined by a border in preparation for manipulation or movement.

shutter The device inside a conventional camera that controls the length of time during which the film is exposed to light. Many digital cameras don't have a shutter, but the term is still used as shorthand to describe the electronic mechanism that controls the length of exposure for the CCD.

shutter speed The time the shutter (or electronic switch) leaves the CCD or film open to light during an exposure.

SLR (Single Lens Reflex) A camera that transmits the same image via a mirror to the film and viewfinder, ensuring that you get exactly what you see in terms of focus and composition.

slow sync The technique of firing the flash in conjunction with a slow shutter speed (as in rear-curtain sync).

snoot A tapered barrel attached to a lamp in order to concentrate the light emitted into a spotlight.

soft-box A studio lighting accessory consisting of a flexible box that attaches to a light source at one end and has an adjustable diffusion screen at the other, softening the light and any shadows cast by the subject.

spot meter A specialized light meter, or function of the camera's light meter, that takes an exposure reading for a precise area of a scene.

sync cord The electronic cable used to connect camera and flash.

telephoto A photographic lens with a long focal length that enables distant objects to be enlarged. The drawbacks include a limited depth of field and angle of view.

TIFF (Tagged Image File Format) A file format for bitmapped images. It supports CMYK, RGB, greyscale files with alpha channels, lab, indexed-colour, and LZW lossless compression. It is now the most widely used standard for good-resolution digital images.

top lighting Lighting from above, useful in product photography since it removes reflections.

TTL (Through The Lens) Describes metering systems that use the light passing through the lens to evaluate exposure details.

tungsten A metallic element, used as the filament for lightbulbs, hence tungsten lighting.

umbrella In photographic lighting umbrellas with reflective surfaces are used in conjunction with a light to diffuse the beam.

vapour discharge light A lighting technology common in stores and street lighting. It tends to produce colour casts.

watt-seconds A measure of lighting power. One watt-second (Ws) is exactly equivalent to one Joule (a more common measure in Europe). Because this is a scientific measure of the energy used by the light, rather than light output, it can sometimes be misleading. For example, a focused spot using the same energy as a diffused light would be much brighter as all the energy is concentrated into a small beam of light.

white balance A digital camera control used to balance exposure and colour settings for artificial lighting types.

window light A softbox, typically rectangular (in the shape of a window) and suitably diffused.

zoom A camera lens with an adjustable focal length, giving, in effect, a range of lenses in one. Drawbacks include a smaller maximum aperture and increased distortion over a prime lens (one with a fixed focal length).

BIBLIOGRAPHY AND USEFUL ADDRESSES

BOOKS
Digital imaging and photography

The Complete Guide to Digital Photography
Michael Freeman, *Ilex Press*, UK 2002

Digital Photography Expert Series:
 Black and White (2005)
 Close Up (2004)
 Colour (2005)
 Light and Lighting (2003)
 Nature and Landscape (2004)
 Portrait (2003)
All by Michael Freeman, *Ilex Press*, UK,

The Digital SLR Handbook
Michael Freeman, *Ilex Press*, UK 2005

On the Road with your Digital Camera
Michael Freeman, *Ilex Press*, UK 2004

Creative Photoshop Lighting Techniques
Barry Huggins, *Ilex Press*, UK 2004

Mastering Black and White Digital Photography
Michael Freeman, *Ilex Press*, UK 2005

Mastering Color Digital Photography
Michael Freeman, *Ilex Press*, UK 2005

WEB SITES

Note that Website addresses may often change, and sites appear and disappear with alarming regularity. Use a search engine to help find new arrivals or check addresses.

Photoshop sites
(tutorials, information, galleries)

Absolute Cross Tutorials (including plug-ins)
www.absolutecross.com/tutorials/photoshop.htm

Laurie McCanna's Photoshop Tips
www.mccannas.com/pshop/photosh0.htm

Planet Photoshop (portal for all things Photoshop)
www.planetphotoshop.com

Ultimate Photoshop
www.ultimate-photoshop.com

Digital imaging and photography sites

Creativepro.com (e-magazine) www.creativepro.com

Digital Photography www.digital-photography.org

Digital Photography Review (digital cameras)
www.dpreview.com

ShortCourses (digital photography: theory and practice) www.shortcourses.com

Software

Photoshop, Photoshop Elements, Photodeluxe
www.adobe.com

Paintshop Pro, Photo-Paint, CorelDRAW!
www.corel.com

PhotoImpact, PhotoExpress www.ulead.com

Toast Titanium www.roxio.com

USEFUL ADDRESSES

Adobe (Photoshop, Illustrator) www.adobe.com

Agfa www.agfa.com

Alien Skin (Photoshop Plug-ins)
www.alienskin.com

Apple Computer www.apple.com

Association of Photographers (UK) www.aop.org

British Journal of Photography www.bjphoto.co.uk

Corel (Photo-Paint, Draw, Linux) www.corel.com

Digital camera review www.dpreview.com

Epson www.epson.co.uk www.epson.com

Extensis www.extensis.com

Formac www.formac.com

Fractal www.fractal.com

Fujifilm www.fujifilm.com

Hasselblad www.hasselblad.se

Hewlett-Packard www.hp.com

Iomega www.iomega.com

Kodak www.kodak.com

Konica Minolta www.konicaminolta.com

Lexmark www.lexmark.co.uk

Linotype www.linotype.org

LaCie www.lacie.com

Luminos (paper and processes) www.luminos.com

Macromedia (Director) www.macromedia.com

Microsoft www.microsoft.com

Nikon www.nikon.com

Nixvue www.nixvue.com

Olympus
www.olympusamerica.com
www.olympus.co.uk

Paintshop Pro www.jasc.com

Pantone www.pantone.com

Philips www.philips.com

Photographic information site www.ephotozine.com

Photoshop tutorial sites www.planetphotoshop.com
www.ultimate-photoshop.com

Polaroid www.polaroid.com

Qimage Pro www.ddisoftware.com/qimage/

Ricoh www.ricoh-europe.com

Samsung www.samsung.com

Sanyo www.sanyo.co.jp

Shutterfly (Digital Prints via the web)
www.shutterfly.com

Sony www.sony.com

Sun Microsystems www.sun.com

Symantec www.symantec.com

Umax www.umax.com

Wacom (graphics tablets) www.wacom.com

INDEX

A

Absolute Zero 21
actuality 77, 86, 129, 158
Adams, Ansel 41
Adobe RGB 118–19
angles 42–47, 176–83, 206, 212–13, 217
aperture 25, 74, 137, 158, 210, 216
Apple Aperture 120
architecture 34, 43, 60, 70, 207
area–lights 106, 169, 196
art 118–19
artefacts 16, 34–35, 158, 208
artificial light 77
ascension 56
Automatic High Dynamic Range Image Acquisition (AHDRIA) 139
Automatic High Dynamic Range Image Creation (AHDRIC) 139
axial lighting 200–1

B

back–lighting 44, 59, 91–92, 114–15, 126, 172, 174–75, 195–97
baggage charges 102
ballast 99–101
bare light sequence 212
barn doors 99, 214, 216
base lighting 196
batch processing 135, 139, 150
Bauhaus 169
beam adjustment 217
beam splitting 200
beauty lighting 63, 192–95, 198
bit–depth 15–17, 39, 126, 131, 136, 138, 140, 146, 148, 150
black body 20–21, 82
black point 122, 124–25
blending 132–35, 139, 150–53, 207
bracketing 38–39, 64, 132–33, 137, 152
brightness 24–25, 32, 38, 53, 66–68, 71, 92, 117,

122–26, 128, 130, 150, 162, 204
broadlights 106
buildings 43, 46, 68, 70

C

calibration 98, 118–19
camera–mounted flash 92–93
camouflage 200
Canon 139
catch–lights 204
centre–circle 22–23
centre–weighted metering 22–24, 64
ceramic lamps 96
chiaroscuro 170–71
chrominance 34
cityscapes 72
clamps 105
clipping 12, 14–15, 26, 30, 32, 38–39, 60, 68, 130
close–ups 91, 175, 201, 210
cloud 41–42, 44, 46, 50–56, 60, 64, 68, 71, 124–25, 152, 162, 202
collapsible reflectors 111
Colour Rendering Index (CRI) 82
colour balance 9
colour cast 10, 19–20, 36, 68, 84–85, 98, 118
colour management 118
colour perception 19
colour temperature 20–21, 36–37, 41, 44, 50–51, 53–56, 58, 63, 68, 72, 78, 82, 96, 100, 164–66
component light sequence 212
compositing 157
composition 60, 64, 152
Constructivism 169
contours 142
contrast 9–10, 16, 22–23, 26, 28–31, 38–39, 45, 52, 59–60, 63, 66–68, 74, 92, 120–22, 124–25, 127–31, 133, 136–37, 140, 146, 148, 150, 162, 169–71, 184–85, 199, 202, 208–12
contre–jour 74

Correlated Colour Temperature (CCT) 20, 36, 77–78, 82
Cubelights 210–11
curve adjustments 142–47
Curves 122–24, 127, 132

D

dark frame extraction 34
daybreak 56–57
daylight 10–11, 41, 43–44, 48, 53, 56, 60, 62–63, 77–78, 82, 88, 97–98, 100, 152–55, 169, 202, 204, 207
daylight lamps (HMI) 84, 91, 96, 98–99, 169, 216
De Meyer 91
Debevec, Paul 139
Dedolight 216–15
depth of field 137
dichroic filters 97
diffusers 50–53, 55, 60, 62, 66, 74, 91, 97, 100, 105–9, 169, 174, 195–96, 208–10
DIY blending 132–34
dust storms 65
dynamic range 12–13, 39, 66, 74, 117, 126, 128–31, 133, 136–40, 146, 150, 152, 156, 158, 162, 184

E

edge–lighting 59
Edison, Thomas 78
effects 91, 112–15, 138, 158
elevation 47
enveloping light 210–11
equipment 91, 169, 204, 207
Eraser 132
exposure 9, 24–26, 32, 38–39, 53, 64, 66, 68, 71–72, 74, 113–15, 118, 129, 132–33, 137, 142–43, 150–51, 164–65, 197, 207
Exposure Value (EV) 24–25, 50, 53, 131, 138
eye 10, 12, 16, 19, 34, 36, 56–57, 65, 72, 74, 82–83, 128–30, 148, 192–93, 204, 216

F

f–stops 12, 25, 38, 50–51, 53, 56, 64, 66, 71, 115, 131–32, 136–38, 150, 152, 197
faces 192–93
fashion 91, 118, 198
fashion shots 63
fill lights 63, 78–79, 92, 98, 177, 184–93, 204
fill–in flash 92–93
filters 97–98, 113–15, 126, 162, 217
fish–fryers 106
fixed–pattern noise 34–35, 71–72
fixtures 106, 110, 115
flags 110–11, 158, 216
flare 10–11, 74–75, 91, 110, 127, 129–30, 139, 158–59, 165, 195
flash 24, 38, 91–96, 100, 106, 112, 200–1, 209
flashlights 113
flicker 99–101
floating point formats 136, 138
Floating Point TIFF 136
floodlights 68, 72, 85
fluorescent light 11, 19–20, 77, 79, 82–84, 86, 100–101
fog 42, 66–67, 160–61
Fresnels 96, 100, 214, 216
frontal lighting 59
Fujifilm 15
full frontal lighting 92, 200–201
fur 198

G

gamma 142–43
gamut 118, 120–21
gels 97–98
ghosts 139
global operators 140
globe lights 115
gobos 171, 216–15
golden light 47, 58–59
GPS handsets 56
gradient banding 17

GretagMacbeth 119
grey card 22, 83
grey point 80, 87
grips 105

H

H&S Details 134–35
hair 198
halogen bulbs 97, 100, 106
hand–held meters 22, 24, 117, 185, 197
hatchet lighting 198
haze 42, 44, 51, 56, 60, 71, 91, 160
heat–resistant fabrics 106
height of light 46
High Dynamic Range (HDR) 12, 17, 30, 78, 132, 134, 140, 146–50, 154, 158, 162, 164
High Dynamic Range Image (HDRI) 74, 117, 128–31, 134, 136–39, 148, 150, 152, 164, 207
high–performance fluorescent 100–101
highlights 9, 12, 14–15, 23, 26, 30, 32, 34, 36, 38–39, 60, 68, 120, 122, 124, 126, 129–34, 137, 140–41, 146, 152, 202, 208, 210
histogram 9, 12, 14–15, 32–33, 52, 60, 66, 94, 120, 122, 132, 142–43, 146–47
housings 100
hue 36–37, 80–81, 83, 85, 87
Hydrargyrum Medium–arc Iodide (HMI) 98–99

I

incandescent light 11, 20, 37, 78–81, 94, 96–98, 100, 106, 165
incident–light reading 22, 24
Industrial Light and Magic (ILM) 138, 149
interpolation 16
inverse square law 11
ISO setting 34–35, 71–72, 77, 94

J

JPEG format 12, 15, 34, 39, 83, 131, 140, 148

K

key tones 26–27
klieg light 91
Kodachrome 129

L

lamp dishes 106–9
lamp performance 79
landscapes 34, 43–44, 46, 51, 56, 60, 64, 91, 158
lasers 114
Lastolite 210
latitude 43–44, 46–48, 58
Layers 132, 134, 156–57, 161, 215
Levels 120, 122–23
light sources 11–12, 77, 86–89, 93, 106, 112, 164, 204–5, 210, 214
light tables 196
light tents 210–9
lightbanks 203
liquids 175
Local Adaptation 142–43, 145–47, 155
local operators 140
long exposure 68, 71, 93, 114
longitude 46
looney 18 rule 71
louvres 100
luminaires 96, 106, 206
luminance 34
lux 25, 71

M

macro 201
main lights 176–83
mains flash 94–95
masking 75
matrix metering 23–24, 64
Merge to HDR 136
merging methods 150–51
metering 22–31, 185, 197
Micro Reciprocal Degrees (MIREDs) 21
mid–tones 9, 14, 34, 39, 129, 146
Midtone Contrast 126
miniature slaves 112
mixed light 86–89
modelling lamps 94, 96
modifiers 106
monitors 148

monobloc flash 94
monochrome 86
moonlight 68, 71
multiple layered lighting 156–57, 214
multiple light sources 204–5, 210
Multiply 132–33

N

nature 91
neutralization 86–87, 89
news photography 92
night 68–72, 77, 84
nikMultimedia 162
Nikon 15, 22–23, 33, 83, 88–89
noise 34–35, 71–72
Noise Ninja 34–35
northlight 20

O

OpenEXR 138–39, 148–50
optical precision lighting 216–15
optimization 61, 86, 120–21
over–exposure 14–15, 25, 32, 38, 64, 92, 134
overhead lighting 202–3, 208

P

pack–shots 118
panning 164
panoramas 164–65
perspective 66
PhaseOne Capture One 120
Photomatix 132, 134, 136–37, 139–40, 144–45, 148–54
Photoshop 33, 36, 38–39, 80–81, 83, 85, 88–89, 118–24, 126, 130, 132–34, 136–40, 142, 146, 150, 152, 155, 158–60, 165, 207, 214
Photosphere 139, 148–49, 158
plug–ins 158
polarized lights 114–15
Portable Float Maps (PFM) 136
portraits 43–44, 51, 60, 63, 91–92, 111, 192–93, 198, 202, 204
positioning 176–83
Preset 36
previews 148–49

product shots 100
profiles 118
projector spots 204, 216–15

Q

QuickTime Virtual Reality (QTVR) 164–67

R

Radiance 136, 150
rainbows 65
Raw format 15–16, 36, 39, 66, 77–78, 80, 83–84, 88, 117, 121, 123, 130, 140
read–noise 35
realism 130–31
rear–curtain sync 93
red eye 92, 201
Redheads 96
reflections 69, 74–75, 196, 198, 201–202, 204, 210
reflectivity 20, 22, 24, 54, 110, 184
reflectors 54–55, 60, 62–63, 71, 93–94, 96, 100, 106, 110–11, 184–93, 209–9
refraction 174, 198
relief 199
Renaissance 170
Replace Color 165
reportage 91–92
resolution 126, 137
RGB colour 37
rim–lights 198–97, 204
ring flash 200–99
ring–lights 91, 100

S

saccadic movements 10, 128
saturation 85, 113, 146, 150, 162
scattering 56
Scotchlite 201
Screen 132–33
seasons 46, 58
sensitivity 34–35, 71, 77, 100, 128
sensor response 14–15, 26, 133
shadows 9, 12, 14, 30, 32, 34–35, 38–39, 41, 44–46, 50, 52–54, 59–60, 62–63, 66, 92, 106, 110, 120, 122, 124, 126–27, 130–31, 133, 137, 140–41, 146, 152, 162, 165, 170–71, 177, 184–85, 192–94, 198,

201–202, 204, 207–6, 210, 214
sharp light 214–13
sharpening 34
shopping plazas 77, 88–89
shot–noise 35
shoulder 14
shutter speed 25, 83, 210
side–lighting 59, 172, 185, 196, 198–97
silhouettes 10–11, 44, 56, 59, 66, 68, 74, 126, 129–30, 152
skies 16, 20–21, 23, 25, 42, 44, 51, 53, 55–56, 63–64, 68, 152, 162
skin 192
slaves 112
smoke 66, 114, 160
snow 24
soft light 60–63, 96–97, 100, 106, 208–8
soft–boxes 106, 169, 196, 208
spaces 206–5
spectrum 18, 82, 85, 87, 100
Spheron 138
spot metering 23–24, 64
spotlights 42, 44, 175, 214–13
sRGB 118
stands 102, 176, 202
Steichen 91
still–life shots 91, 100, 102, 169, 177, 196, 202, 208, 210
stormlight 64–65
strip lights 197–96
studio lighting 46, 50, 54, 59, 63, 82, 91, 94–95, 100, 102, 169, 176–77, 184, 196, 202, 204
style 91–92, 169–70, 204, 214
subtractive lighting 62, 110
sun–viewing filters 65
sunlight 11, 18, 20–21, 32, 34, 36, 41–49, 51, 53–54, 56, 60, 63–64, 71, 74–75, 93, 114, 162–63, 165, 197, 202–203, 214
sunny 16 rule 71
supports 102–5, 176, 195
swimming pools 106

T

texture 172–73, 192, 196, 198–97
three–quarter lighting 176, 192

TIFF format 15, 39, 83, 130–31, 136
time of day 43–44, 46, 48–49, 52, 54, 56, 72–73, 152
time–lapse daylight 152–55
timed exposure 34
toe 14
tonal range 120–22, 124, 130, 136, 146, 202
tone–mapping 137, 140–45, 148, 150–51, 154–55, 159, 162
top–lighting 202, 208
Totalites 96
translucency 174–75
transparency 174–75
tripods 34, 71, 113, 132, 137, 152, 165, 176–77
tropical sunlight 48–49, 58, 203
tungsten light 10, 20–21, 36, 78, 82, 97, 100, 152, 201
twilight 68–71

U

ultraviolet 113–14
under–exposure 25, 32, 38–39, 72, 74, 92, 134

V

vapour discharge lamps 11, 19–20, 77, 84–86, 98
video lights 96
vignetting 196

W

Ward, Greg 138–39
wavelengths 18–20, 113–14
weather 42, 44, 46, 50–51, 54, 56–58, 60, 64–66, 68, 124, 162
Weston, Edward 208
white balance 9, 36–39, 44, 72, 77–78, 80, 82–84, 86–87, 113, 117–18, 165
white point 122, 124–25
wide–angle 16, 206
wild–life 91
wind 51, 53
window light 106, 169, 213

Z

zenith 43, 46